A M E R I C A
A V I S U A L J O U R N E Y

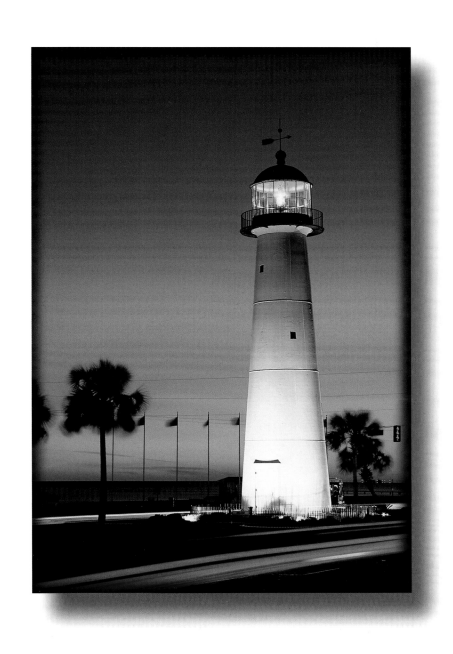

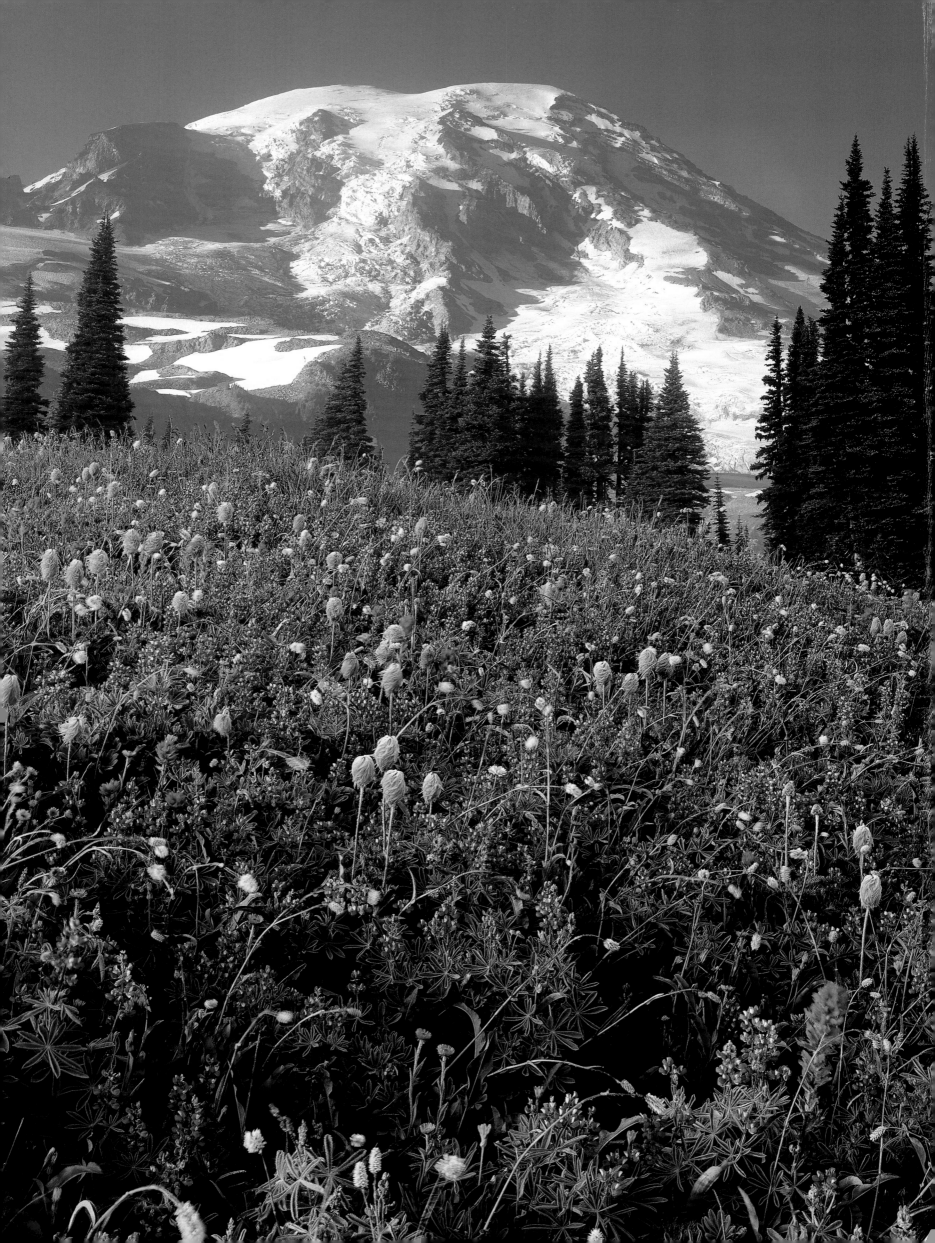

AMERICA
A VISUAL JOURNEY

WHITECAP BOOKS

Text by Tanya Lloyd Kyi
Edited by Elaine Jones
Reviewed by Michelle Roehm McCann
Proofread by Lisa Collins
Cover design by Tanya Lloyd / Spotlight Designs
Interior design by Margaret Lee / bamboosilk.com

Printed and bound in Canada

NATIONAL LIBRARY OF CANADA CATALOGUING IN PUBLICATION DATA

Kyi, Tanya Lloyd, 1973-
 America

 Includes index.
 ISBN 1-55285-345-4

 1. United States—Pictorial works. I. Title.
E169.04.K94 2002 973.931'022'2 C2002-910015-1

The publisher acknowledges the support of the Canada Council and the Cultural Services Branch
of the Government of British Columbia in making this publication possible. We acknowledge the
financial support of the Government of Canada through the Book Publishing Industry Development
Program for our publishing activities.

For more information on other Whitecap Books titles,
please visit our web site at www.whitecap.ca

Biloxi Lighthouse sent its first beams over Mississippi Sound in 1848. By the 1890s, four seafood
canneries had joined the beacon along the shoreline, and the city was the world's largest
exporter of oysters by 1910. More recently, shoreline casinos have replaced the fisheries as
the area has become one of the nation's fastest-growing regions. *(page 1)*

According to a legend told by the native people of the Pacific coast, Ocean was desperate to keep
his children, Rain and Cloud, close to home. He created a massive barrier of earth, too high for
them to cross. Today, we know that barrier as Washington's Cascades, where Mount Rainier rises
far above all other peaks to a majestic 14,410 feet. A national park has protected the mountain's
slopes since 1897. *(page 2)*

Archeologists believe that the earliest residents of Canyon de Chelly National Monument
departed about A.D. 1200, for reasons no one today understands. They left behind their elaborate
cliffside villages, sheltered by the canyon's towering red walls. The preserve that now protects
these sites is jointly managed by the federal government and the Navajo Nation. *(right)*

In 1886, the people of France presented the people of America with the Statue of Liberty, one
of the world's most recognized symbols of democracy. Sculptor Frederic Auguste Bartholdi
designed the work with the engineering expertise of Alexandre Gustave Eiffel, creator of the
Eiffel Tower. From the ground to the tip of her torch, Lady Liberty stands 305 feet high and
visitors gain panoramic views from the observation deck in the crown. *(overleaf)*

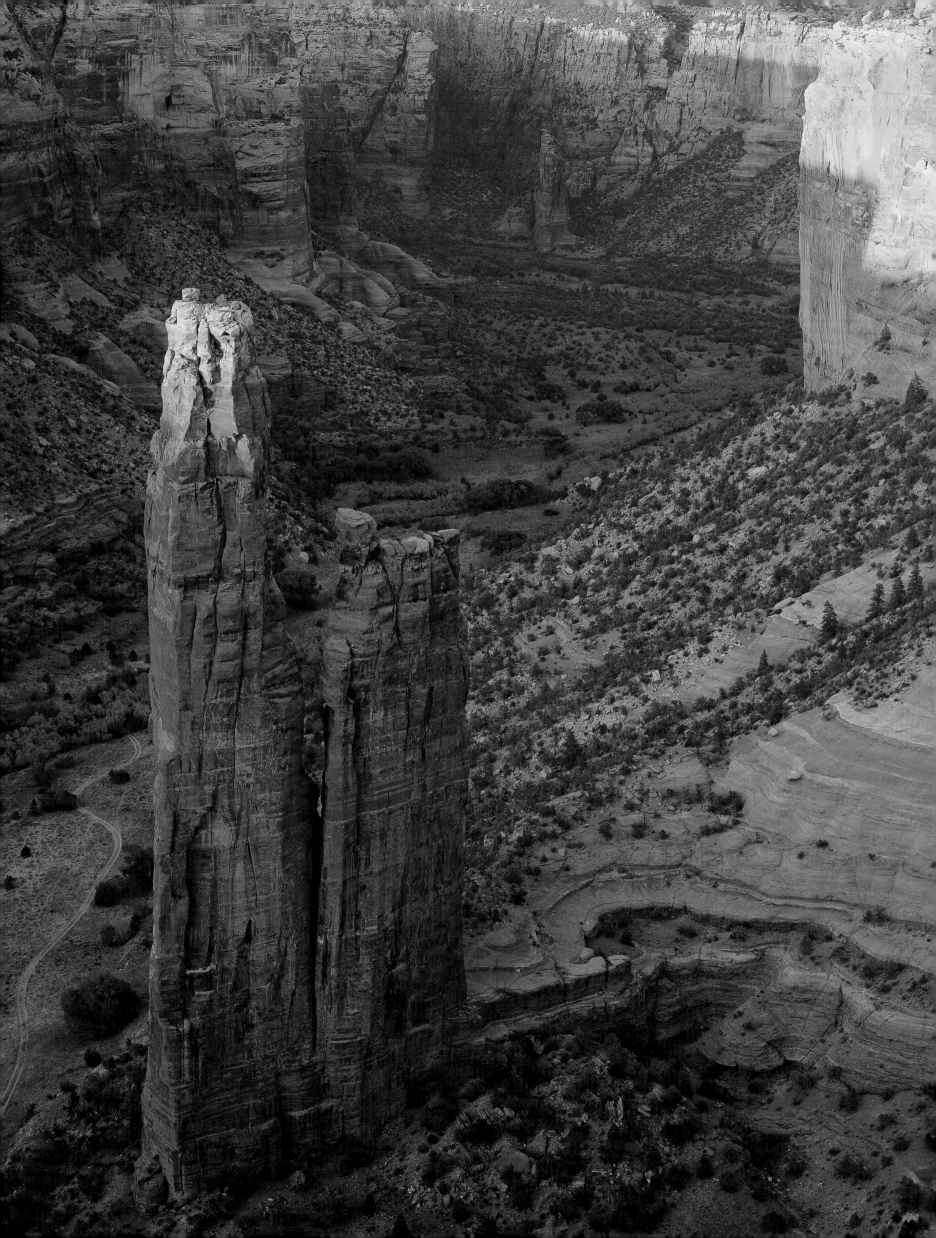

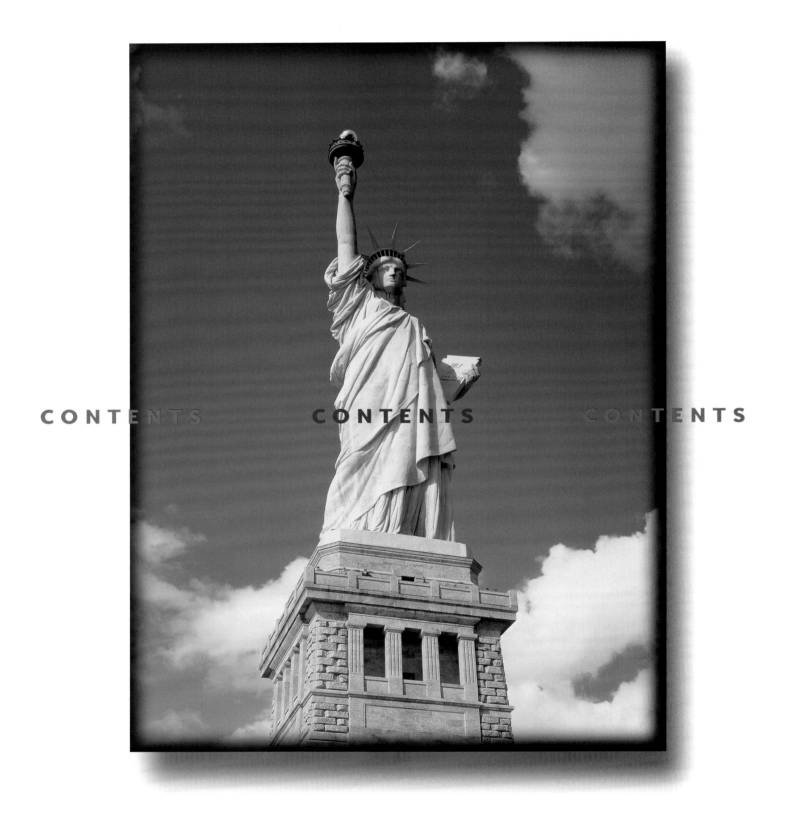

CONTENTS CONTENTS CONTENTS

IT TOOK EUROPEAN EXPLORERS CENTURIES TO realize the breadth and scope of this land. Spanish sailors skirting the Atlantic coast in the early 1500s, stocking their holds with sea turtles and charting the shores of the Florida Keys, would never have imagined that islands half a world away would one day be part of the same nation. In fact, they did not yet guess the existence of Hawaii. Captain James Cook would not reach these islands for another two centuries.

A M E R I C A
A V I S U A L J O U R N E Y

Even in the late 1700s, when America's eastern coast was dotted with farming towns and fishing villages, when thirteen newborn states won their independence from Britain, when Thomas Jefferson penned the Declaration of Independence, few paused to think beyond the Appalachians. No one imagined the northern coastlines of Alaska, then home to native peoples and a tiny village of hardy Russian settlers. Few even thought of the great plains of the west. It wasn't until 1805, when Shoshone guide Sacagawea strapped her baby to her back and took army officers Meriwether Lewis and William Clark on an unprecedented transcontinental journey, that most Americans began to realize the extent of the continent.

How could they have known? Before the railway forged through the mountain passes, before highways girded the

towns, and long before jets crisscrossed the skies, how could these new arrivals grasp numbers that seem unimaginable even now? Modern America encompasses 3,717,796 square miles, almost 40 times the land mass of Britain. This vast territory is bordered for more than 2,000 miles by the Atlantic Ocean, for 1,630 by the Gulf of Mexico, and for 1,290 by the Pacific. Alaska is skirted by another 6,640 miles of water.

Satellites and navigation instruments can now verify these numbers. They show those tiny eastern settlements

America's population grew exponentially, many of the nation's natural sites were threatened. Often, it was the will of a single individual that ensured the land's preservation. In the 1890s, explorer George Bird Grinnell watched as homesteads and mining operations ate away at the edges of the Rocky Mountain wilderness. Thanks to his efforts, the government established Glacier National Park. Behind Acadia National Park in Maine lies the vision of George B. Dorr, a New England businessman who dedicated

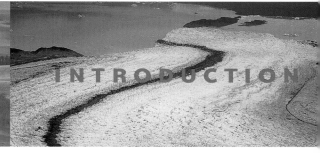

INTRODUCTION INTRODUCTION INTRODUCTION

grown into metropolises, and people traveling back and forth across the continent as if it was small. These same systems reveal some things that are unchanged. Between the human achievements — the neon lights of New York City and the Strip of Las Vegas, the Memorial Arch of St. Louis and the carved portraits of Mount Rushmore in South Dakota — there lie landmarks untouched by the centuries. On the shores of California, redwoods that were seedlings 2,000 years ago were already towering hundreds of feet high when missionaries arrived along the coast. To the Shenandoah Mountains, born when the earth's crust was thrust upward over a billion years ago, the entire history of human habitation is a mere heartbeat.

Places such as these remain unchanged by the last few centuries. Yet as progress poured over the passes and as

more than four decades to fund-raising for the preserve. Perhaps the most influential conservationist in American history was Franklin D. Roosevelt, who was so inspired by the grasslands of North Dakota that he designated 18 national monuments during his presidency.

At some point, every American is likely to fall in love with an outdoor retreat, whether it's a regional campground, a backcountry stream, or a national park. And visitors quickly discover their own favorites. The pages of *America: A Visual Journey* celebrate such places. From the glaciers of Alaska and the beaches of California to the Florida Everglades and the shores of the Great Lakes, these images honor the landscapes of a nation — both its wild spaces and its communities — which remain as diverse as its people.

THE NORTHEAST THE NORTHEAST THE NORTHEAST

THE NORTHEAST THE NORTHEAST THE NORTHEAST

Maine's Pemaquid Point Light was built in 1835 to replace a deteriorating 1827 beacon. Rising 38 feet from its rock ledge, the light boasts a picturesque picket fence, restored keeper's quarters now open to the public, and abundant legends of shipwrecks, storms, and rescues.

The most enticing parts of Connecticut's history swirl in the currents of the coastal harbors and river mouths. Here, ships and shoreline battlements defended a newly independent nation, the whaling industry saw its nineteenth-century peak, and fishing villages harvested the offshore bounty. *(previous pages)*

In 1901 a new invention — the gasoline-powered sawmill — threatened the forests of Maine. Affluent businessman George B. Dorr, who had spent many of his summers in Acadia, dedicated the next decade to raising funds and purchasing land in the region. A national preserve since 1916, Acadia National Park highlights the geography and natural history of Maine's rugged coastline. *(overleaf)*

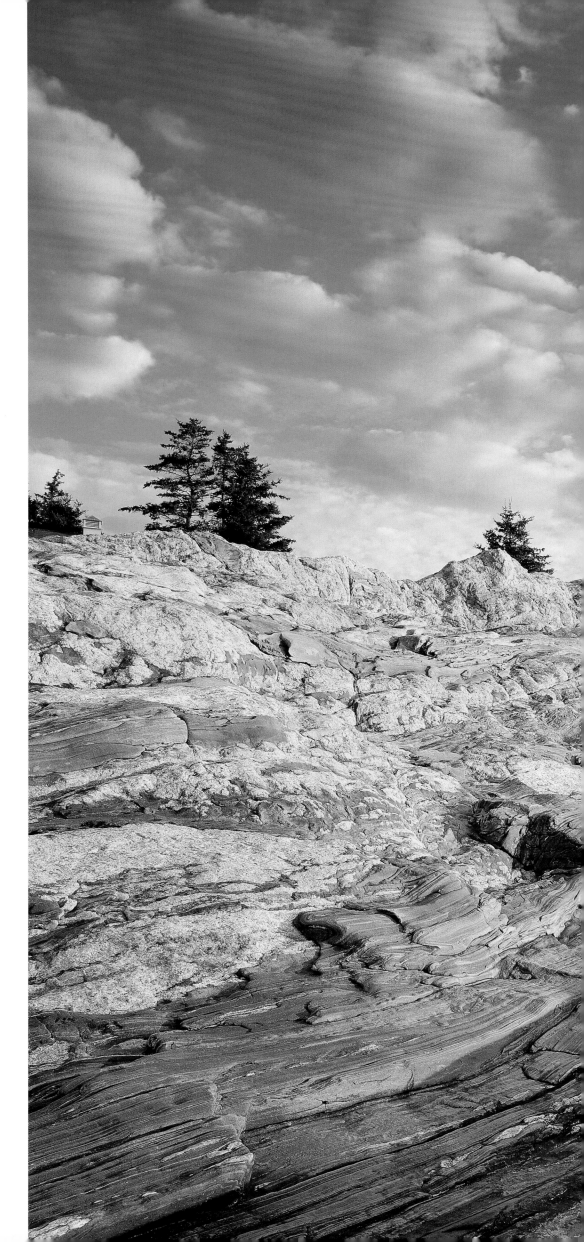

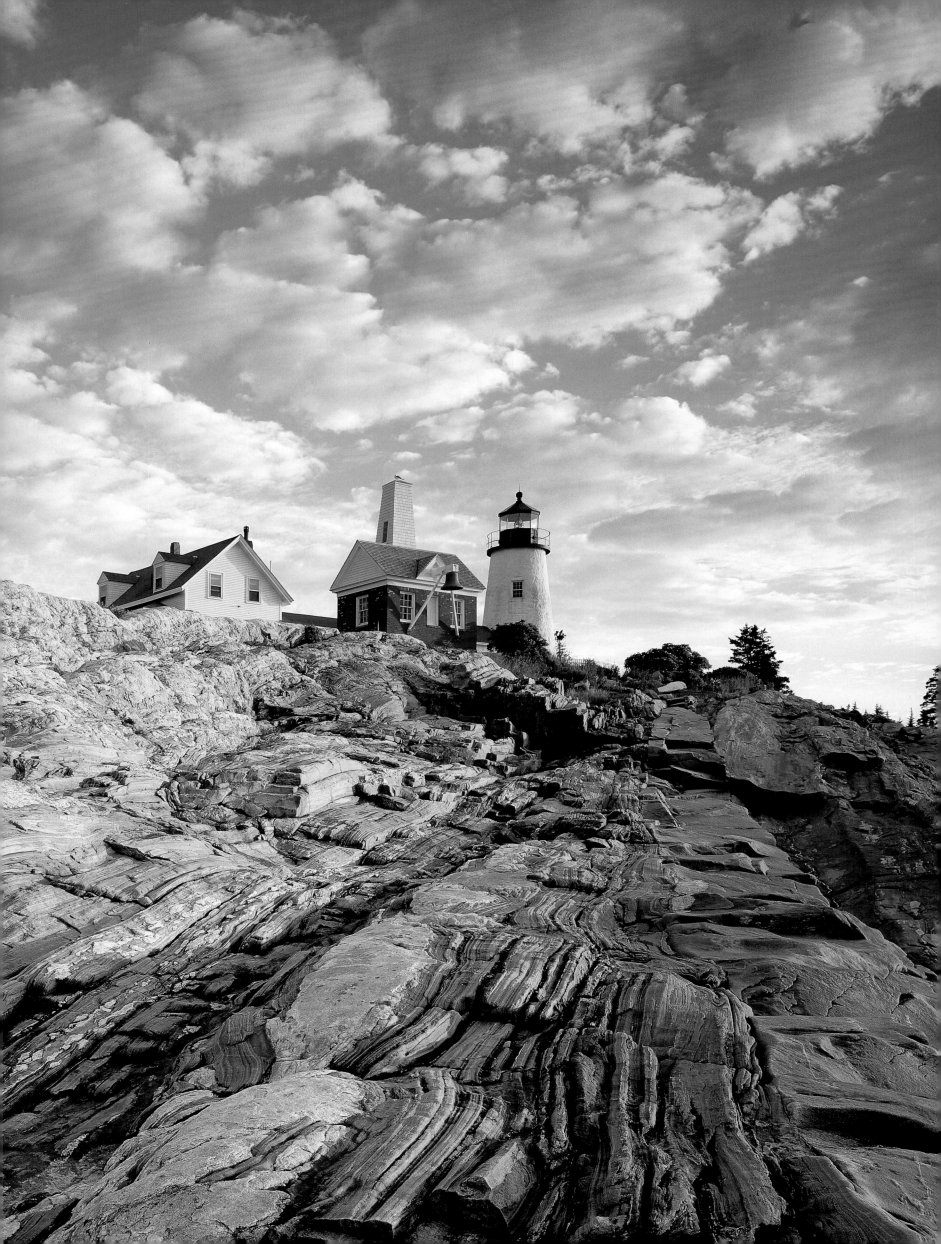

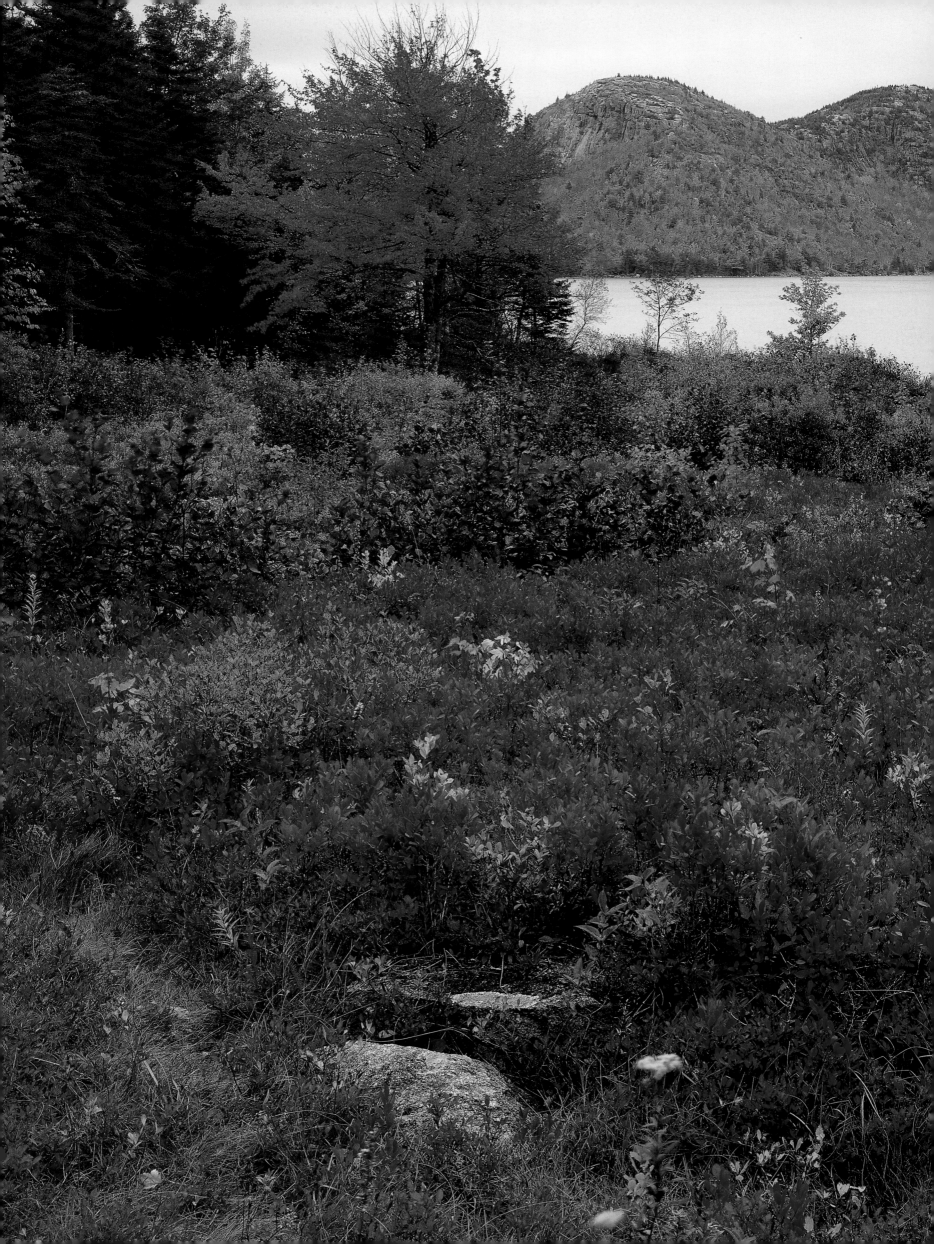

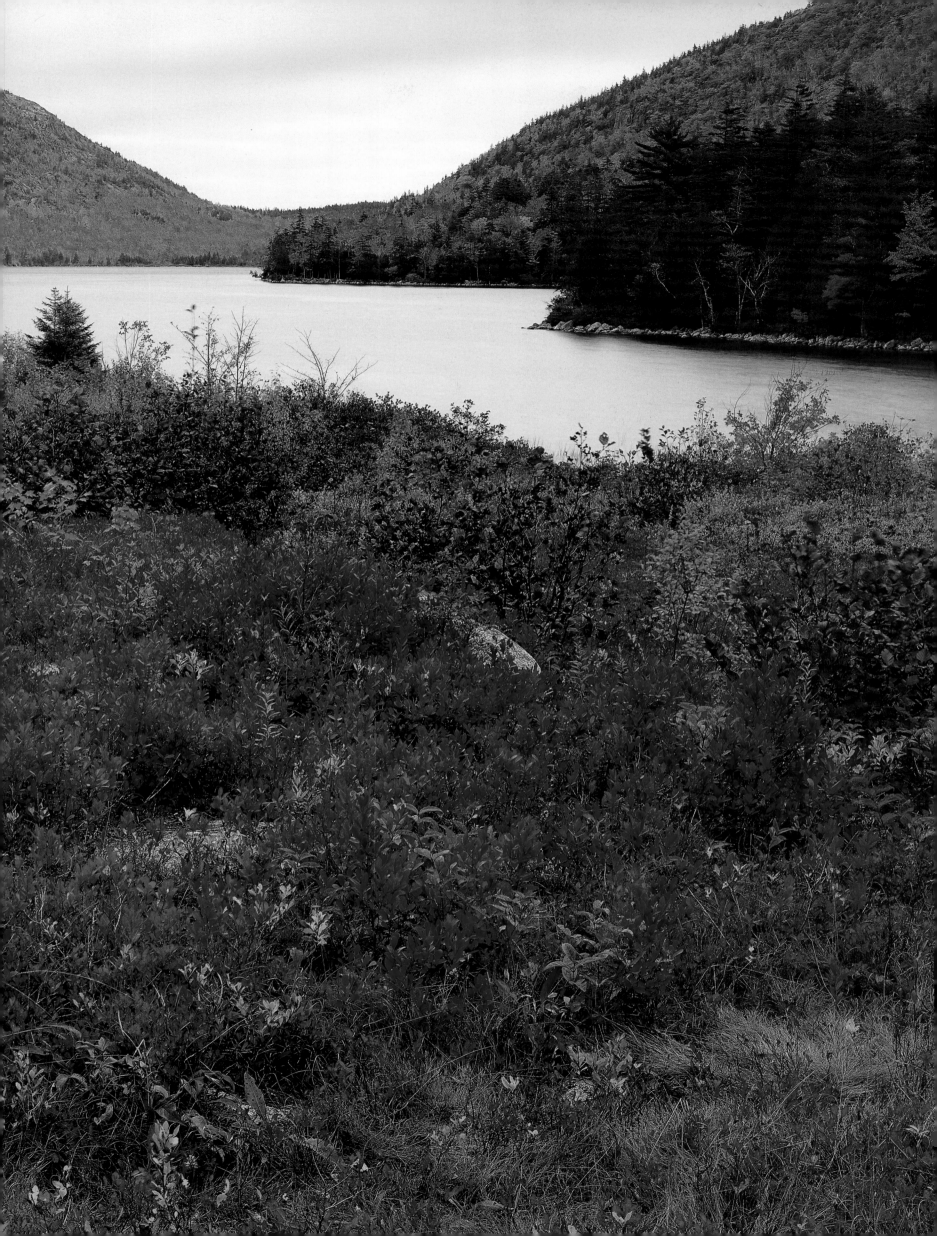

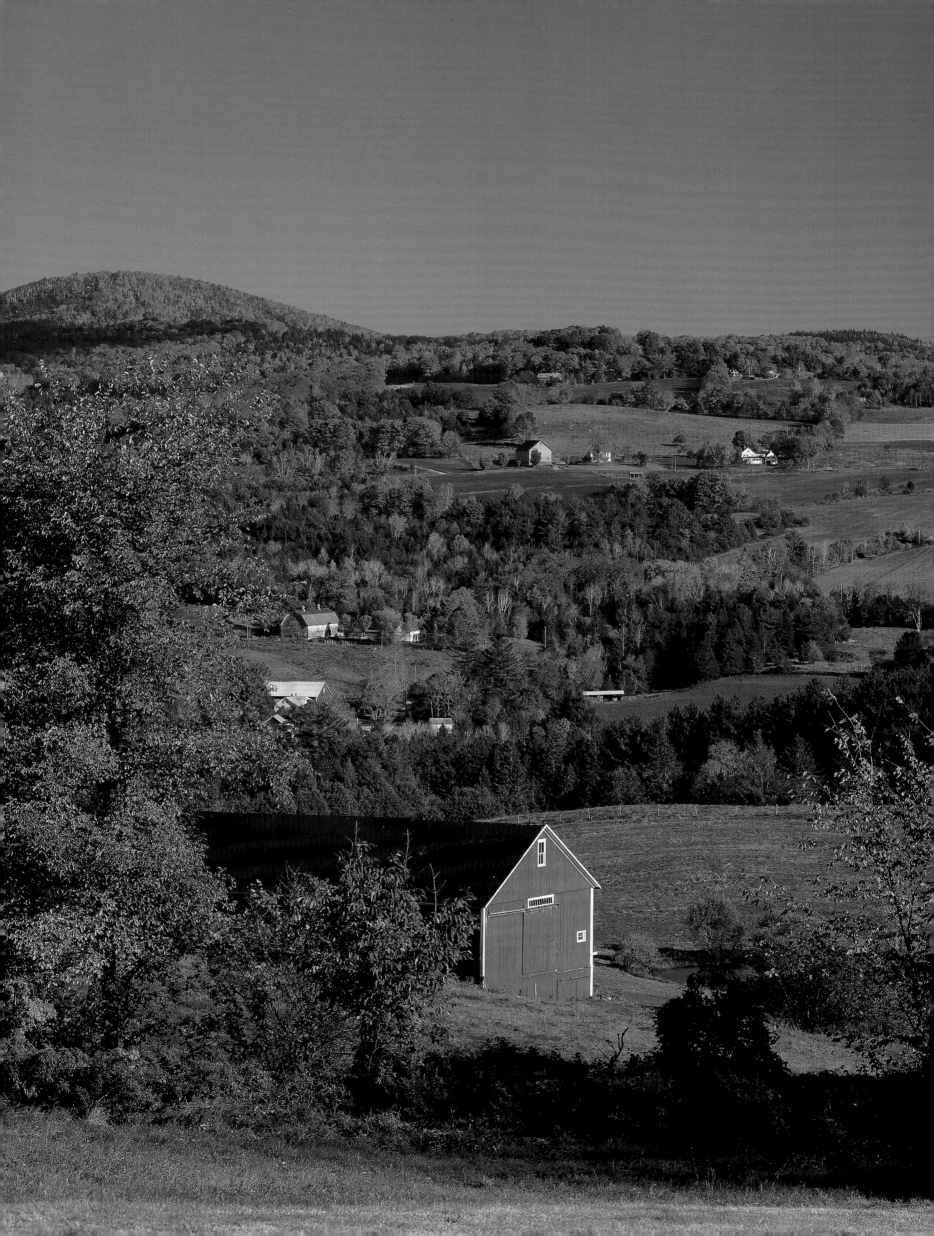

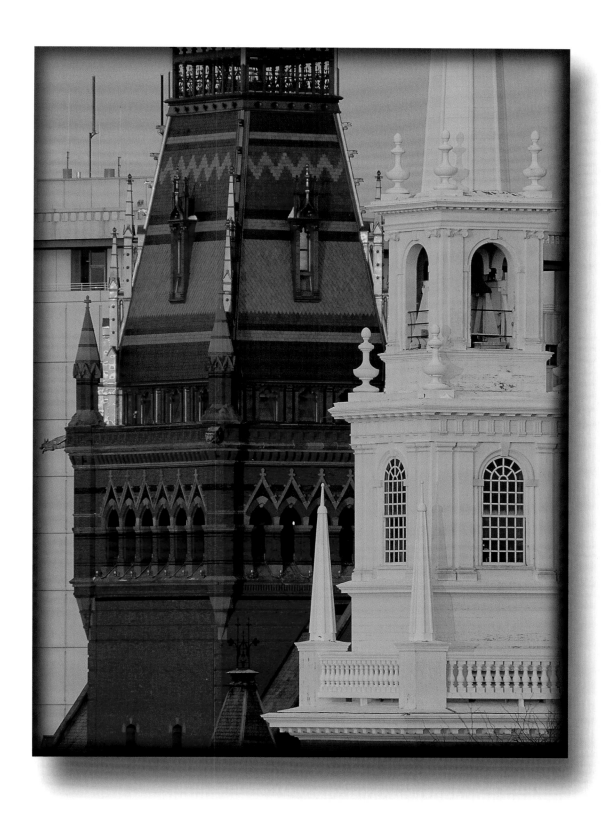

America's first university, Harvard was founded in 1636 (only 16 years after the Pilgrims arrived) with nine students and a single instructor. Today, more than 18,000 students attend classes, and alumni include six U.S. presidents. The university is named for John Harvard, a minister who bequeathed half of his estate and his entire collection of books to the fledgling school in 1638.

Vibrant fall colors, rolling fields, and quaint village greens have made the landscapes of Vermont famous. About 6,000 farms here produce most of America's maple syrup and more than half of New England's milk, along with bountiful crops of apples, potatoes, honey, and vegetables. *(left)*

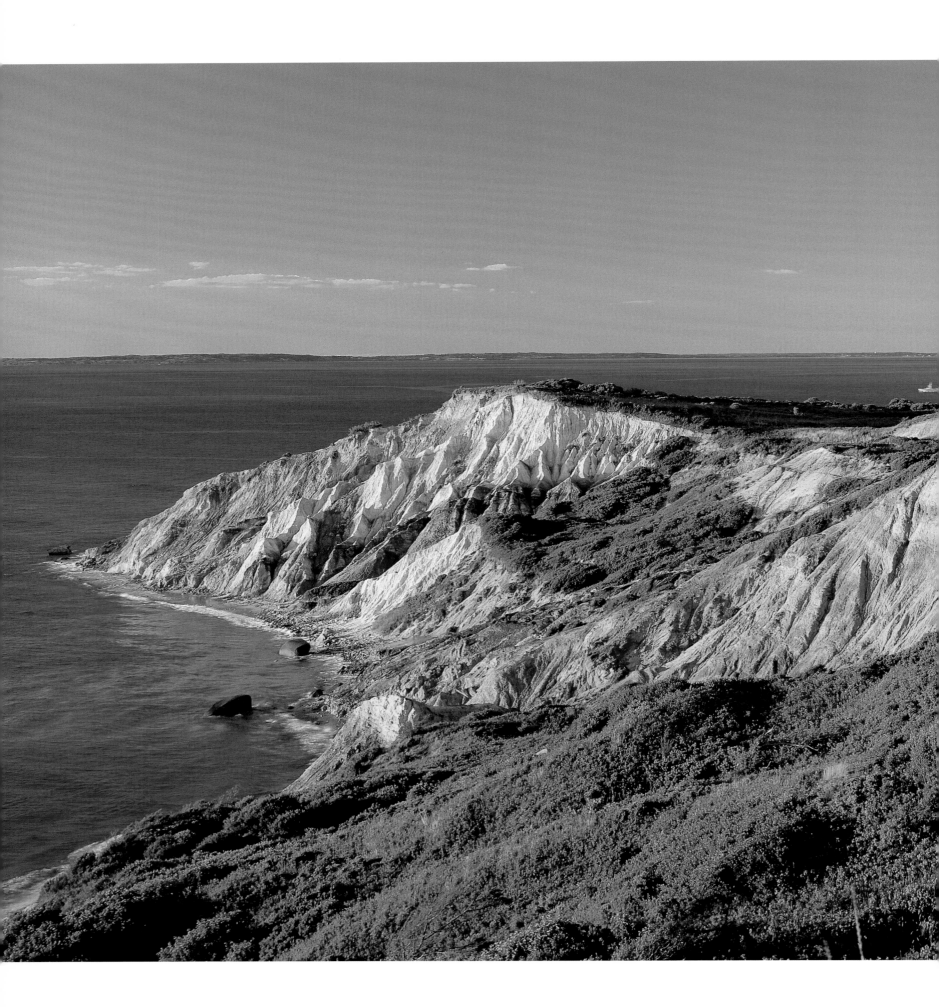

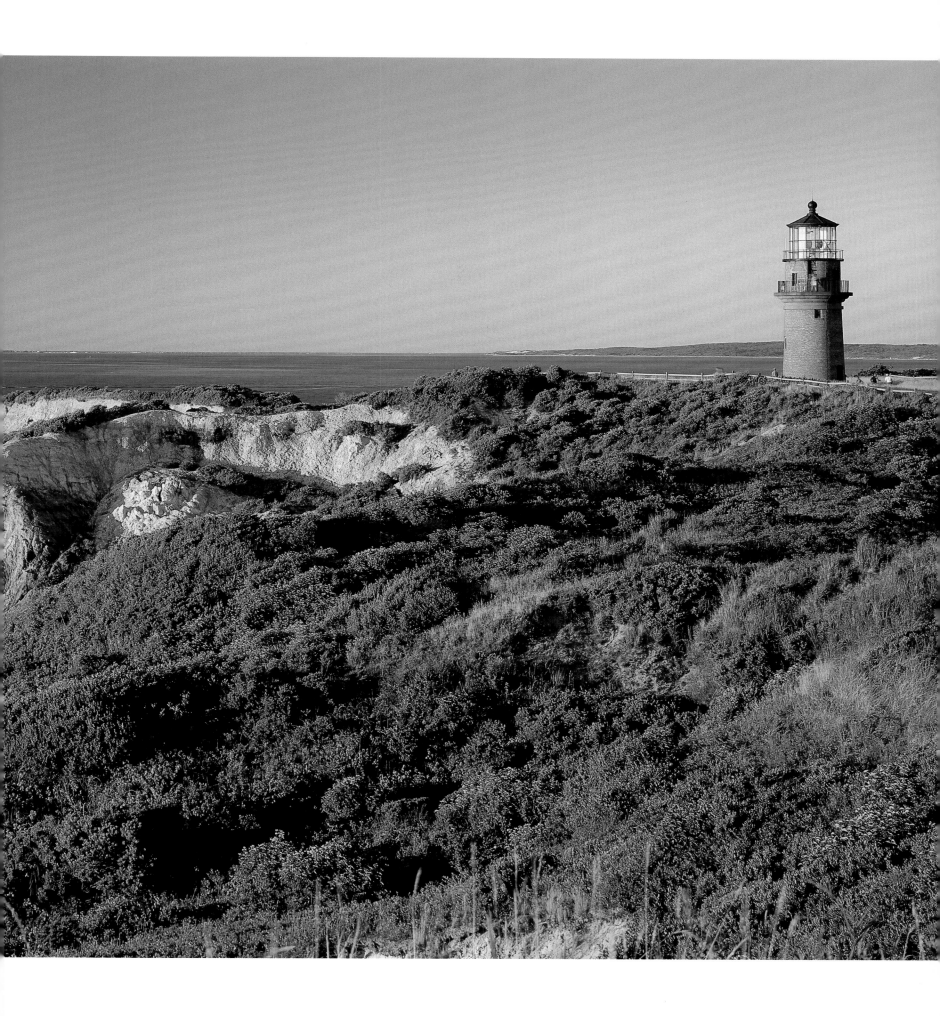

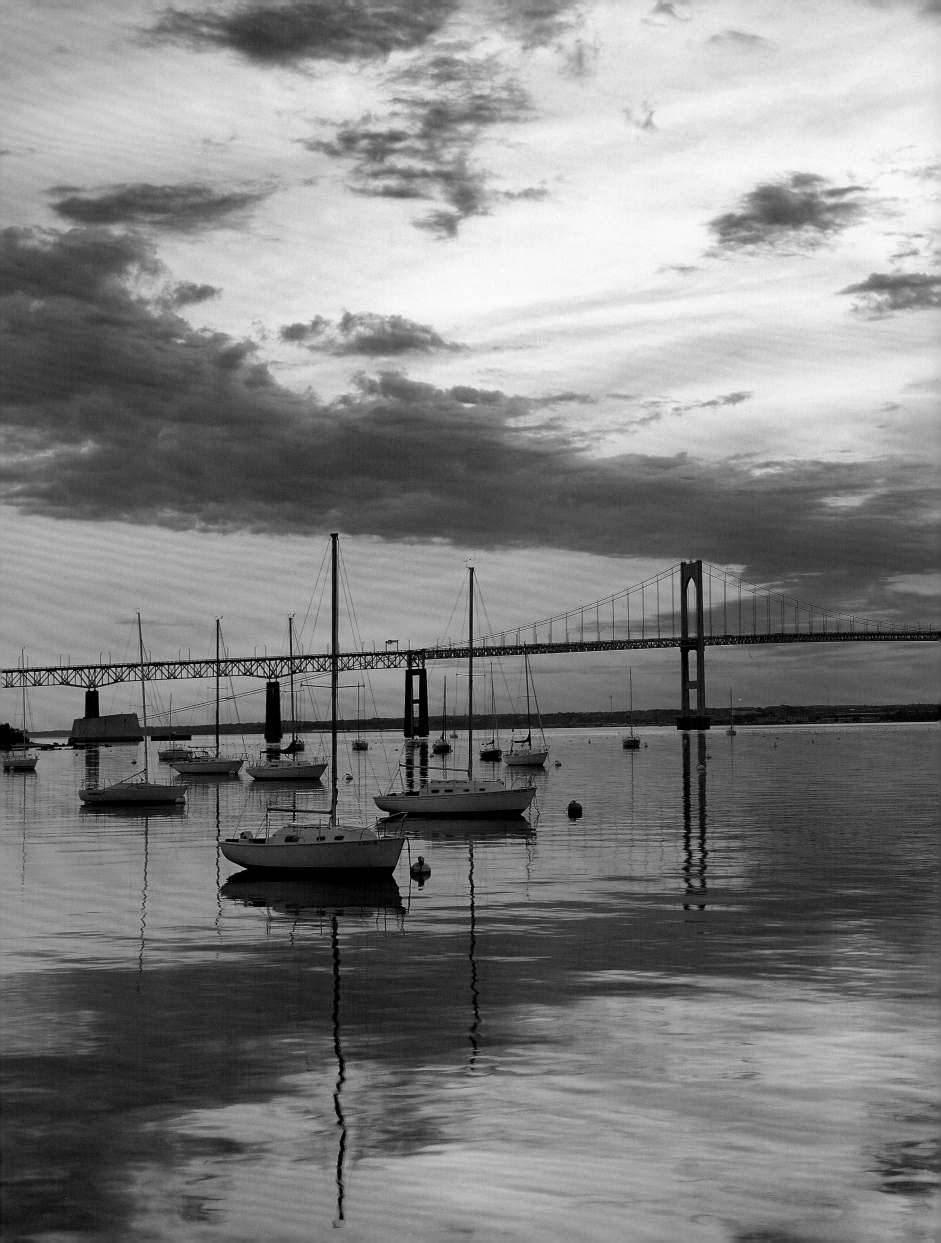

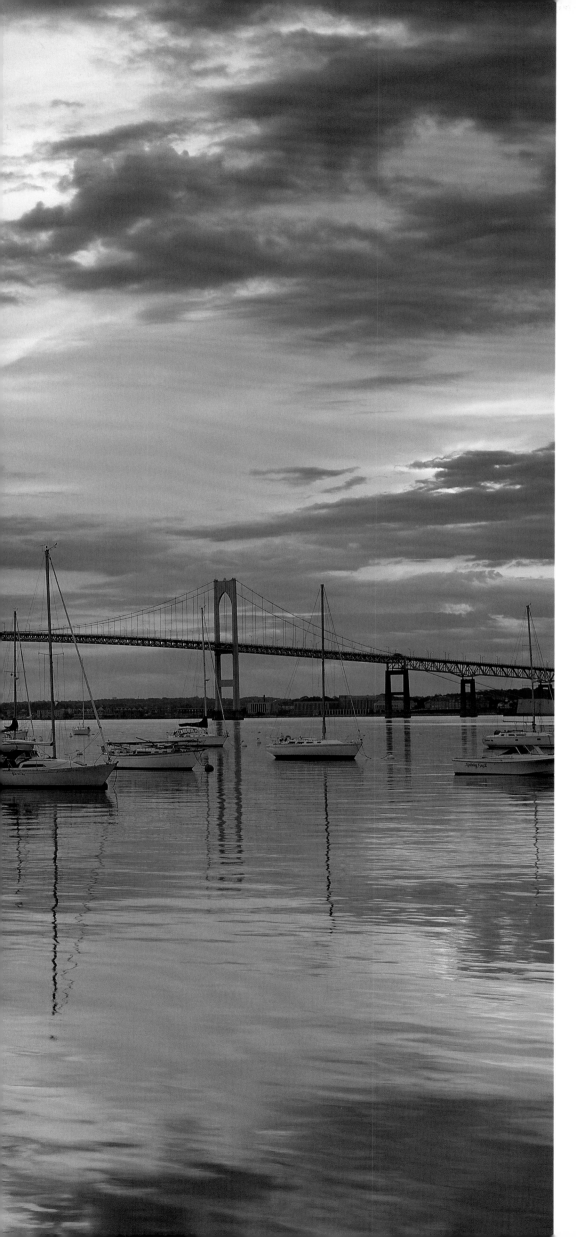

Roger Williams established the first European settlement in Rhode Island in 1636, after the Puritans of New England banished him for religious dissent. Today, Rhode Island is the smallest state in the nation but, with more than a million residents, one of the most densely populated. Summer visitors use historic Jamestown as a base from which to explore the island's bays and beaches.

Only seven miles from the Massachusetts mainland, Martha's Vineyard offers everything a New England visitor could want — quaint village shops, sunny beaches, historic inns, and five unique lighthouses. This one, standing guard atop the Aquinnah cliffs, was built in 1856. *(previous pages)*

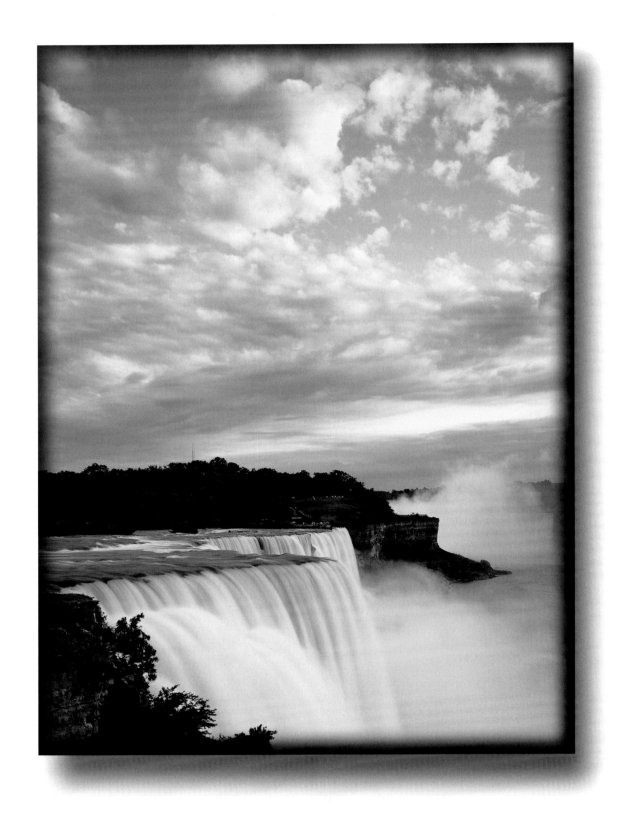

Thundering over the 182-foot cliffs of the Niagara Escarpment, Niagara Falls spans the border between New York and Canada. Sam Patch leapt unprotected into the falls twice in 1829 and survived, only to die a year later attempting to conquer New York's Genesse Falls. The first person to tightrope across Niagara Falls was European acrobat Jean Francois Gravelet — the "Great Blondin" — in 1859.

Bordered by the towering peaks of the Presidential Range, New Hampshire's Great Gulf Wilderness is a 5,552-acre oasis, free of logging, motorized vehicles, and even roads. The preserve is part of White Mountain National Forest, a hiking destination so popular that it draws more sightseers than Yellowstone and Yosemite national parks combined. *(right)*

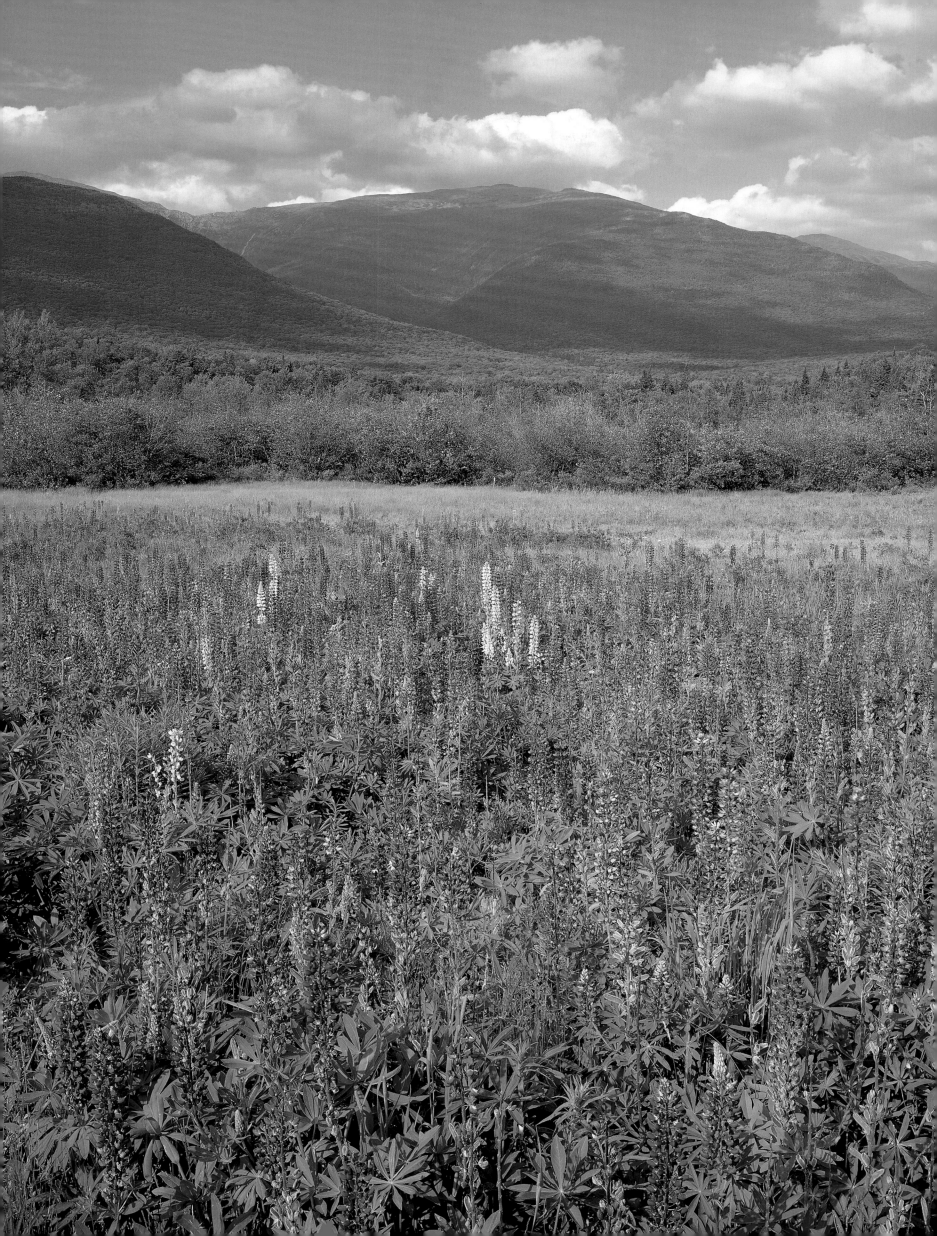

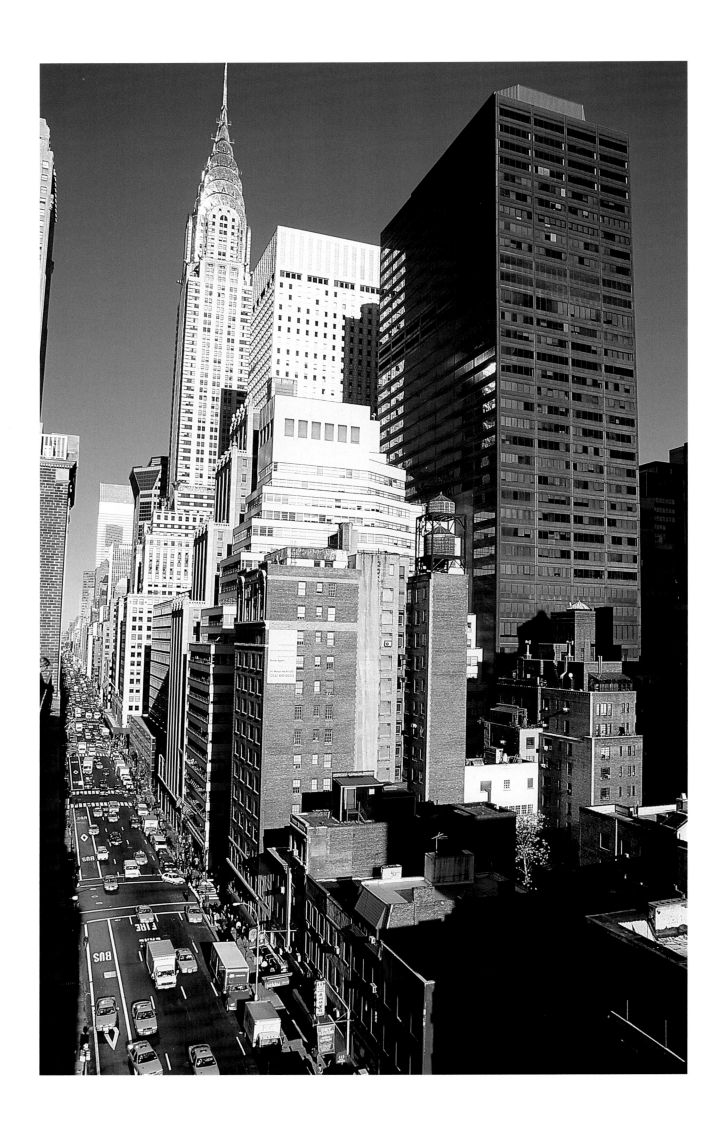

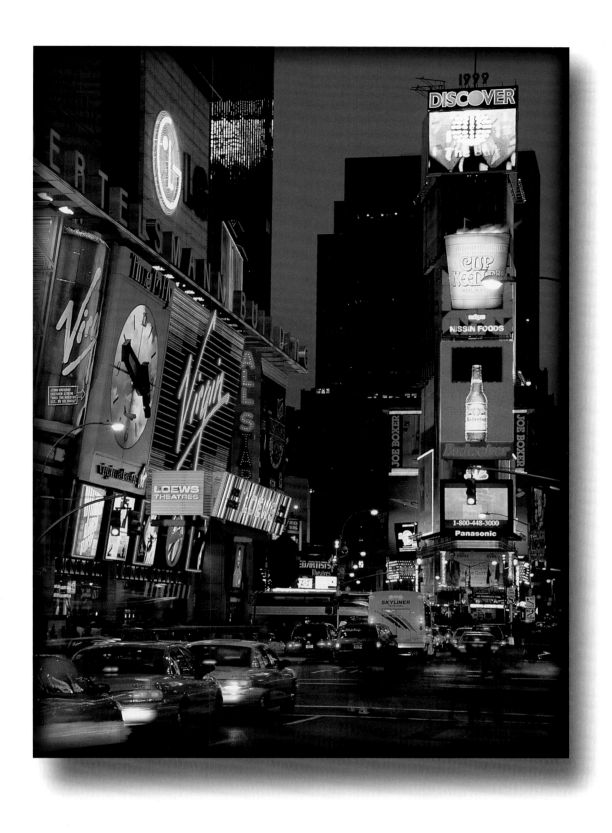

From the marquees of Broadway to the lights of Times Square, New York — the city that never sleeps — has 400 neighborhoods, 18,000 restaurants, 150 museums, and almost 200 performance venues. The cabs that swerve through the metropolis's 6,374 miles of streets have been yellow since 1907, when John Hertz read that this was the easiest color to see and founded the Yellow Cab Company.

The 1,046-foot Chrysler Building, completed in 1930, was the tallest in the world for a few months before the Empire State Building surpassed it. The tip of the skyscraper's gleaming stainless steel façade features triangular windows decorating seven arches, which narrow to a final spire. In the midst of the city's skyscraper craze, the builder and the architect of the Chrysler Building kept the decorative design a secret until it was erected in under two hours. *(left)*

THE MID-ATLANTIC STATES THE MID-ATLANTIC STATES

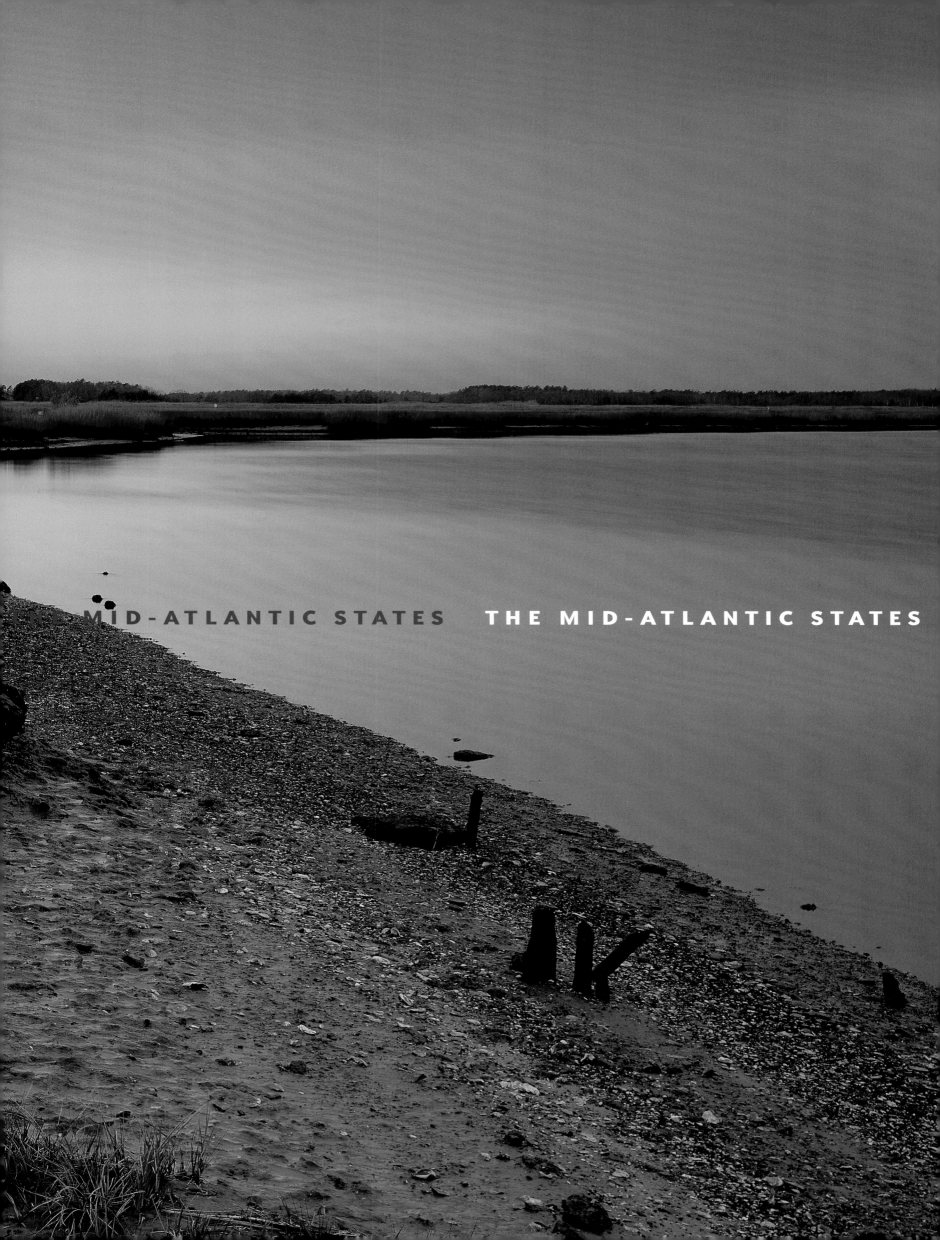

MID-ATLANTIC STATES THE MID-ATLANTIC STATES

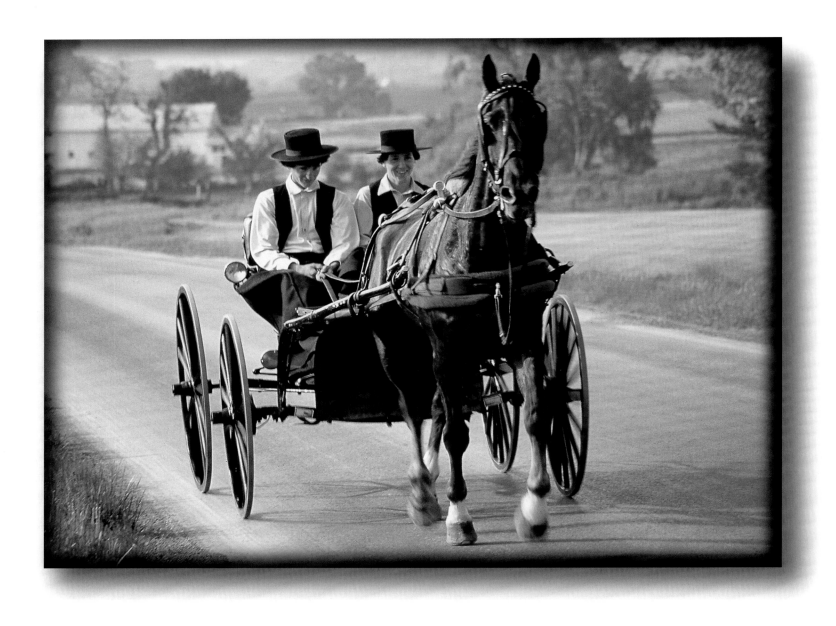

Pennsylvania has a long history of diversity and tolerance, born when Quaker William Penn left Britain and established a settlement here in the 1660s. Today's Pennsylvania Dutch — members of Amish, Mennonite, and Brethren sects — have farmed in Lancaster County in southeastern Pennsylvania for centuries, descendants of families who fled religious persecution in Europe.

Delaware Water Gap National Recreation Area protects 40 miles of the Delaware River along with 70,000 acres of the New Jersey and Pennsylvania shorelines. The river itself remains largely pristine — it is one of the last major waterways in America without hydroelectric dams — and scientists have recorded 1,086 plant, 221 bird, and 46 mammal species within the preserve. *(right)*

Dawn highlights the wetlands that surround Broadkill River as it winds its way to the mouth of Delaware Bay and the Atlantic Ocean. A low plain extends along Delaware's 18-mile coastline — in fact, the average elevation of the entire state is only 60 feet above sea level. *(previous pages)*

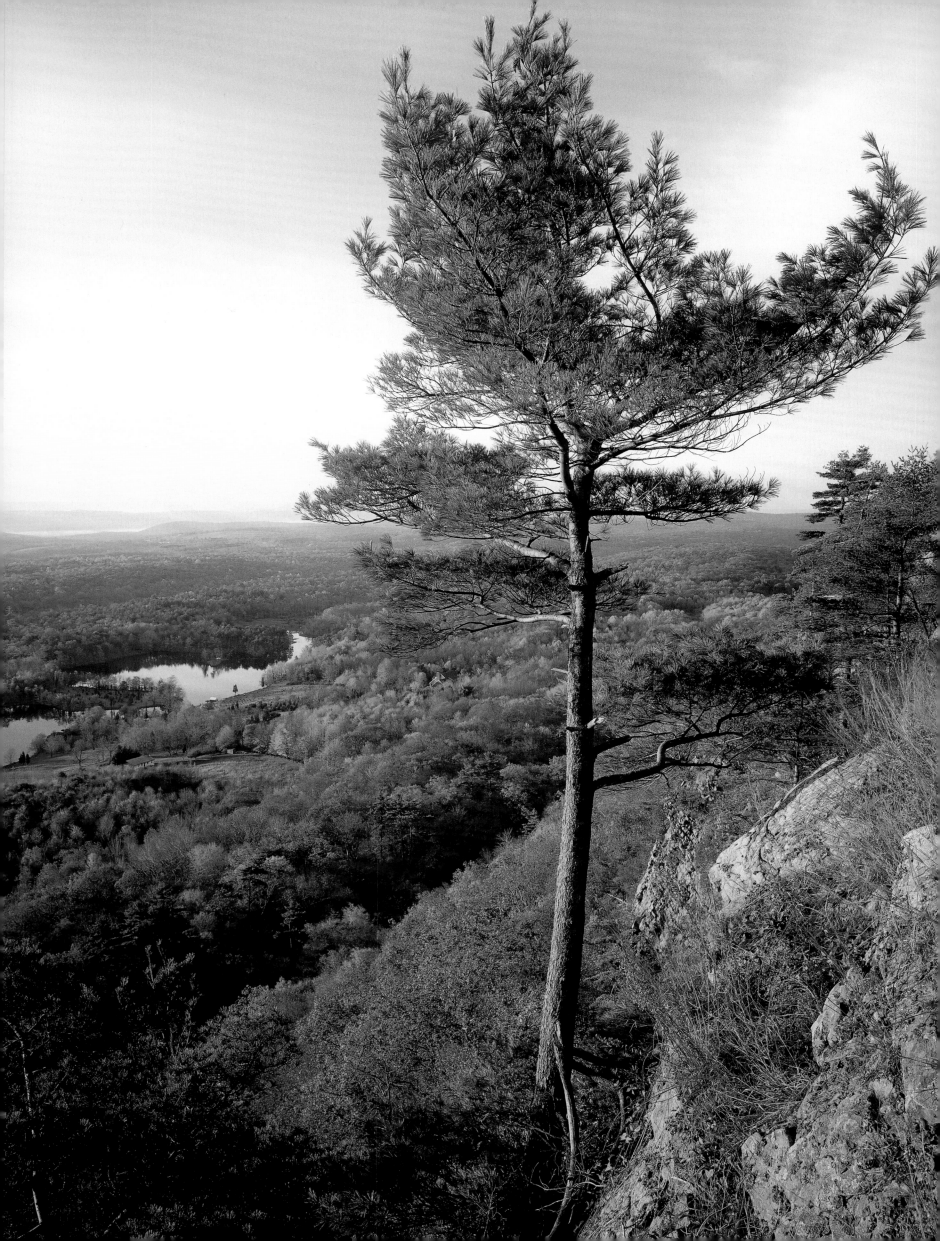

Many of Baltimore's shops and attractions are clustered around the city's bustling Inner Harbor. As one of the country's largest cities in the nineteenth century, Baltimore was home to countless American firsts, including the first gaslight company in 1817, umbrella factory in 1828, public girls' high schools in 1844, and electric elevator in 1856.

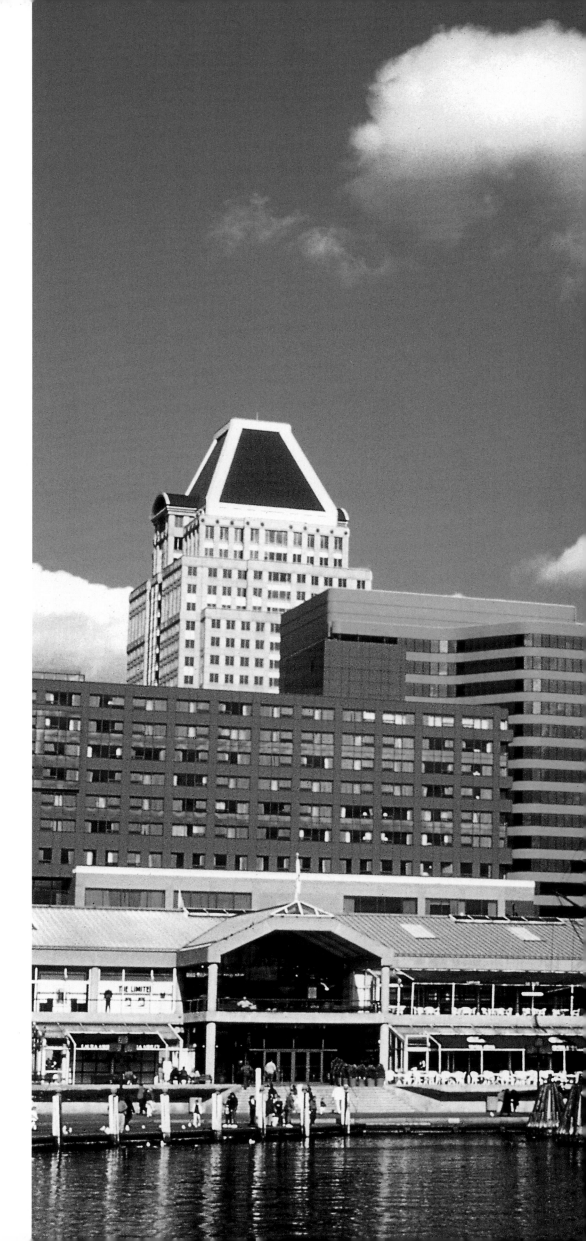

As British forces attacked Maryland's Fort McHenry in 1814 and the American troops valiantly resisted, poet and lawyer Francis Scott Key penned the words to "The Star Spangled Banner." In 1939, eight years after the song became America's national anthem, the federal government declared the star-shaped fort a national monument and a historic shrine.

Billed as the nation's oldest seashore resort, New Jersey's Cape May first attracted upper-class pleasure-seekers and sunbathers in the mid-1700s. By the early 1800s, steamboats were arriving with passengers from Washington, Baltimore, Philadelphia, and New York. Thanks to minister Carl McIntire, who preserved many Victorian-era buildings in the 1960s, the town is now listed on the National Register of Historic Places. *(right)*

Seen here from across the Tidal Basin, the Jefferson Memorial in Washington, D.C., commemorates the life of the third president of the United States. Within the white marble rotunda with its 26 columns, a 19-foot statue of Thomas Jefferson sits amid excerpts of his writings, including the Declaration of Independence.

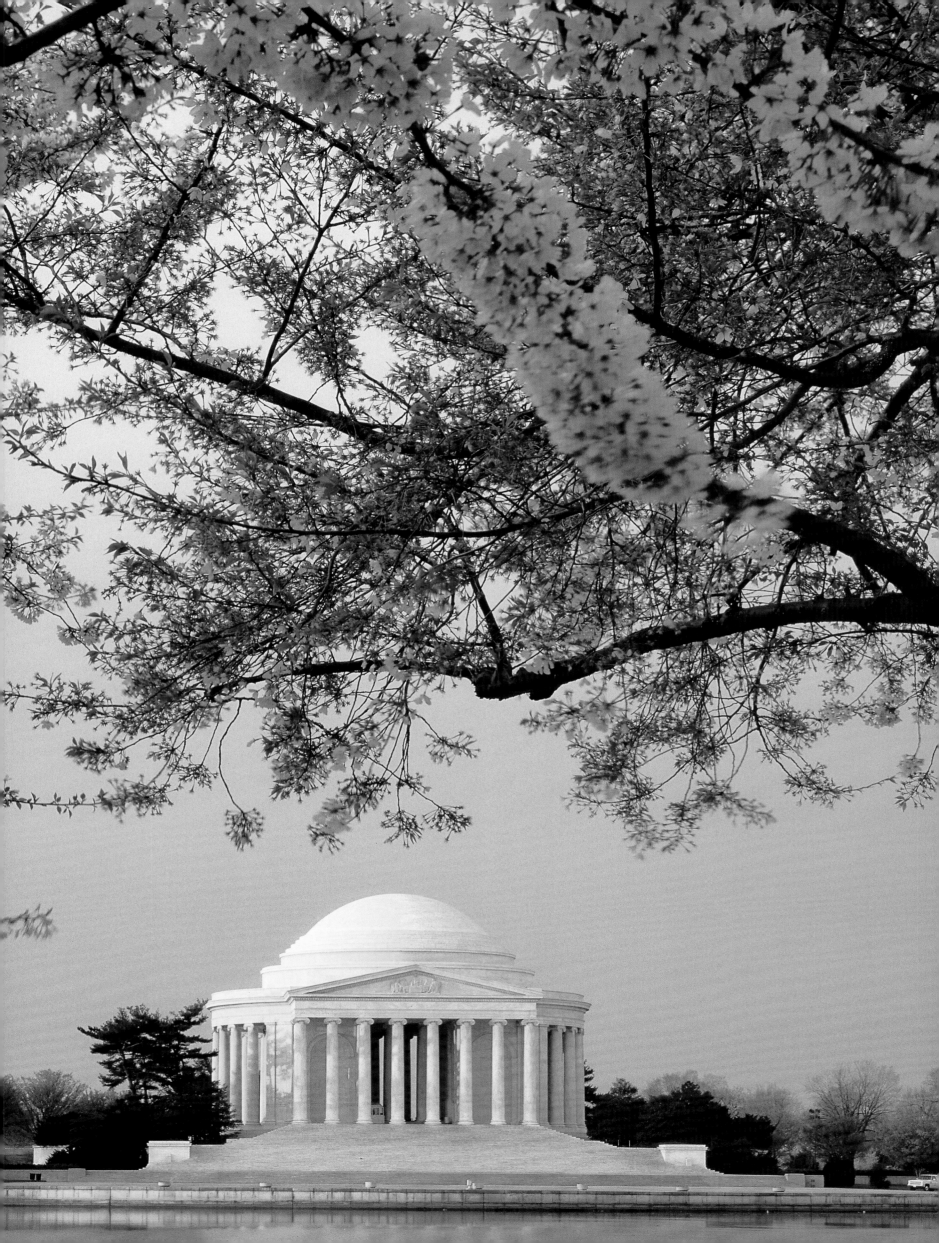

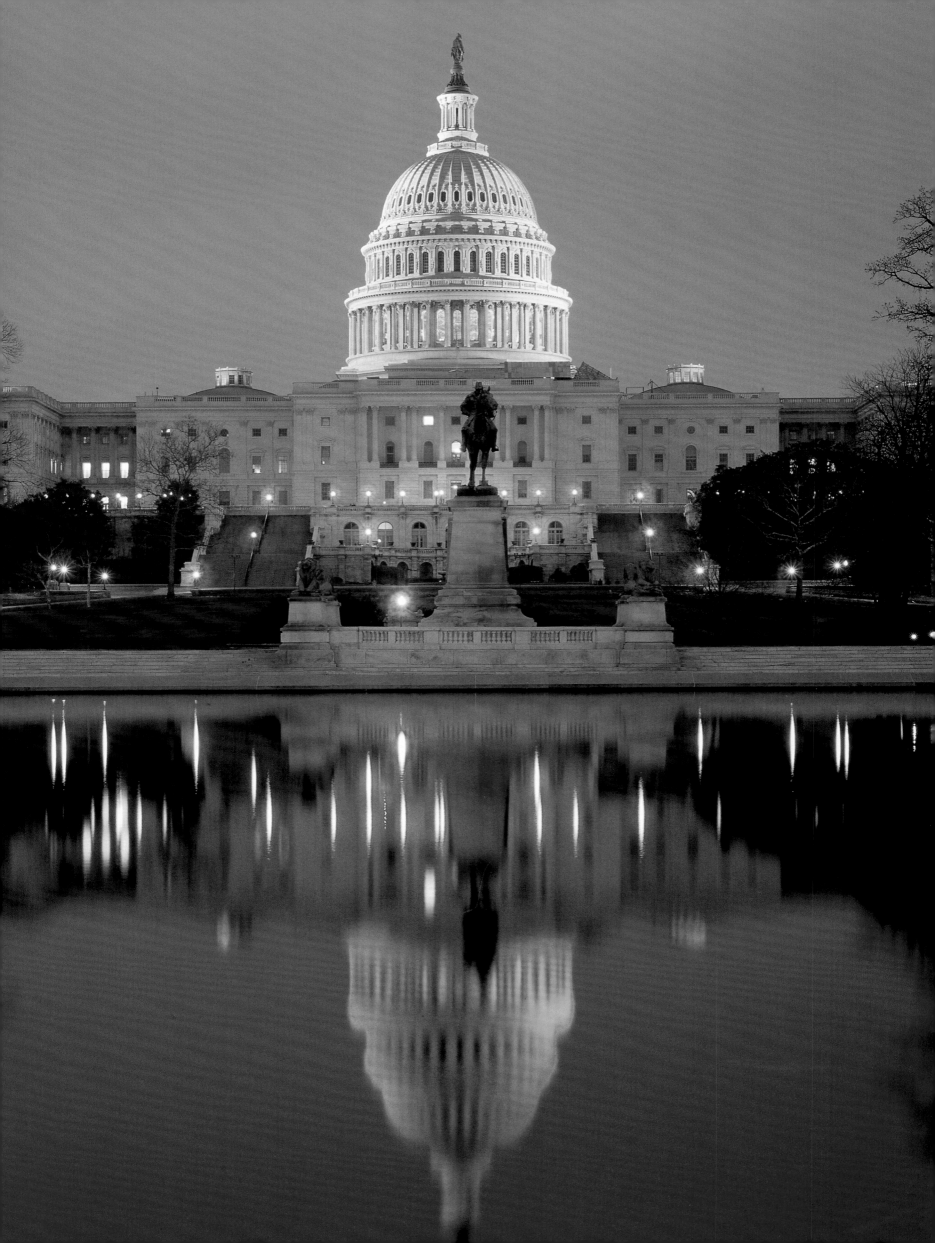

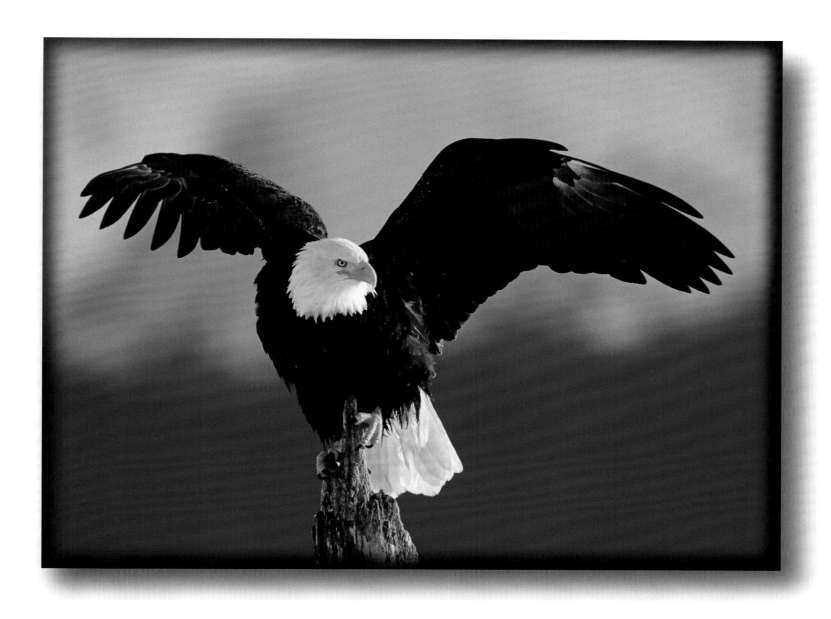

Representing freedom, strength, and majesty, the bald eagle has served as a symbol for the United States since it first appeared on the great seal in 1782 (after Benjamin Franklin lost a valiant argument for the wild turkey). Threatened by loss of habitat, pesticides, and hunting bounties, bald eagles hovered on the brink of extinction in the mid-1900s. Their numbers have slowly recovered and more than 13,000 birds now winter in the contiguous United States.

French engineer Pierre Charles L'Enfant planned the city of Washington, D.C., in the early 1790s. But when he refused to show plans for the Capitol to the city's commissioners — claiming he had all of his ideas stored in his head — the commissioners replaced his mysterious plans with the more concrete drawings of Dr. William Thornton. A series of architects supervised the construction after George Washington laid the cornerstone in 1793. *(left)*

Three ships — the *Susan Constant,* the *Godspeed,* and the *Discovery* — brought 100 colonists to Virginia Beach in 1607. From here, the new arrivals moved to Jamestown, where they founded the first English settlement in America. The first beach resort along these shores opened in the 1880s and tourists continue to flock to the sandy shores and boutique-lined streets. *(overleaf)*

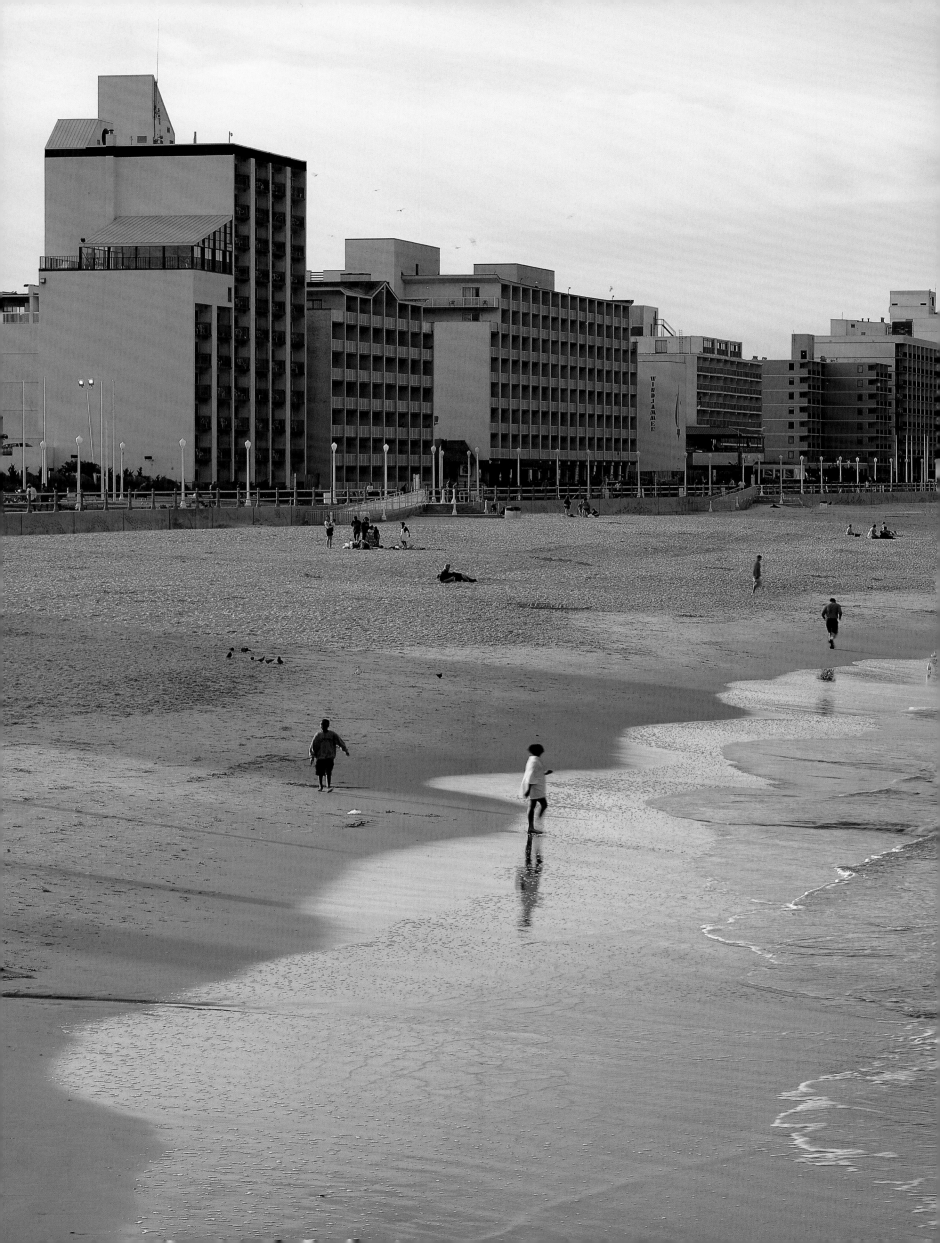

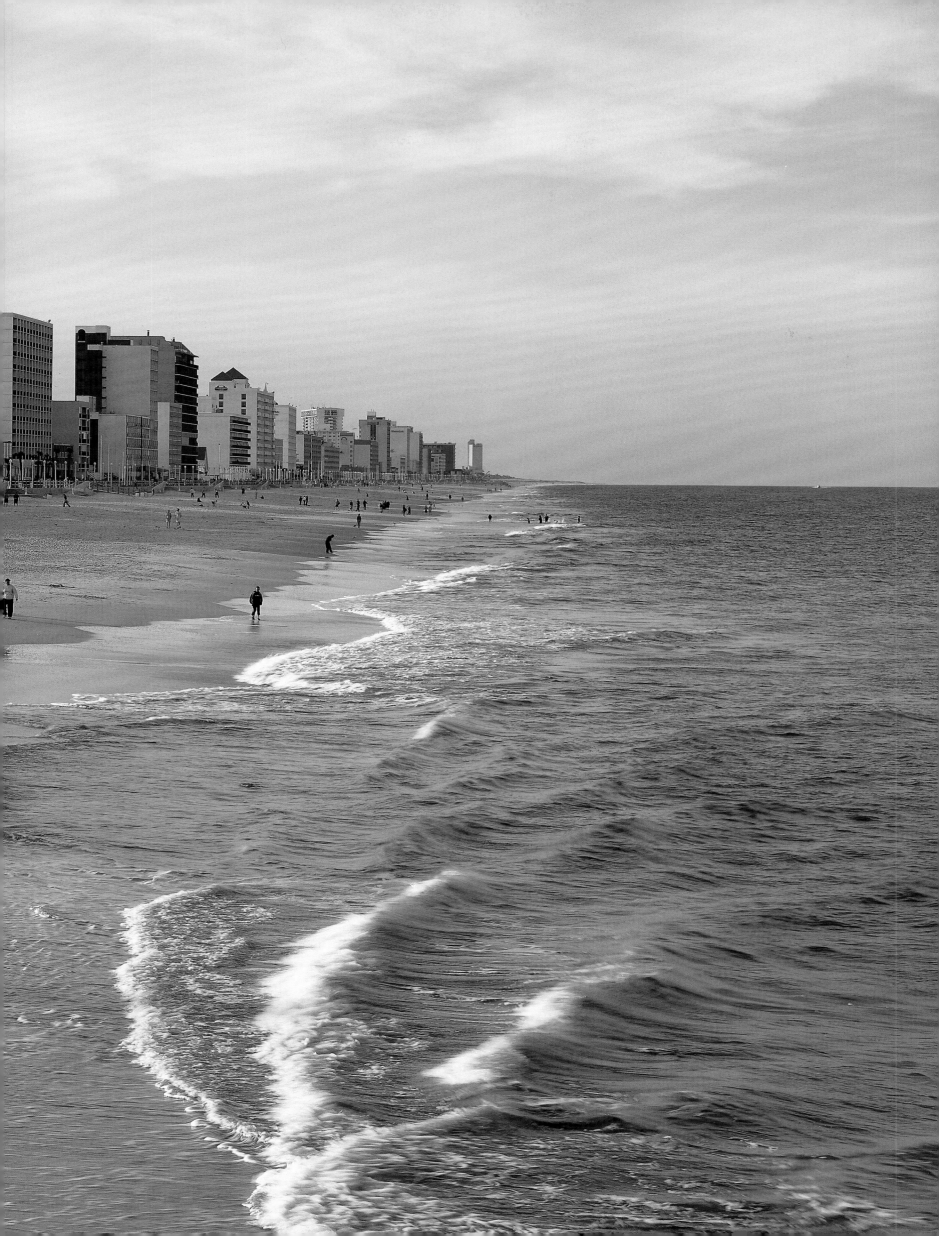

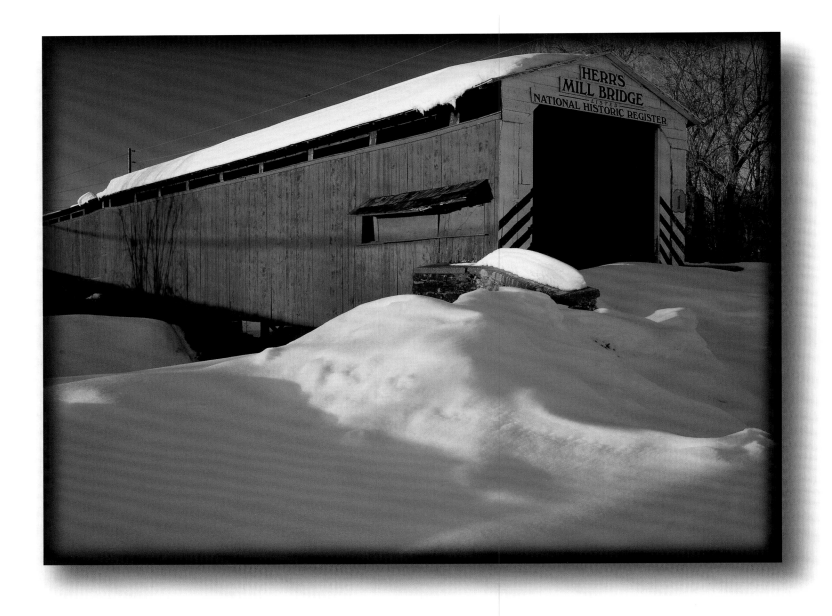

There are 219 covered bridges in Pennsylvania, more than 25 of them in Lancaster County alone. Many of the bridges, originally covered to protect the wood from rotting and to keep carriage horses from slipping on the wet boards, were built in the eighteenth and nineteenth centuries. Their shadowy recesses have earned them the nickname "kissing bridges."

Commander of the Continental Army, leader of the American Revolution, and first president of the United States — George Washington's achievements are still celebrated more than two centuries after he formed his first government. Created with American marble in the form of an Egyptian obelisk, the 555-foot monument was completed in 1884. A stairway inside leads to an upper observation deck. *(right)*

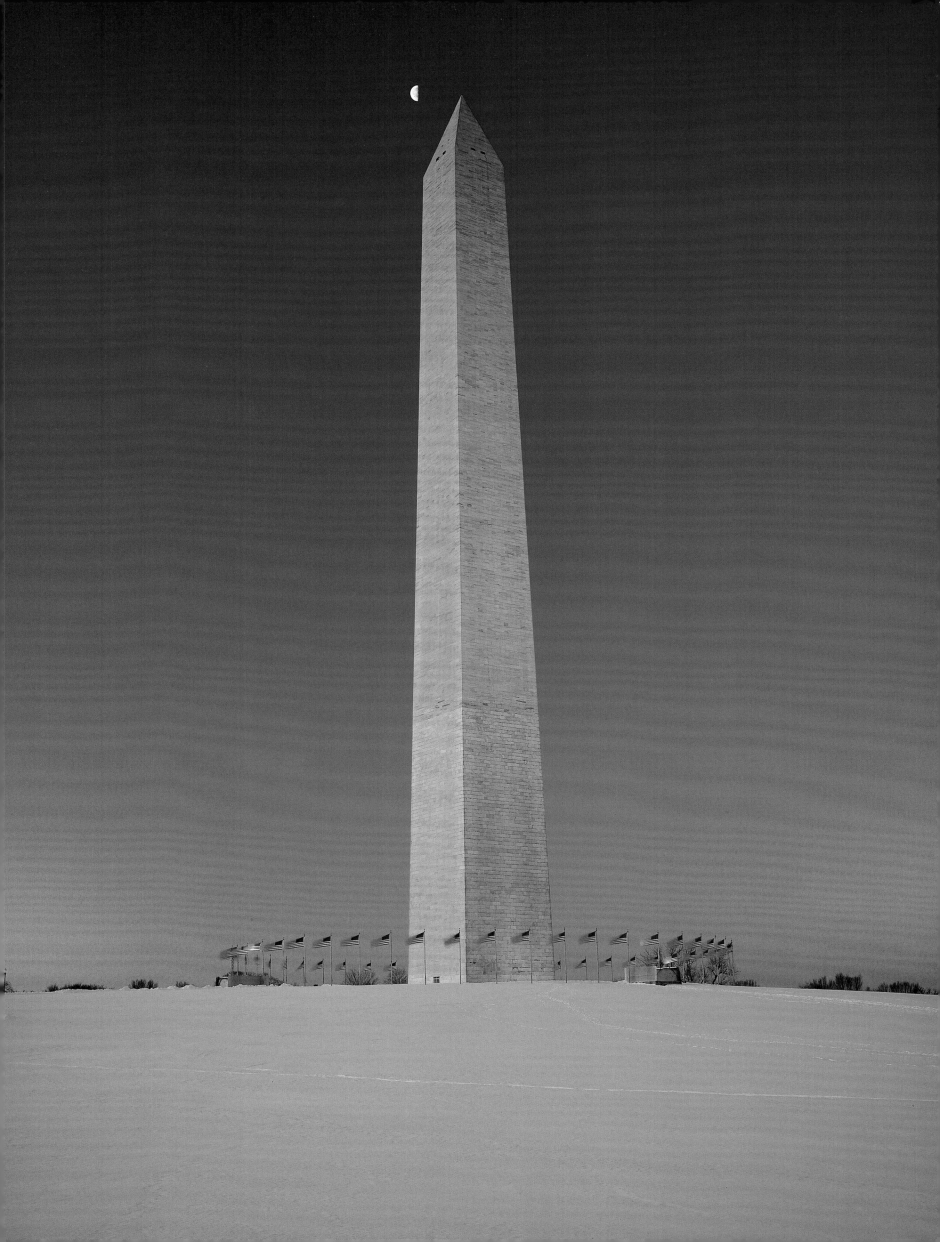

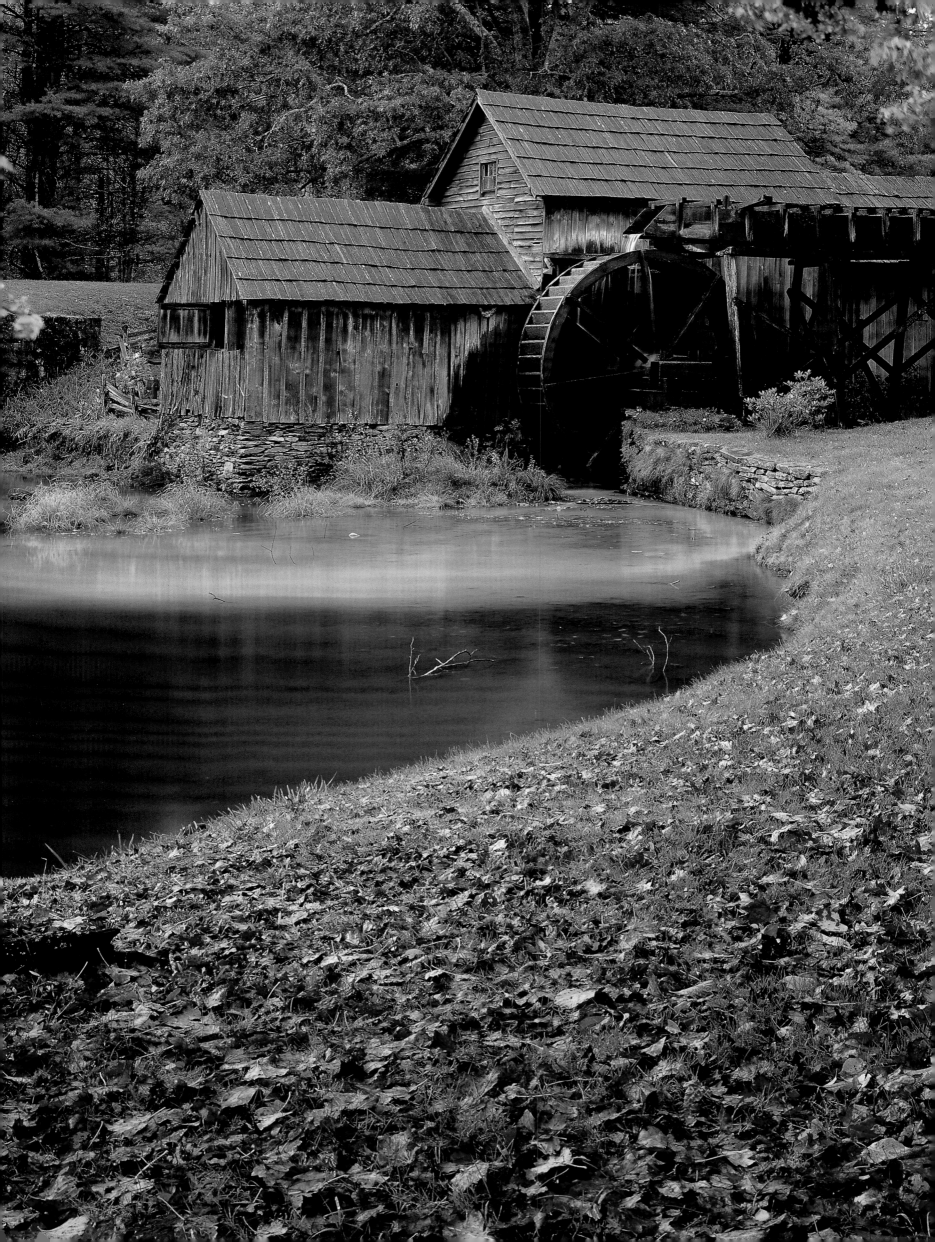

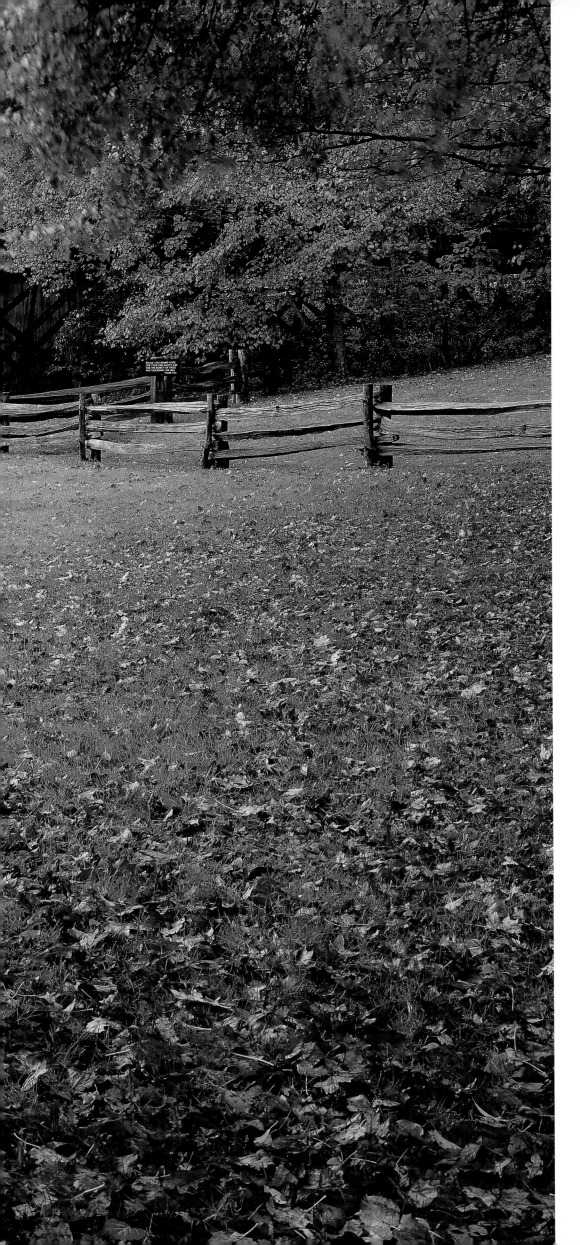

The most photographed sight along the Blue Ridge Parkway, Mabry Mill dates from the early nineteenth century, when small homesteads and remote villages dotted the mountains. Landowner Edwin Boston Mabry used his water power to run his blacksmith shop, and later a wheel-wright's shop, a sawmill, and a grist mill.

One of the country's most scenic drives, the Blue Ridge Parkway winds 469 miles from Virginia's Shenandoah National Park to Great Smoky Mountains National Park. On the Virginia side, more than 20 over-looks offer both panoramic views and access to the Appalachian Trail, the rugged 2,144-mile route from Maine to Georgia. *(overleaf)*

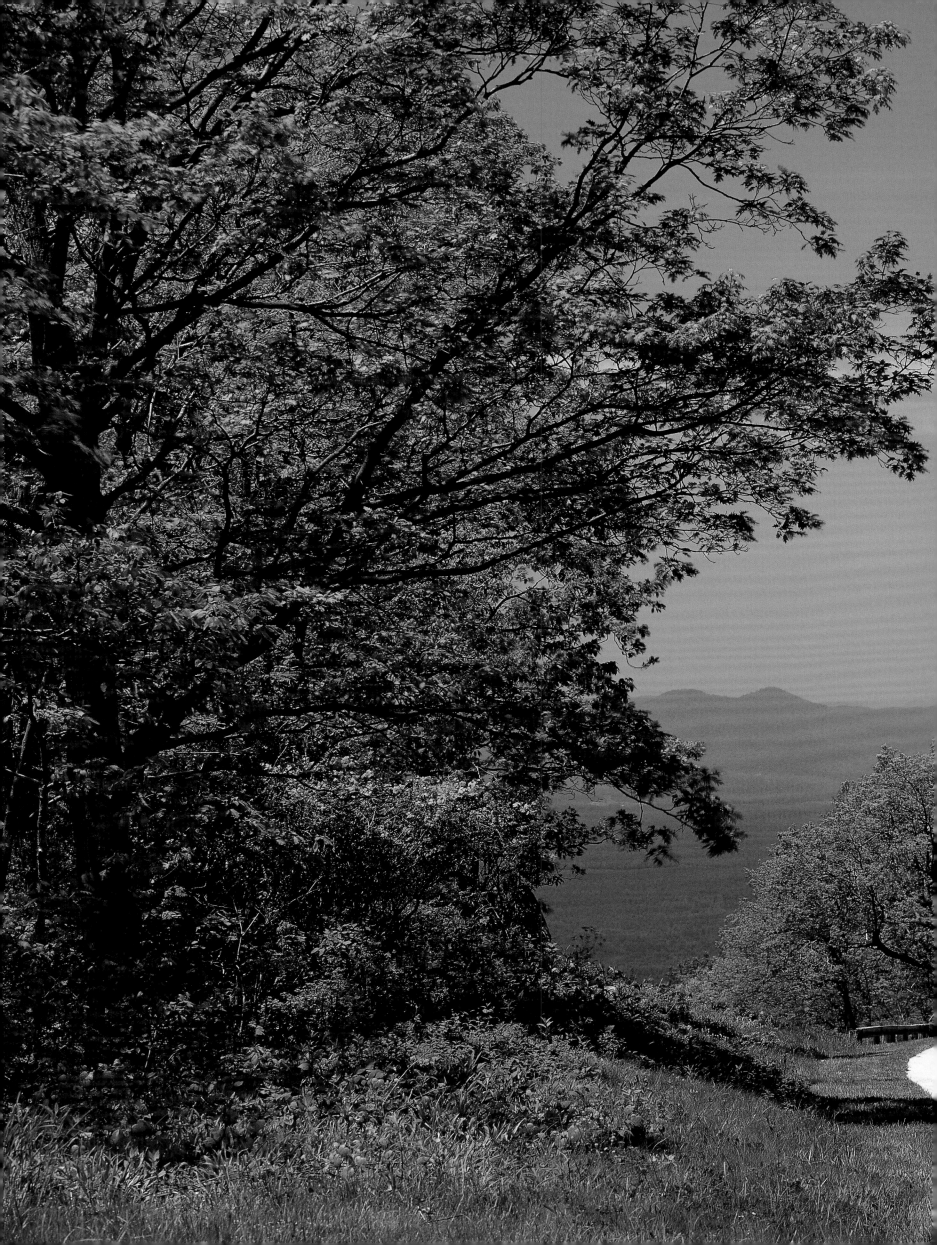

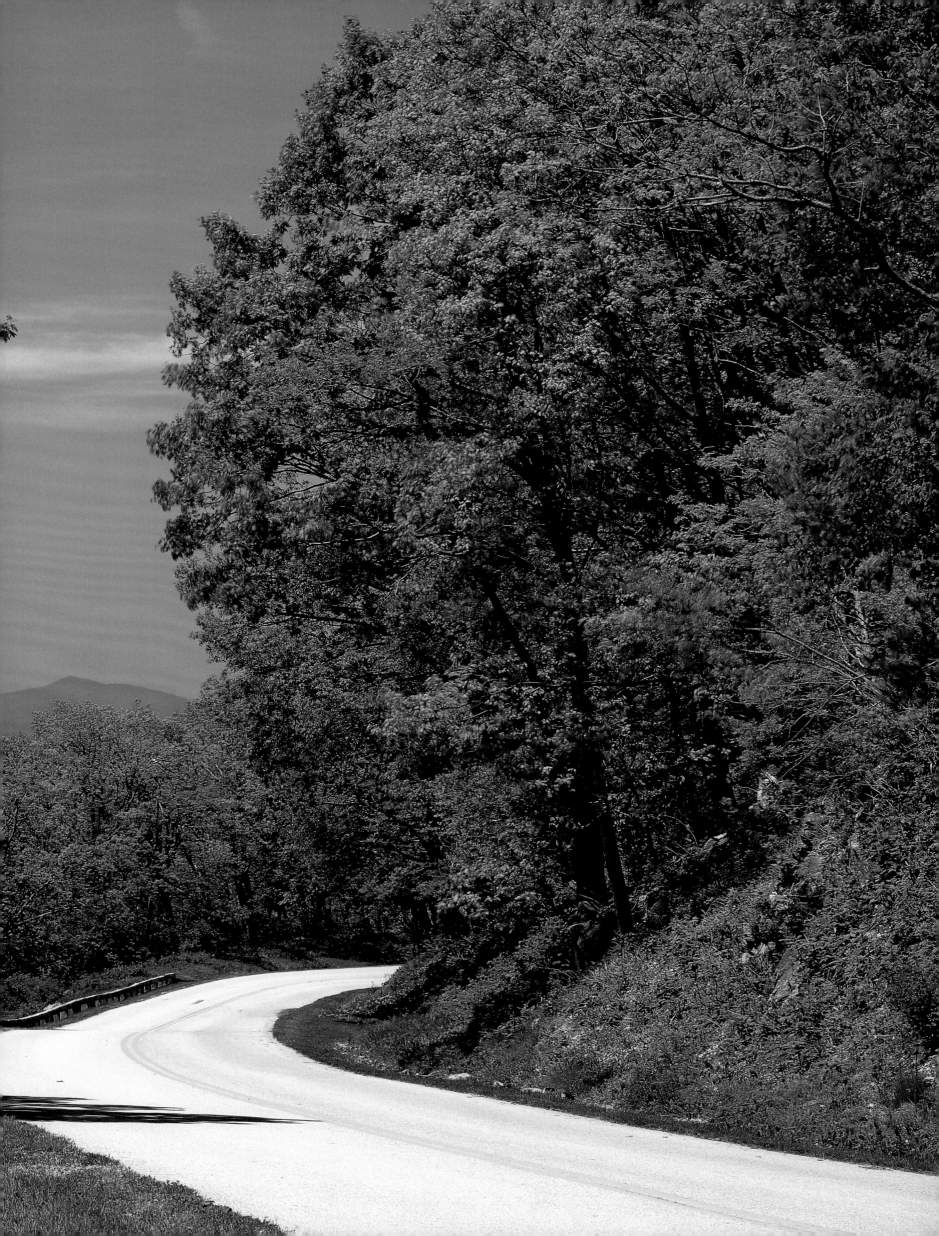

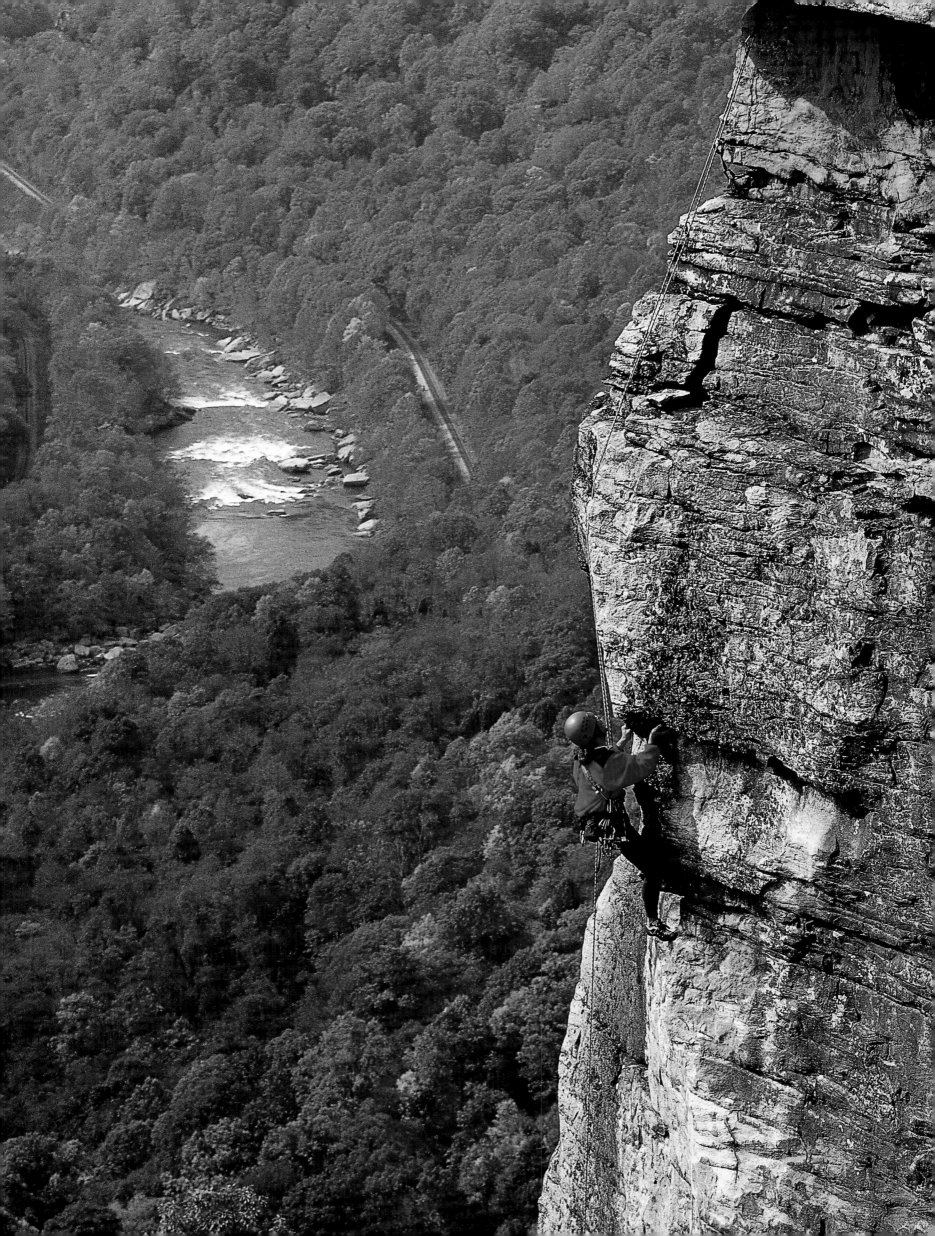

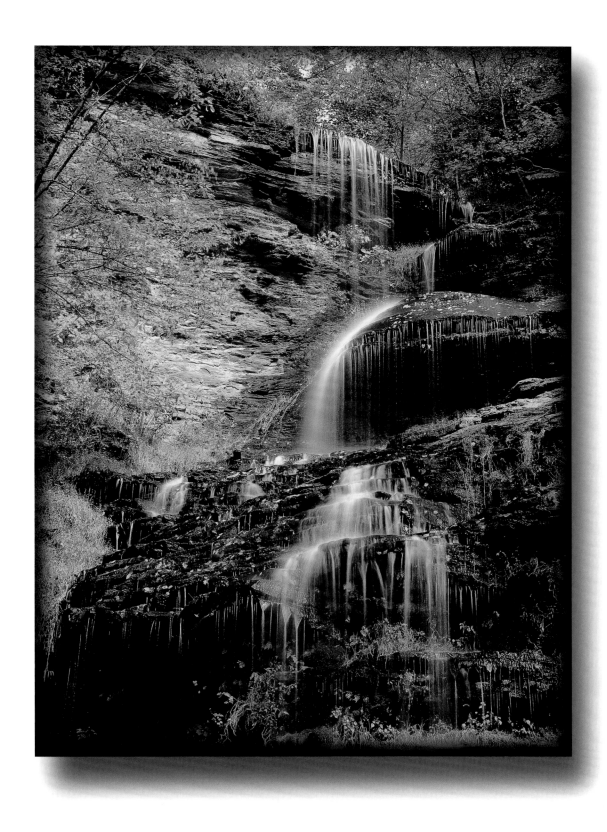

More than 80,000 acres of state parkland and 100,000 acres of state forest combine to protect West Virginia's diverse landscapes, from Civil War battlefields to the towering forest groves and isolated waterfalls of the Appalachian Highlands.

For rock climbers, hikers, and whitewater paddlers, West Virginia's New River Gorge National River is about more than spectacular scenery. The 63,000-acre park provides approximately 1,400 established climbing routes, most suitable for the experienced climber. *(left)*

THE SOUTHEAST THE SOUTHEAST THE SOUTHEAST

THE SOUTHEAST THE SOUTHEAST THE SOUTHEAST

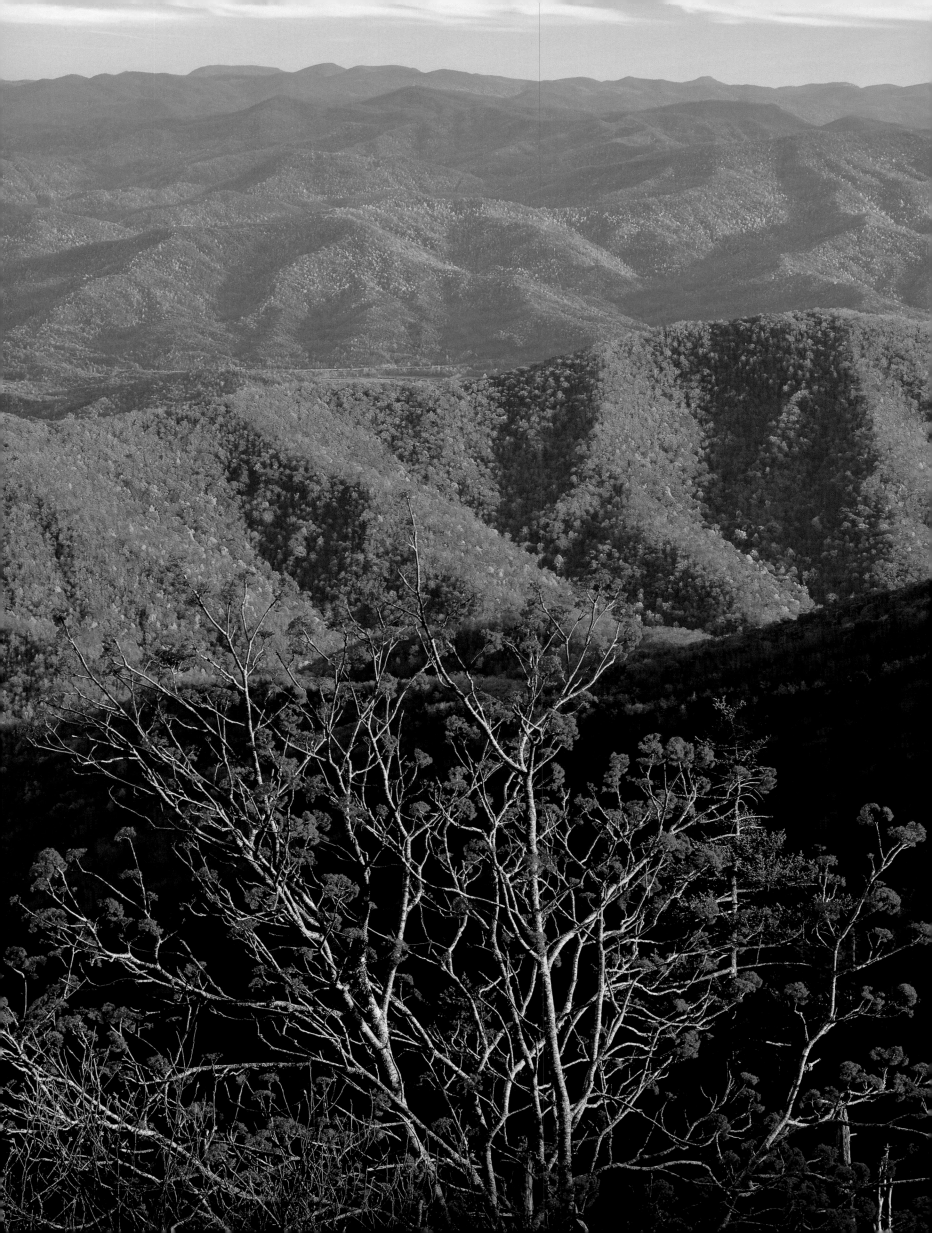

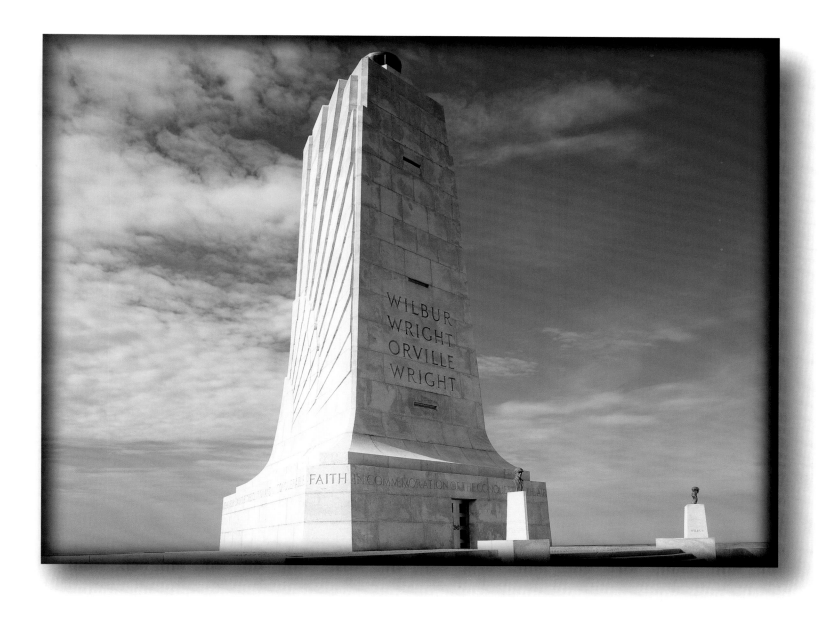

On December 17, 1903, Wilbur and Orville Wright took flight from a North Carolina hillside. The brothers — owners of a bicycle shop in Ohio — had labored on their flying machines in relative obscurity for three years. This 60-foot monument commemorates their feat — the world's first sustained, powered flight in a machine heavier than air.

In the 1920s, a park commission raised $2.5 million through the donations of school children and the pledges of private donors to create Great Smoky Mountains National Park. Yet when the Depression struck, funds fell short. It wasn't until the Rockefeller family stepped forward with an additional $5 million that the government was able to purchase the land. *(left)*

From Mile High Overlook on the Blue Ridge Parkway in North Carolina, sunset seems to descend suddenly on the Great Smoky Mountains. Protecting 4,000 plant species, along with countless birds and mammals, the Great Smoky Mountains preserve has earned the designation of International Biosphere Reserve and World Heritage Site from the United Nations. *(previous pages)*

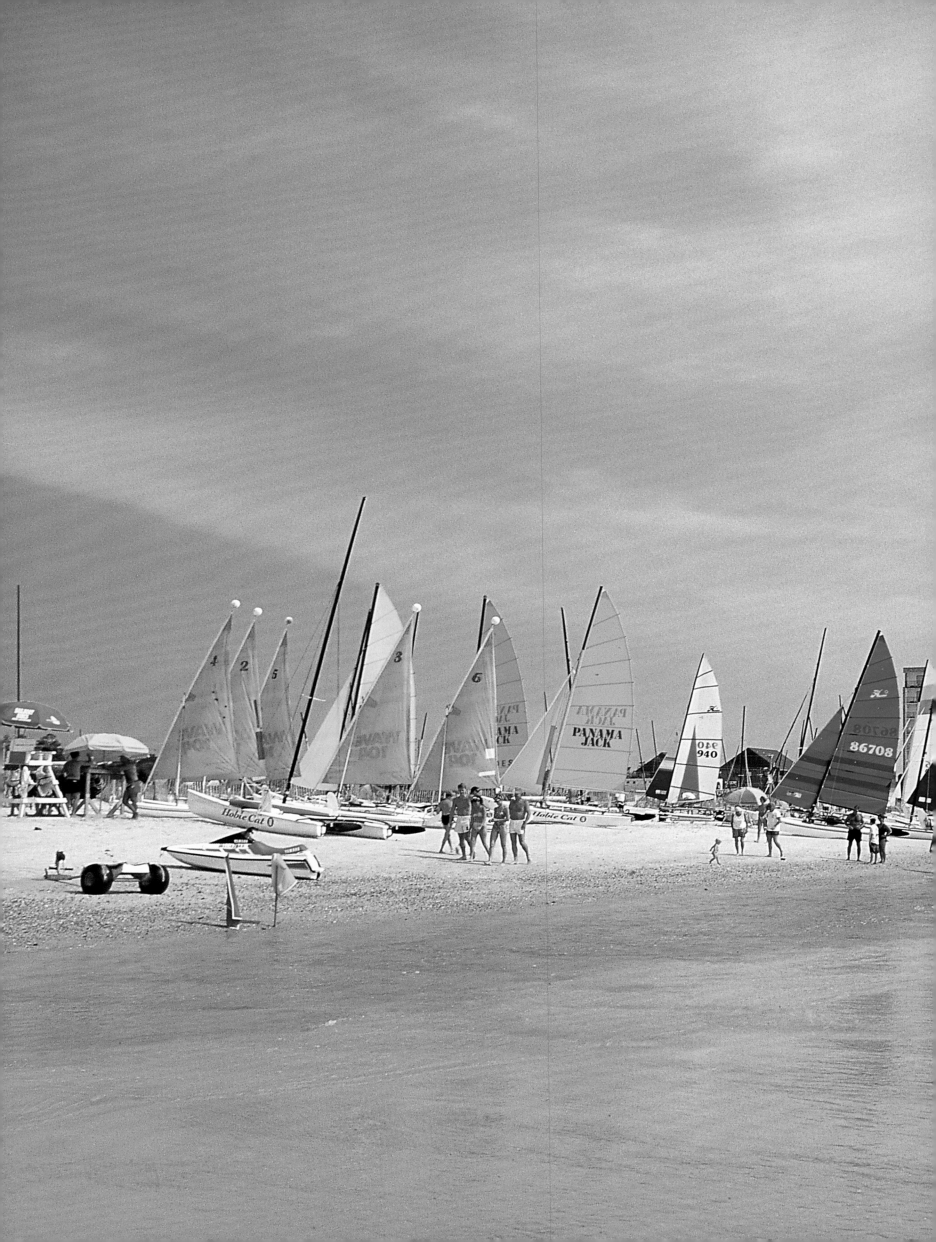

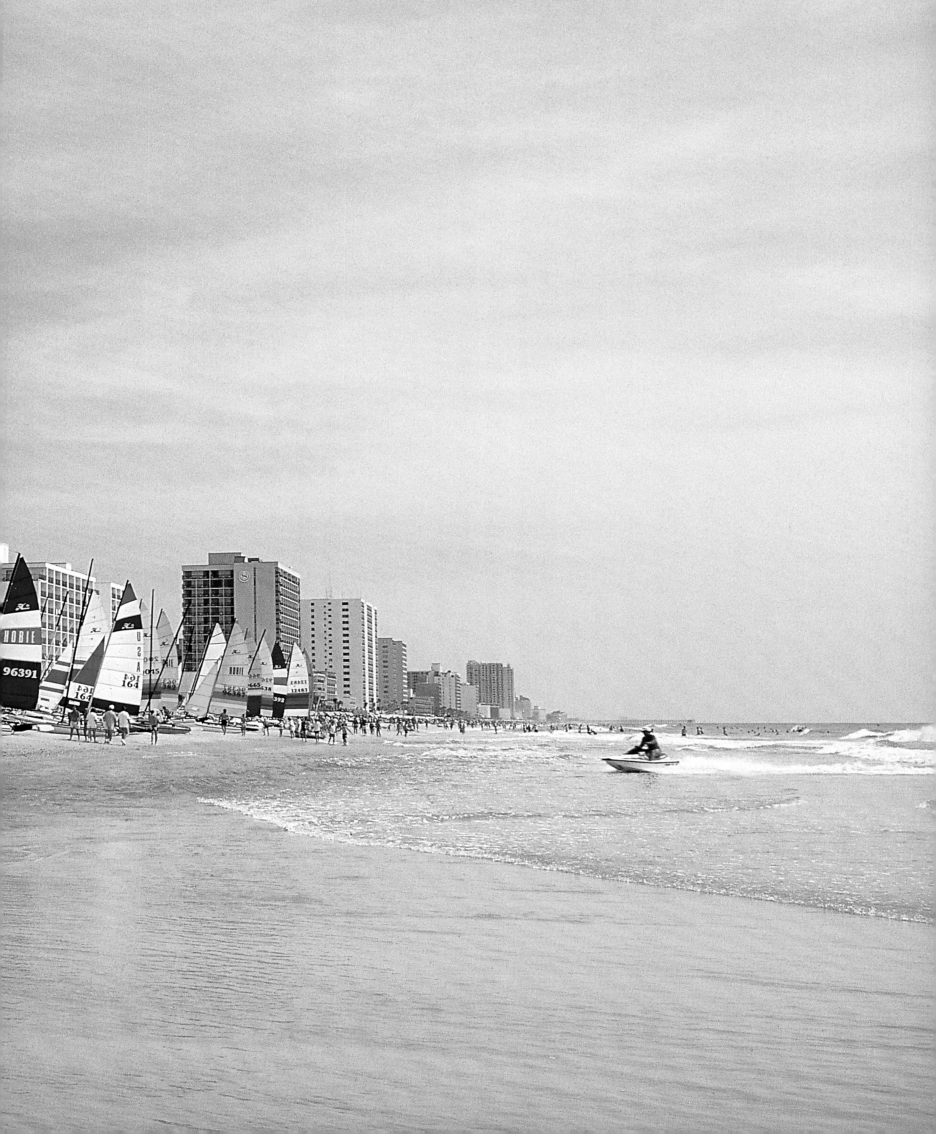

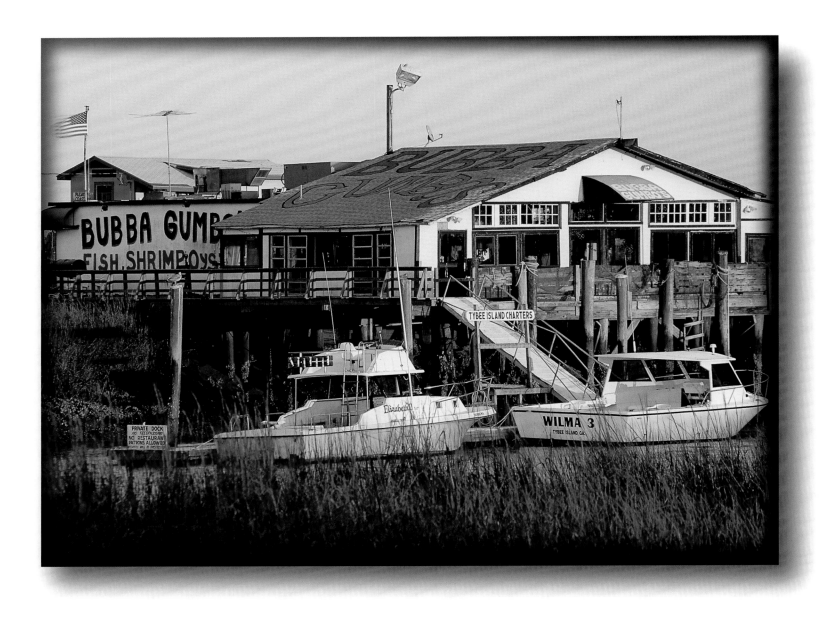

Just east of Savannah, Georgia, Tybee Island is named for a Euchee native word meaning "salt." The barrier island on the edge of the Atlantic serves as a summer retreat for Georgia residents, offering miles of white sand beaches, popular fishing tours, and a historic lighthouse to explore.

The World of Coca-Cola celebrates one of America's most famous exports, first served in the city of Atlanta more than a century ago. In the background stands Georgia's state capitol, completed in 1889 and set on a foundation of granite quarried within the state. *(right)*

South Carolina's Myrtle Beach — nicknamed the Grand Strand — combines 60 spectacular miles of coastline with more than 200 days of sun each year. With more than 100 golf courses, 1,700 restaurants, and 11 theaters, the area is well equipped to cater to year-round vacationers. *(previous pages)*

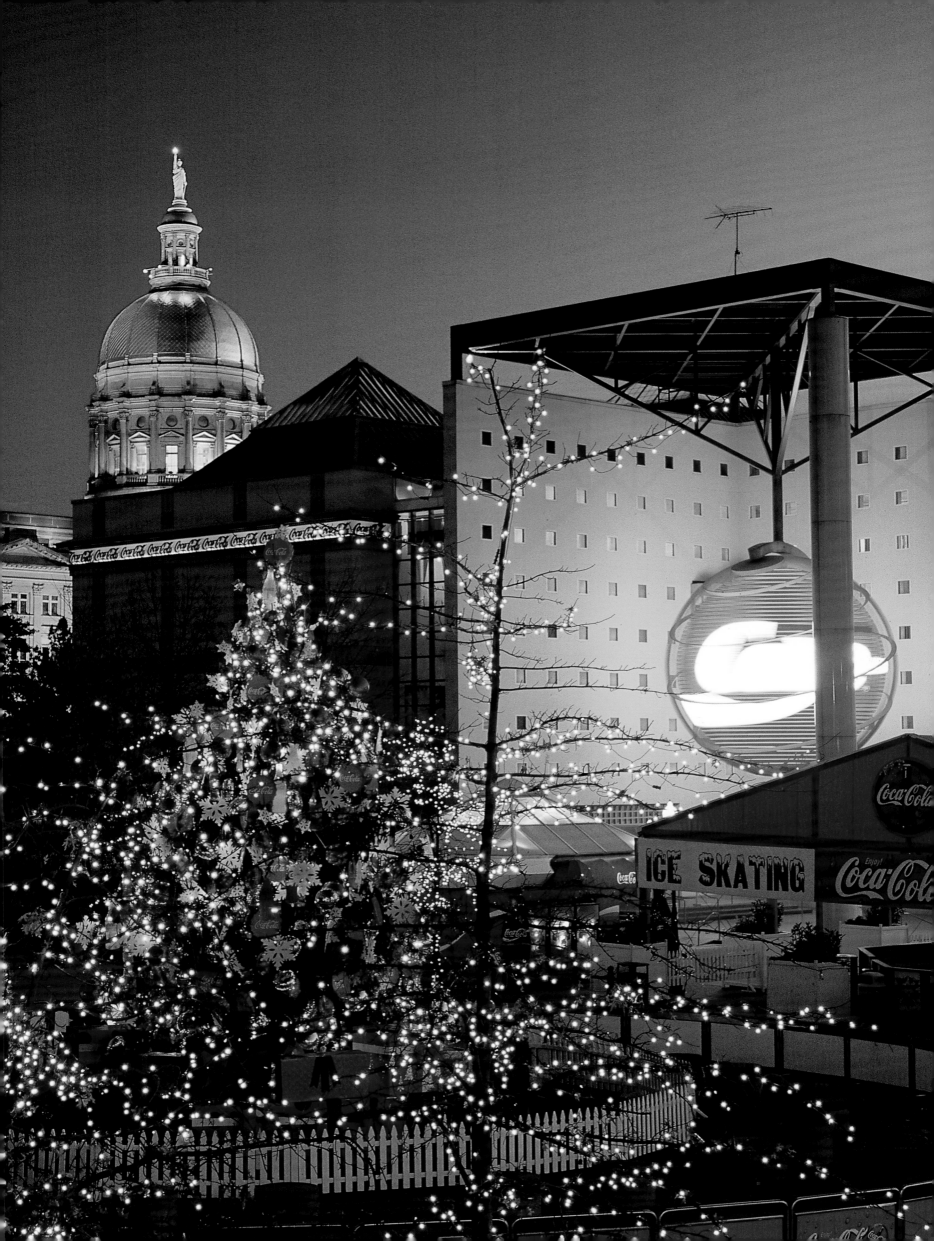

Wet-season waters slowly flood Everglades National Park in Florida, spreading until most of the area is under water. Protecting 13 endangered species, including snail kites and wood storks, the park is a UNESCO International Biosphere Reserve. Yet as canals upstream divert more water for human consumption and pollutants leach into the groundwater, conservationists fear the unique ecosystems within the Everglades may soon disappear.

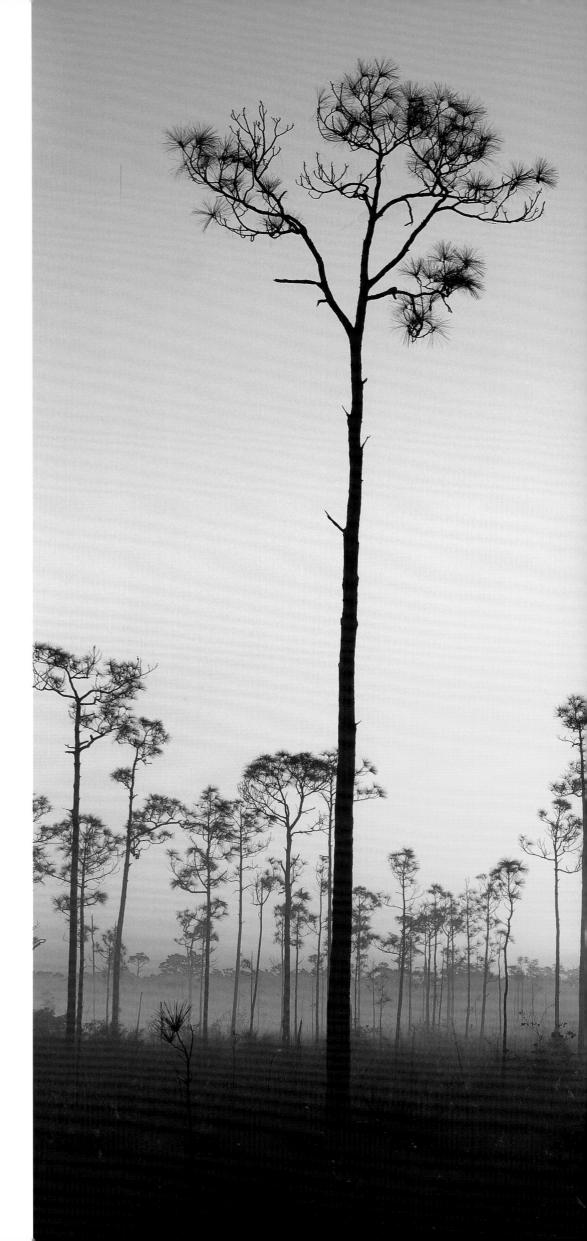

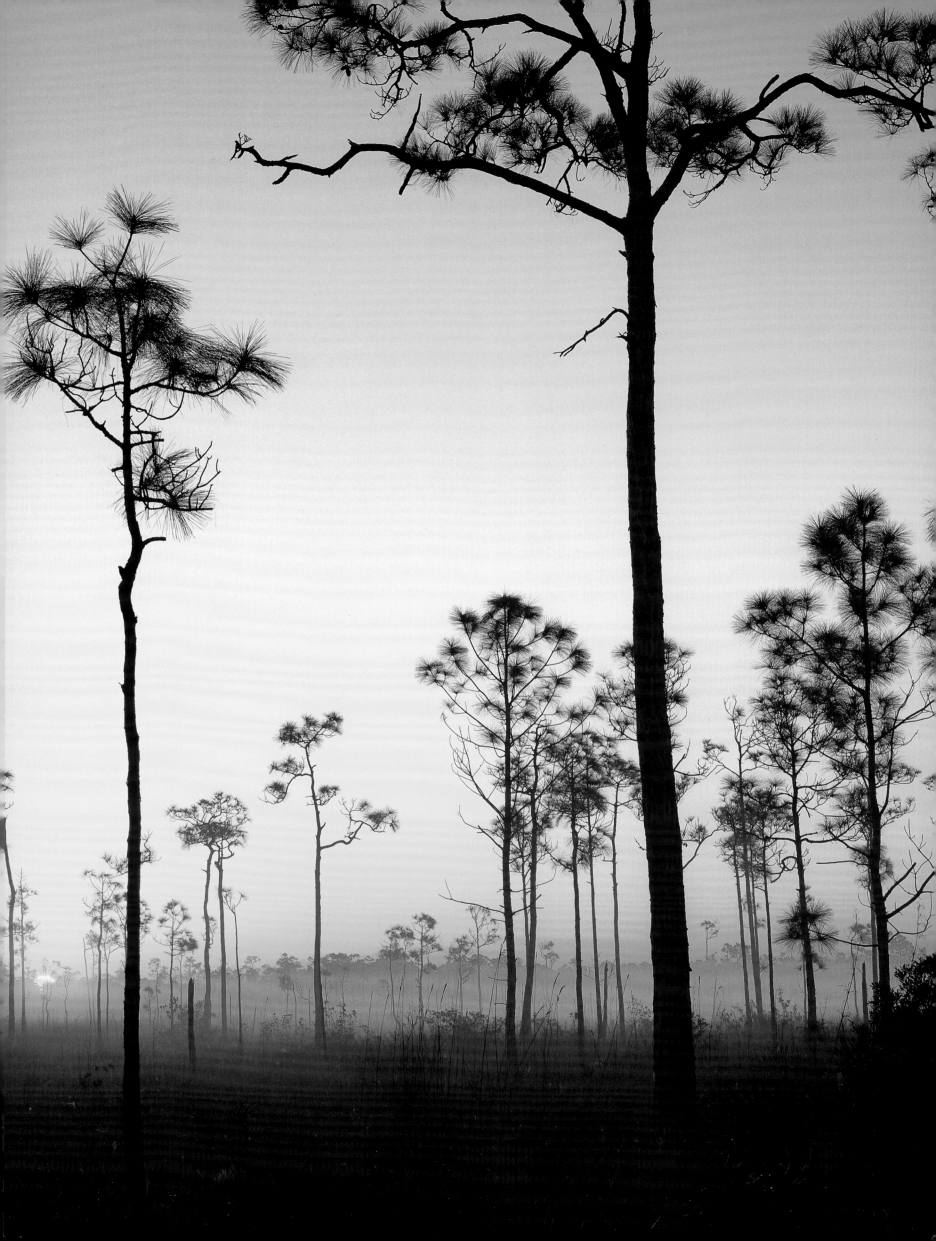

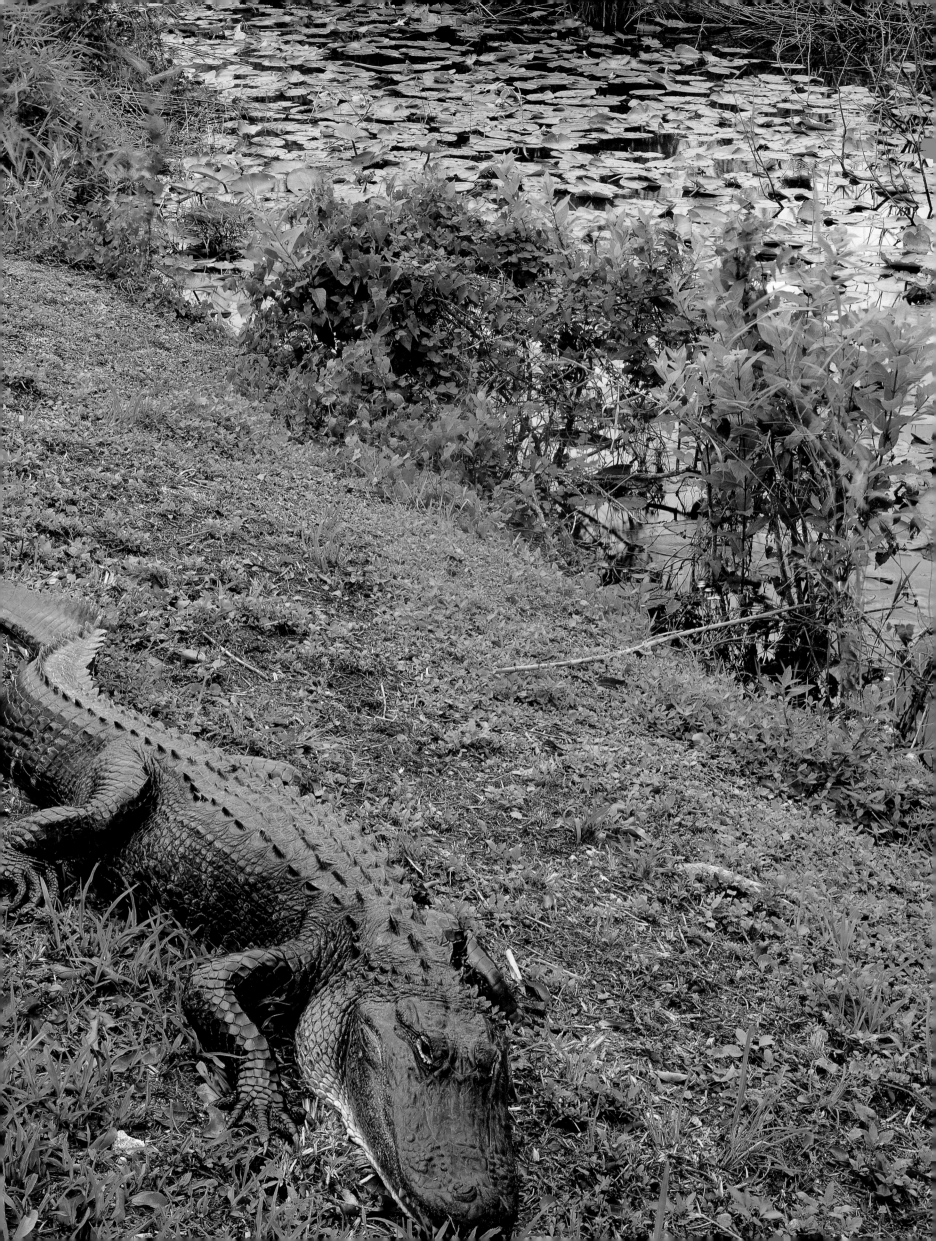

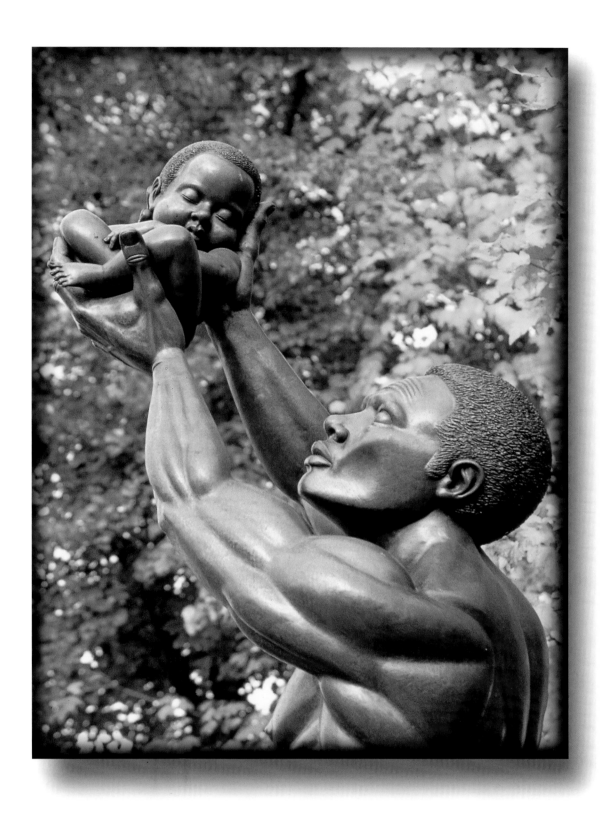

Set in Peace Plaza at Martin Luther King Jr. National Historic Site in Atlanta, the *Behold* monument by sculptor Patrick Morelli honors the life of Martin Luther King, Jr. Morelli chose a pose inspired by an ancient African tradition of holding newborns toward the sun, that they might behold a power greater than themselves.

An American alligator usually moves slowly on land, dragging itself in a lumbering walk. But by lifting its tail and walking on its toes, it can sustain a short sprint of up to 30 miles an hour — part of the reason park staff advise visitors to remain more than 15 feet away from alligators at all times. *(left)*

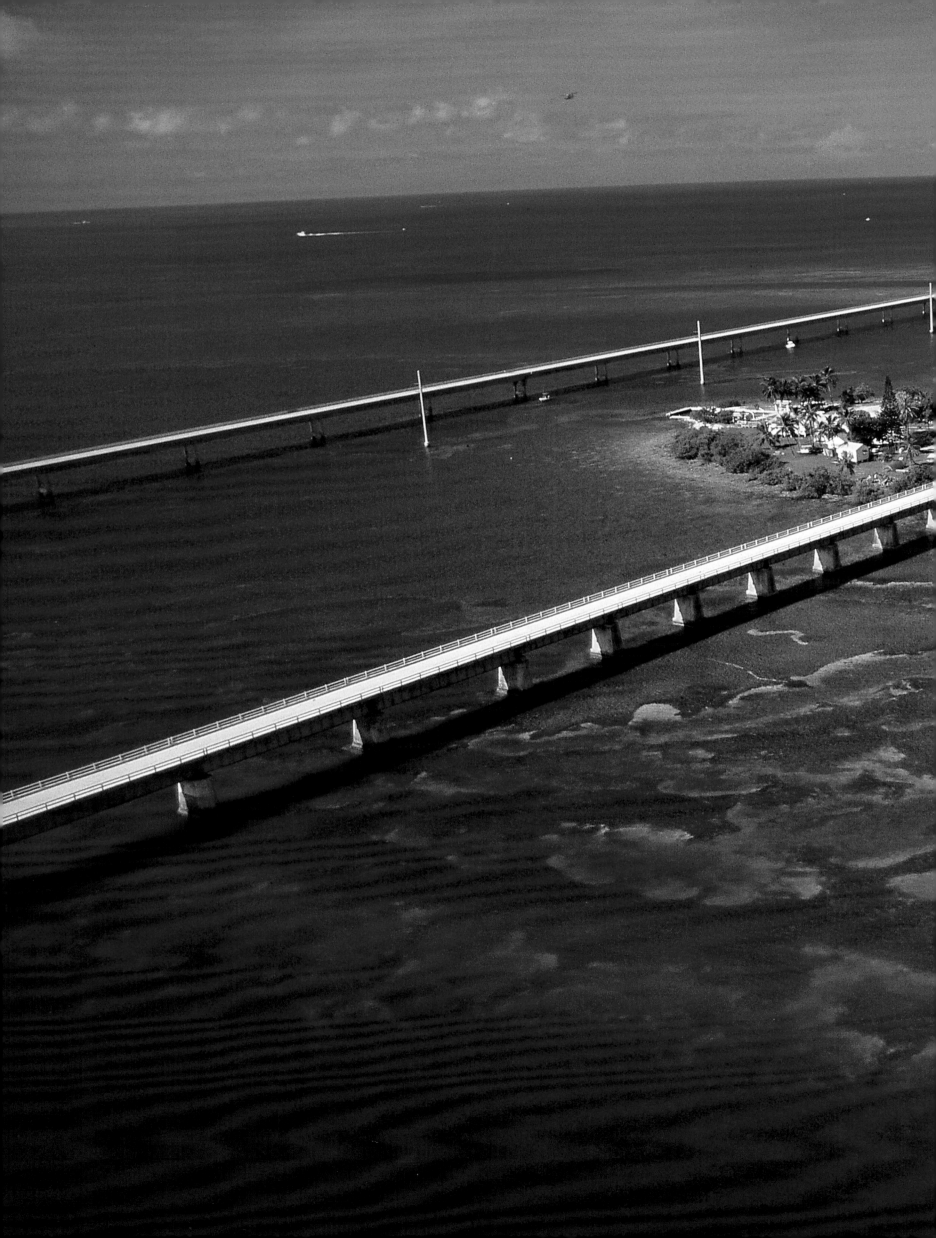

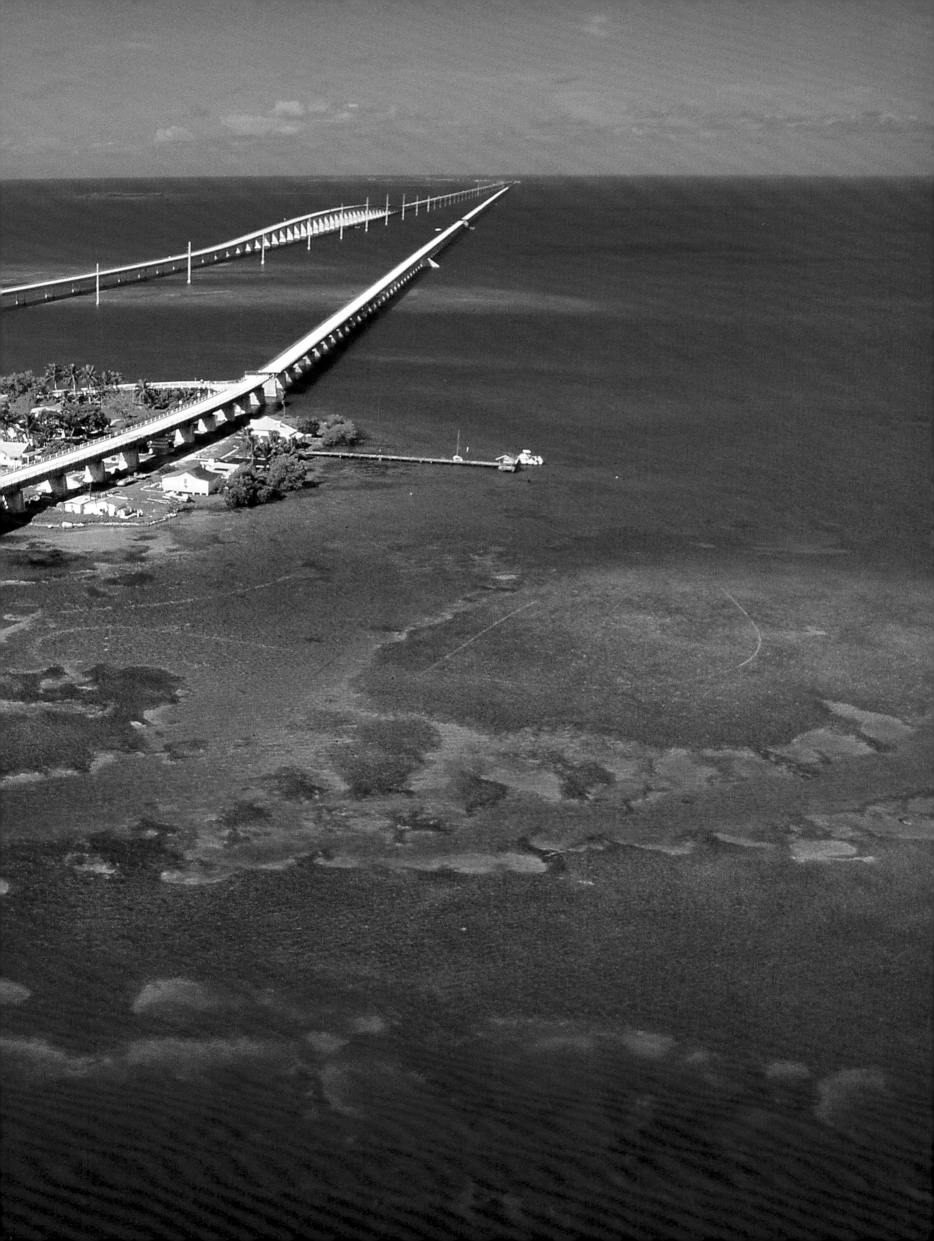

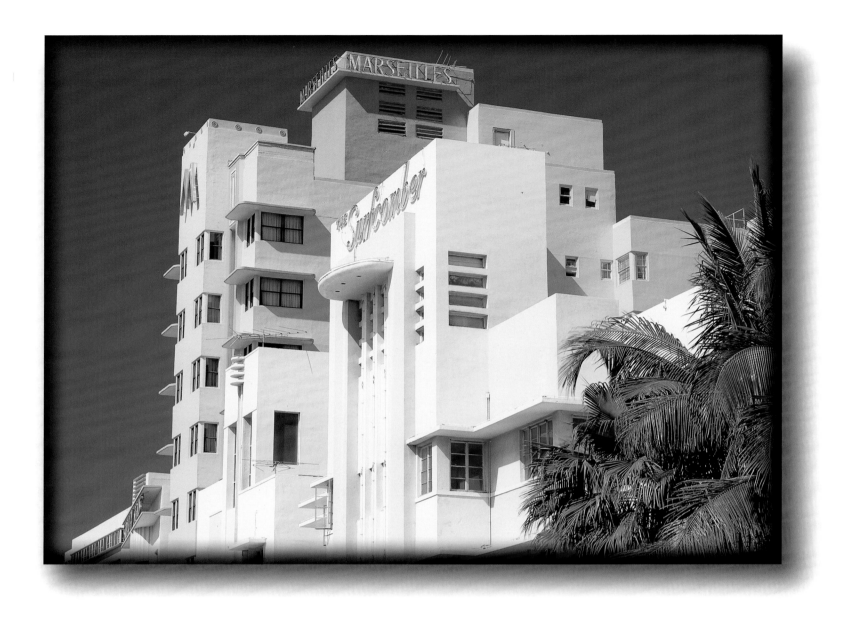

Some of Miami Beach's most popular accommodations — catering to the 10 million visitors who arrive each year — are the Art Deco historic hotels that line South Beach. There are more than 800 Art Deco buildings in the city, built between the 1920s and 1940s. Visitors here enjoy ocean sports, shopping, and Miami's varied nightlife.

Carving its route through Alabama's Lookout Mountain, Little River Canyon National Preserve encompasses 600-foot sandstone cliffs, challenging rapids, and a 23-mile canyon rim drive. Also protected within the park: carnivorous green pitcher plants, endangered blue shiner minnows, and aquatic plants found nowhere else on earth. *(right)*

The Florida Keys gained their name from explorers who arrived in the 1700s — *cayos* is a Spanish word for "islands." The region remained under Spanish control until 1763, when it was traded to the British government. Formed of coral and limestone, the keys lie in jewel-blue waters — perfect for swimming, diving, and boating — between Miami Beach and Dry Tortugas at the state's southern tip. *(previous pages)*

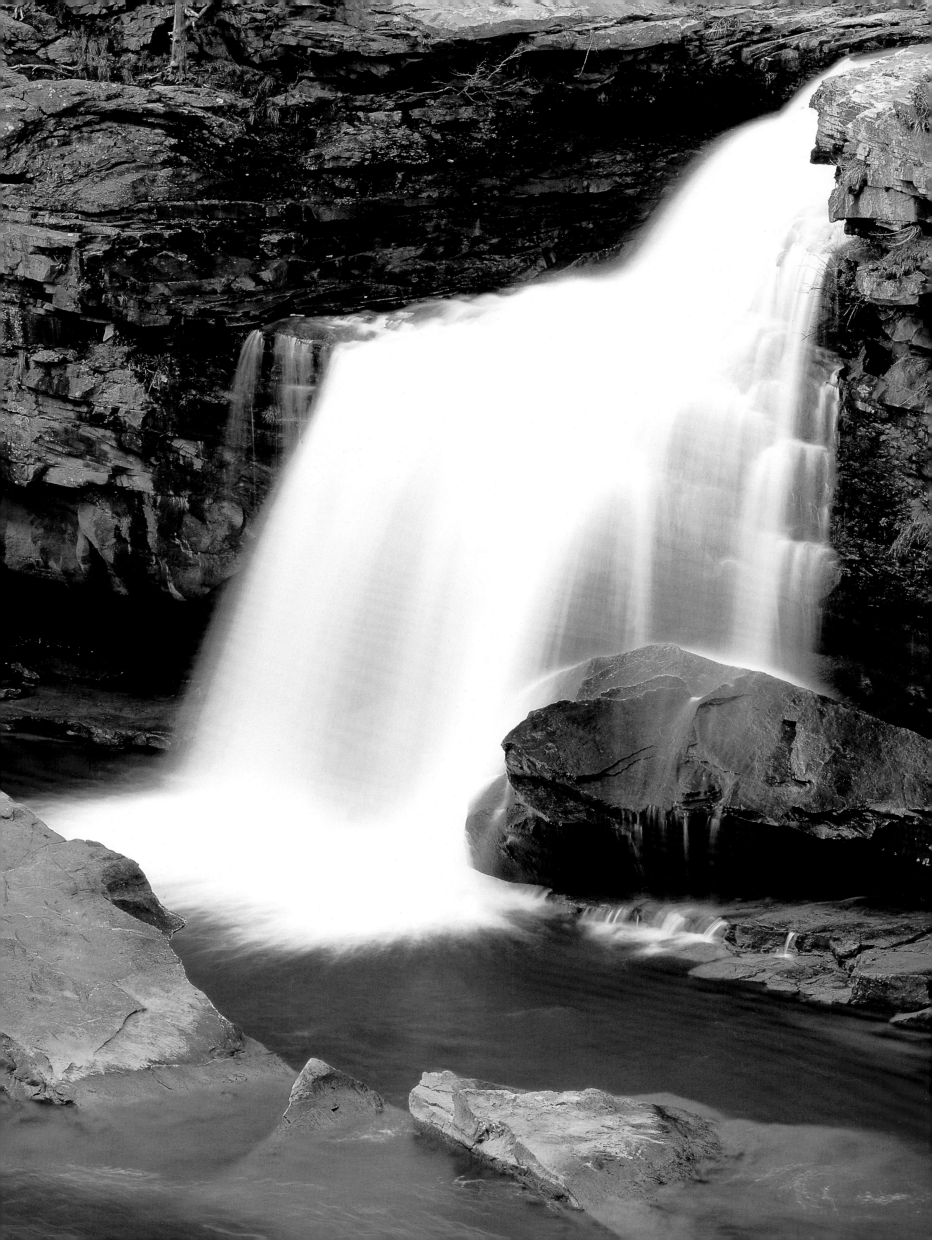

THE MISSISSIPPI VALLEY THE MISSISSIPPI VALLEY

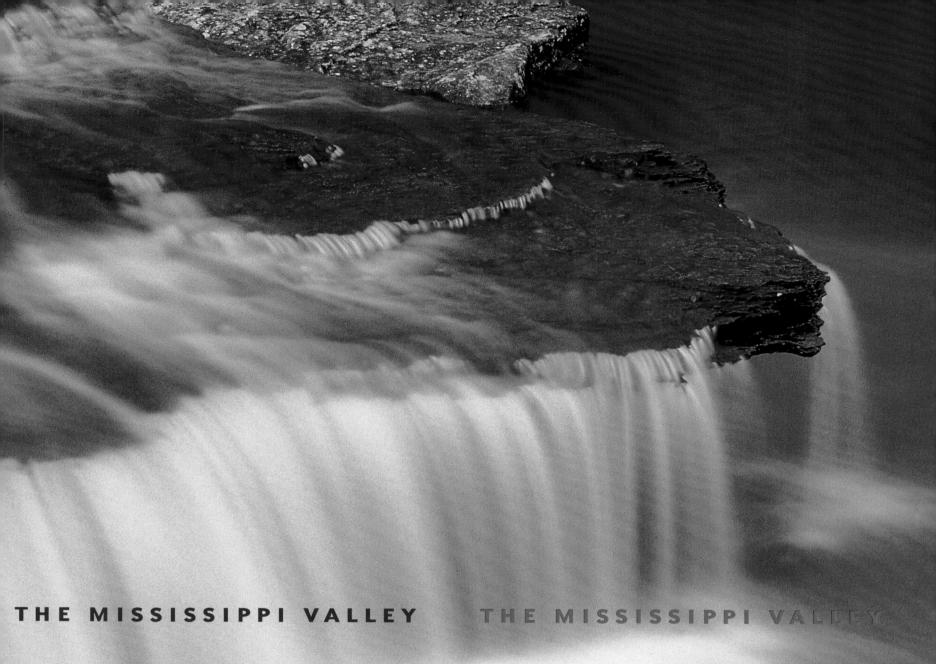

THE MISSISSIPPI VALLEY THE MISSISSIPPI VALLEY

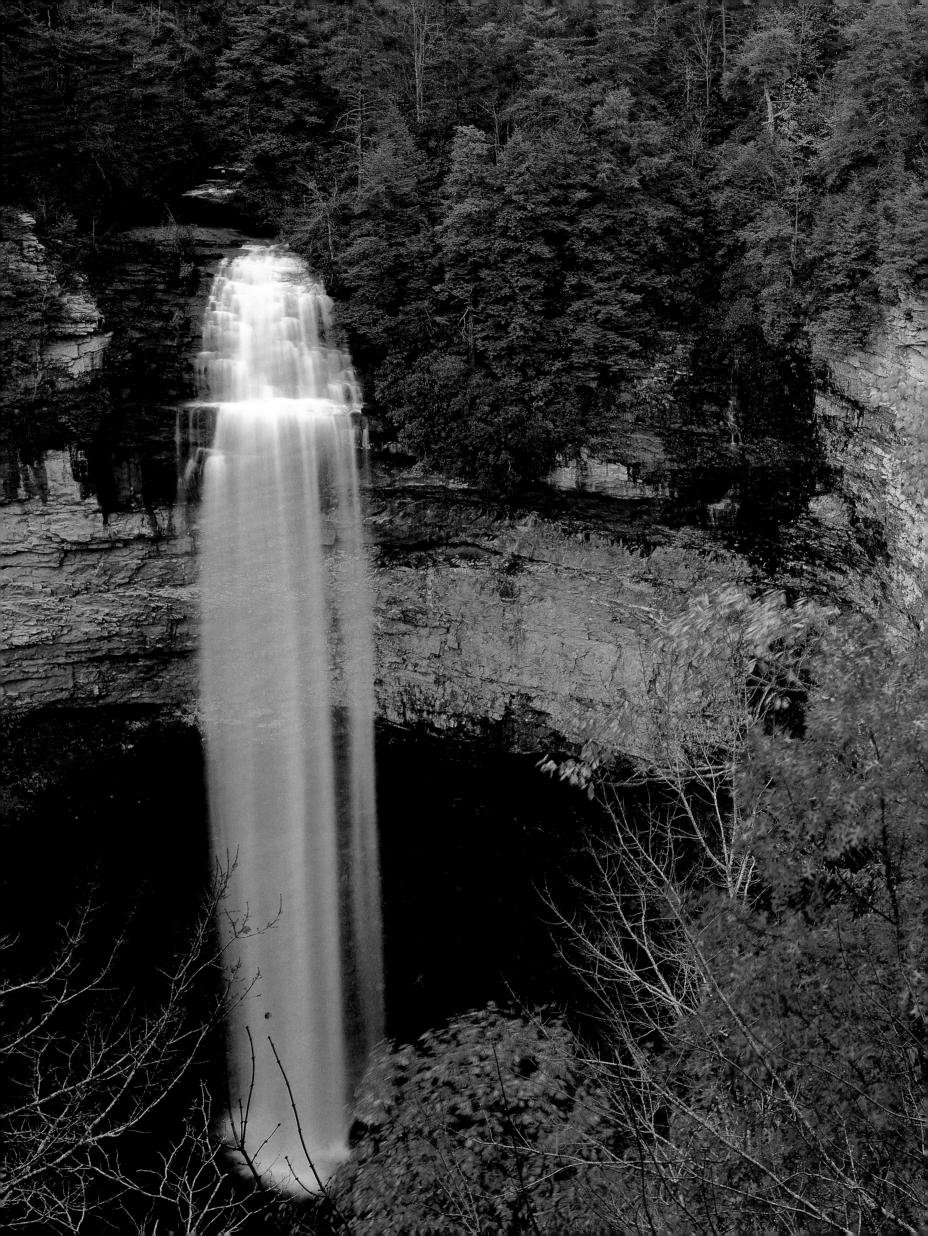

Tennessee's Fall Creek Falls tumble
256 feet, the highest falls east of the
Rockies. Throughout the surrounding
state park, thick forest gives way
suddenly to plunging gorges lined
with tulip poplar, hemlock, mountain
laurel, and rhododendrons. More than
200 campsites and three backcountry
sites allow visitors to explore the region.

Encompassing more than a million acres,
Ozark National Forest includes a large
corner of northwestern Arkansas. This was
once the home of the Bow native people,
and the name Ozark is an anglicized
version of the French *aux arcs,* or "with
bows." Offering more than 300 campsites
and 230 miles of hiking trails, this is a
favorite summer escape for state residents.
(previous pages)

Daniel Boone, charged with forging a
route for future homesteaders to follow,
charted the forests of eastern Kentucky
between 1769 and 1771. Modern-day
hikers can follow his 268-mile path
through Cumberland Gap and what
is now Daniel Boone National Forest.
(overleaf)

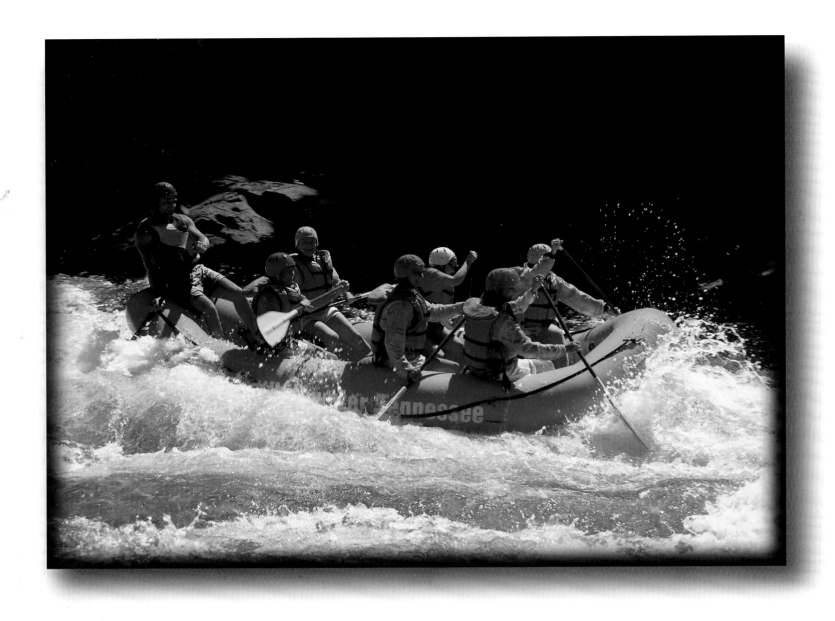

Tennessee's Ocoee River played host to some of the world's best paddlers in 1996, as part of the Olympic Canoe and Kayak Slalom Competition. Also within Cherokee National Forest, the French Broad, Tellico, Conasauga, and Hiwassee rivers offer varying levels of whitewater challenge.

A viewpoint in Upper Buffalo Wilderness in Arkansas allows hikers to survey the thick woodlands of Ozark National Forest. France gained sovereignty over this land through the Treaty of San Ildefonso in 1800 and sold it to the United States in the Louisiana Purchase. Arkansas District, the region that would eventually become the state, was created in 1806. *(right)*

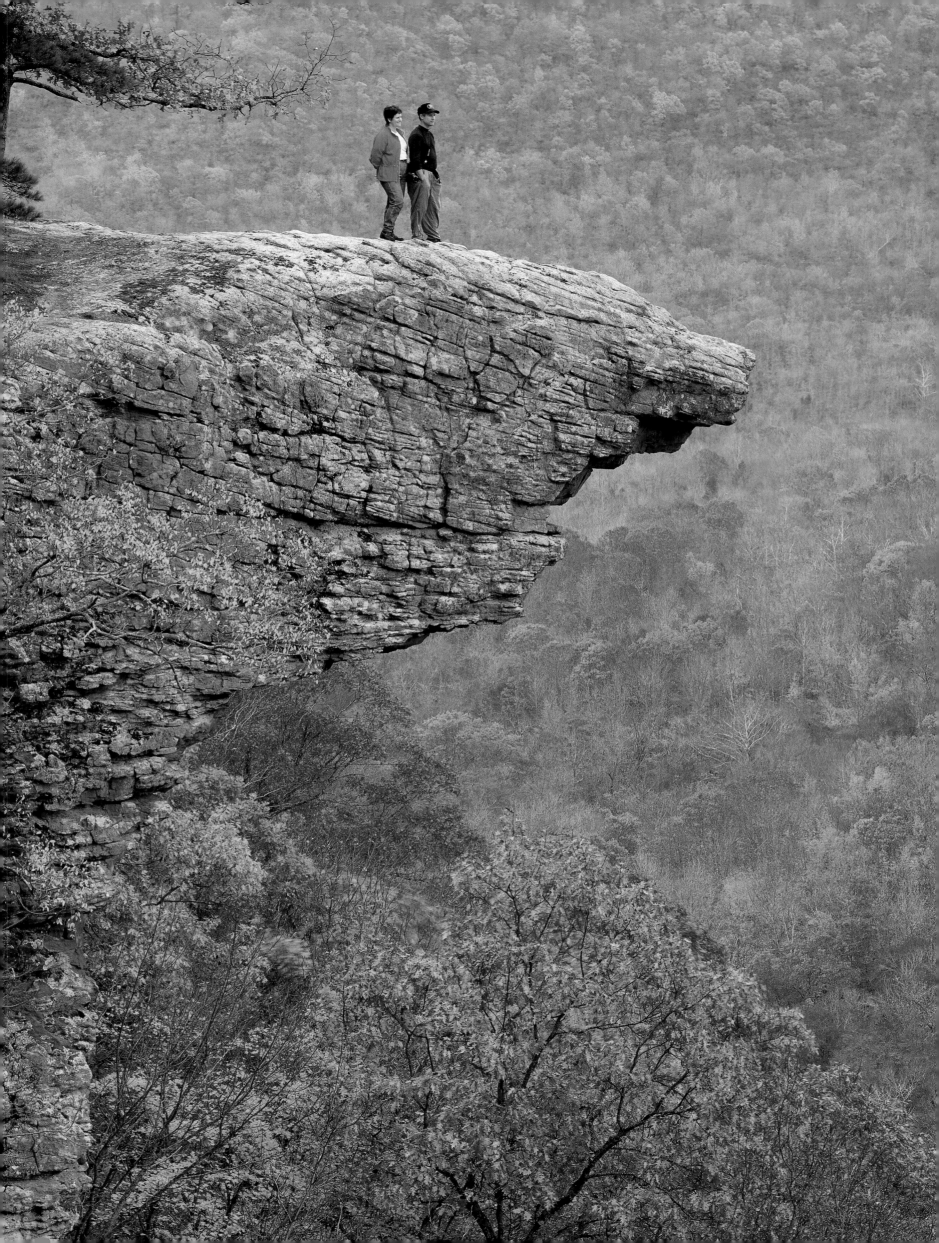

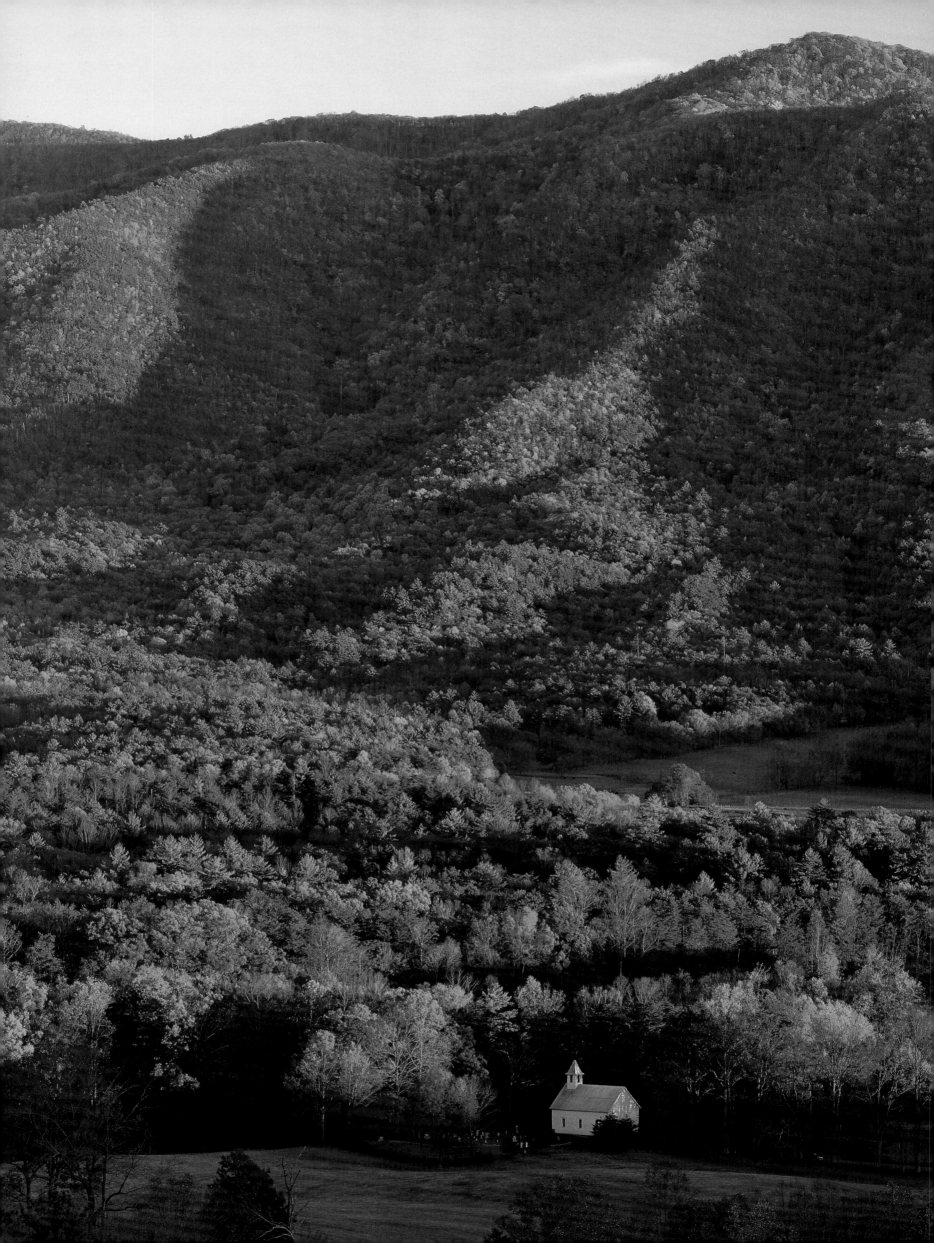

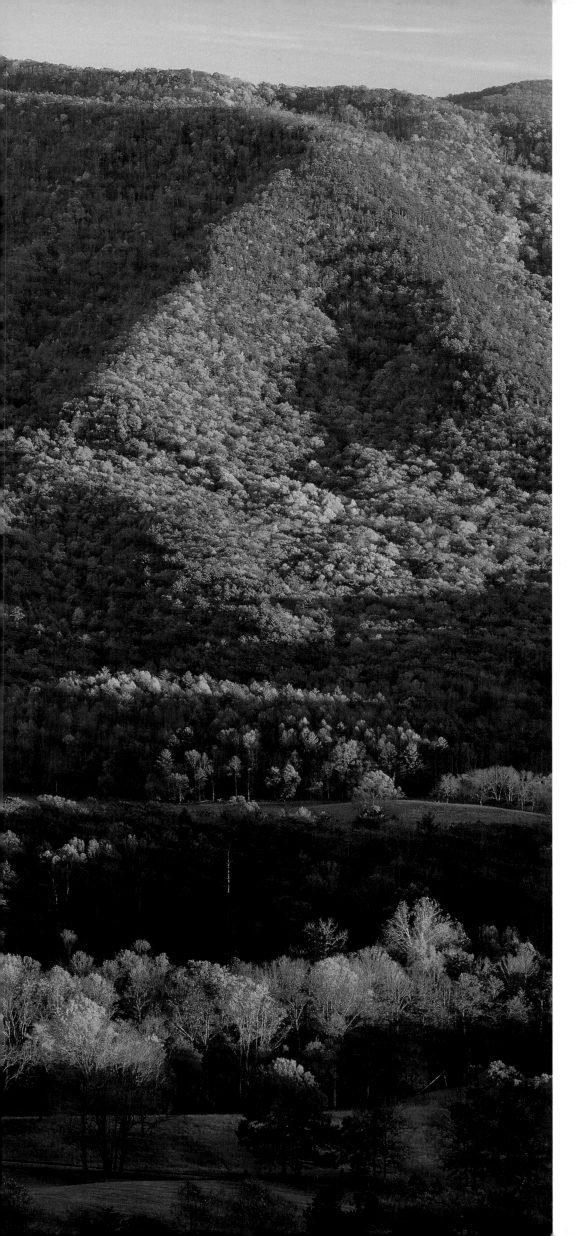

Protected by Tennessee's portion of Great Smoky Mountains National Park, Cades Cove was once home to the Cherokee people, who operated successful farms and plantations here in the early 1800s. In 1838, President Andrew Jackson forced the Cherokee to leave their land for reserves in Oklahoma, an exodus known as the "Trail of Tears." More than 4,000 people died on the journey.

Kentucky's first official racetrack ran down Lexington's main street in 1780. Colonel M. Lewis Clark staged the first Kentucky Derby in 1875, and the state has been famous for its thoroughbred racing and breeding ever since. *(overleaf)*

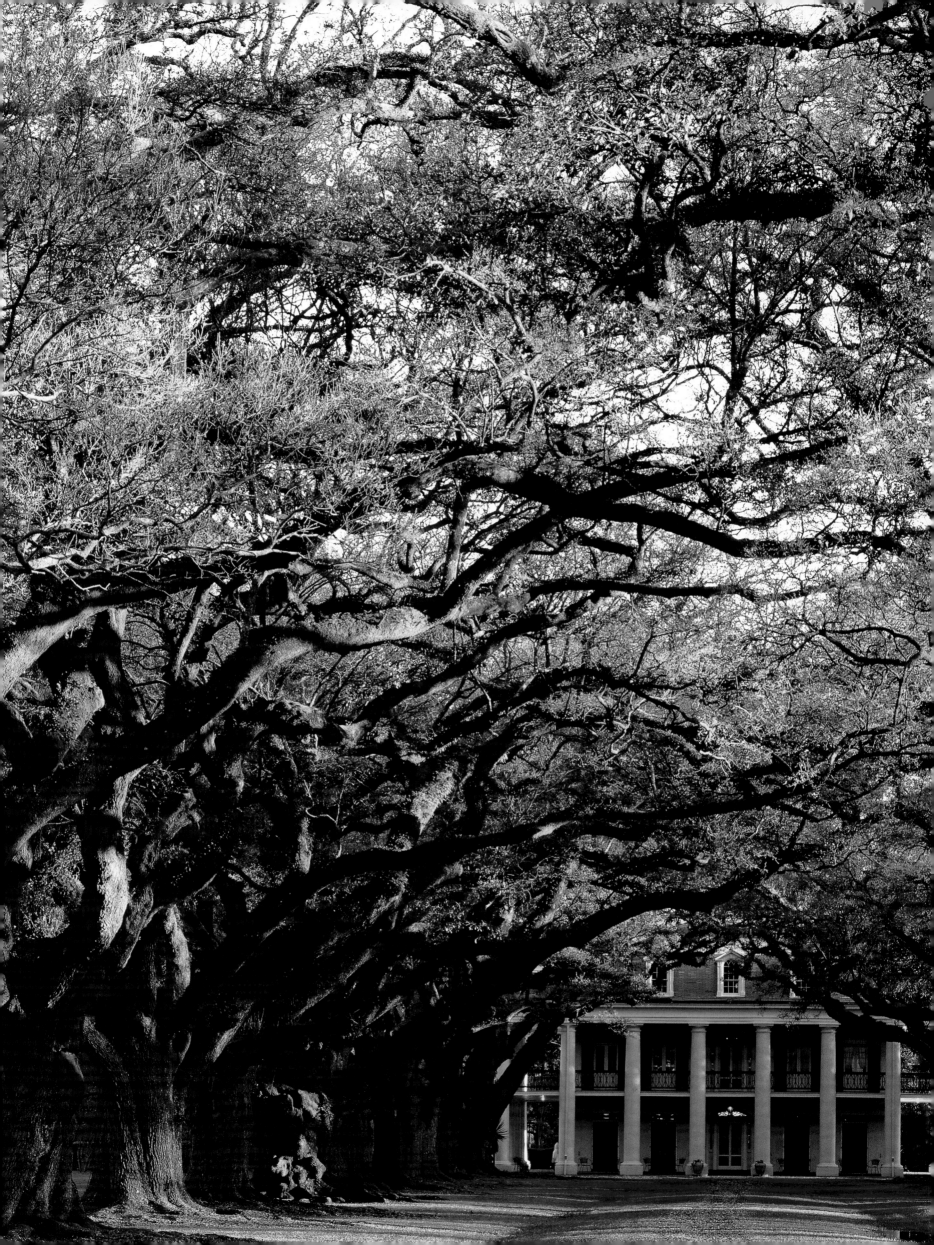

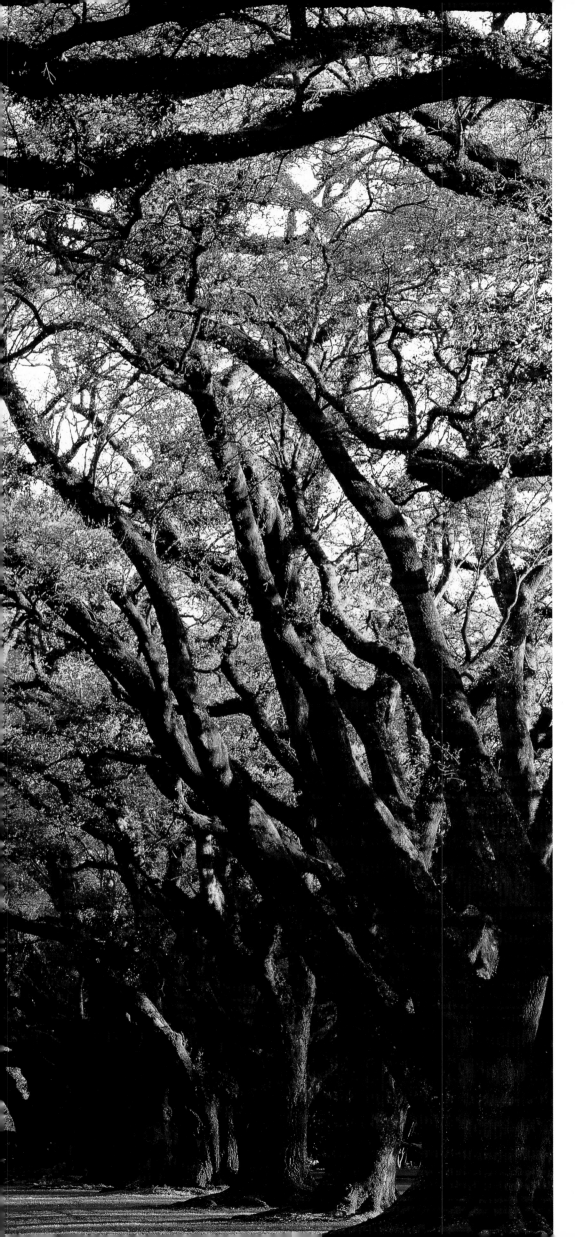

The stately trees lining the drive to Louisiana's Oak Alley Mansion were there long before the residence was built. Historians believe a French settler planted the native oaks more than three centuries ago, dreaming of future prosperity. The trees of the unknown settler became part of the 1839 plantation home of Jacques Telesphore Roman and his wife Celina Pilie, now preserved as a museum.

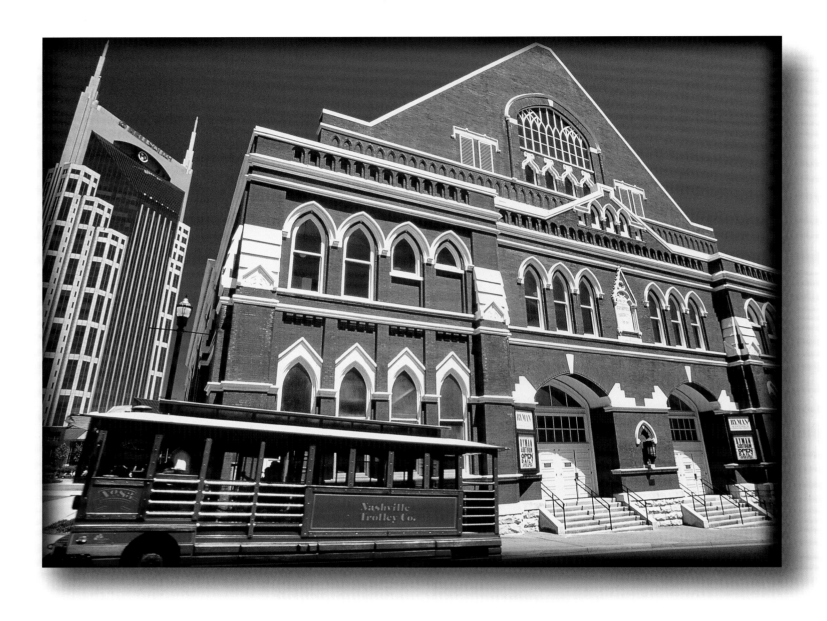

More than 10 million visitors descend on Nashville each year, most for the city's thriving country music scene. From dance bars to concert halls, the nation's most famous country and western singers and some of the most promising up-and-comers perform here. The Ryman Auditorium first opened its stage curtains in 1892 and hosted the *Grand Ole Opry* from 1943 to 1974 — everyone from Elvis to Dolly has played there.

Visitors who come to New Orleans to experience Mardi Gras and explore the famous French Quarter might find themselves in Jackson Square, before the soaring spires of St. Louis Cathedral. Built in 1720, the cathedral is the oldest on the continent. Pope John Paul II visited in 1987, personally greeting more than a thousand clergy members before celebrating a lakeside mass for 200,000. *(right)*

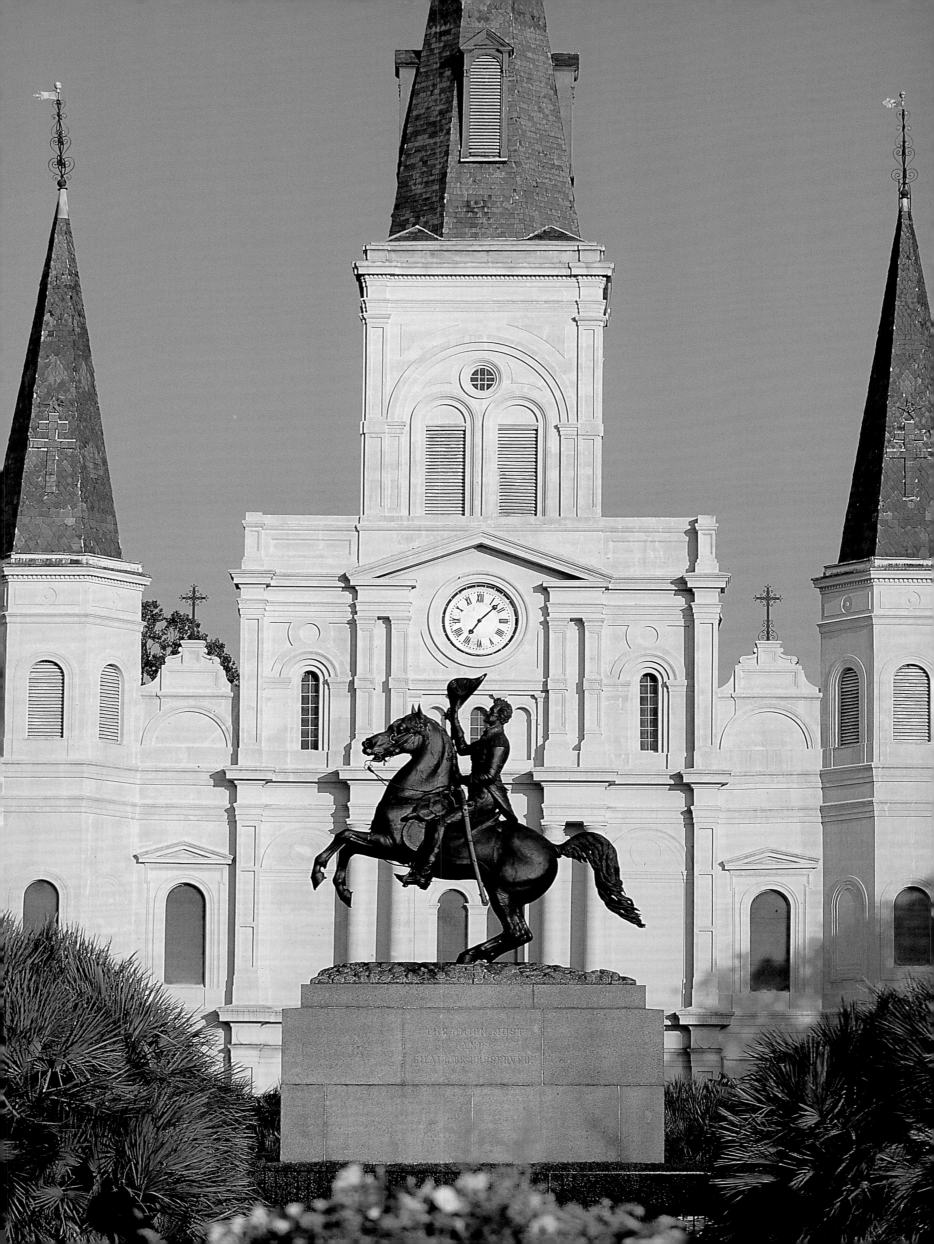

THE MIDWEST AND GREAT LAKES THE MIDWEST A

THE MIDWEST AND GREAT LAKES

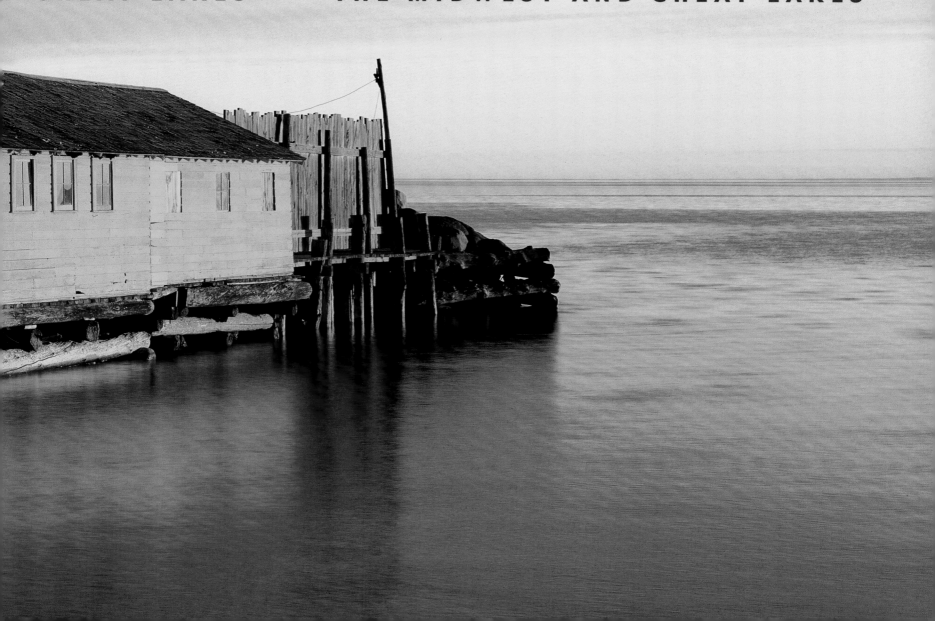

Wisconsin isn't famous only for cheese. About 300 farms — many along the fertile 75-mile stretch of the Door County peninsula on the western edge of the state — harvest thousands of pumpkins each fall. Wisconsin's cranberry marshes provide half the nation's crop, and orchards produce 70 million pounds of apples annually.

Established in 1966, Michigan's Pictured Rocks National Lakeshore was the first such preserve in the nation. The caves and arches that line 15 miles of the Lake Superior shoreline and give the park its name are part of an ancient cliff, carved by the waves into forms that reach 50 to 200 feet high. *(right)*

The Hokenson Fishery at Little Sand Bay in Wisconsin is a reminder of the industry that once flourished within what is now Apostle Island National Lakeshore. Scattered in the frigid waters of Lake Superior, the islands were named in honor of Jesus' apostles by early Jesuit missionaries. When they arrived in this area during the seventeenth century, the missionaries counted only 12 islands, not the 22 that actually exist. *(previous pages)*

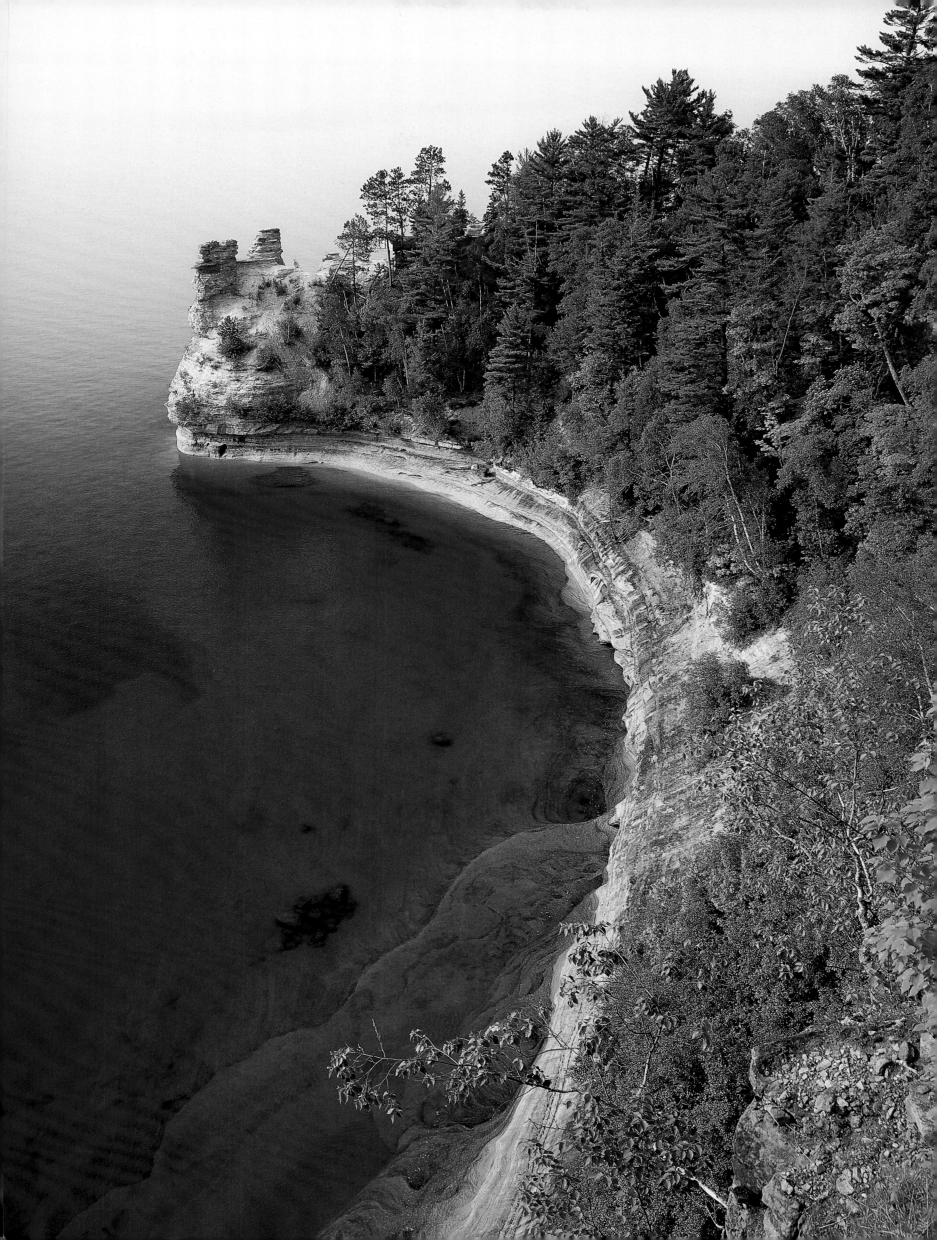

About 80 percent of Illinois is farmland —
78,000 farms encompass almost 28 million
acres. In a single spring day, Illinois
farmers can plant 500,000 acres of
soybeans in neat rows such as these
ones in LaSalle County.

No one knows exactly how or why
Ohio's Serpent Mound was created, but
archeologists believe the quarter-mile-
long coils had religious significance to the
Adena people who lived here more than
2,000 years ago. The formation's shape
seems to represent an uncoiling snake.
(previous pages)

In 1673, French explorer Louis Joliet
and missionary Pere Jacques Marquette
became the first Europeans to discover
this rich farmland near the banks of the
Mississippi River, in what is now the state
of Illinois. The two men followed the river
north after native guides described a
"Great Water" flowing across the continent.
(overleaf)

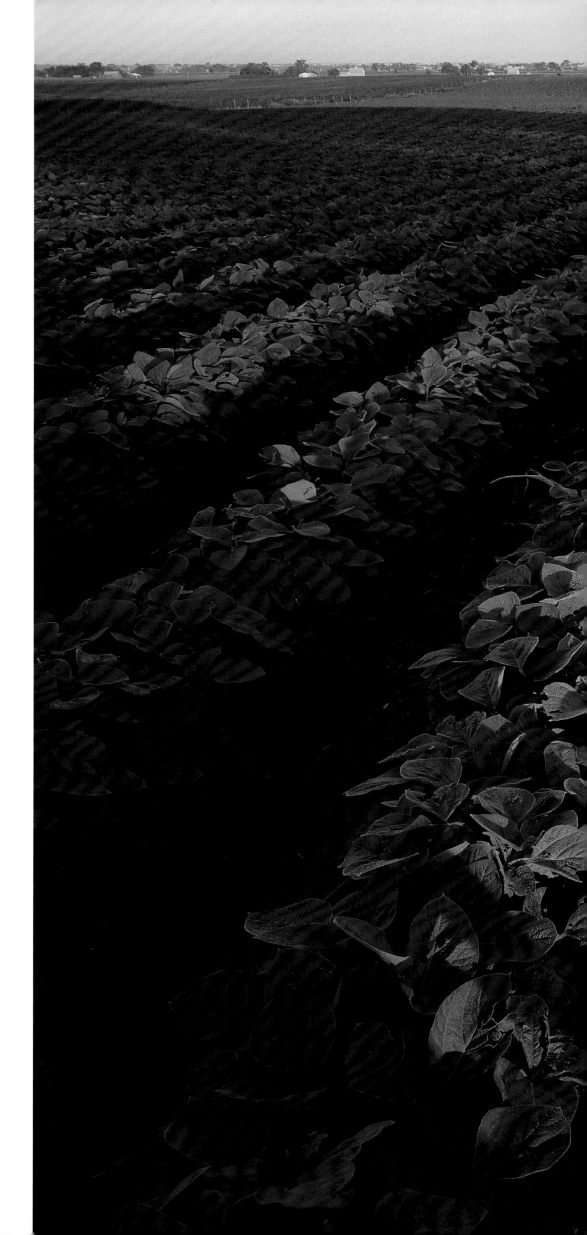

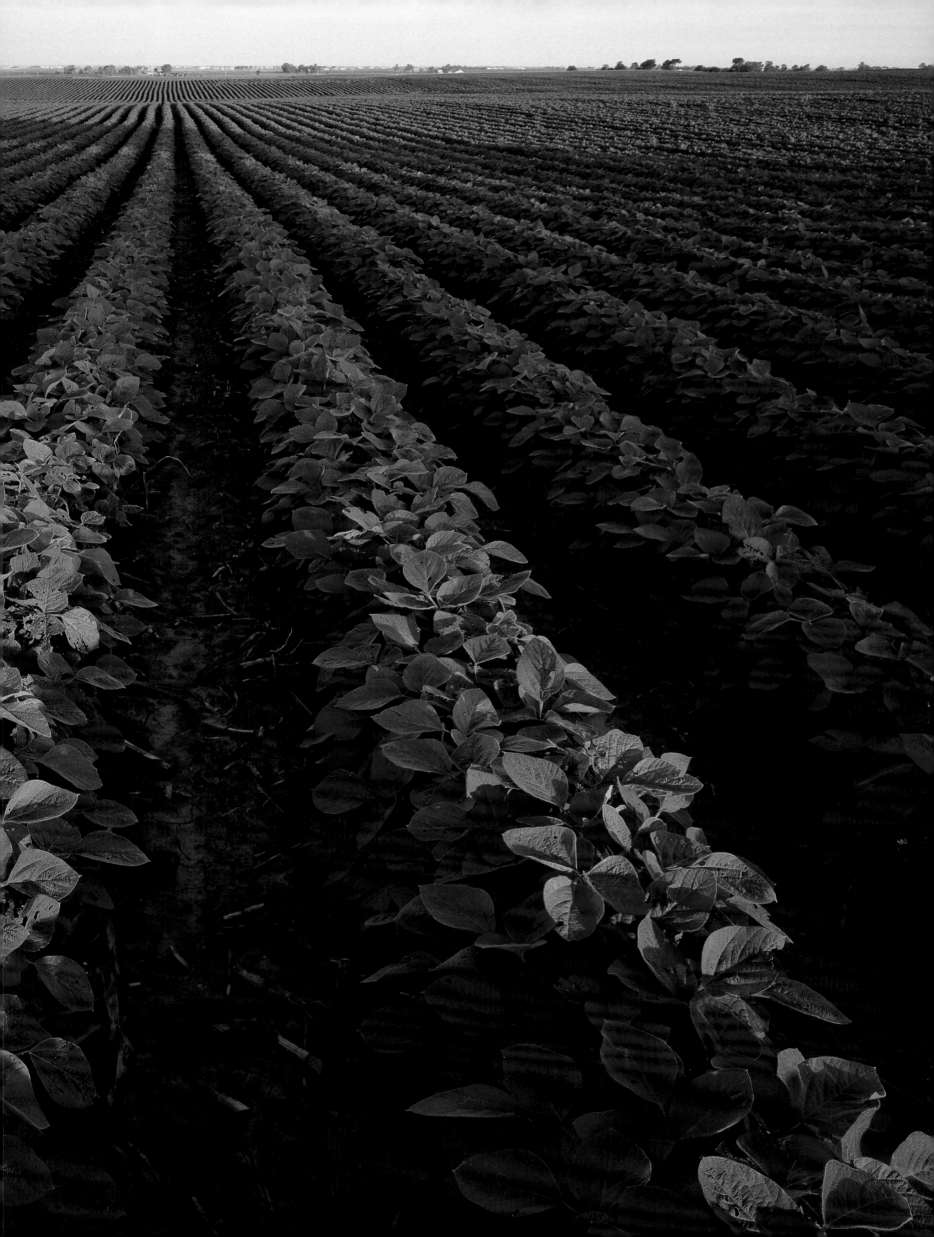

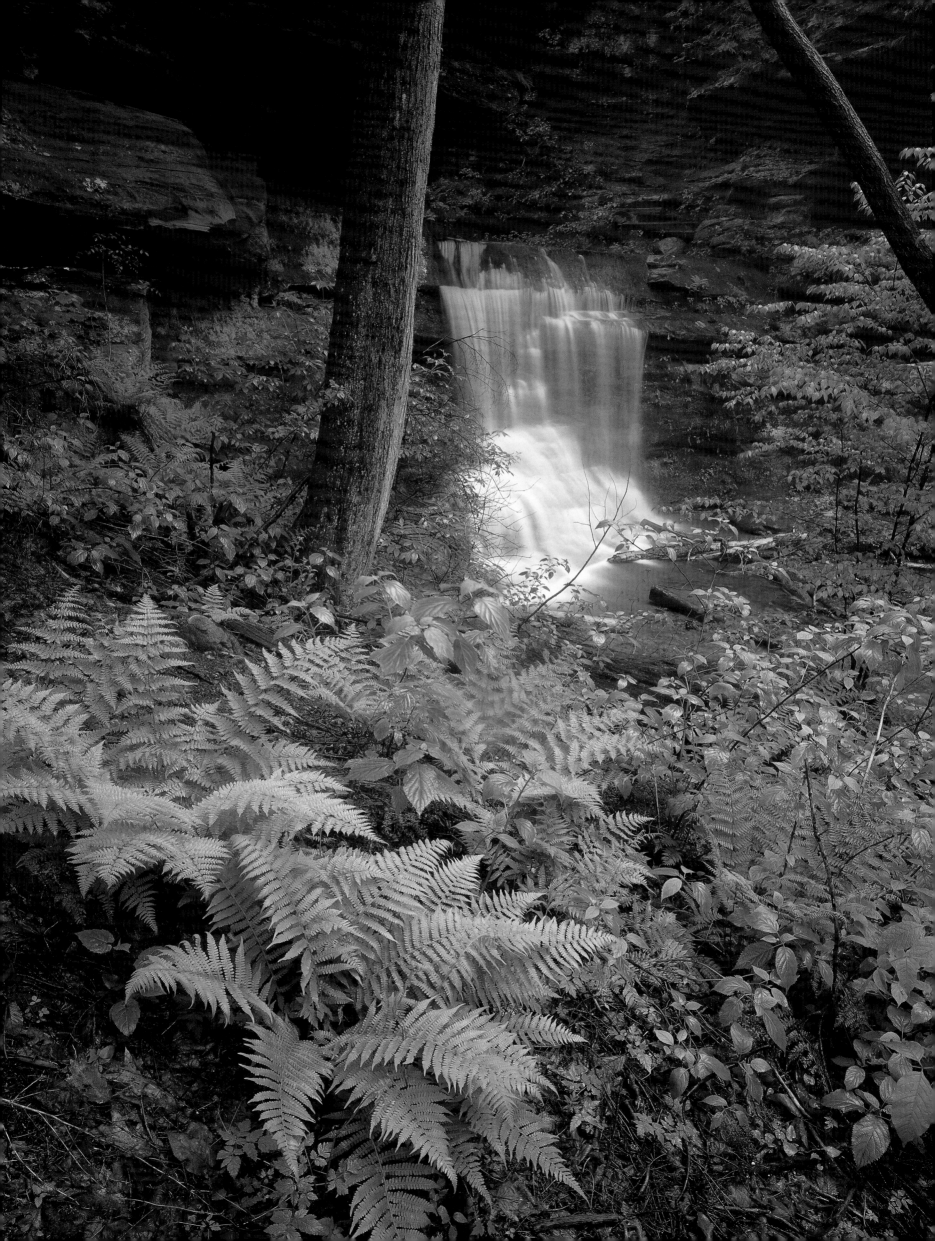

Extending through six counties, Chequamegon National Forest spans 858,400 acres of
Wisconsin's north woods. Much of this area was heavily logged and homesteaded in the early
1900s, before the federal government began to purchase the land. The forest's name comes
from an Ojibwa word meaning "place of shallow water," which describes the Lake Superior
bay to the north of the forest.

With nine state parks and more than 9,000 acres of government-owned forest, Ohio's Hocking
Hills region is a favorite outdoor recreation destination. Old Man's Cave State Park, one of the
most popular sites in the region, is named for recluse Richard Rowe, who made his home in
a cave near here in the late 1700s and spent most of his days exploring and hunting in the
surrounding woods. *(left)*

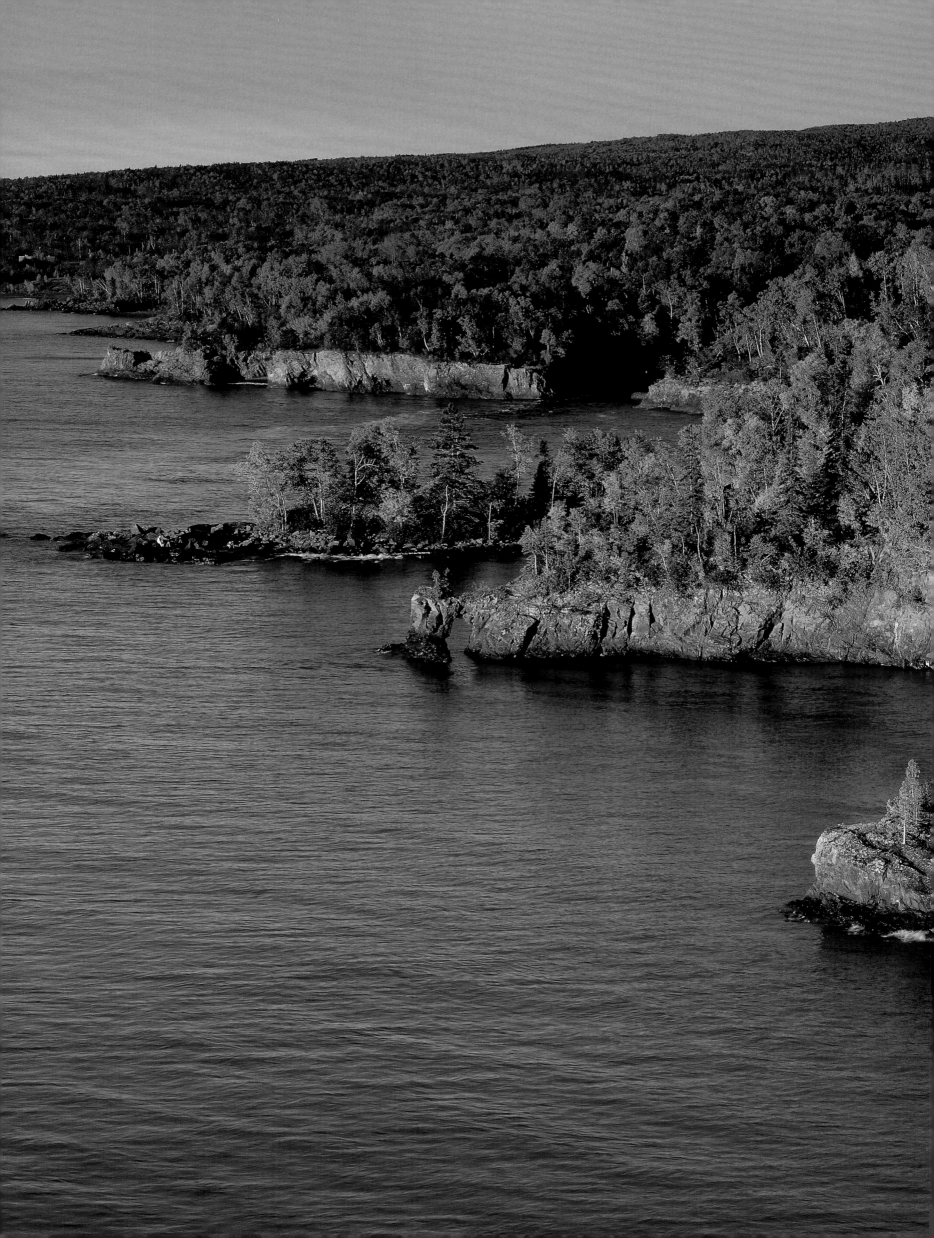

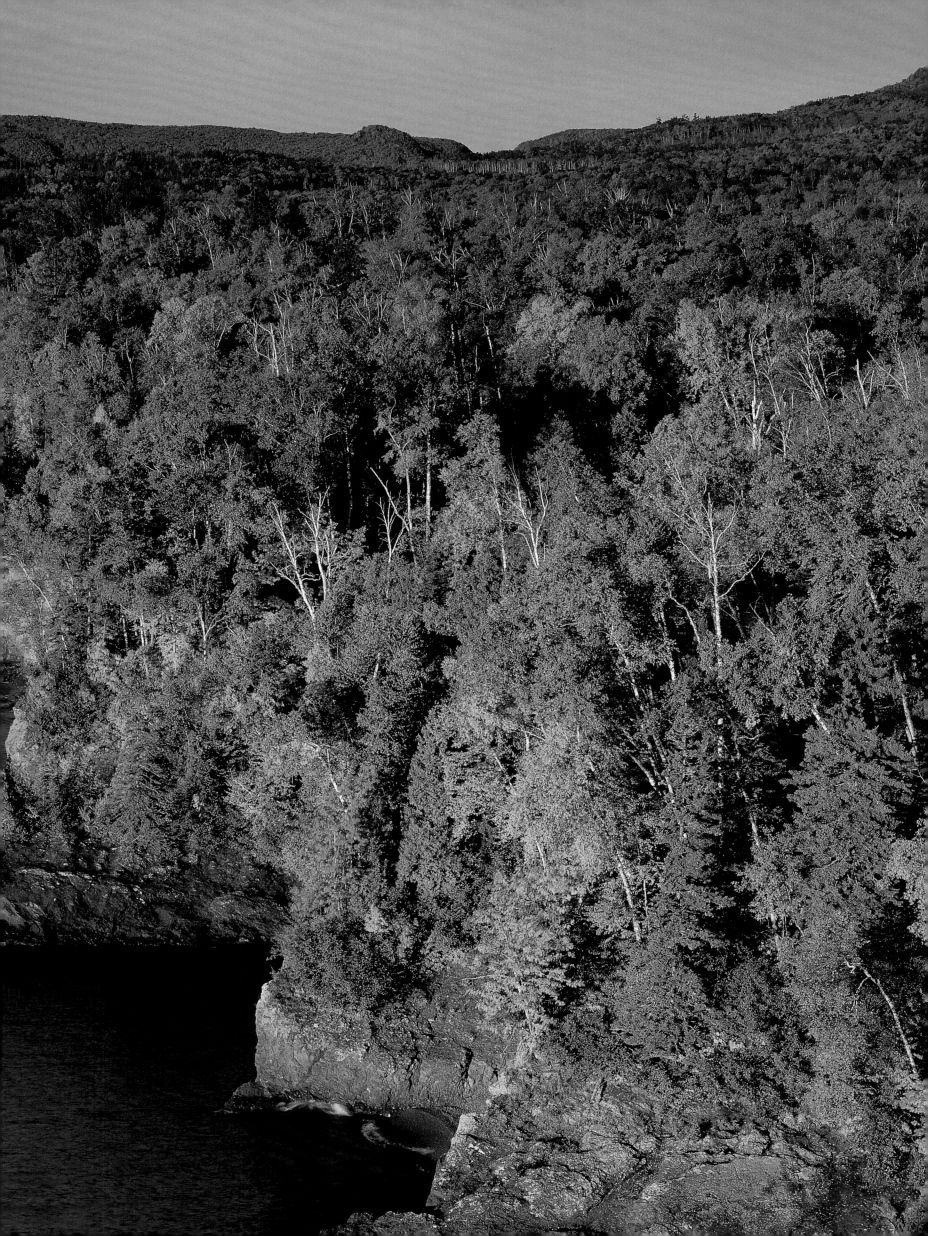

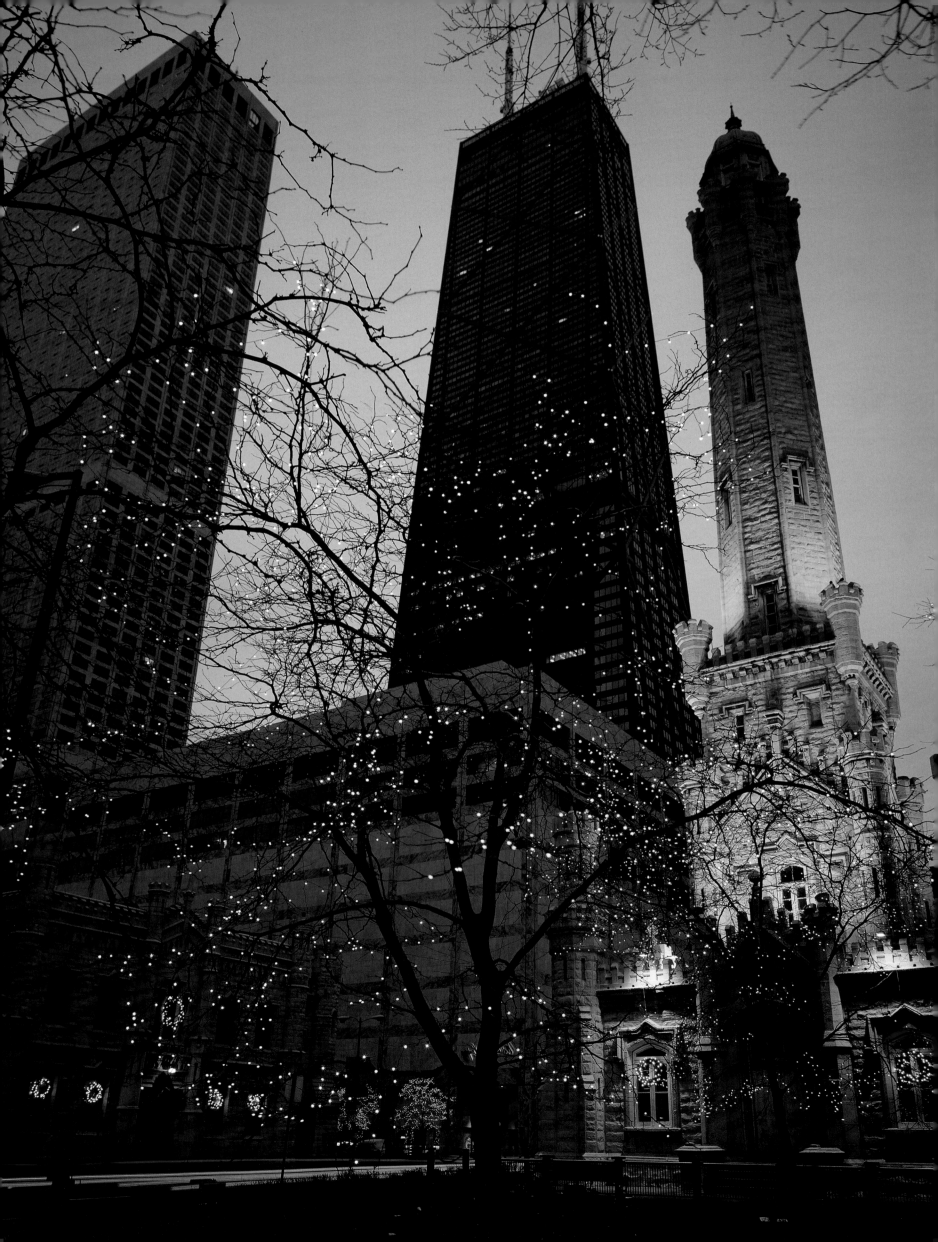

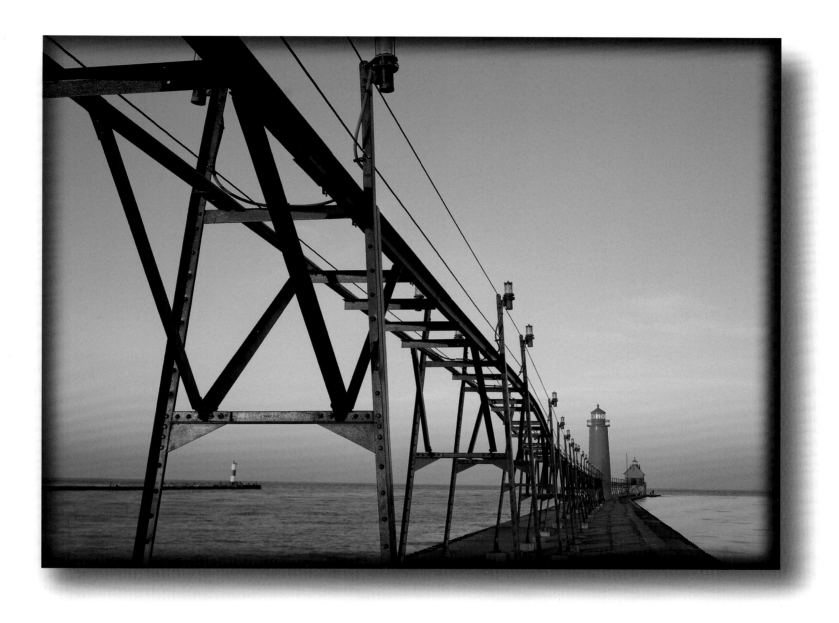

This Grand Haven beacon stands guard where the Grand River pours into Lake Michigan. The five Great Lakes drain 290,000 square miles and contain 20 percent of the world's fresh water.

After a hot, dry summer in 1871, Chicago's early warning system failed and a blaze tore through downtown in hours. When rain tamed the flames 36 hours later, 2,000 acres lay in ruins. The Water Tower, with its distinctive limestone façade, was designed by William W. Boyington in 1869 and survived the Great Chicago Fire two years later. *(left)*

Bordered by Lake Superior to the north and crisscrossed by countless lakes and streams, Minnesota is known as the "land of 10,000 lakes." When the glaciers of the last ice age retreated, they left pockets of ice behind, which melted to form the waterways of today. *(previous pages)*

THE GREAT PLAINS THE GREAT PLAINS THE GRE

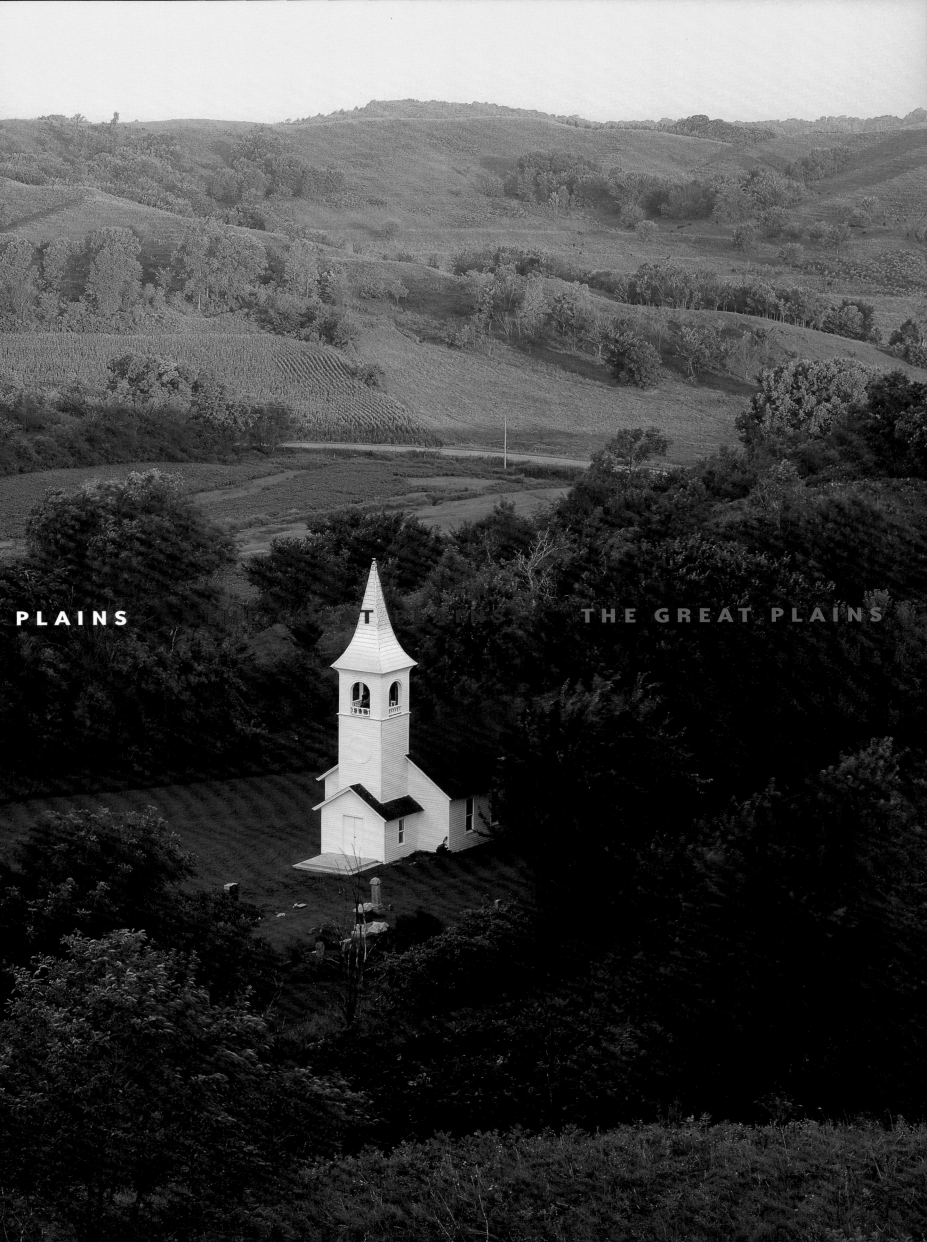

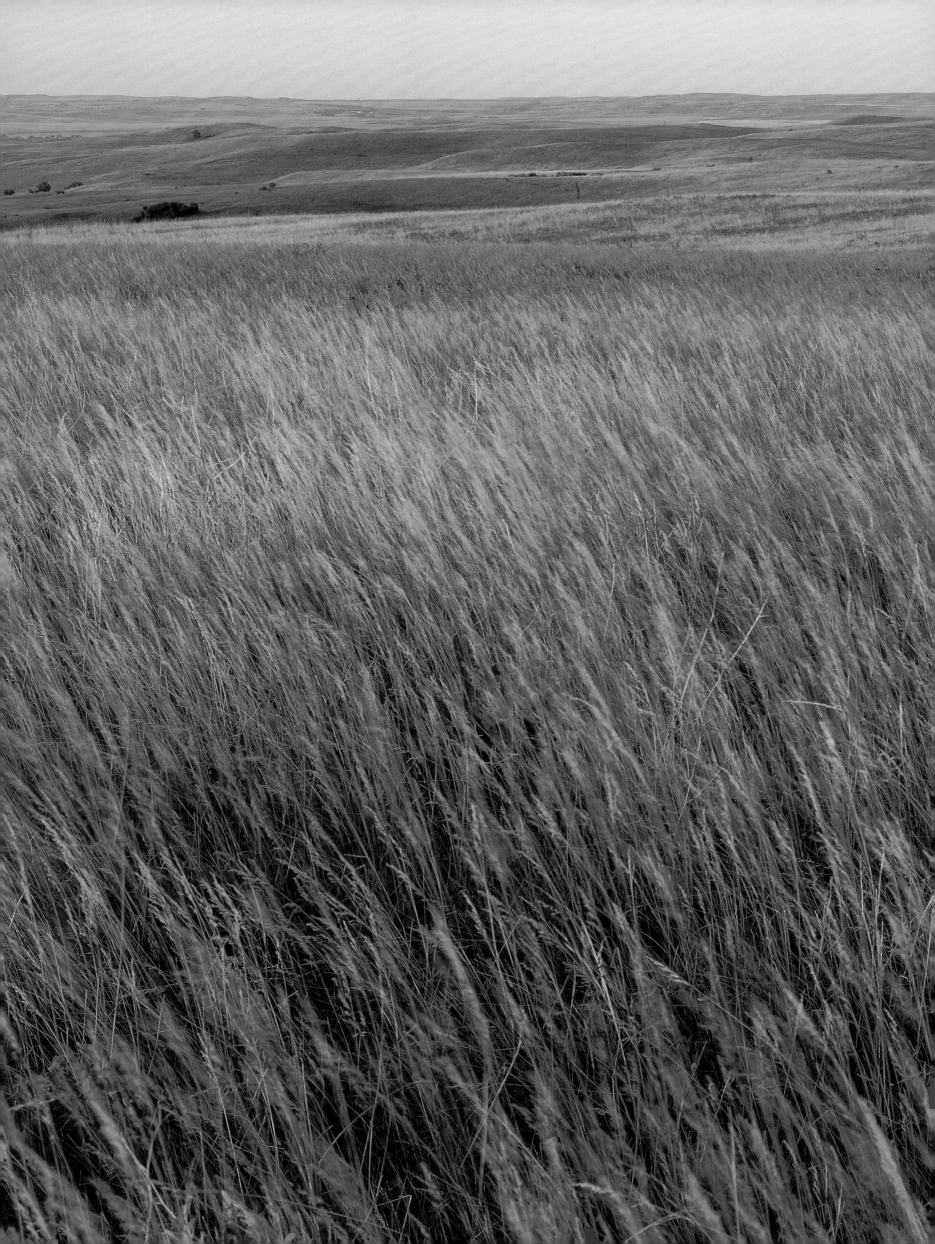

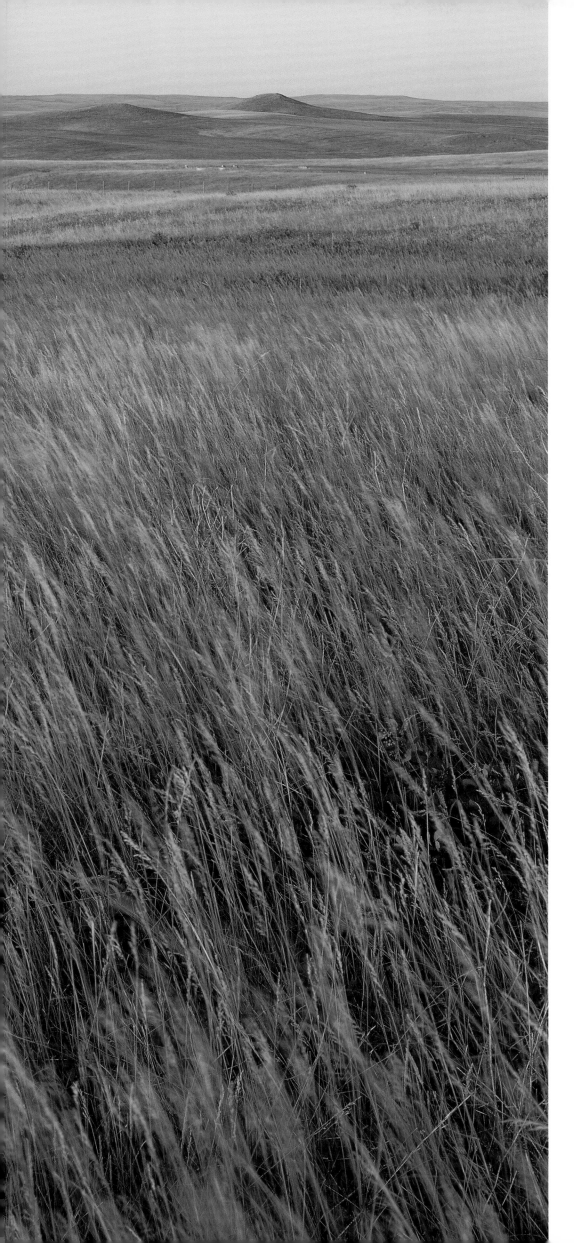

Theodore Roosevelt fell in love with North Dakota's grasslands in the late 1800s and grew increasingly alarmed at the damage wreaked by hunting and overgrazing. He carried these concerns with him to the presidential office, where he established the Forest Service, proclaimed 18 national monuments, and suggested more than 200 future preserves. North Dakota's Theodore Roosevelt National Park honors his vision.

Iowa's Loess Hills are named for the yellow soil — loess — that forms these ridges, left behind by the glaciers of the last ice age and carved by the wind. Rising above the surrounding agricultural land, the hills follow the shores of the Missouri River for 200 miles along the state's western edge. *(previous pages)*

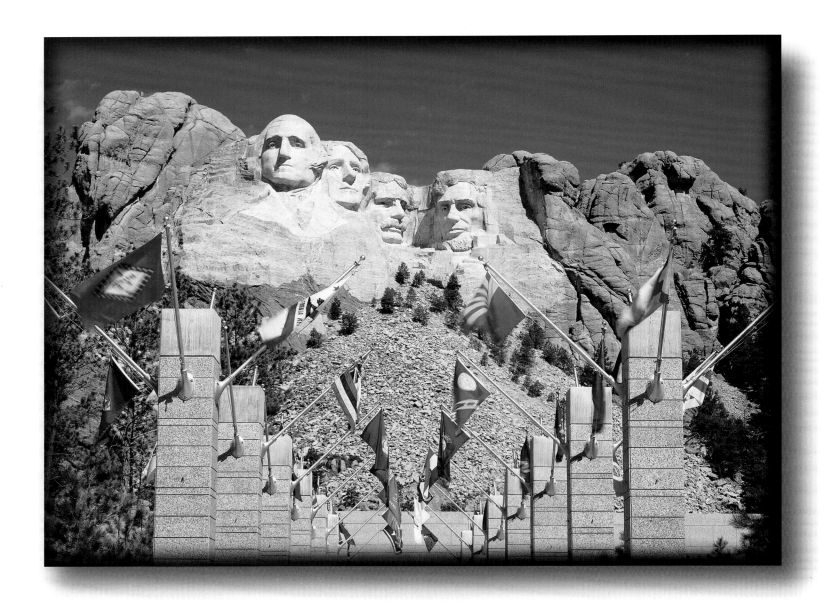

It took 400 workers, under the direction of sculptor Gutzon Borglum, 14 years to immortalize presidents George Washington, Thomas Jefferson, Theodore Roosevelt, and Abraham Lincoln in the granite of South Dakota's Mount Rushmore. Beginning in 1927, explosives experts used dynamite to create four rough egg-shapes. Then sculptors, working from large-scale plaster models, painstakingly created each portrait.

The story of North Dakota's Badlands is the story of the continent's formation. About 60 million years ago, rivers swept down the slopes of the newly born Rocky Mountains carrying minerals and soil, which they deposited across the flatlands to the west. As water and wind continued to sculpt the land, harder deposits remained behind, creating the eerie forms that line the Little Missouri River today. *(right)*

Forty million years ago, Badlands National Park in South Dakota was a lush jungle with a warm climate, plentiful water, and a mammal population that included the ancestors of the rhinoceros, sheep, and pig. Even now, the park — encompassing America's largest mixed-grass prairie — supports a diverse community of life, including the black-footed ferret, the continent's most endangered land mammal. *(overleaf)*

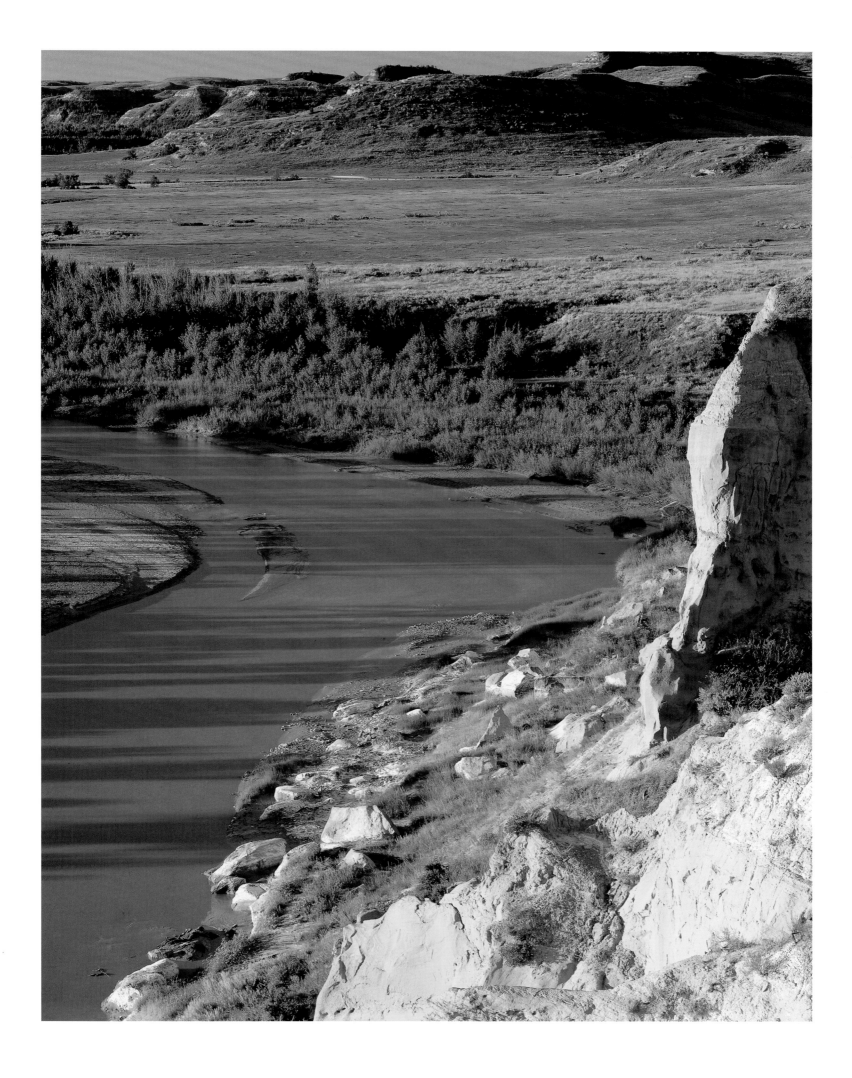

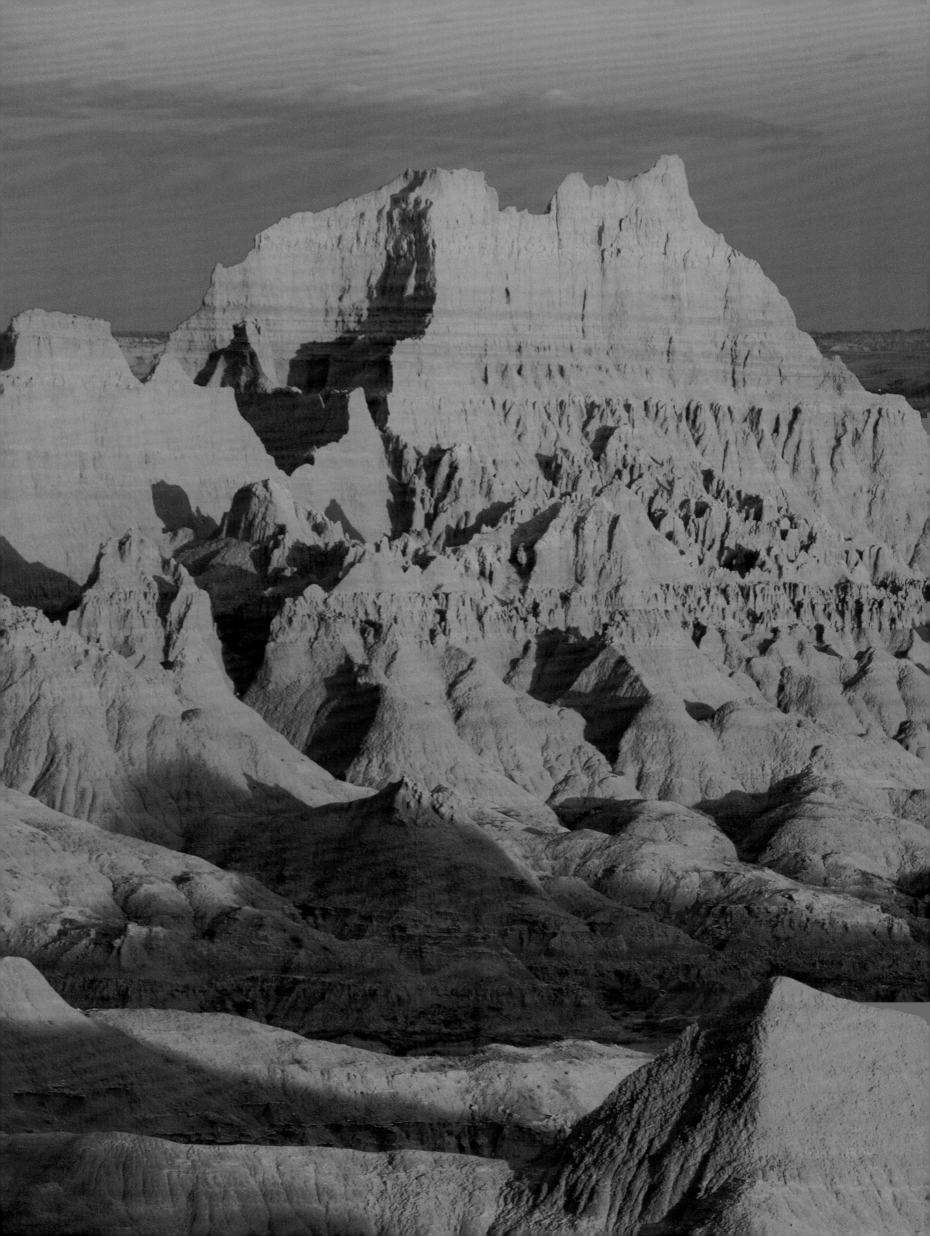

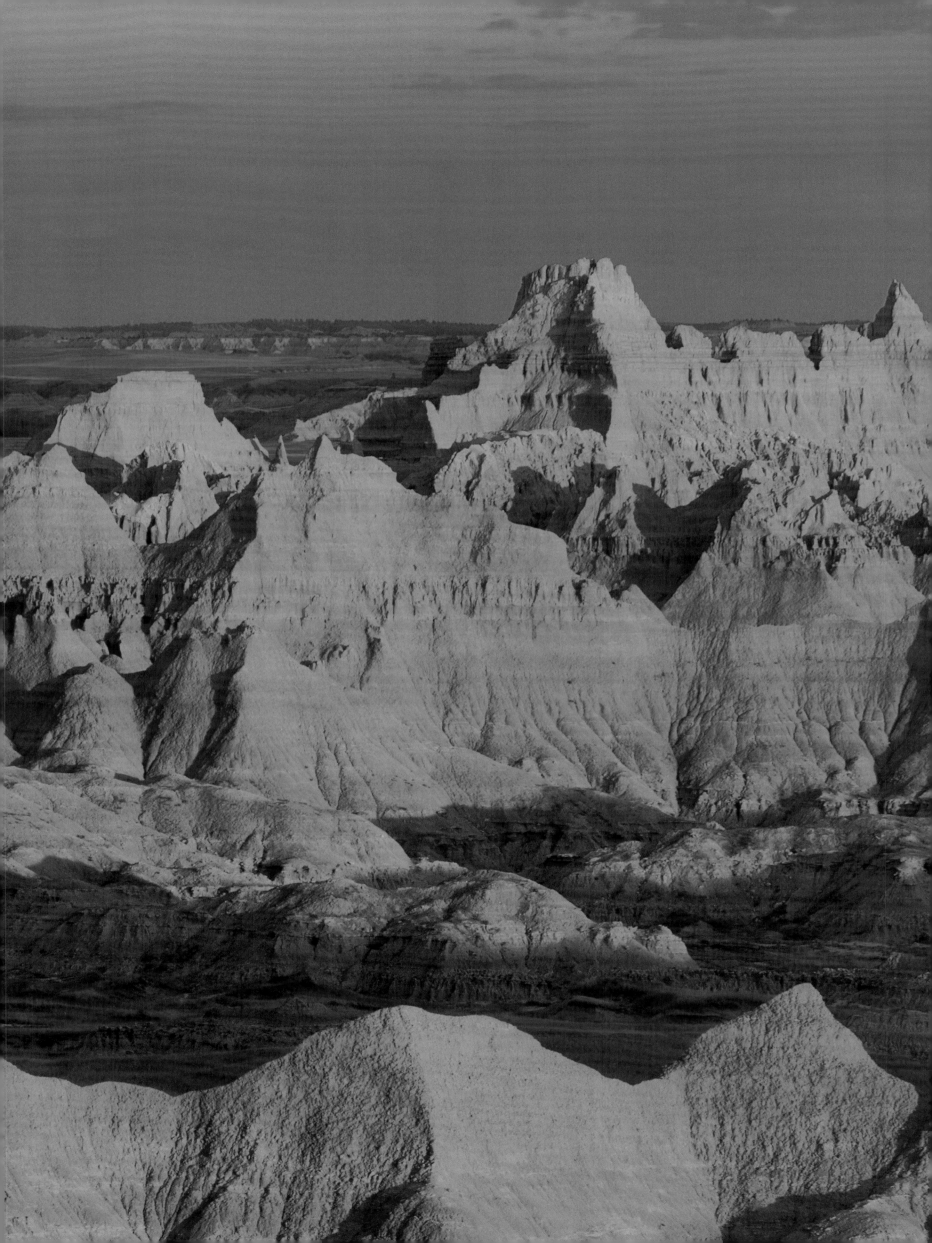

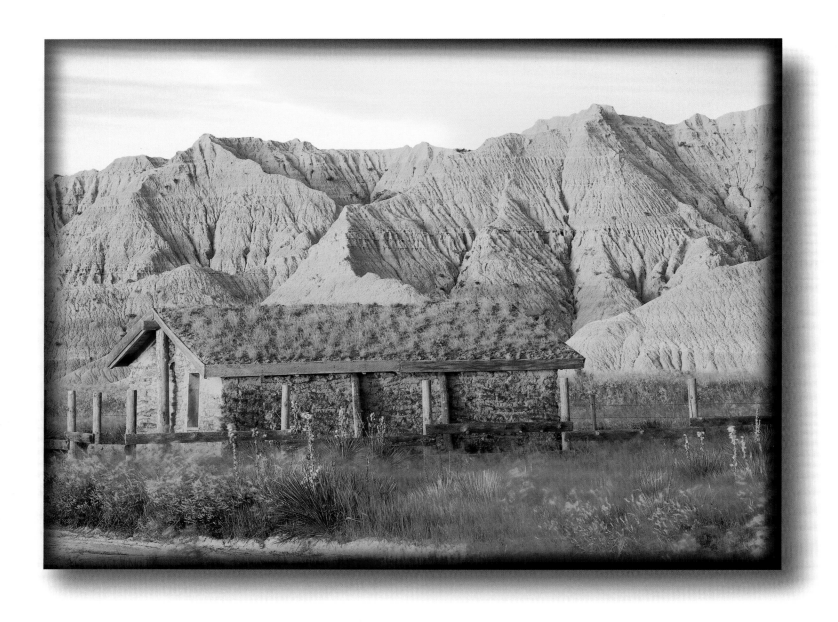

In the shadow of the Rocky Mountains, Nebraska's Oglala National Grassland offers refuge to the pronghorn, swift fox, mule and white-tailed deer, grouse, and endangered burrowing owl. This reconstructed sod house within the preserve reveals the struggles of early homesteaders, forced to build their shelters with only materials readily available from the surrounding plains.

It's the nineteenth century. You've left family and home behind and set off for the frontier lands of California and Oregon. What belongings does your wagon hold? That's one of the questions posed at the visitor center at Nebraska's Chimney Rock National Historic Site, where exhibits honor the thousands of west-bound settlers for whom this formation served as a milestone. *(right)*

Dawn brightens the Mississippi River as it flows through Iowa's Effigy Mounds National Monument. North America's largest river, the Mississippi runs from Minnesota's Lake Itaska to the Gulf of Mexico, where it pours out 593,000 cubic feet of water every second. It follows channels carved 10,000 years ago by melting glacial water. *(overleaf)*

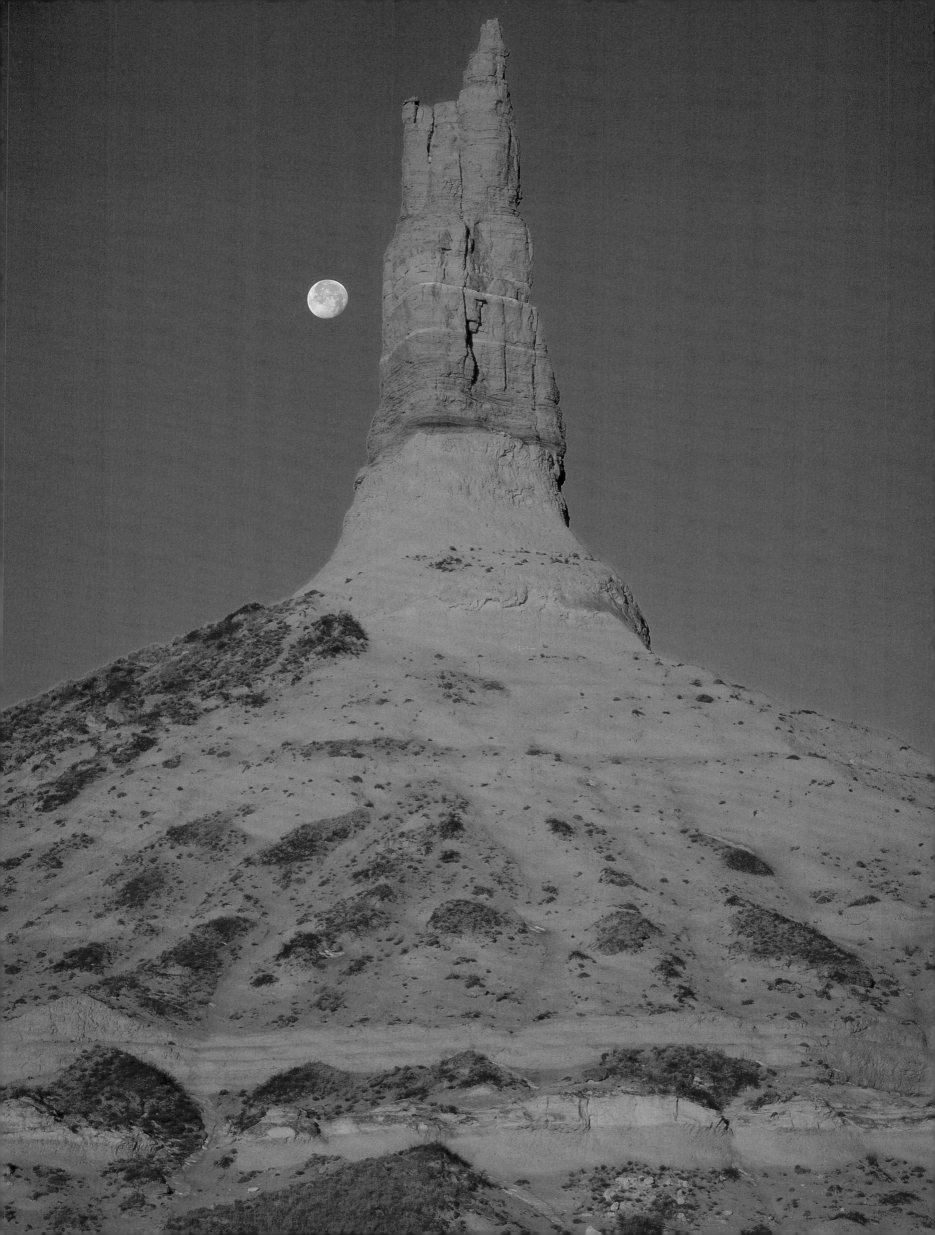

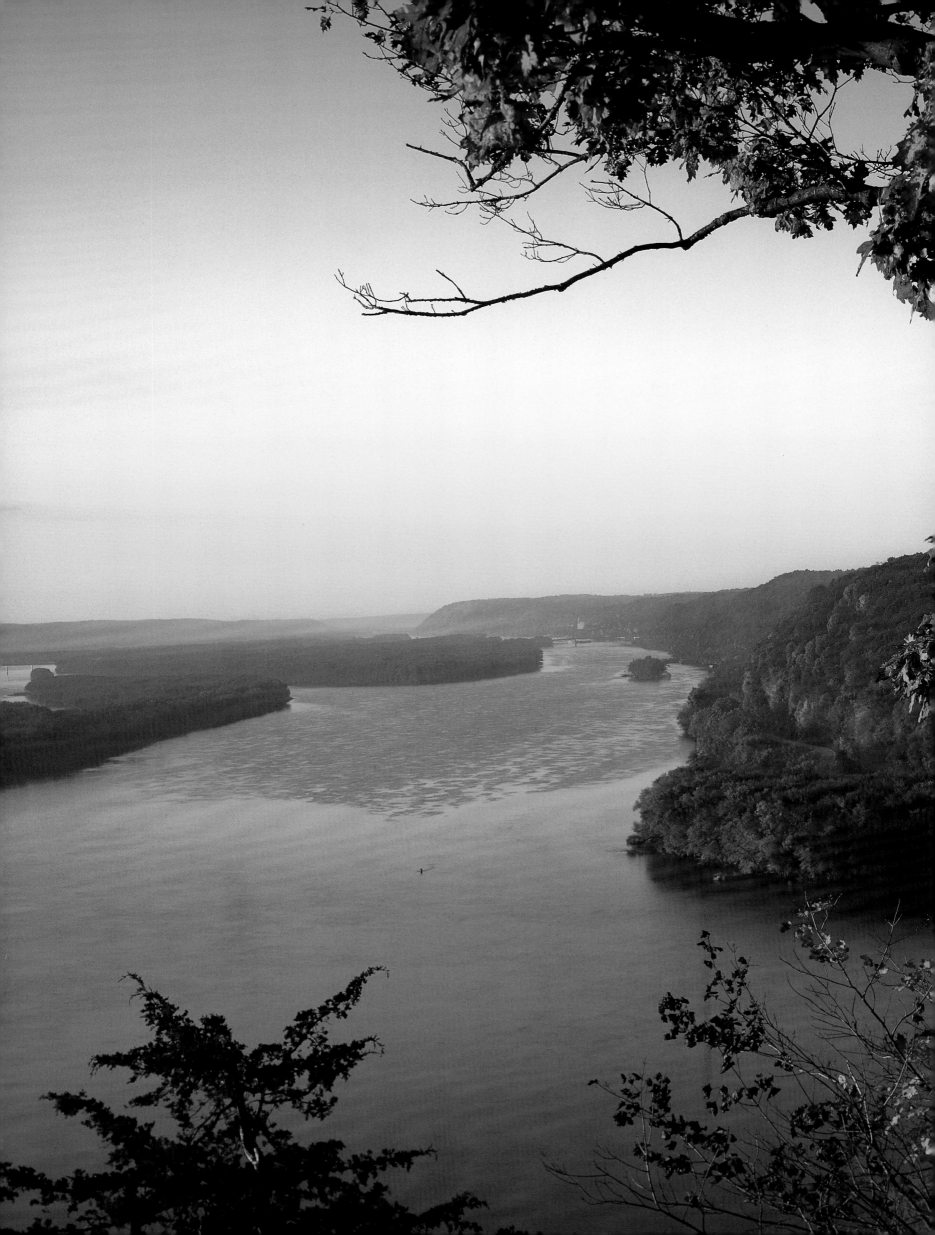

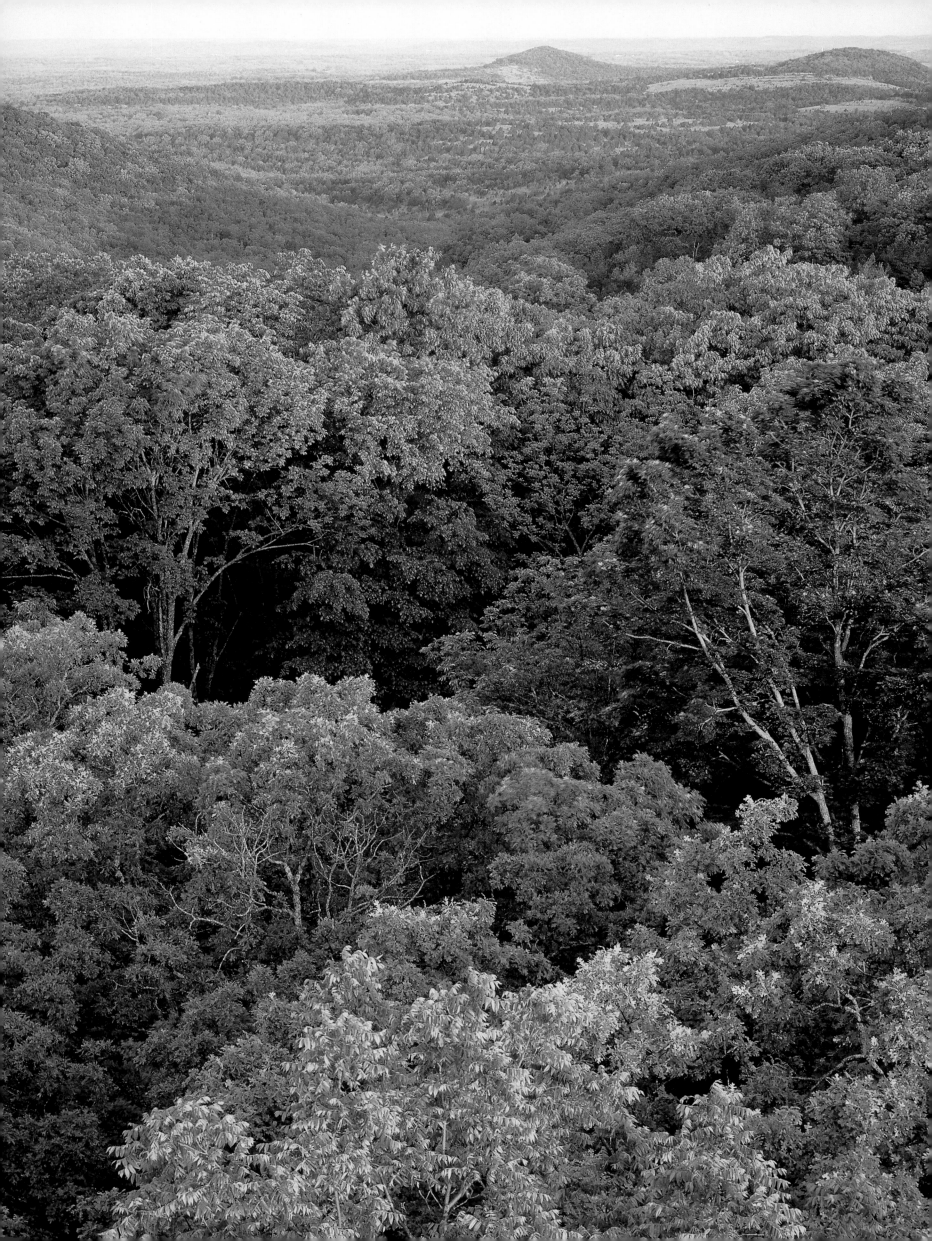

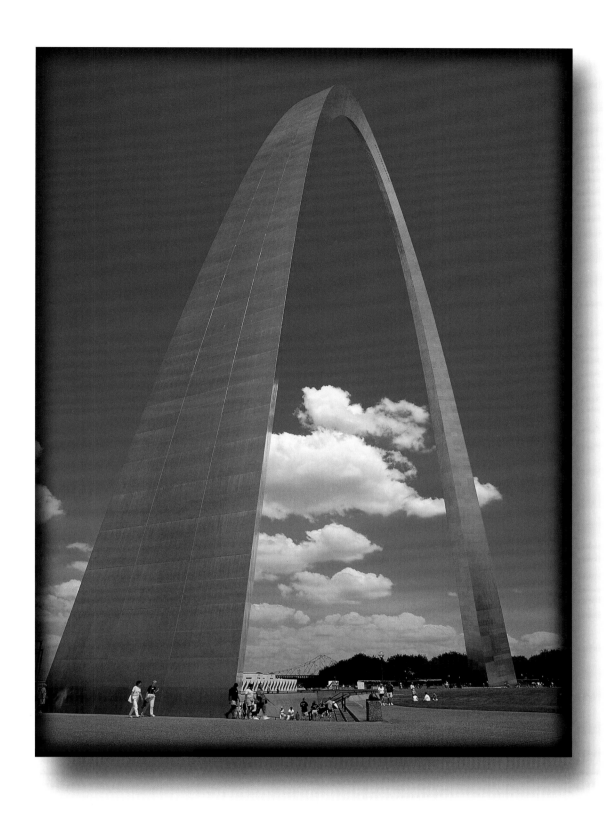

Measuring 630 feet tall and 630 feet wide at ground level, the Gateway Arch in St. Louis, Missouri, is the creation of architect Eero Saarinen. Saarinen won a national contest with his design to honor Thomas Jefferson, as part of the Jefferson National Expansion Memorial, which commemorates the president's role in the westward growth of the nation. Visitors can travel up the legs of the arch, via 40-passenger trams, to an observation deck at the top.

The fate of Missouri's Mark Twain National Forest is a tale of environmental success and a forest's rebirth. Ravaged by timber companies between 1870 and 1930, the land has regrown into a lush and diverse wilderness, encompassing 1.5 million acres from the St. Francois Mountains to the grasslands on the banks of the Missouri River. Campers, hikers, and anglers enjoy forest groves and wildflower meadows. *(left)*

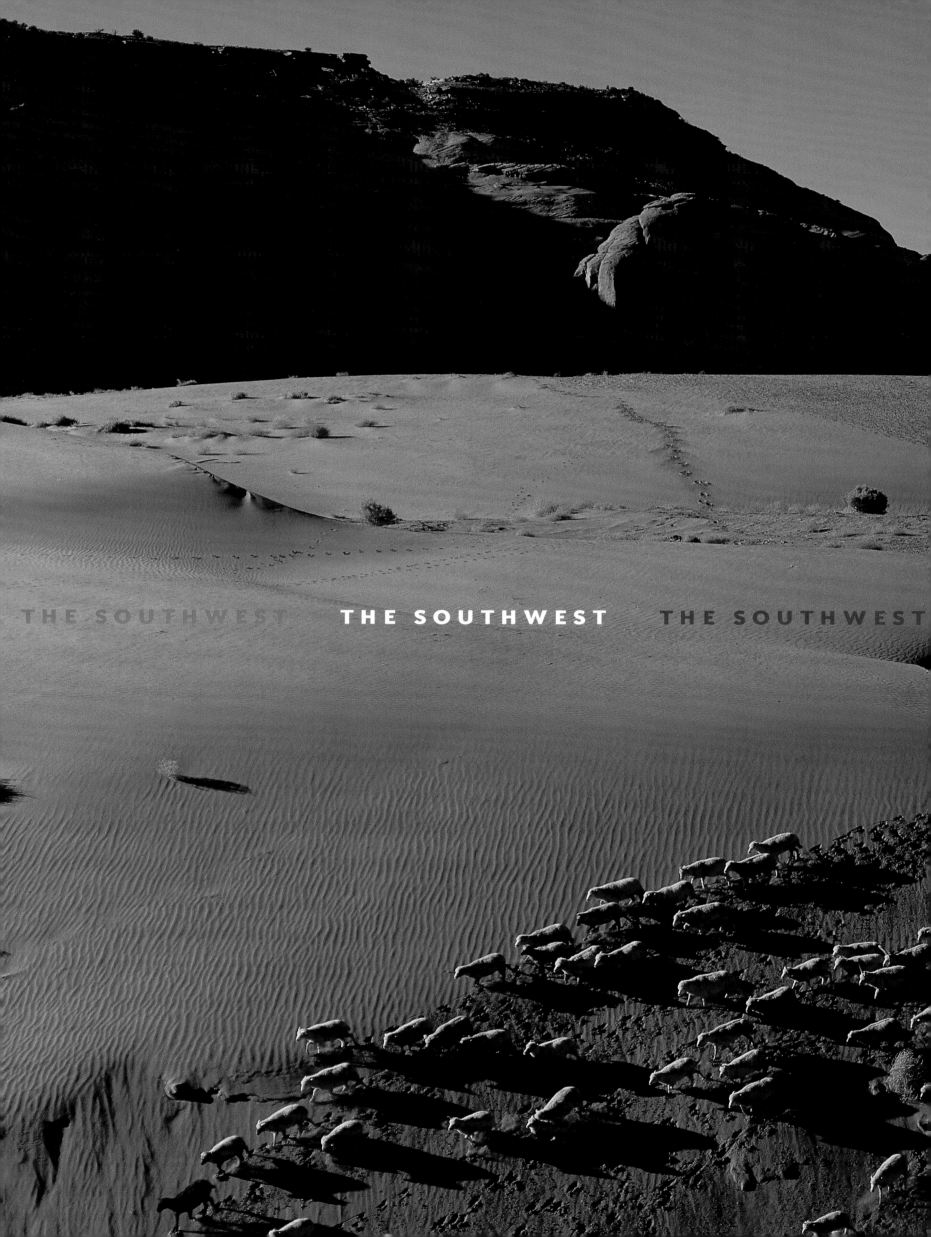

THE SOUTHWEST

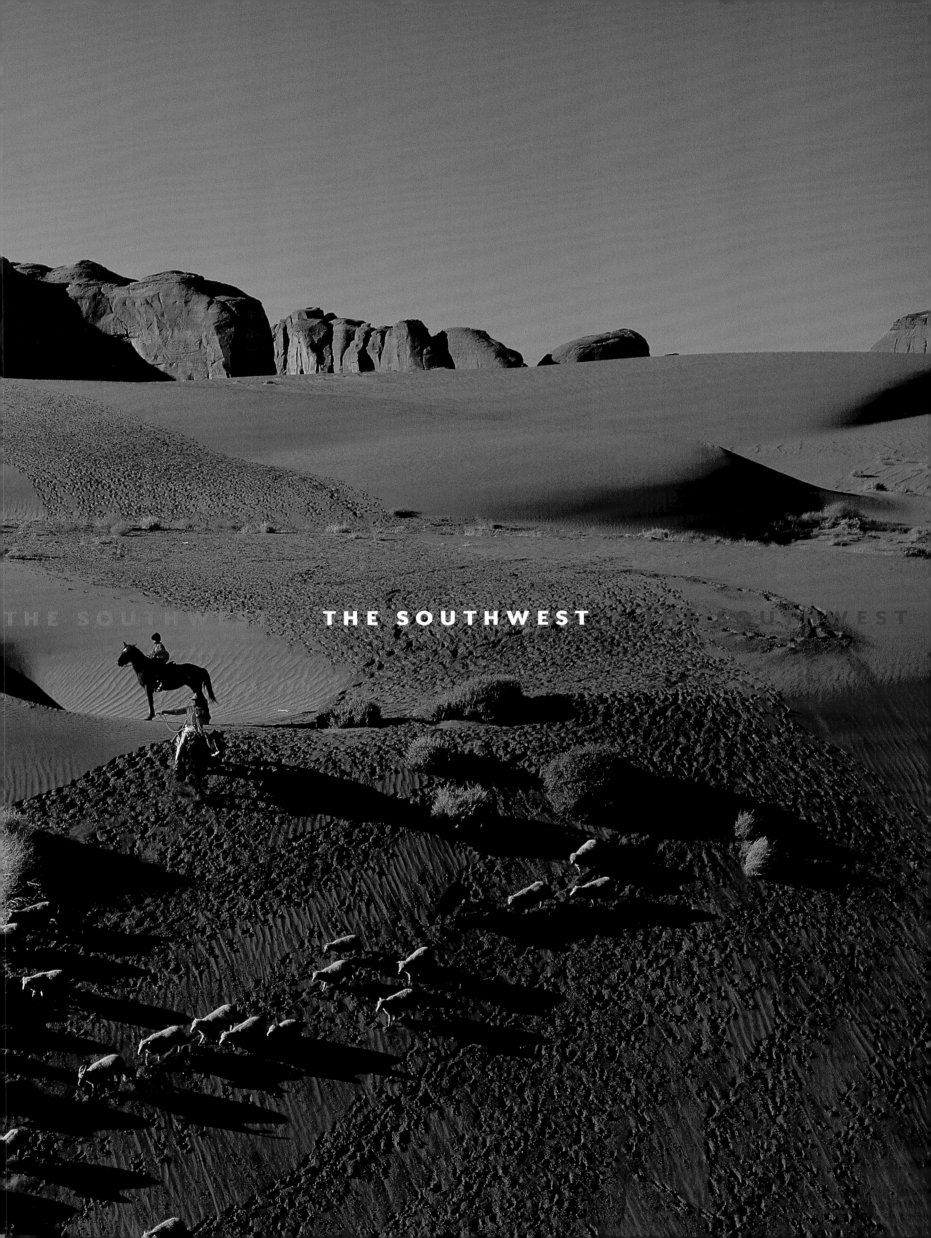

THE SOUTHWEST

The Spanish were the first non-native people to stumble upon what is now Pecos National
Historic Park in New Mexico. When they arrived in 1540, there were 2,000 native people living
here. In 1838, 500 years after the settlement was built, the last 17 residents departed for more
contemporary homes.

The founding of Misión San Antonio de Valero by Spanish missionaries in 1718 marked the birth
of San Antonio. The settlement was to become better known for war than for worship in 1836.
Fewer than 200 Texans, including Davy Crockett and James Bowie, defended the Alamo,
a Franciscan mission, to the death against a Mexican force of 5,000. *(right)*

Sprawling across the Arizona-Utah border, the Navajo Indian Reservation allows members of
the Navajo Nation to protect some of their ancestral territory and their traditional ways of life.
To showcase the region's most striking features, including some of America's most spectacular
spires and buttes, the Navajo established Monument Valley Tribal Park within the reservation.
(previous pages)

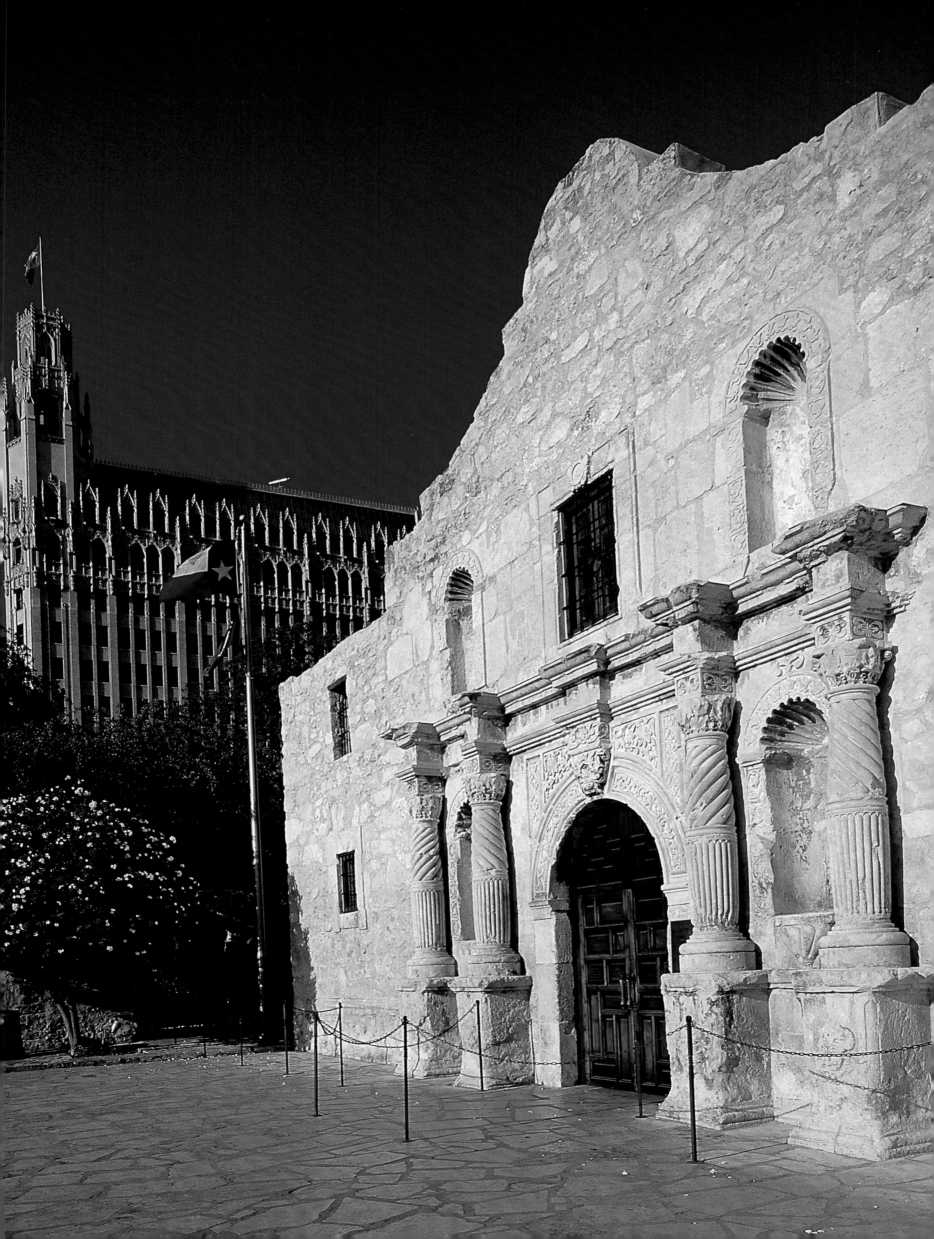

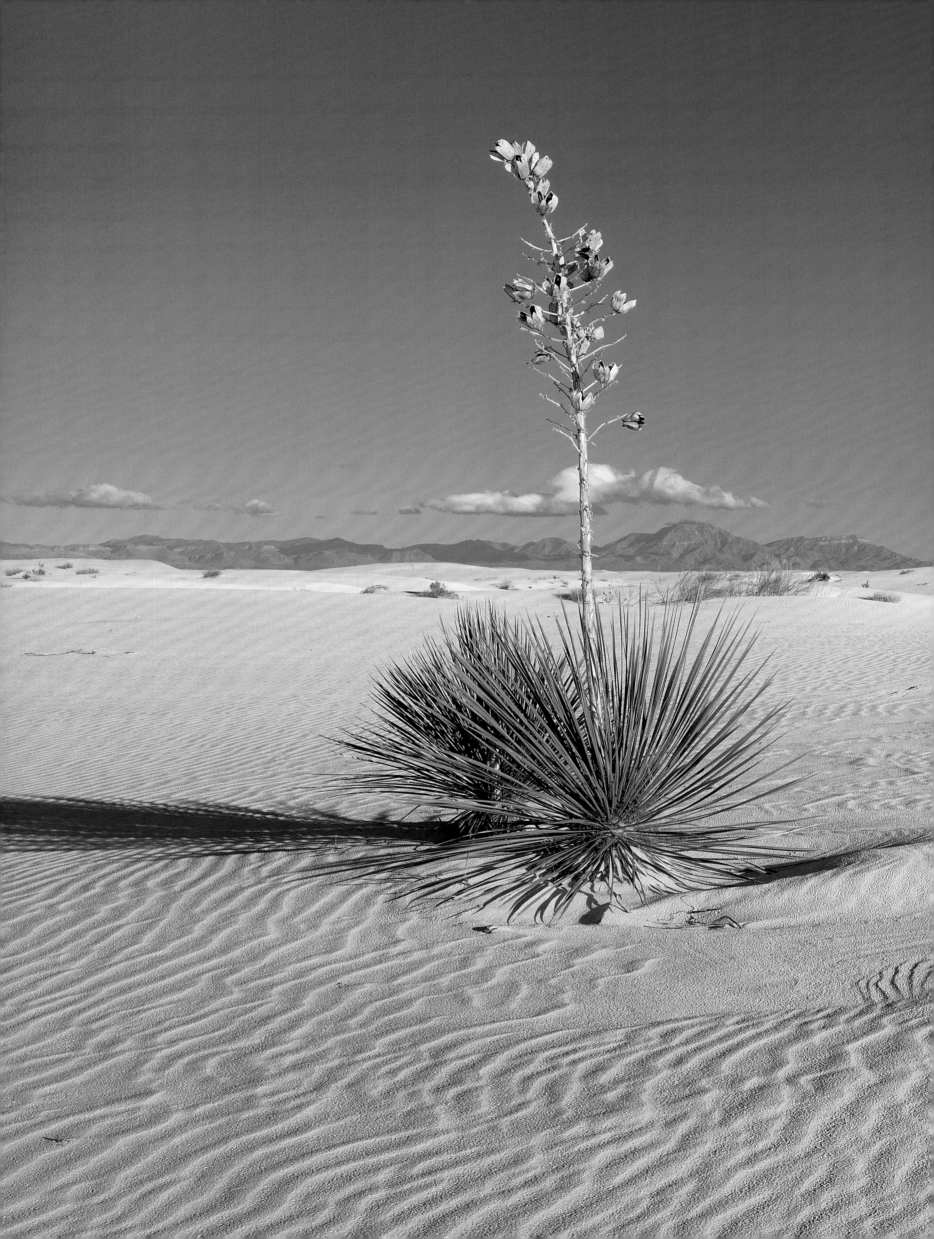

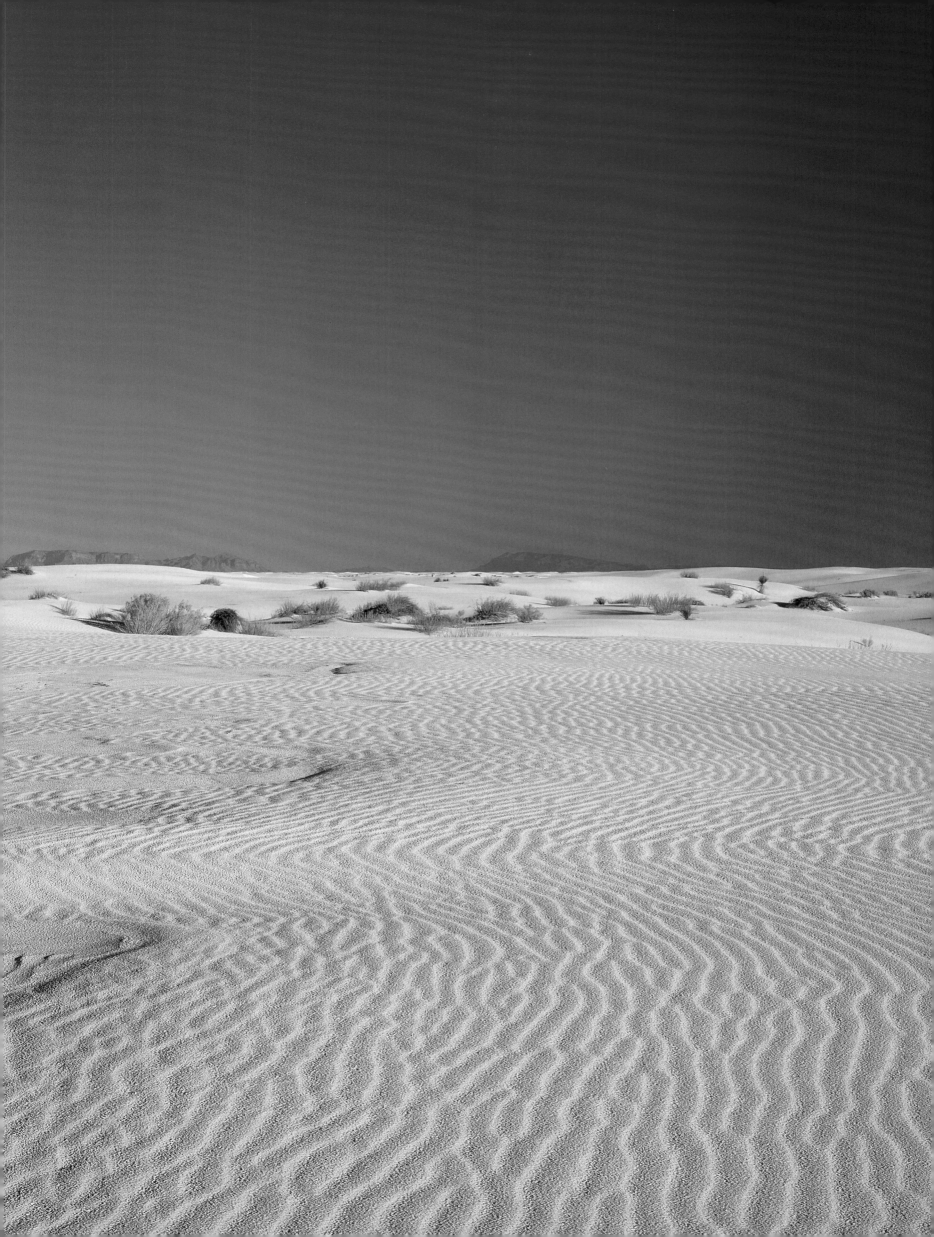

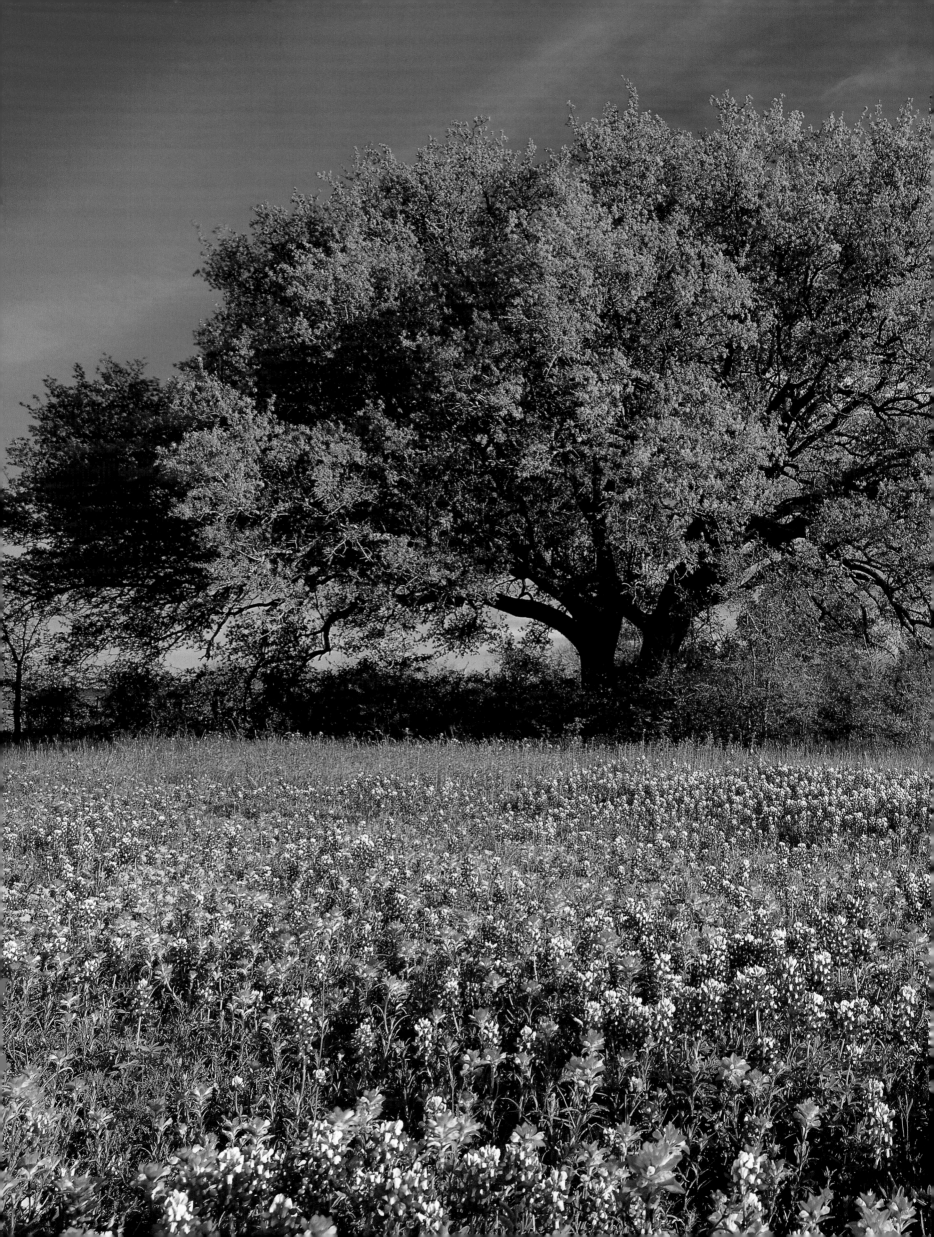

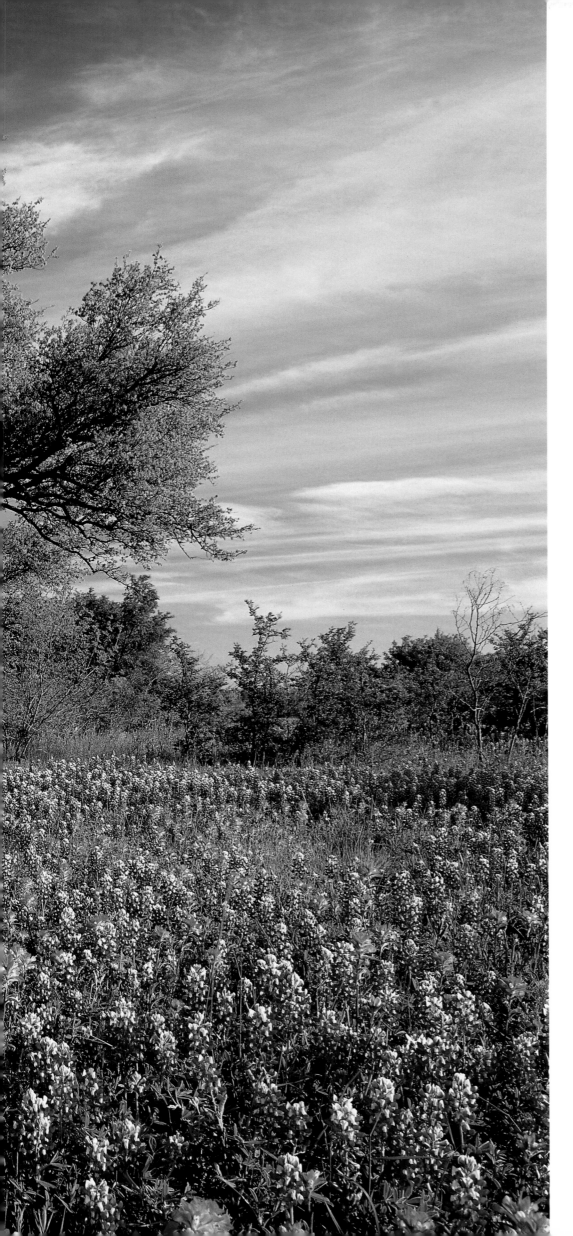

Blooming in the rolling meadows of the Hill Country, along roadsides and river-banks, in the shade of the national forests, 5,000 species of flowering plants flourish in Texas. Grasslands cover 80 percent of the state, and despite the overgrazing that has historically threatened native species, wildflowers such as these paintbrushes and bluebonnets continue to thrive.

A hardy yucca weathers the barren dunes of New Mexico's White Sands National Monument. As the prehistoric sea that once covered this land retreated, it left behind tiny gypsum crystals, which have been churned and molded by the wind into 30-mile-long dunes. Moonlight tours and slide shows offer summer visitors a unique way to experience the landscape. *(previous pages)*

117

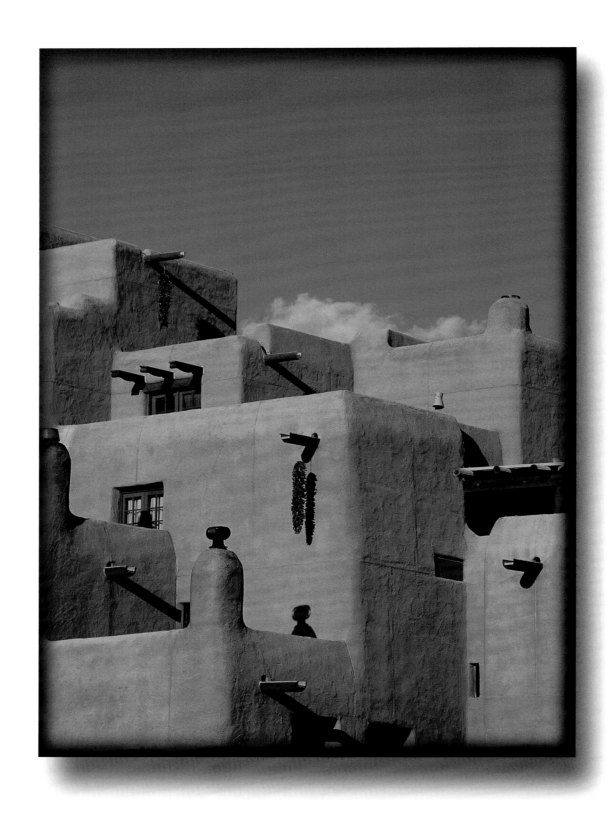

Anchoring the southern tip of the Rocky Mountain Range, Santa Fe, New Mexico, was for centuries a site of contention between the native Pueblo people, the Spanish, and, finally, the American settlers who took control in 1846. The Pueblo people continue to preserve the intricate arts of their ancestors, including pottery, baskets, and jewelry.

Big Bend is just that — a sudden corner in the course of the Rio Grande as the river shifts from southeast to northeast, to churn through the mountain canyons and the Chihuahuan Desert. Big Bend National Park in Texas protects an amazing diversity of life, from cacti and Douglas fir to black bears and diamondback rattlesnakes. *(right)*

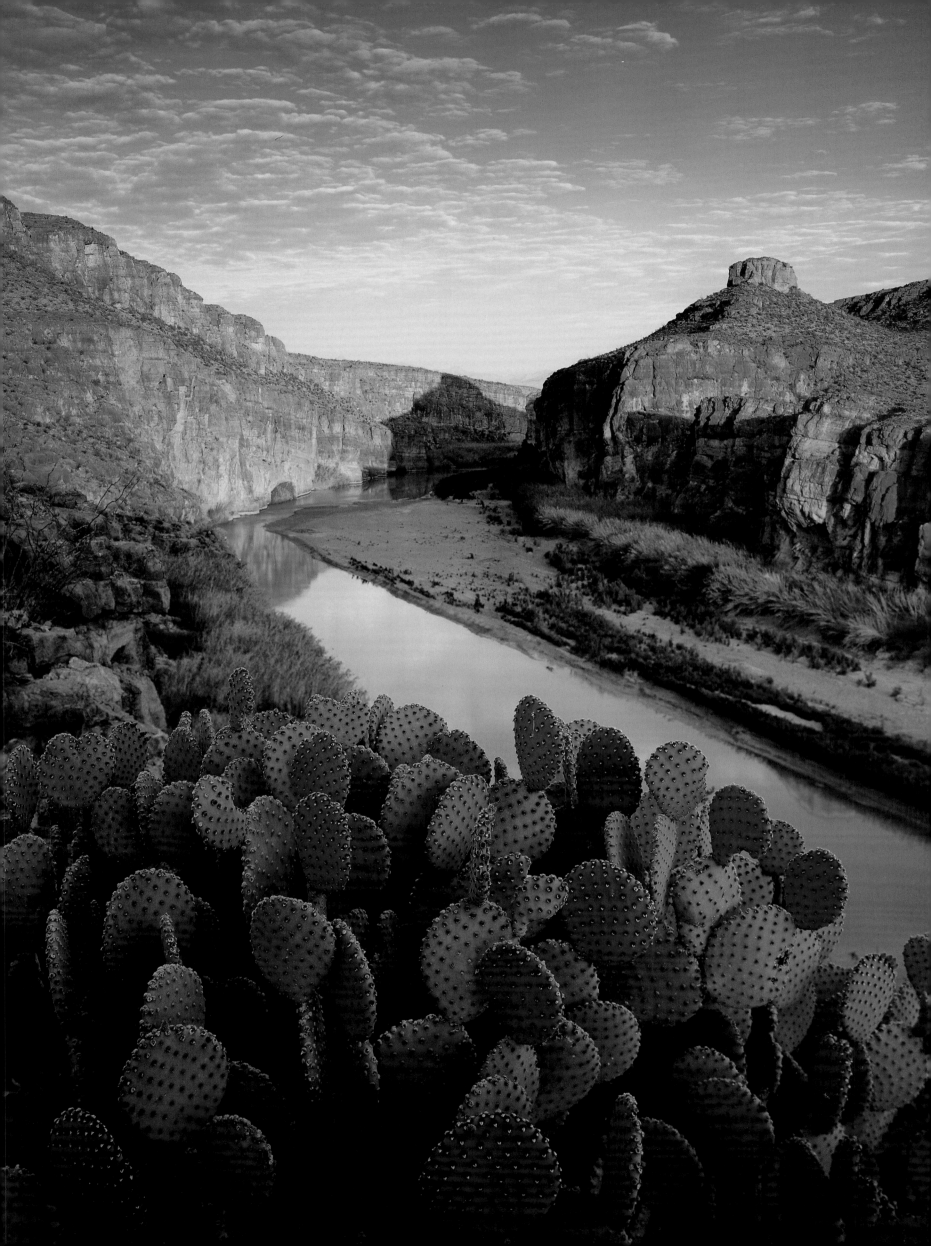

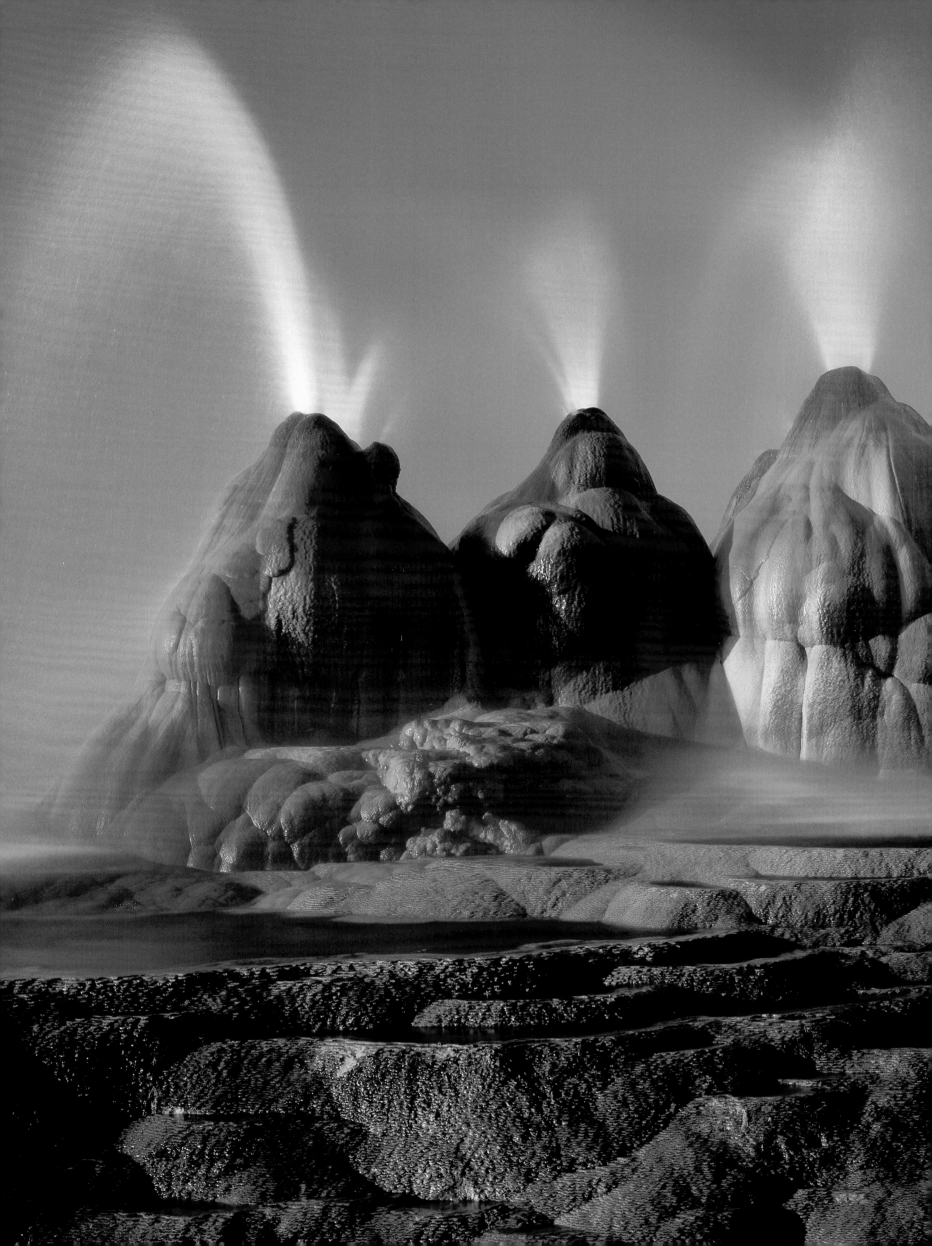

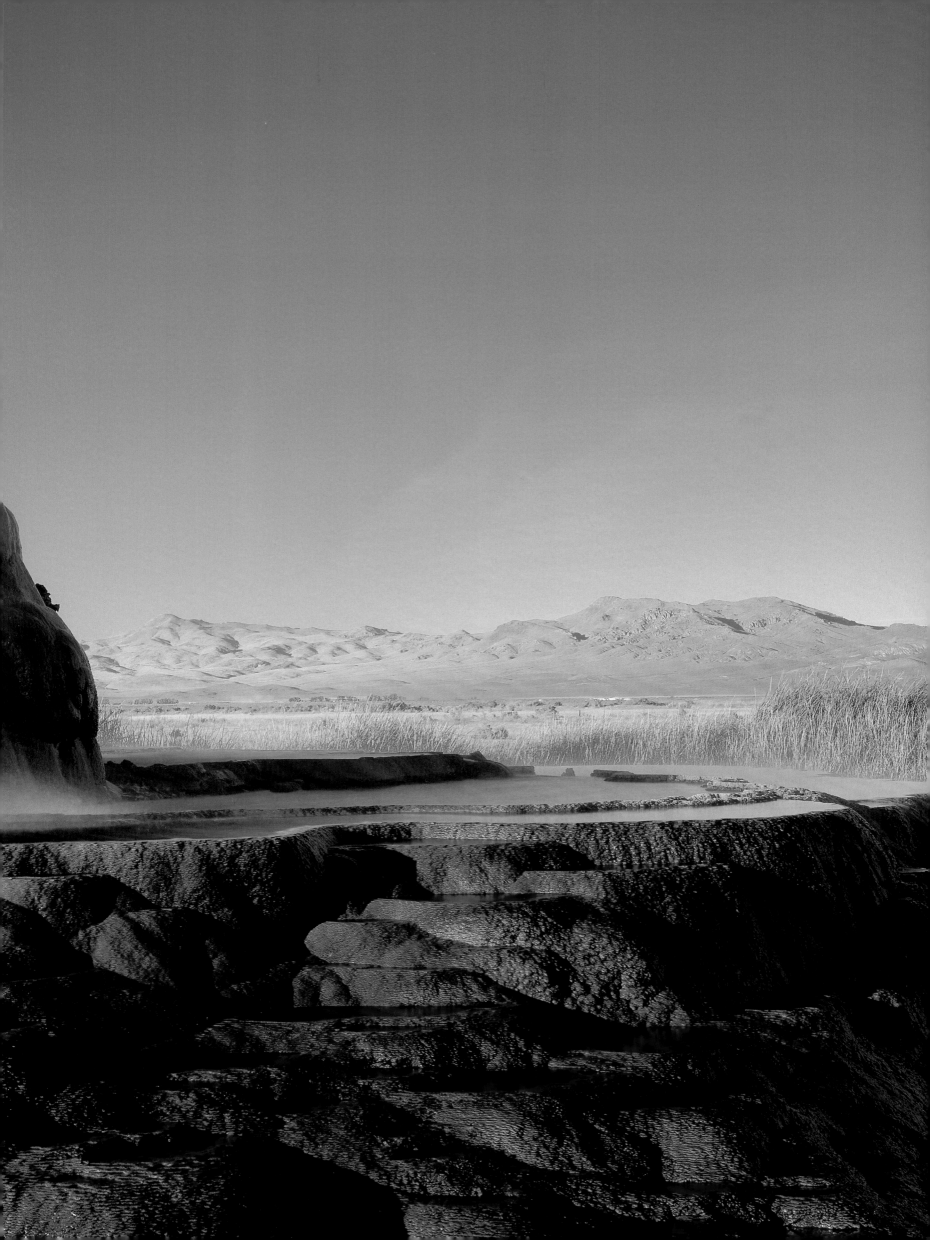

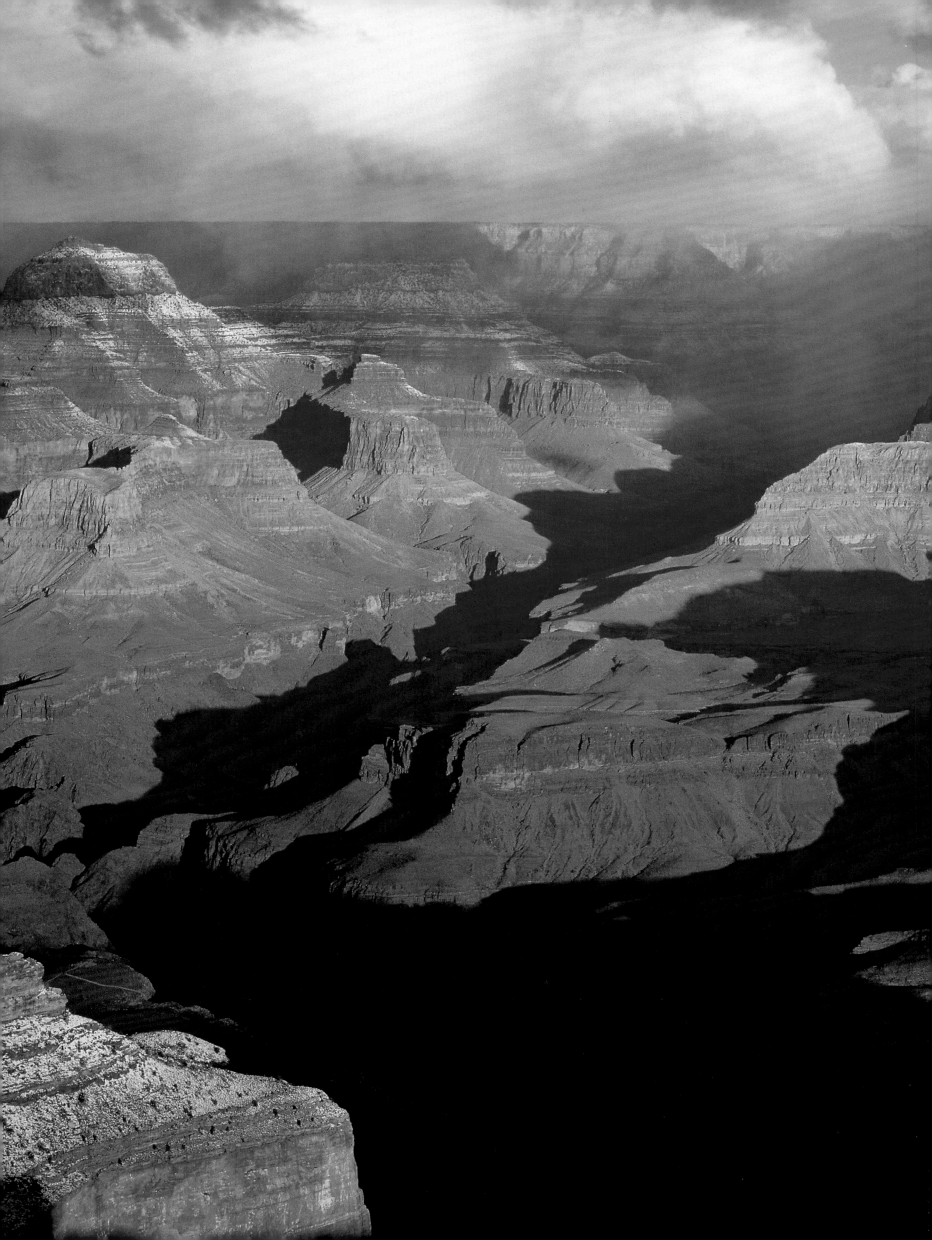

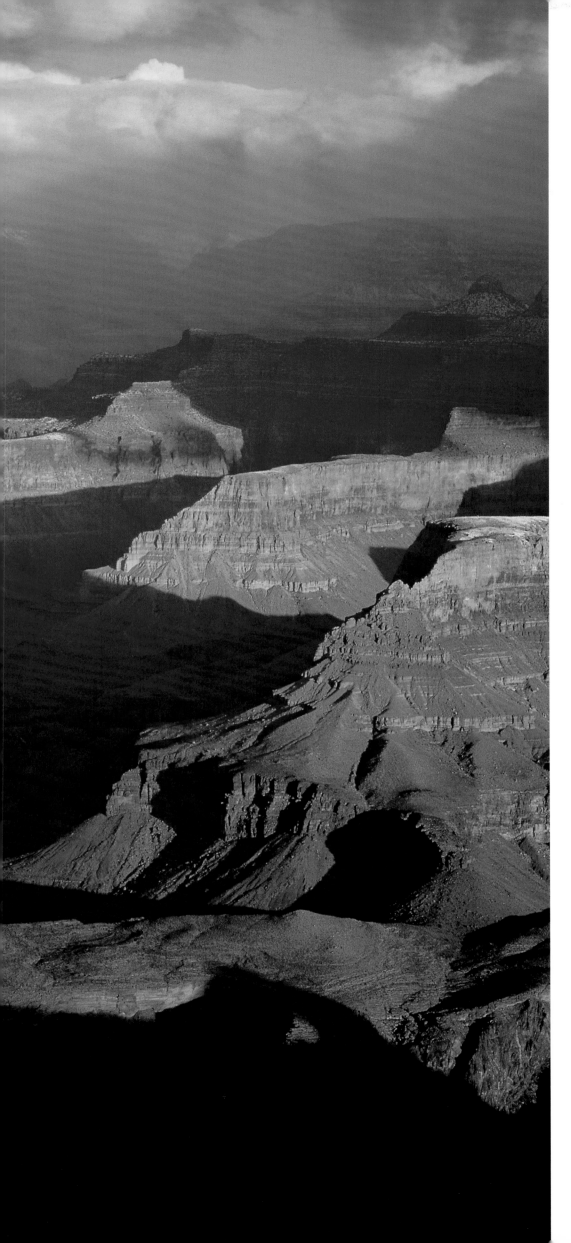

While plant and animal life flourishes on the Grand Canyon's rim, the inner canyon is mainly desert, with temperatures up to 30 degrees higher than those above. Cacti and drought-resistant plants eke out an existence and a few hardy bighorn sheep, bobcats, coyotes, and ringtails pick their way from the forested rims to the green streamside regions.

Rising from the flat expanse of Nevada's Black Rock Desert, Fly Geyser is one of several hot springs that dot the region northeast of Reno and attract adventure-seekers. The geyser sends up a constant stream of water and steam, so hot that it is impossible to walk on the surrounding rocks. Algae in the springs gives the geyser its distinctive colors. *(previous pages)*

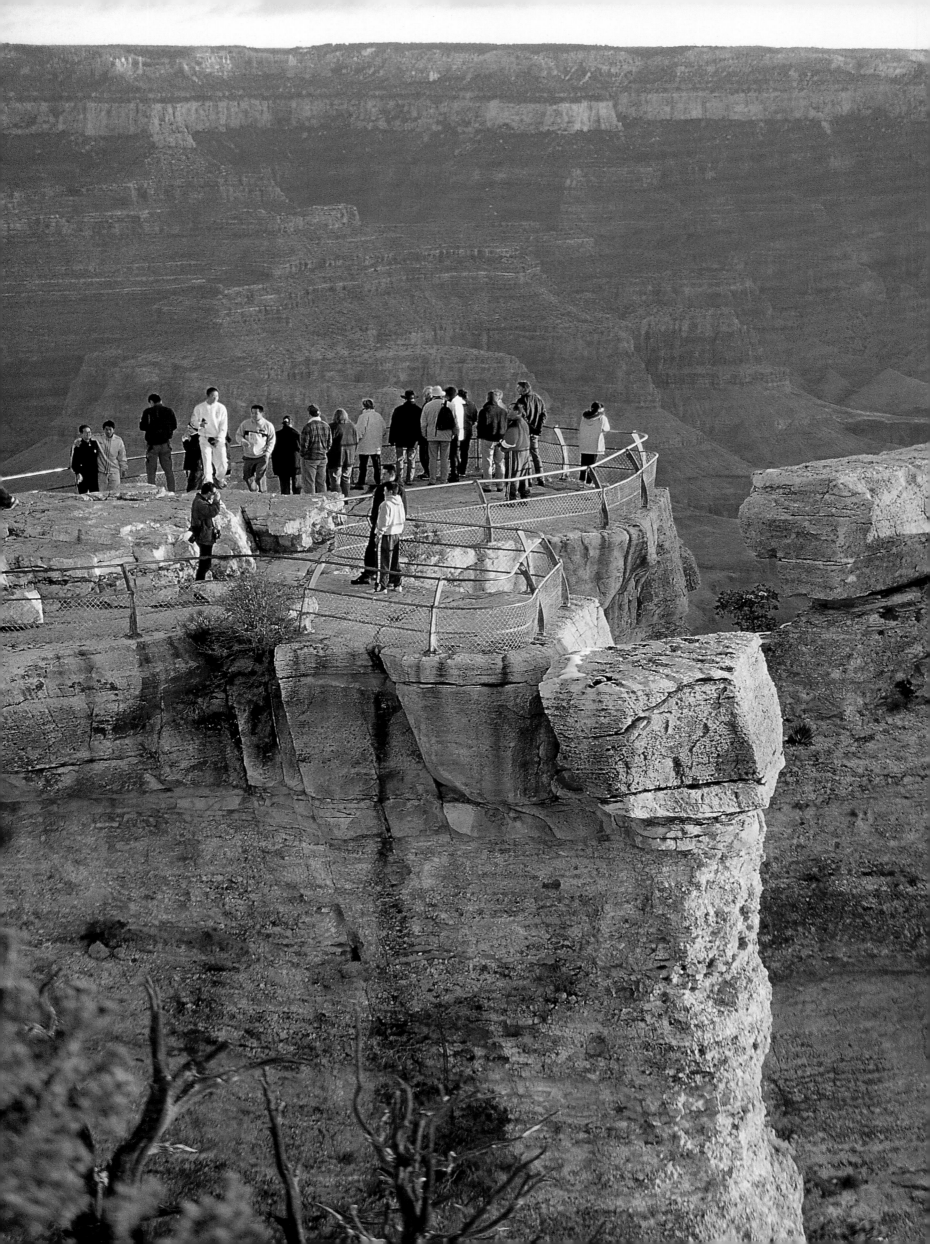

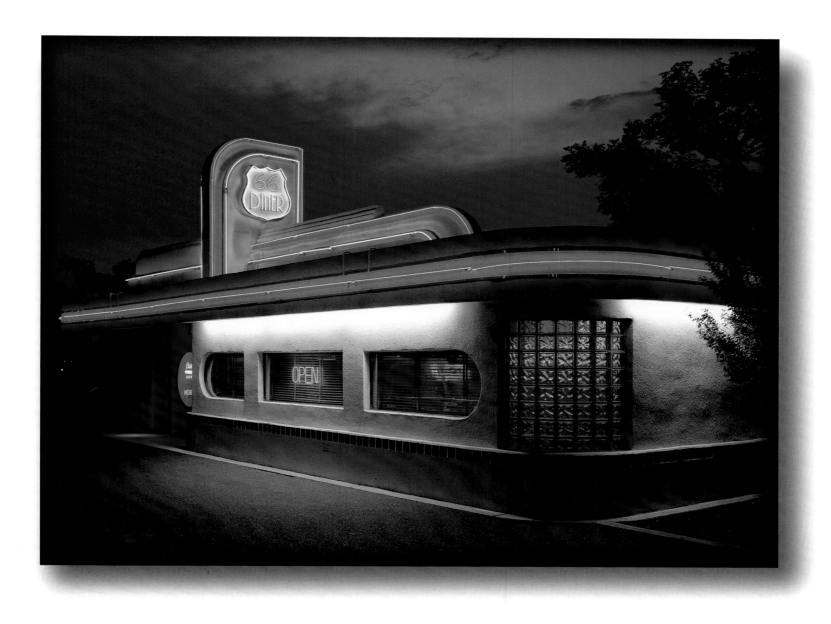

Part of Old Route 66, Albuquerque's Central Avenue leads New Mexico travelers past the Route 66 Diner, its colorful booths and milkshake counter a reminder of a bygone era. Route 66 was built in the 1920s to link Chicago with California. Since then, the travels of John Steinbeck, Jack Kerouac, photographer Dorothea Lange, and others have assured the highway a place in the history books of American culture.

Tourists gather at a viewpoint on the south rim of the Grand Canyon, gazing down at layer upon layer of time captured in the canyon walls. Scientists have used the rocks to gain information about the world as it existed 550 to 250 million years ago, long before the Colorado River carved this amazing path through Arizona. *(left)*

Each casino on the famous Las Vegas strip tempts vacationers with unique attractions, from New York-New York's soho-style eateries to the Luxor's replica of King Tut's tomb, Mandalay Bay's elaborate pools, and Bellagio's waterworks. Nevada legalized gambling in 1931. About 30 million people now visit each year, contributing more than $7 billion to the state's economy. *(overleaf)*

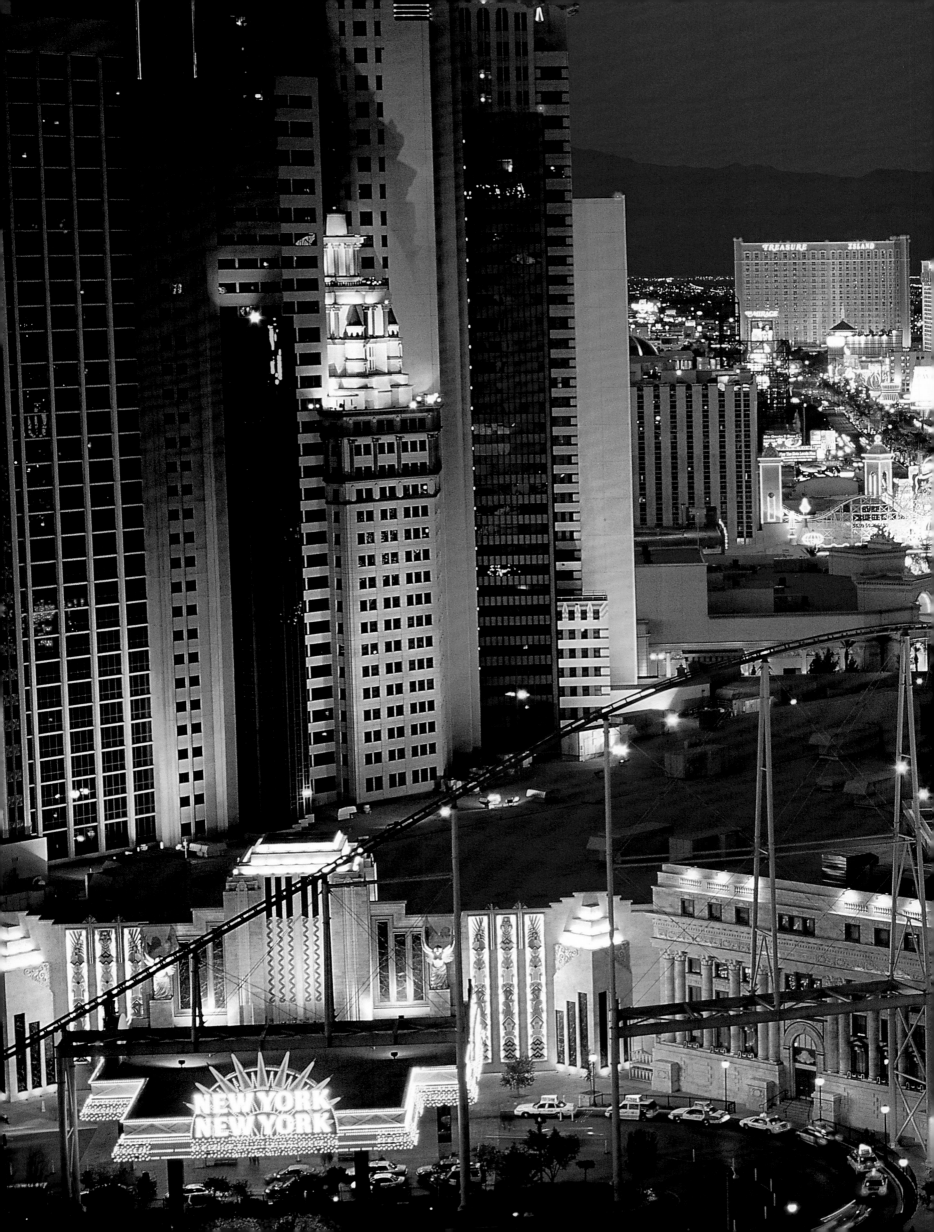

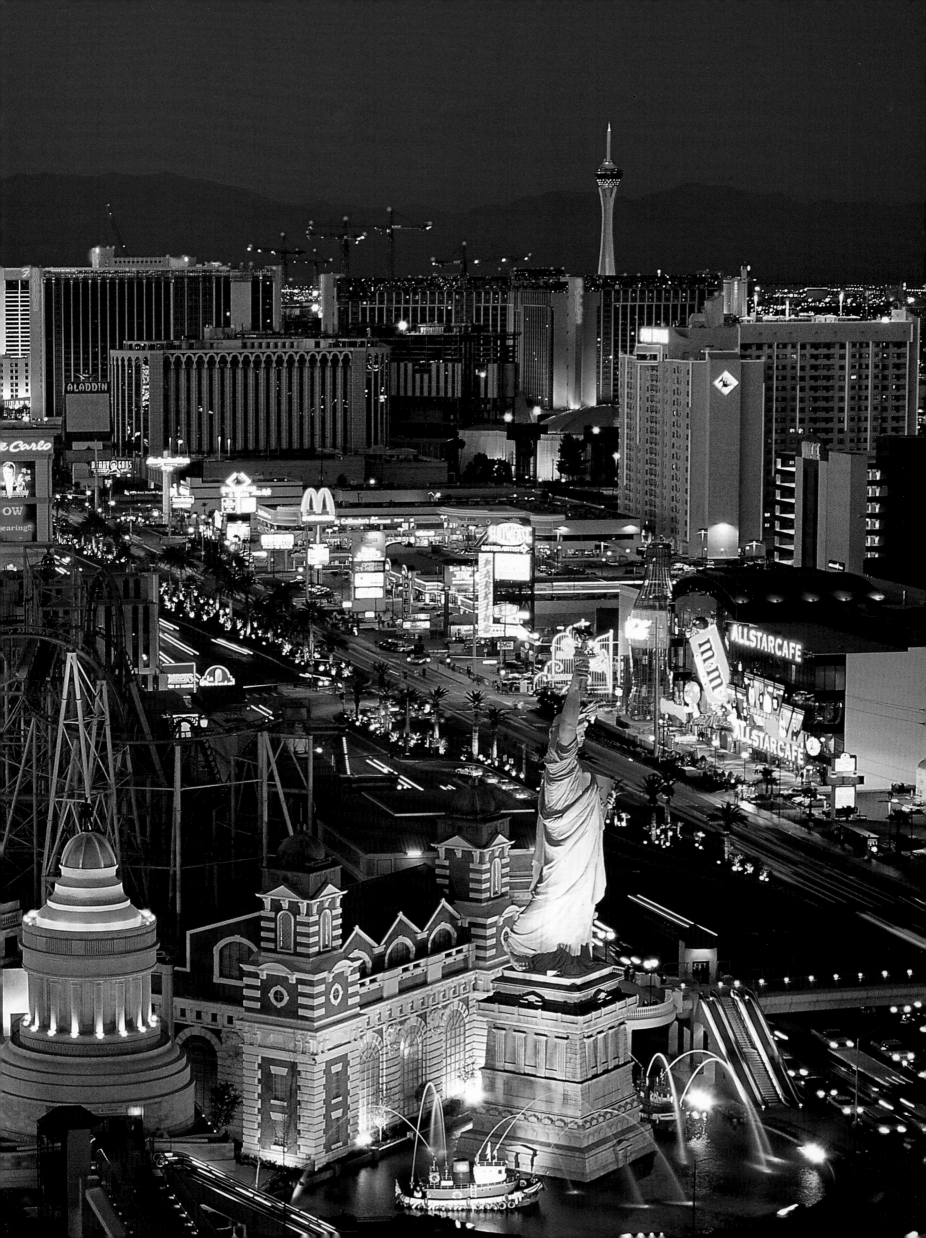

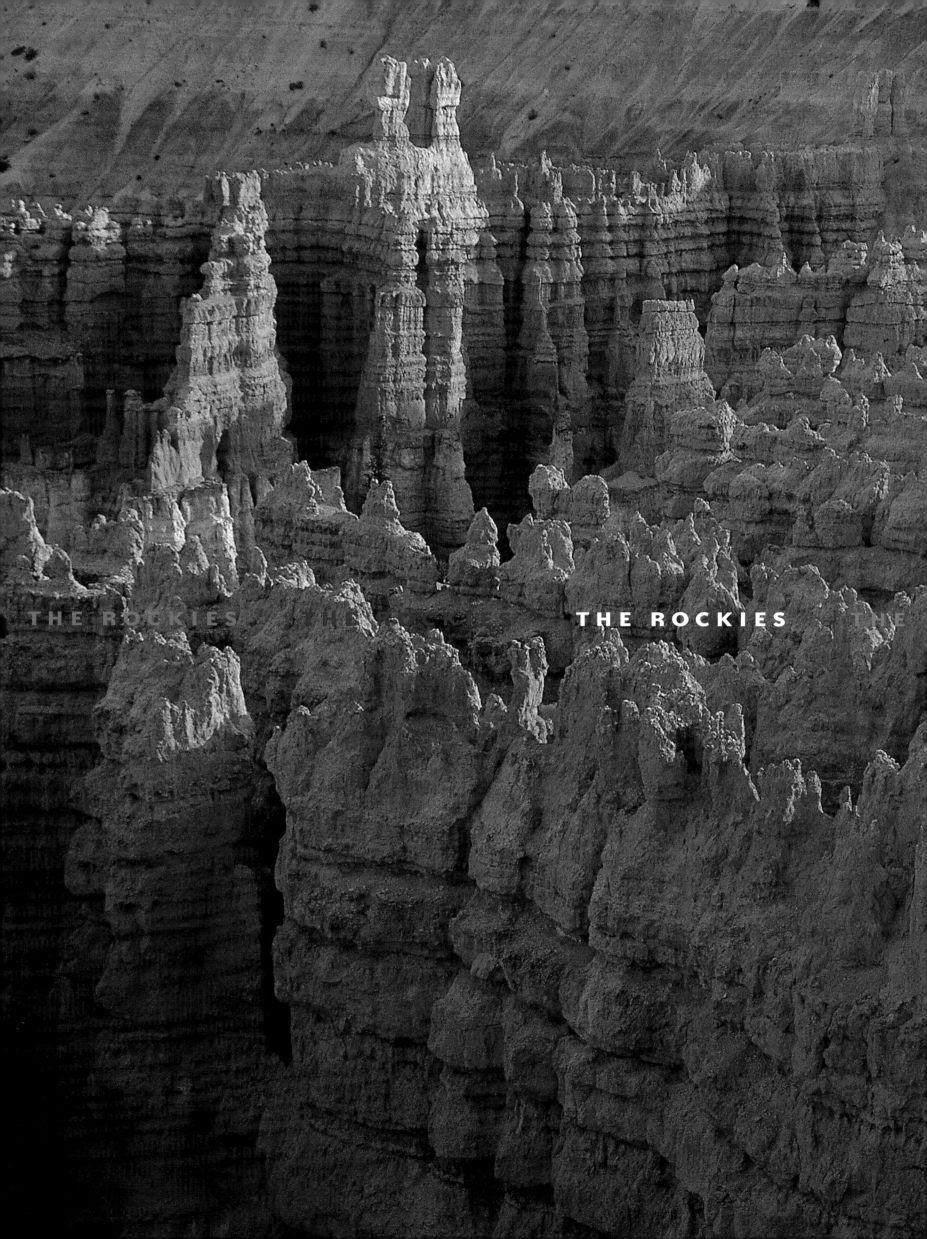

THE ROCKIES

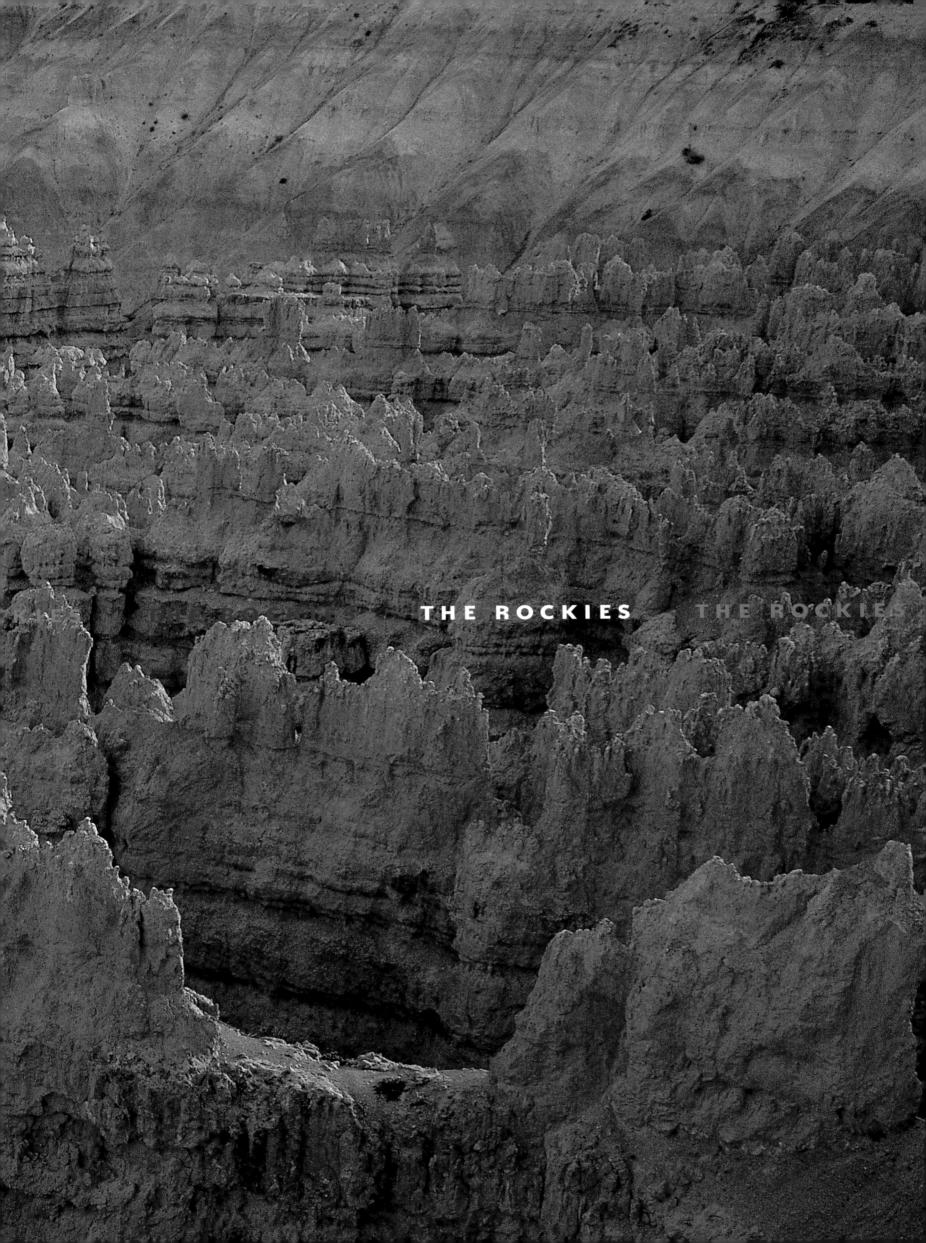

THE ROCKIES THE ROCKIES

Even the valleys in Rocky Mountain National Park are 8,000 feet above sea level. The peaks tower above, many reaching up to 12,000 feet, crowned in glaciers and year-round snow. The prospectors of the mid-1800s left these Colorado passes relatively empty-handed and the government established the national preserve in 1915.

Pink Cliffs, Queen's Castle, Hindu Temples — the names that grace the formations of Utah's Bryce Canyon National Park conjure their colors and shapes. The series of twelve natural bowls, or amphitheaters, plunge 1,000 feet deep in places and the limestone structures within seem to change color with the position of the sun. *(previous pages)*

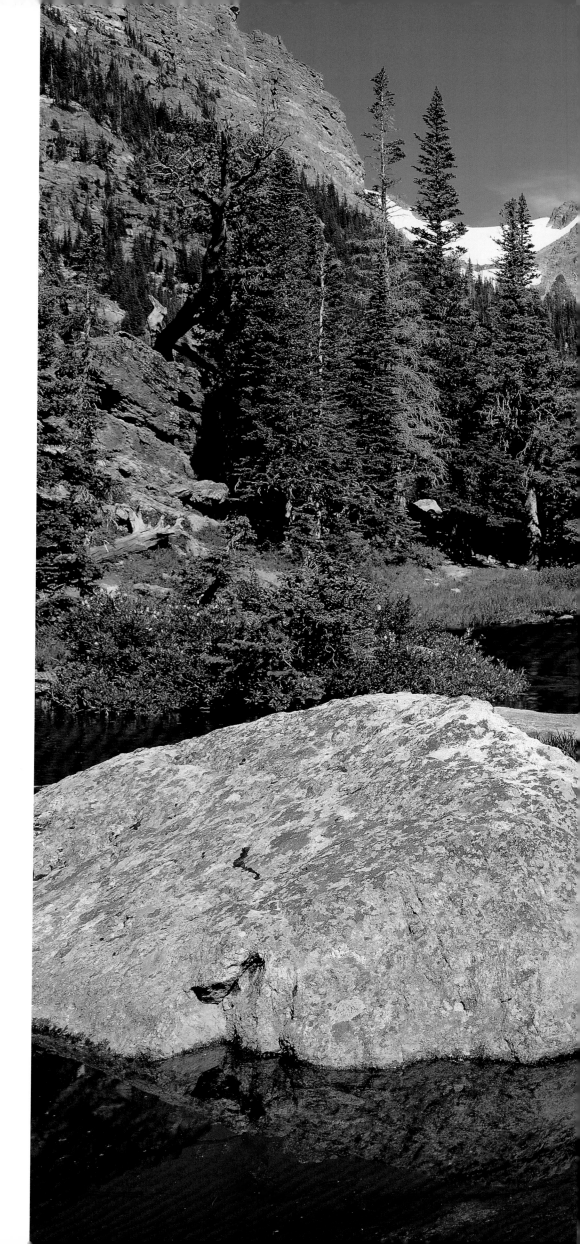

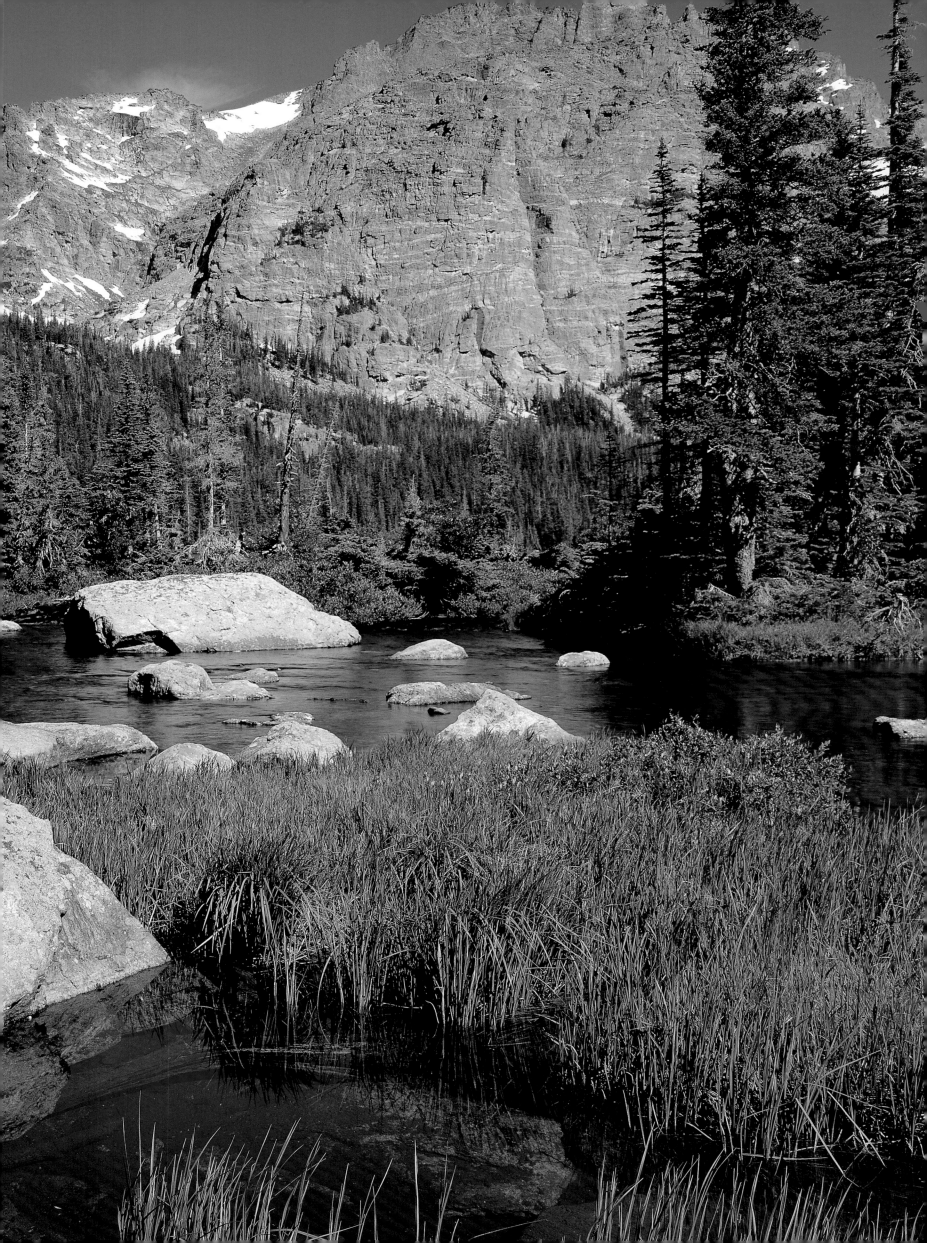

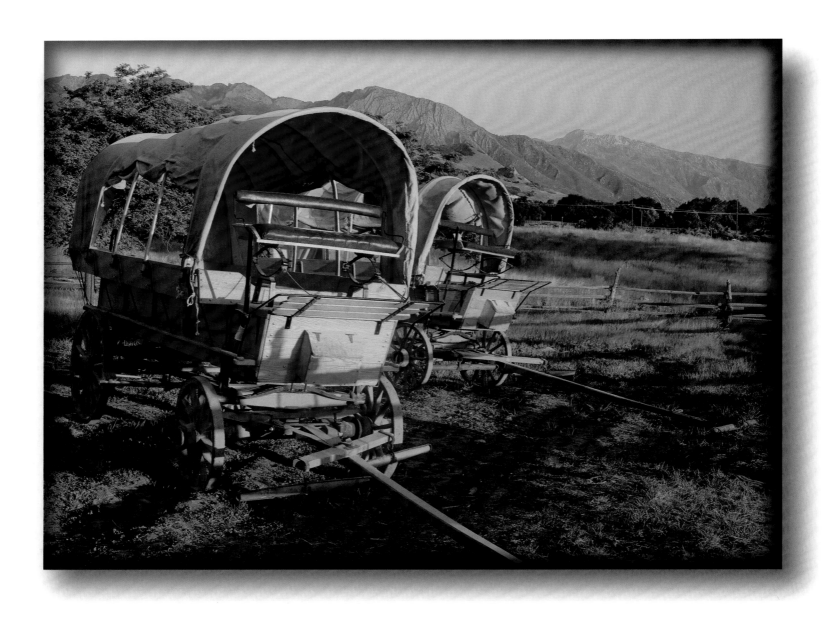

These covered wagons near the Wasatch Mountains in Utah commemorate the journey of more than 70,000 Mormons between 1846 and 1869. Searching for an isolated place where they could maintain their religion and culture free from persecution, the Mormons followed what is now known as the Mormon Pioneer Trail from Nauvoo, Illinois, to the Valley of the Great Salt Lake. In a land widely thought to be unusable desert, they established thriving settlements.

Mormon pioneers settled the land near Zion Canyon in the 1850s, naming the formation with a Hebrew word meaning "place of refuge." In 1919, Congress created Zion National Park to protect the region and the 800 native species that grow here — the greatest diversity of life in Utah. *(right)*

Swept in on southwesterly winds and trapped against the slopes of Colorado's Sangre de Cristo Mountains, the sand that forms Great Sand Dunes National Monument rises up to 700 feet, higher than any other dunes in North America. Summer sun can bake the barren hills at temperatures of up to 140 °F. *(overleaf)*

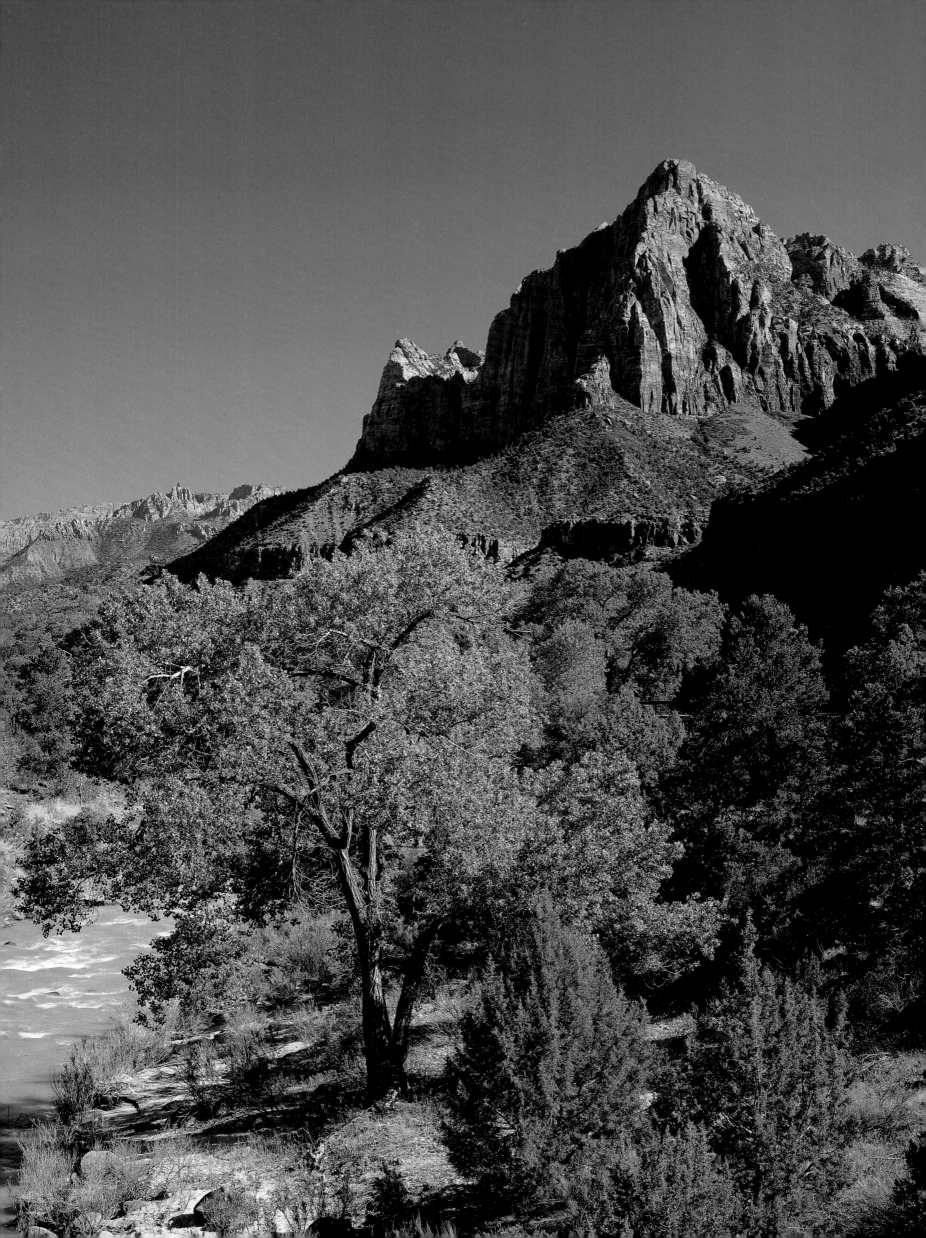

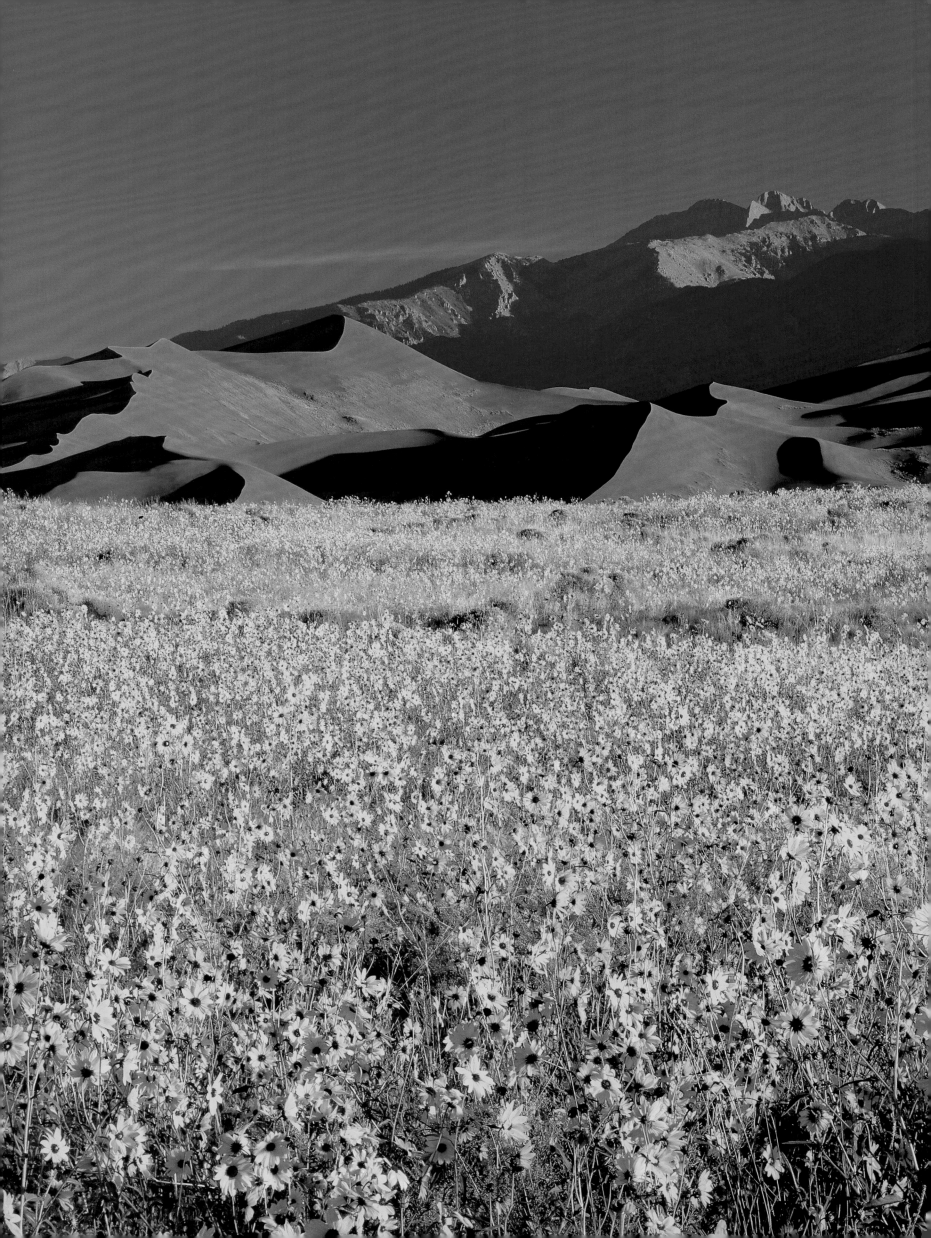

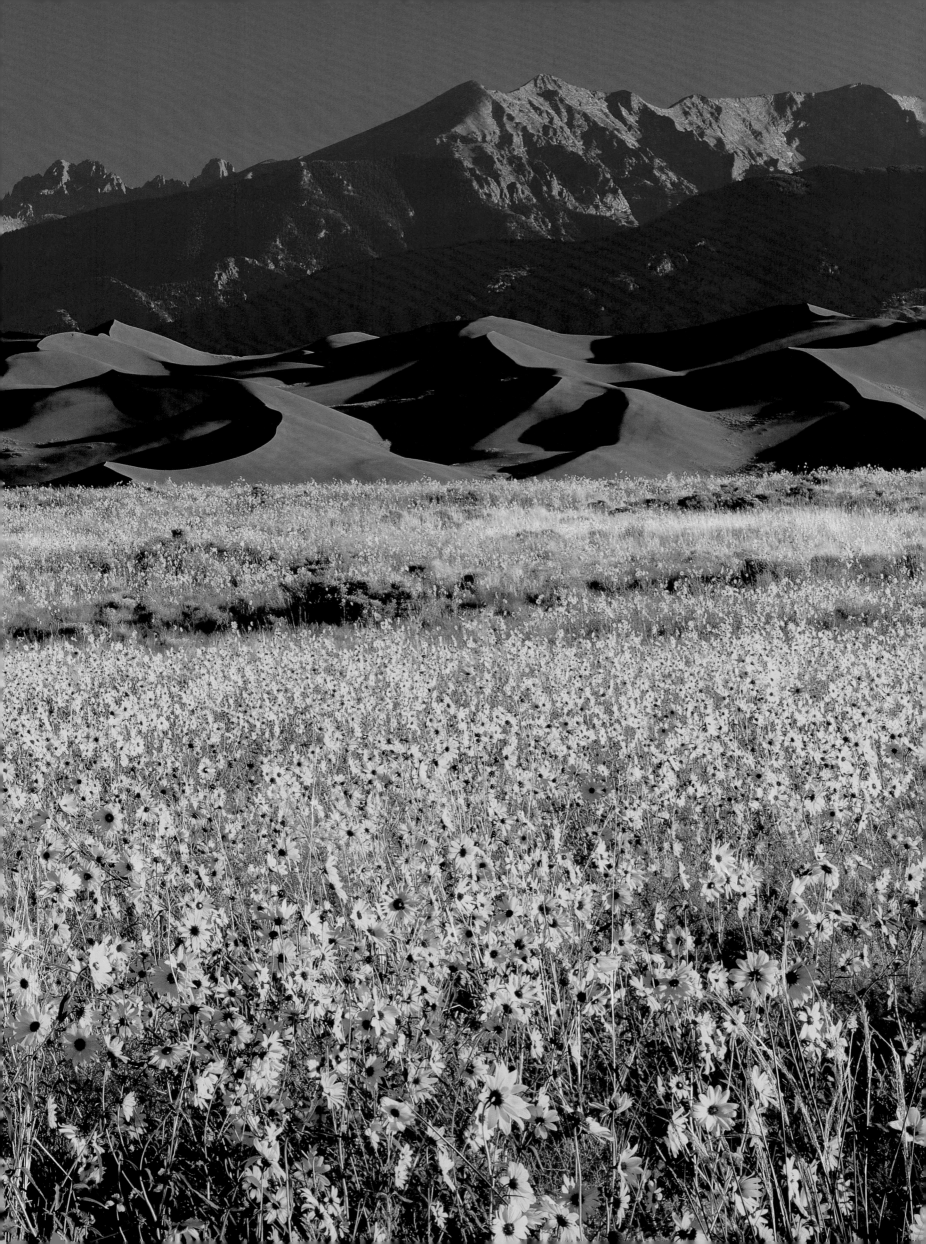

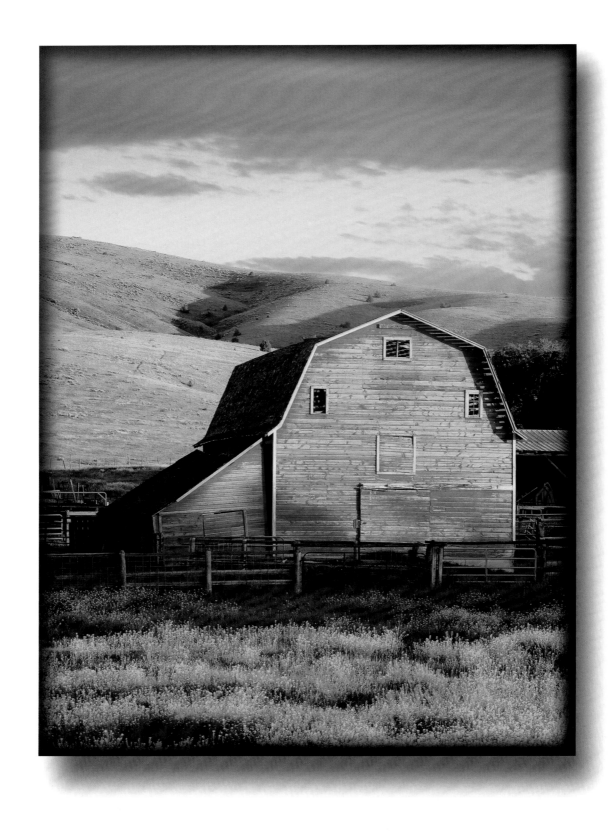

When Lewis and Clark traveled Montana's plains, they found the land carpeted in blooming wildflowers — and an inch of late-spring snow. At that time, 13 million bison massed over the grasslands. Scientists surveying in the 1970s could find only 25 of these animals remaining.

Encompassing more than a million acres, Glacier National Park in northern Montana includes rugged peaks, crystal lakes in alpine bowls, and enormous mounds of rock and debris — all the result of glaciers that carved out this region. George Bird Grinnell, one of the first Europeans to explore the slopes, lobbied to have the region set aside as a forest preserve, then a national park in 1910. *(right)*

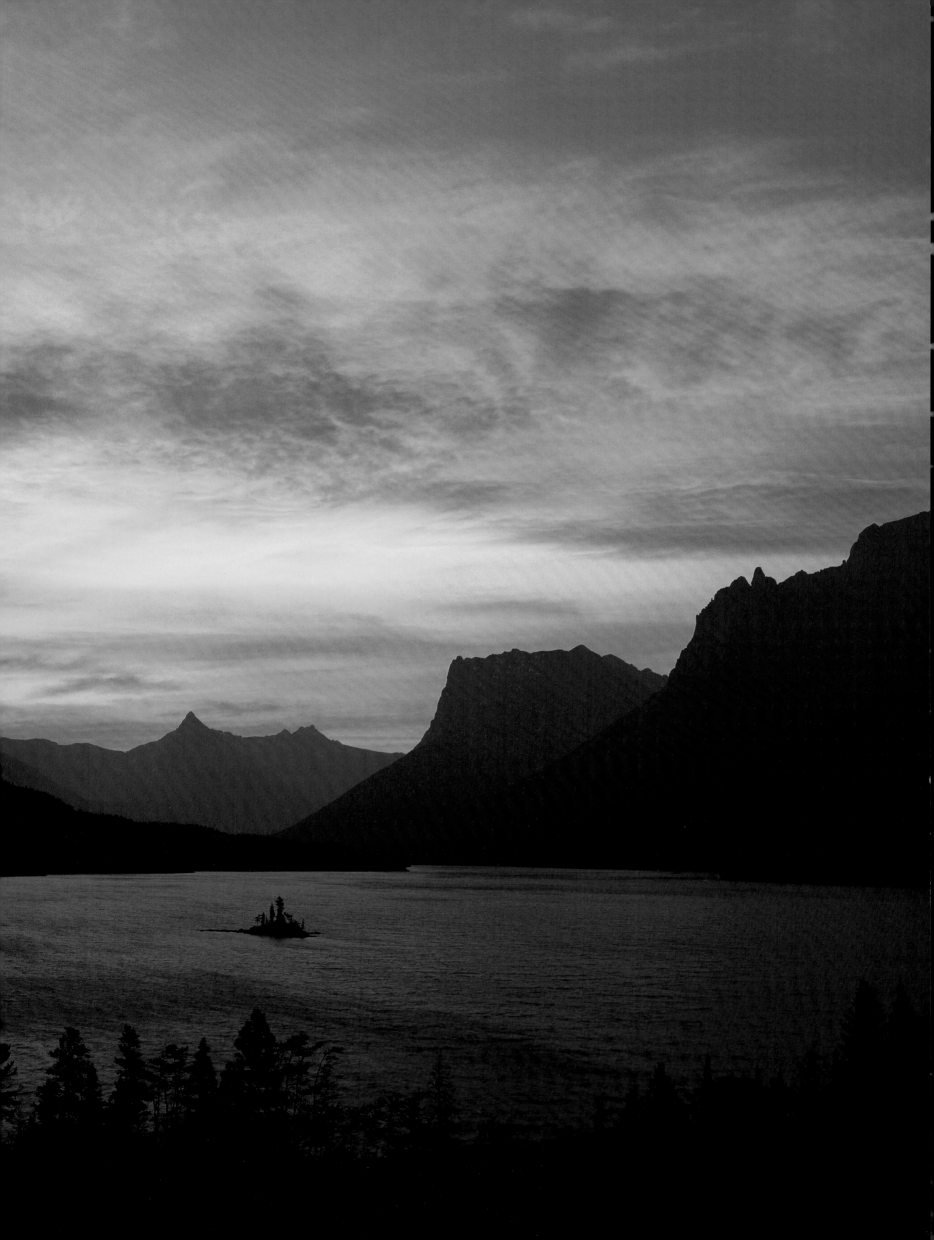

Almost 2,000 years ago, the people of southern Colorado turned gradually from nomadic hunting to a more settled life of farming. They first created pueblos along the riverbanks, then homes on the mesa tops, and finally elaborate villages within the caves of the local cliffs. In the 1300s, the people slowly abandoned these settlements — now Mesa Verde National Park — for reasons archeologists have yet to understand.

Just north of Moab, Utah, Arches National Park features more than 2,000 natural sandstone arches, formed in three distinct geological stages. First, a cycle of flooding and evaporation millions of years ago left salt fields thousands of feet thick. Silt and debris buried the salt fields and caused them to shift. Finally, the formation of rock over the soft sandstone and salt, and the rock's erosion during the last 10 million years, has left behind the awe-inspiring formations here today. *(overleaf)*

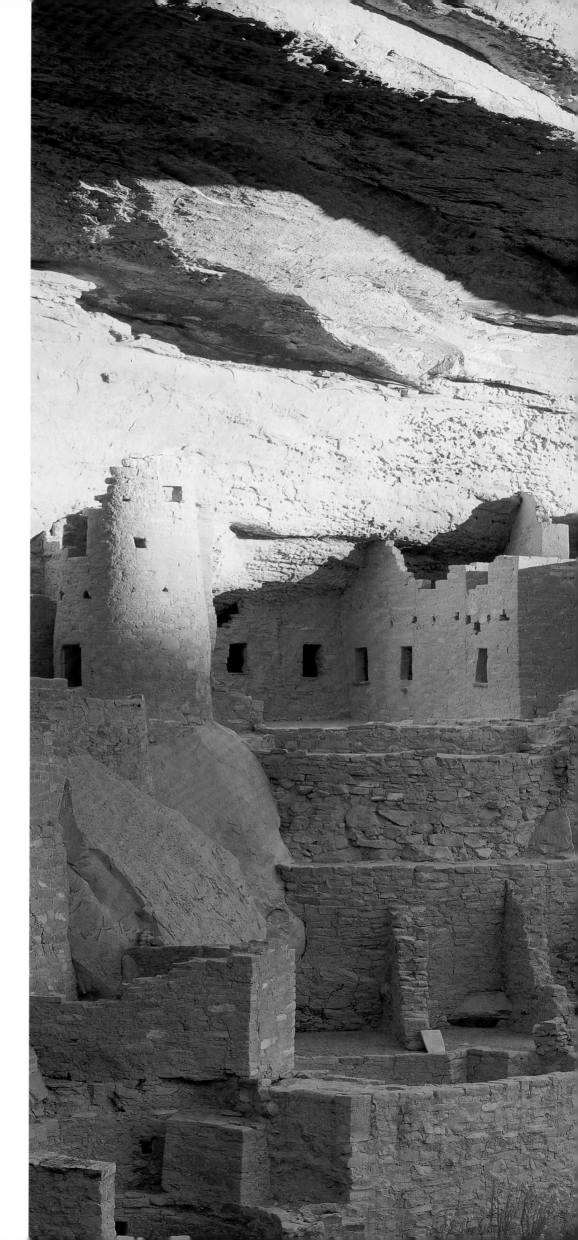

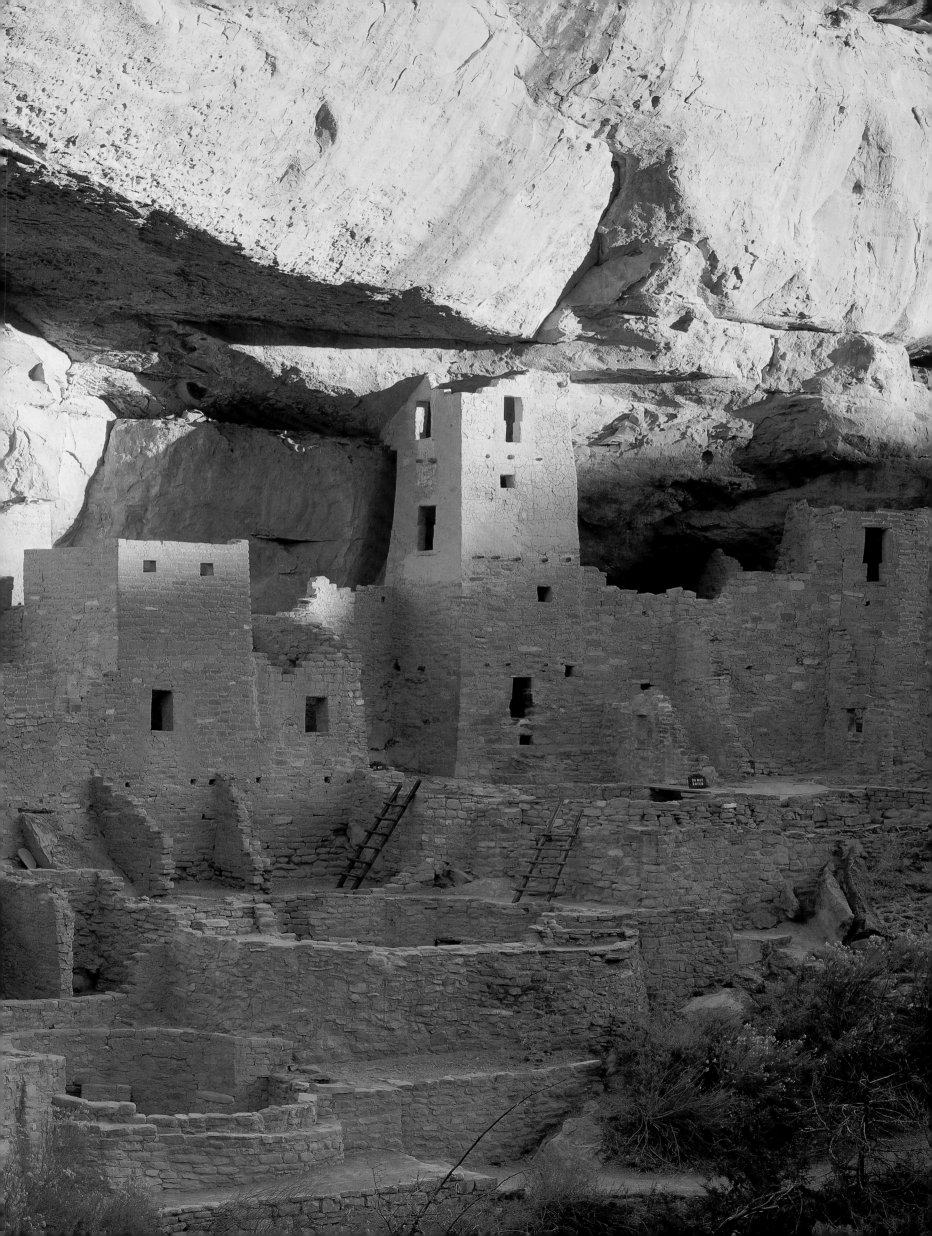

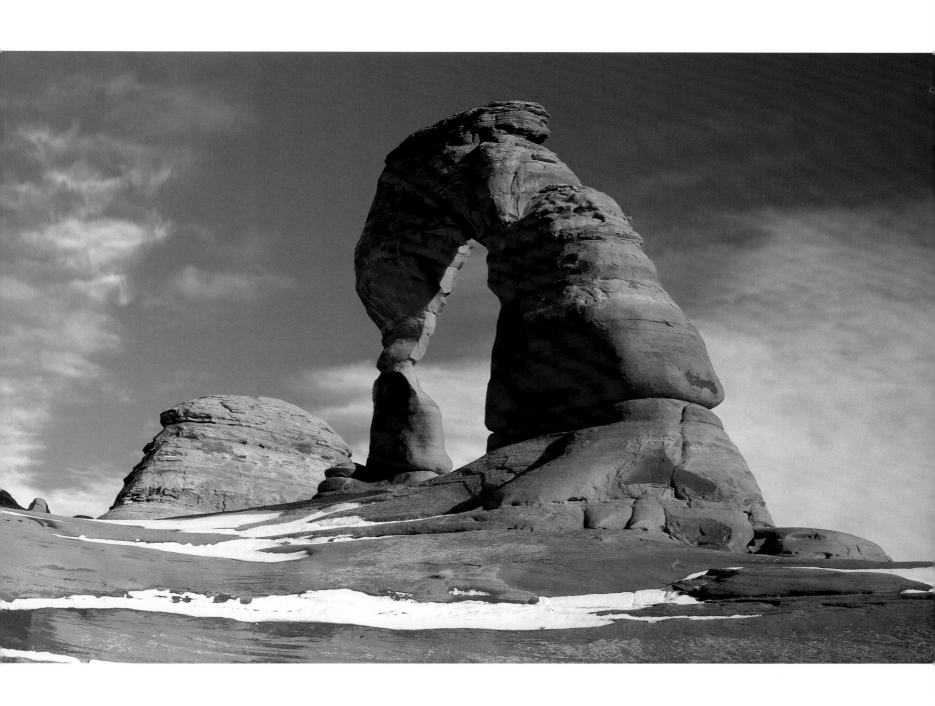

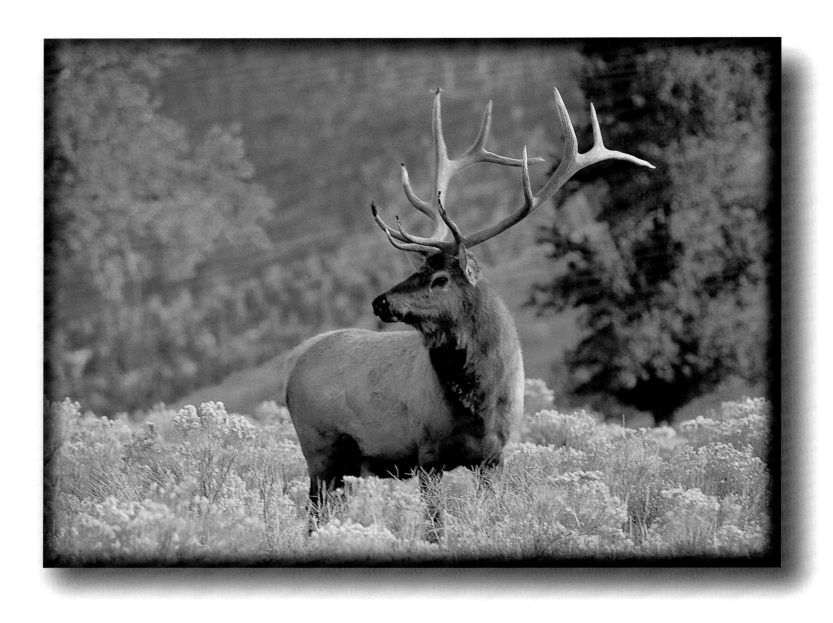

For more than a thousand years, elk have roamed the mountain slopes and meadows of
Yellowstone National Park in Wyoming. Up to 30,000 summer here and up to 22,000 remain
throughout the winter. The park also supports black and grizzly bears, mountain lions, bobcats,
coyotes, moose, bison, wolves, and abundant smaller mammals and birds.

Along with glacier-capped summits, Grand Teton National Park in Wyoming encompasses more
than 100 lakes, 50 miles of the Snake River, and the mountain valley of Jackson Hole. Once driven
north into Canada by hunting and human settlement, wolves are again roaming these ranges.
They were introduced into Yellowstone National Park in 1995 and 1996, and within a few years
expanded their territory to include the Teton Range. *(right)*

The construction of Glen Canyon Dam between 1956 and 1962 has been one of the most
hotly debated projects in recent history and served as a catalyst for the early environmental
movement. Conservationists continue to work towards the destruction of the dam and the
draining of Lake Powell. In the meantime, Utah's Glen Canyon National Recreation Area draws
anglers, hikers, campers, and boaters. *(overleaf)*

142

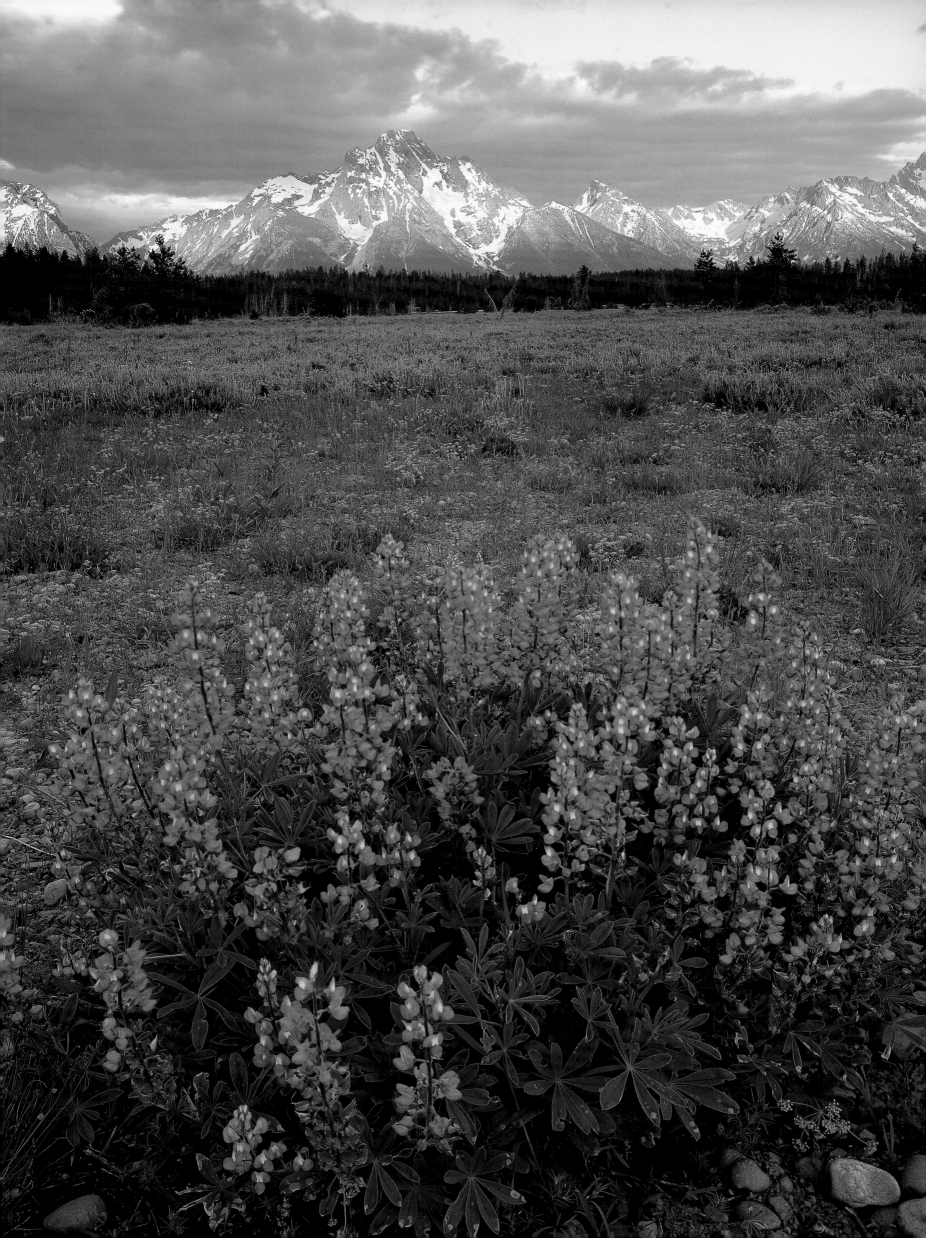

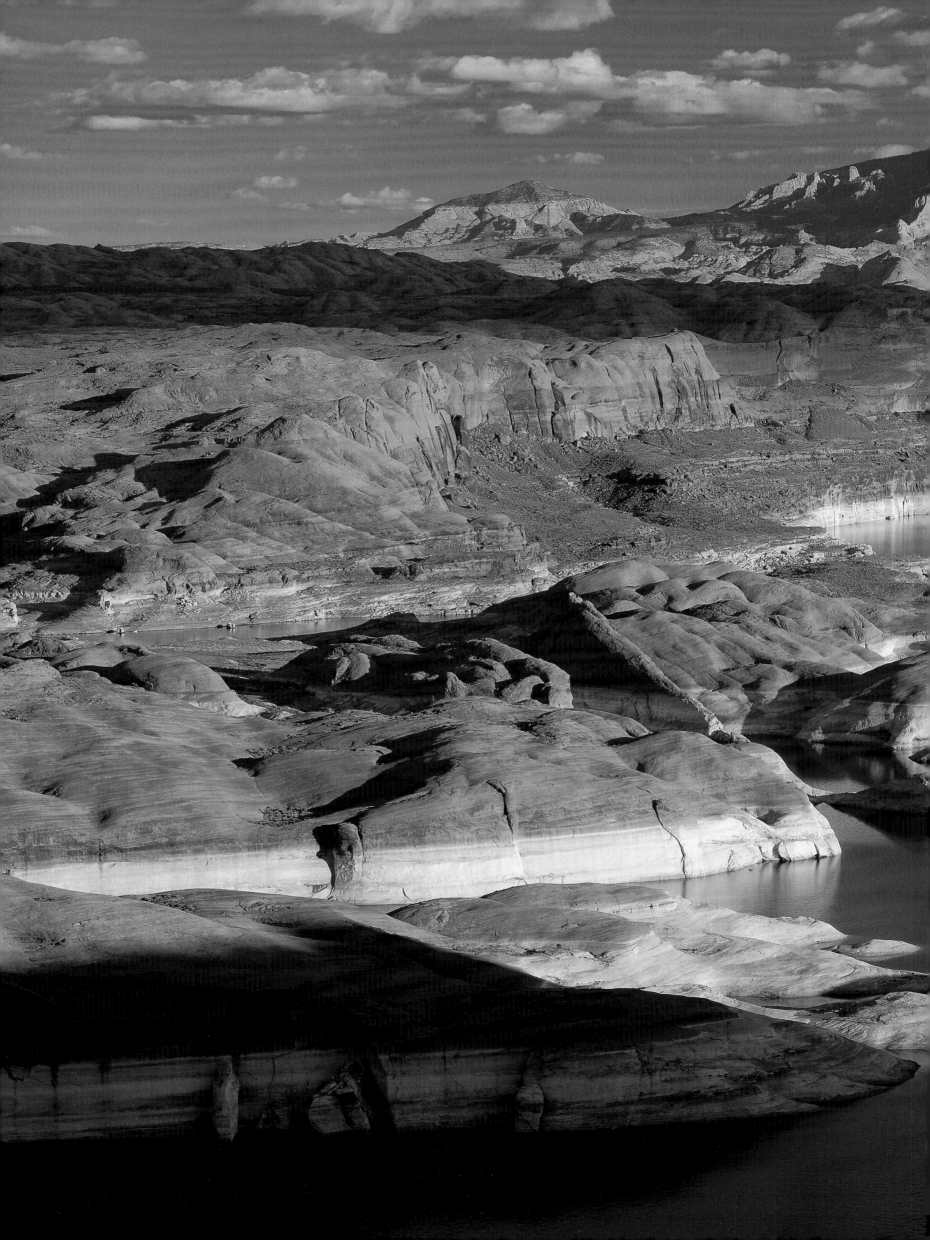

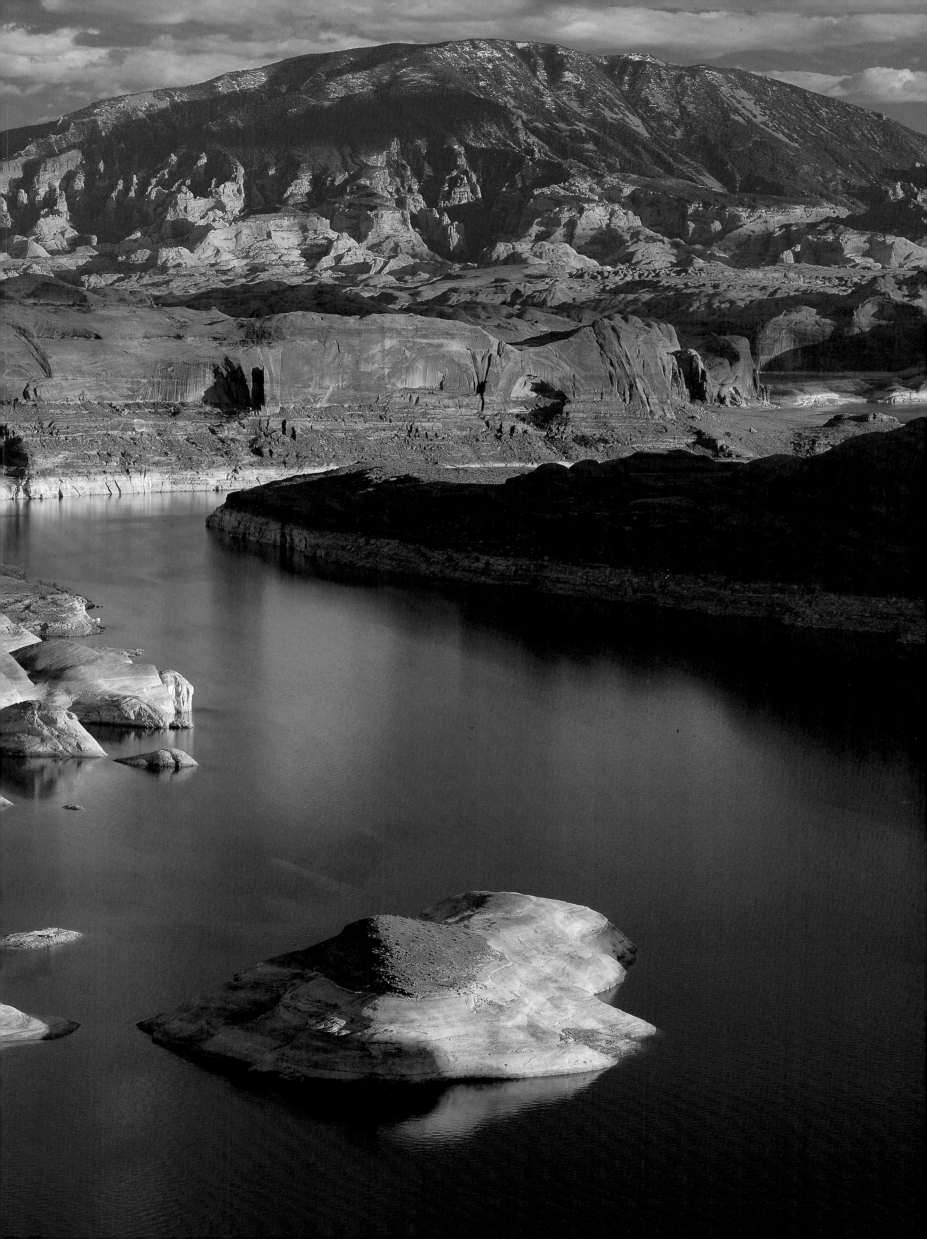

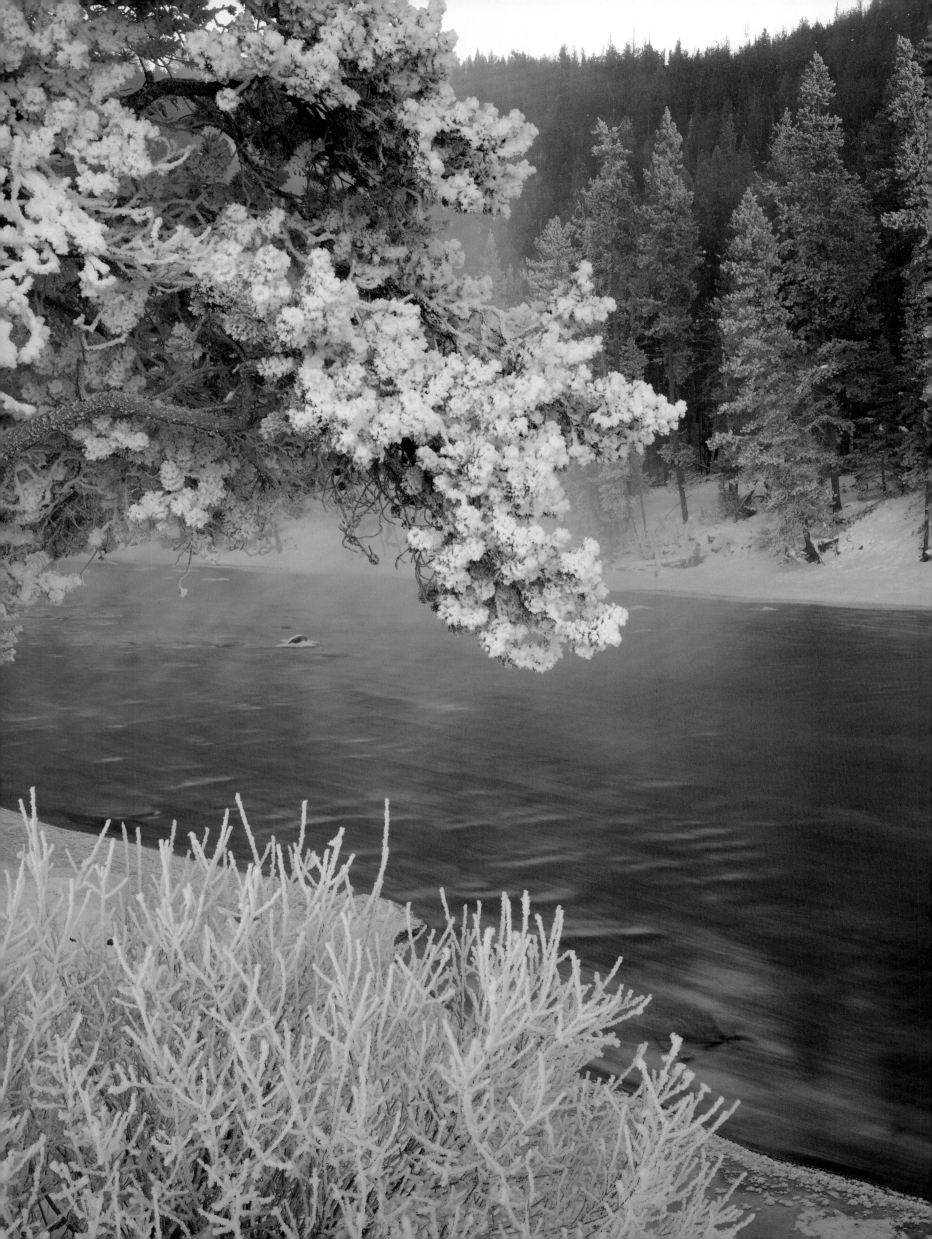

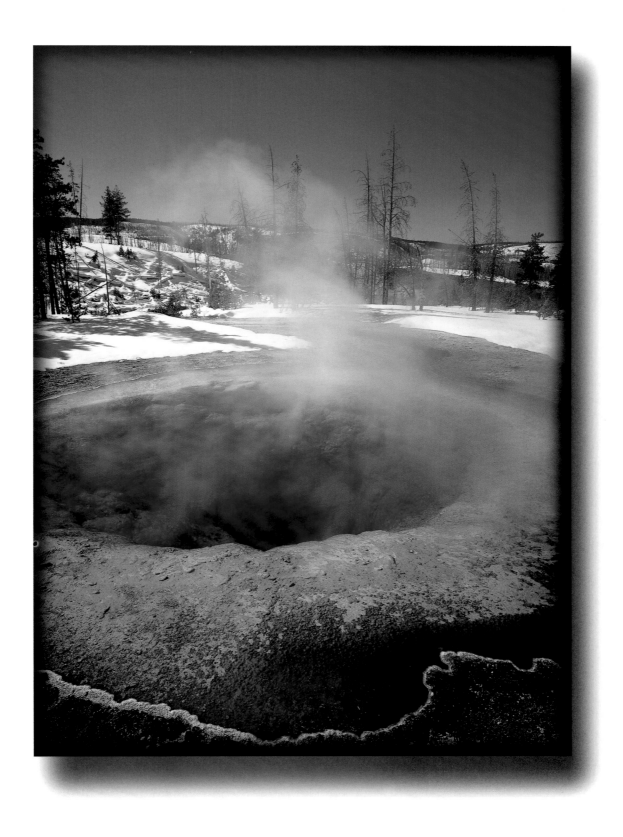

Morning Glory Pool in Yellowstone National Park glistens amid the surrounding snow. Steaming pools such as this one are formed when meltwater is heated by magma 10,000 feet below the earth's surface. Under intense pressure, the water is forced back to the surface through vents and fissures in the crust.

Winter ice glistens on Idaho's Salmon River, one of the country's longest undammed rivers. In the warmer months, this is a favorite destination for whitewater rafters and kayakers. A canyon 6,000 feet deep — deeper than the Grand Canyon — along the waterway's course has earned this the nickname River of No Return. *(left)*

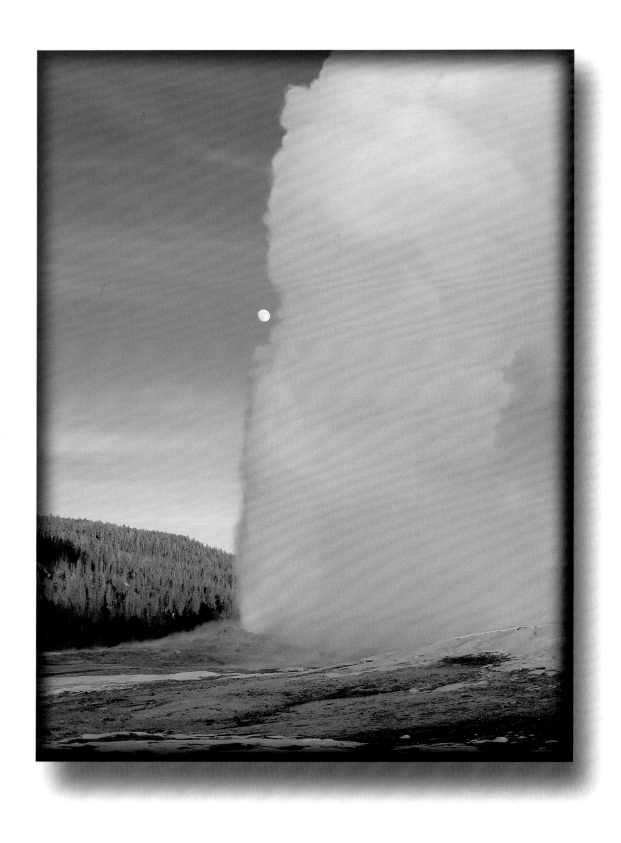

The first national park in the world, Yellowstone National Park has welcomed nature-loving guests since 1872. Old Faithful is the most famous of more than 300 geysers found within the preserve — two-thirds of the geysers on earth. Every 35 to 120 minutes, Old Faithful sends hot water and steam arching more than 100 feet into the air.

Bedecked for the Christmas season, Salt Lake City's Temple Square is home to Salt Lake Temple and the Tabernacle, with its famed Mormon Tabernacle Choir. The first Mormon pioneers arrived in Salt Lake Valley in 1847. Within two hours, they had begun to plow fields. They formed an irrigation dam later that day and planted their first crops early the next morning. More than 180,000 people now call Salt Lake City home. *(right)*

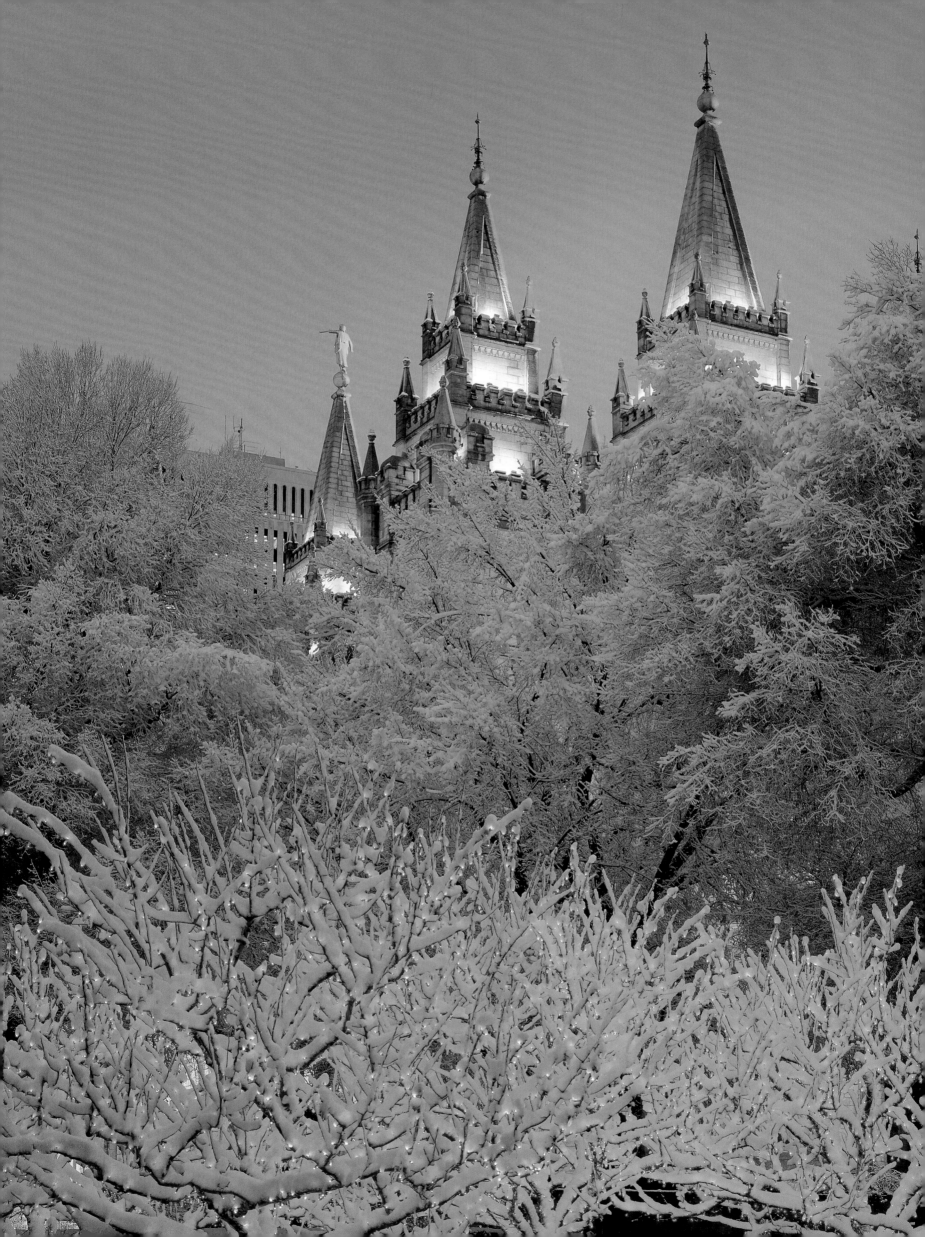

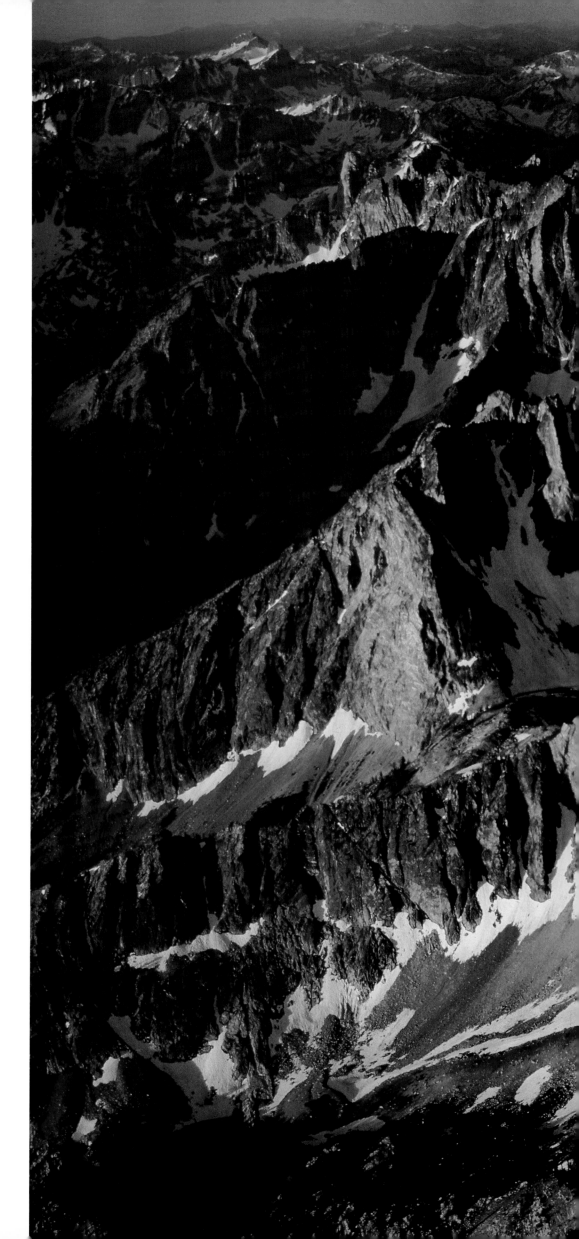

The Sawtooth Mountains form a formidable barrier across Idaho. The state was the last to be charted by Europeans, and when Lewis and Clark finally forged their way through the passes on their 1805–1806 explorations, they called it one of the most difficult parts of their journey. Even after the state became American land in 1846, the only Europeans who lived in these peaks were missionaries and trappers.

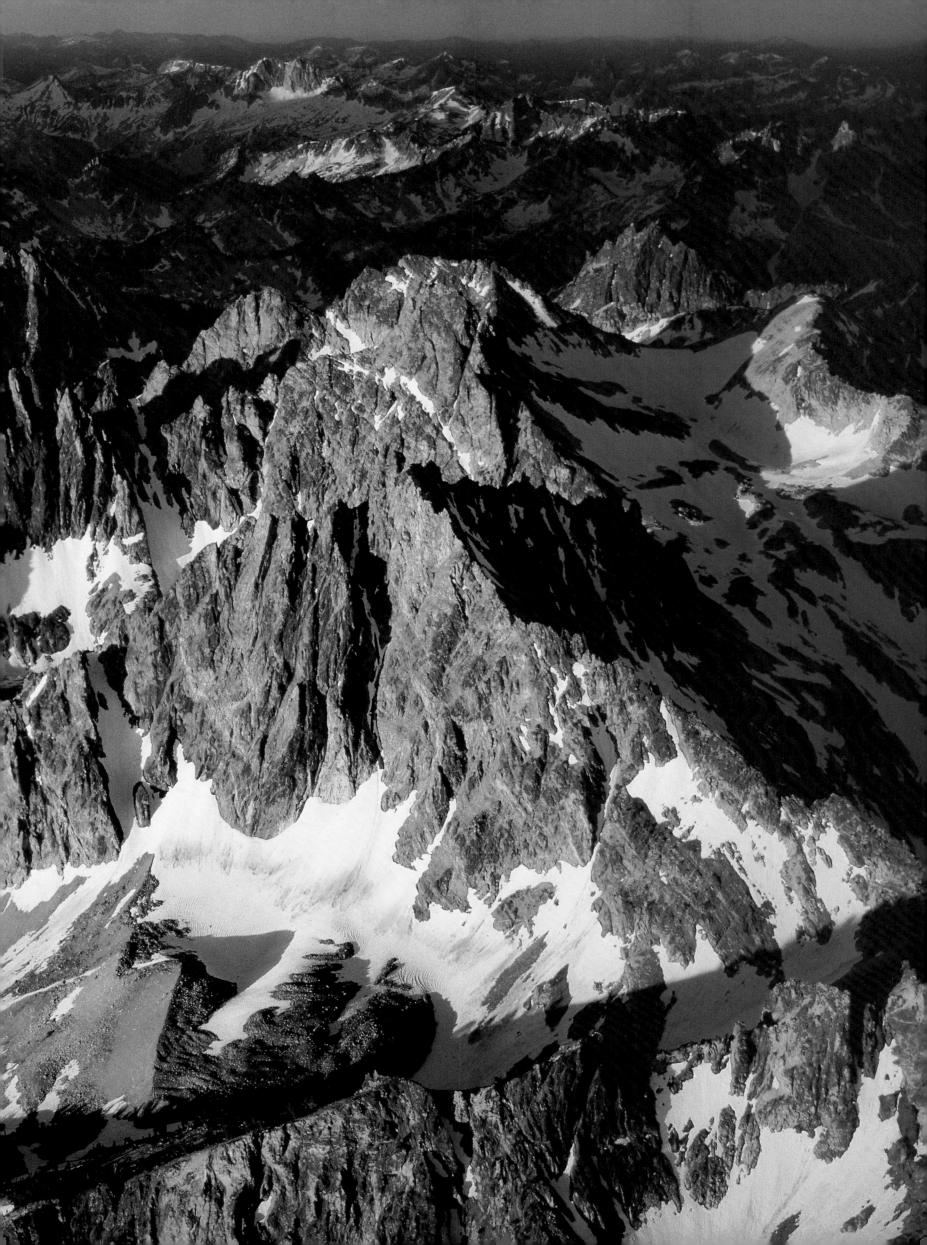

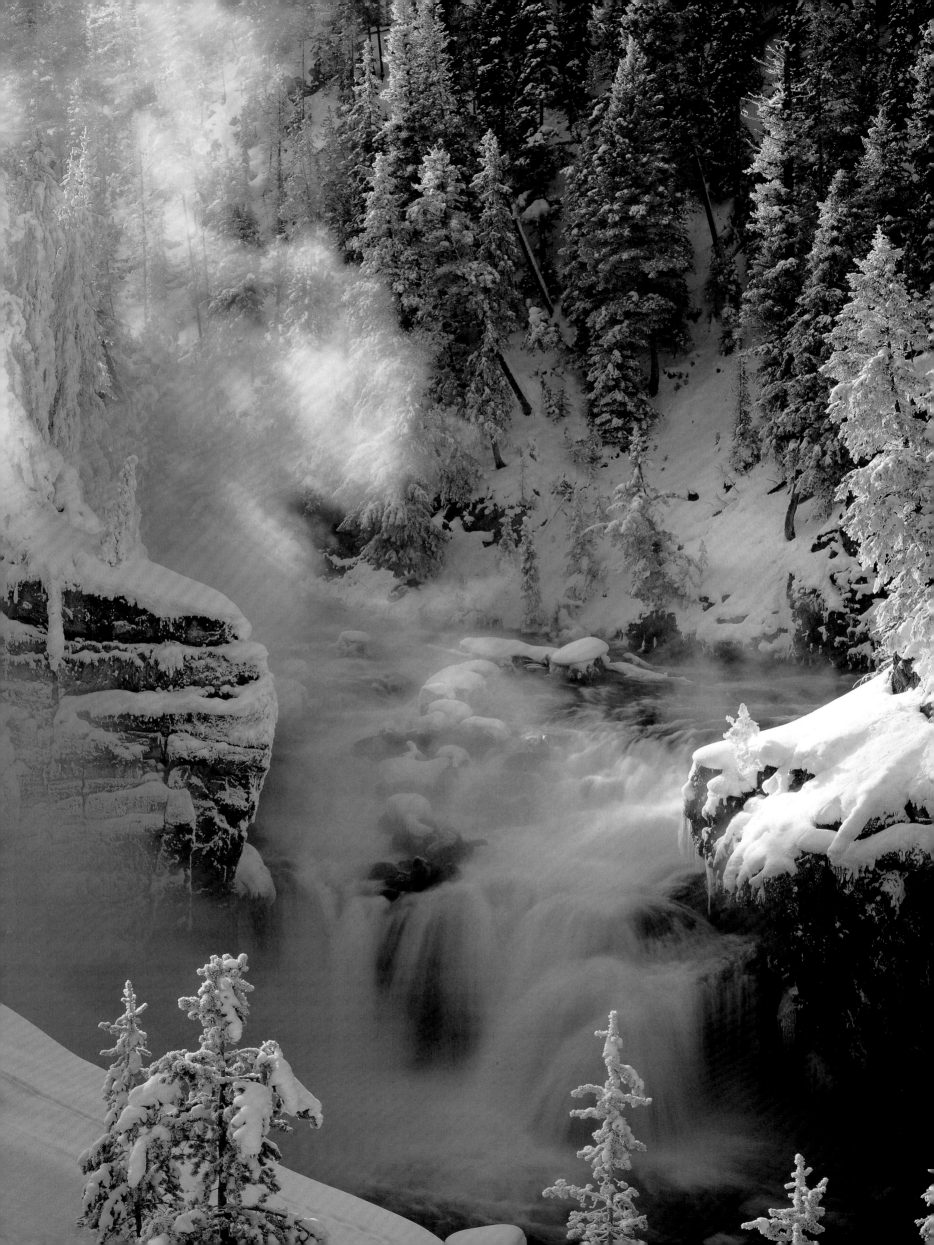

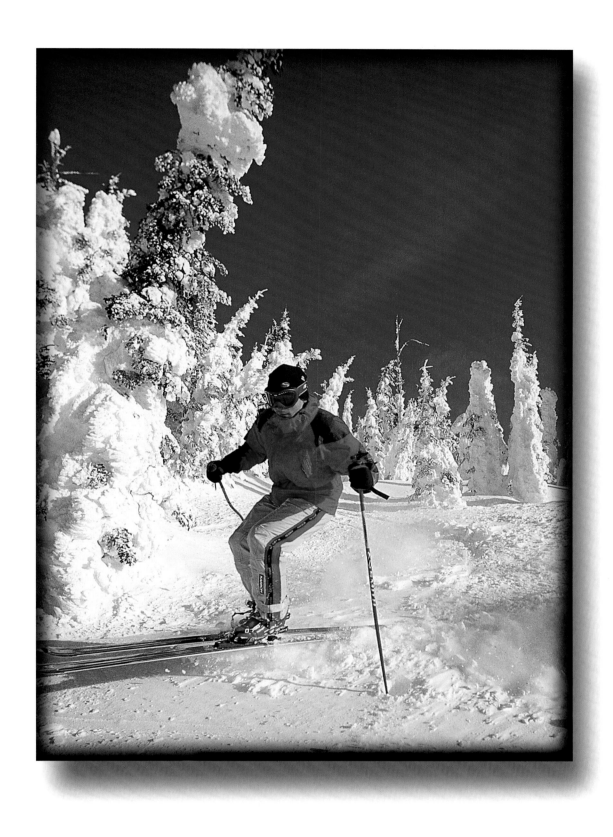

Big Mountain in Whitefish, Montana, is named for its 2,500 vertical feet of powder. With 3,000 acres and more than 80 runs, the ski resort is one of the most popular in North America.

Firehole River Falls is one of almost 300 waterfalls within Yellowstone National Park. With abundant rain and melting snow from the mountains of the Continental Divide, Wyoming is the source for some of the nation's largest drainage systems, including the Missouri River and the Colorado. *(left)*

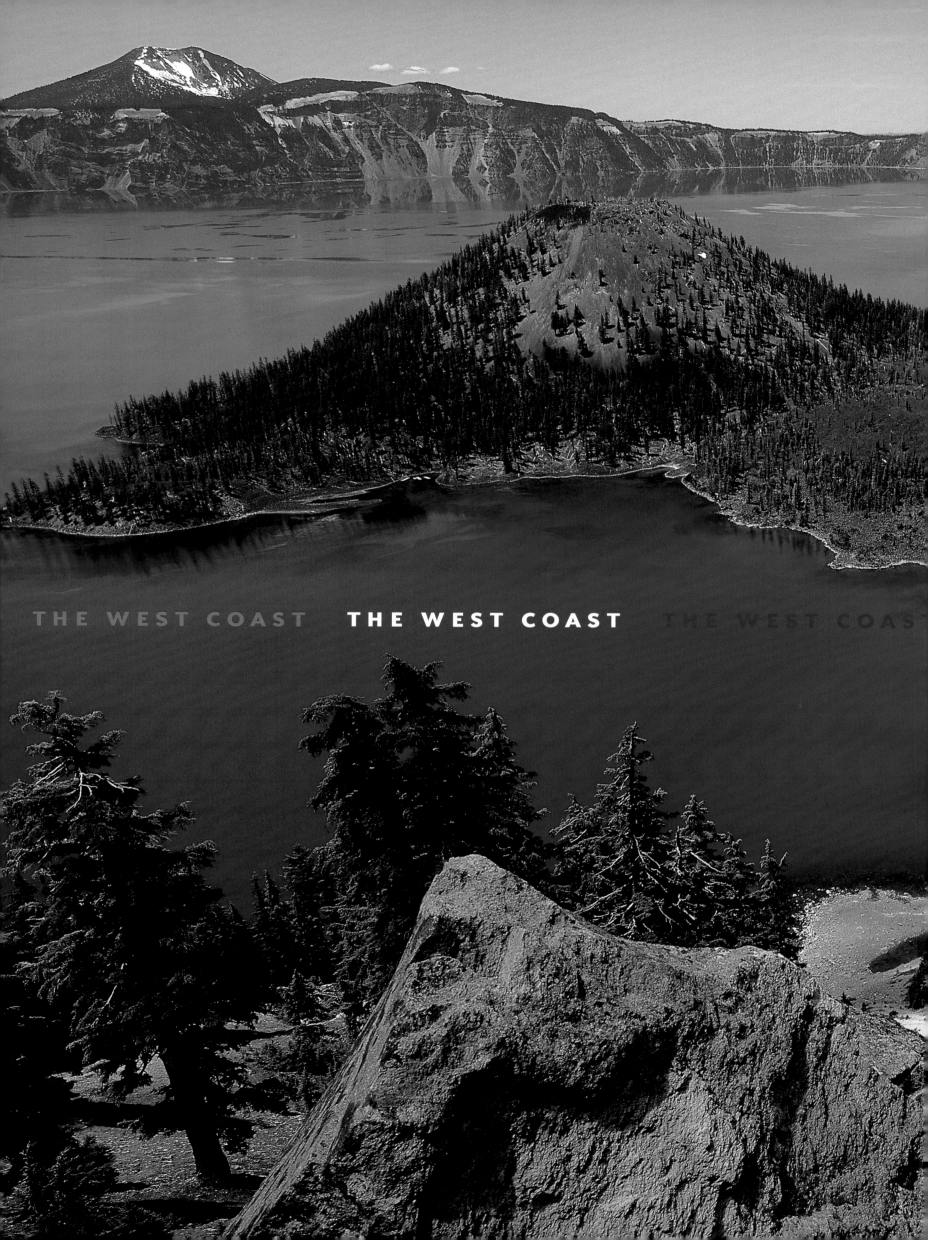

THE WEST COAST
THE WEST COAST
THE WEST COAST

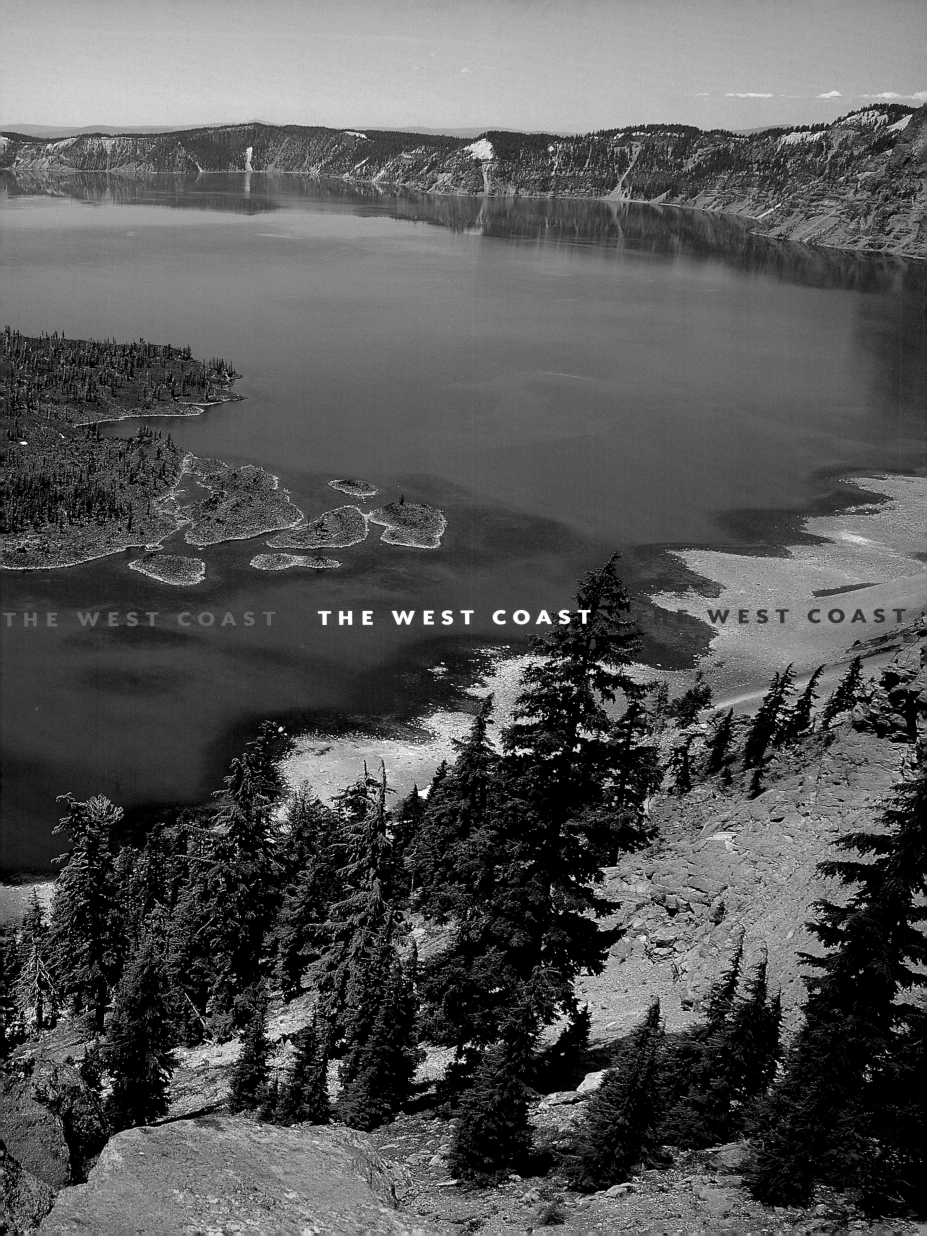

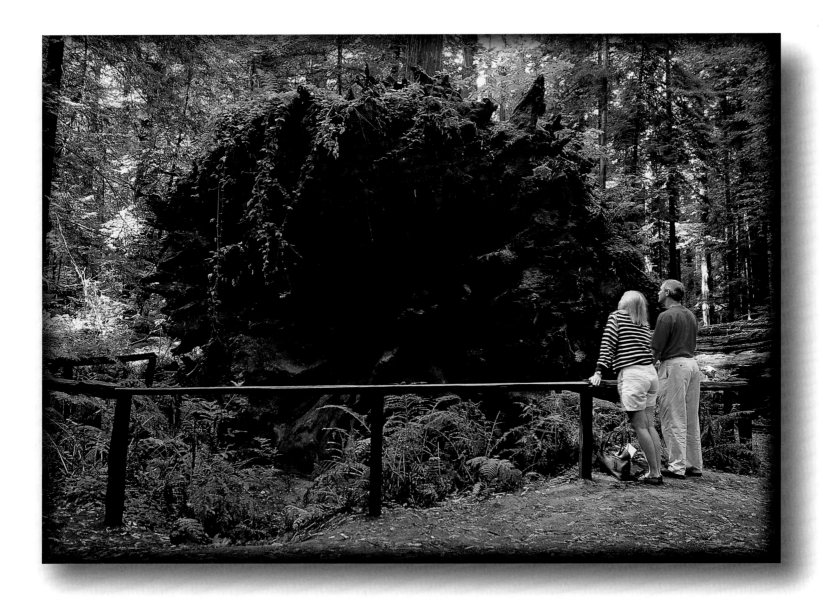

Sightseers are dwarfed by the stump of a redwood tree, one of hundreds protected by Humboldt Redwoods State Park, California's largest redwood preserve. Thriving in the fog, these trees grow naturally at lower elevations along the coast, usually not more than 50 miles inland. Their scientific name, *Sequoia sempervirens,* means "ever living."

Sequoia and Kings Canyon national parks protect more than 1,300 square miles, including the rugged slopes of the Sierra Nevada mountain range and America's largest giant sequoias, some of them more than 250 feet tall. The largest of these trees is believed to be 2,300 to 2,700 years old. *(right)*

Six miles wide, the caldera which forms the centerpiece of Crater Lake National Park was born with the eruption and collapse of Mount Mazama about 7,000 years ago. The local Klamaths people, whose ancestors witnessed the eruption, believed the lake to be sacred. While they guided explorers to many other local peaks, they kept Crater Lake hidden until three prospectors stumbled upon it in 1853. *(previous pages)*

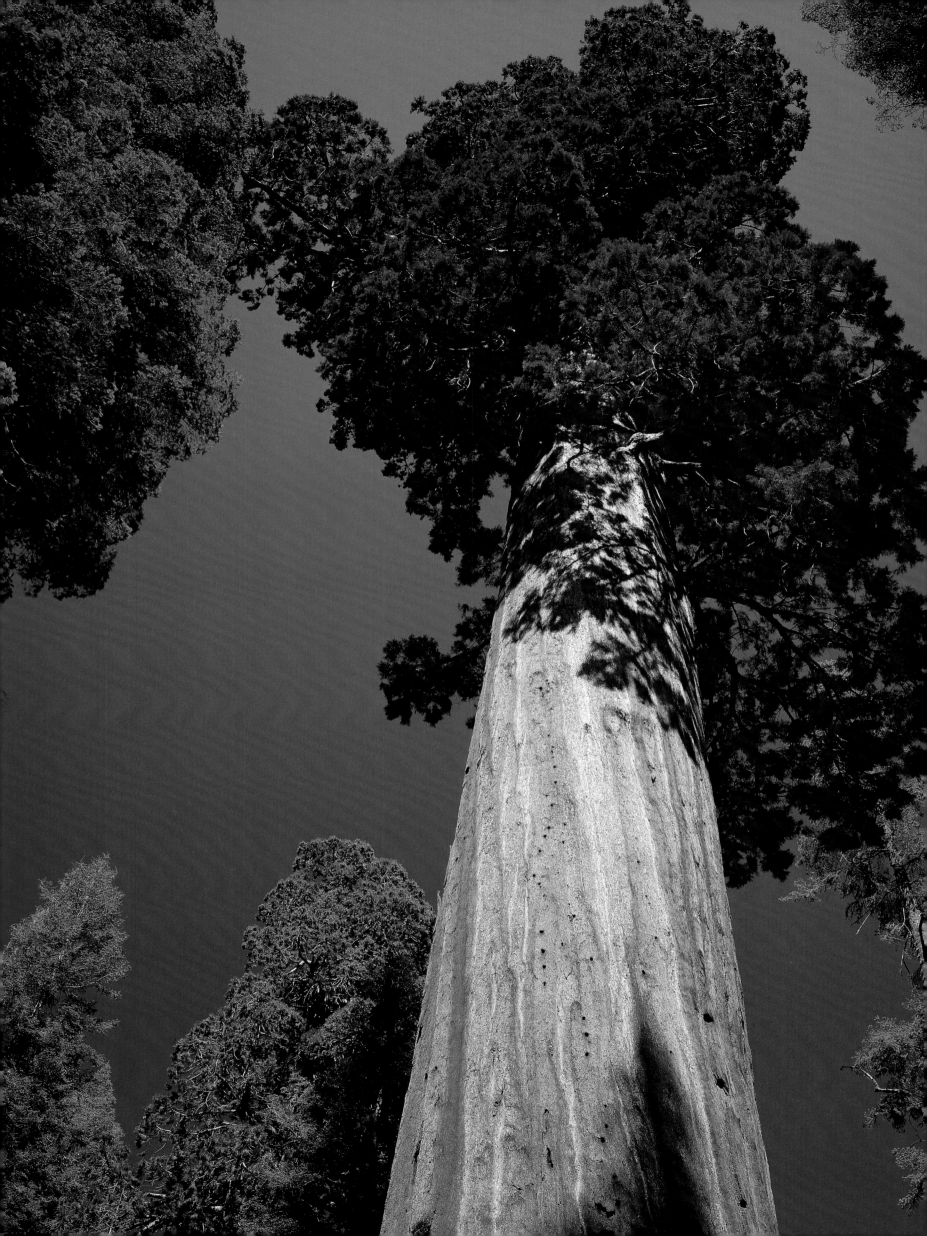

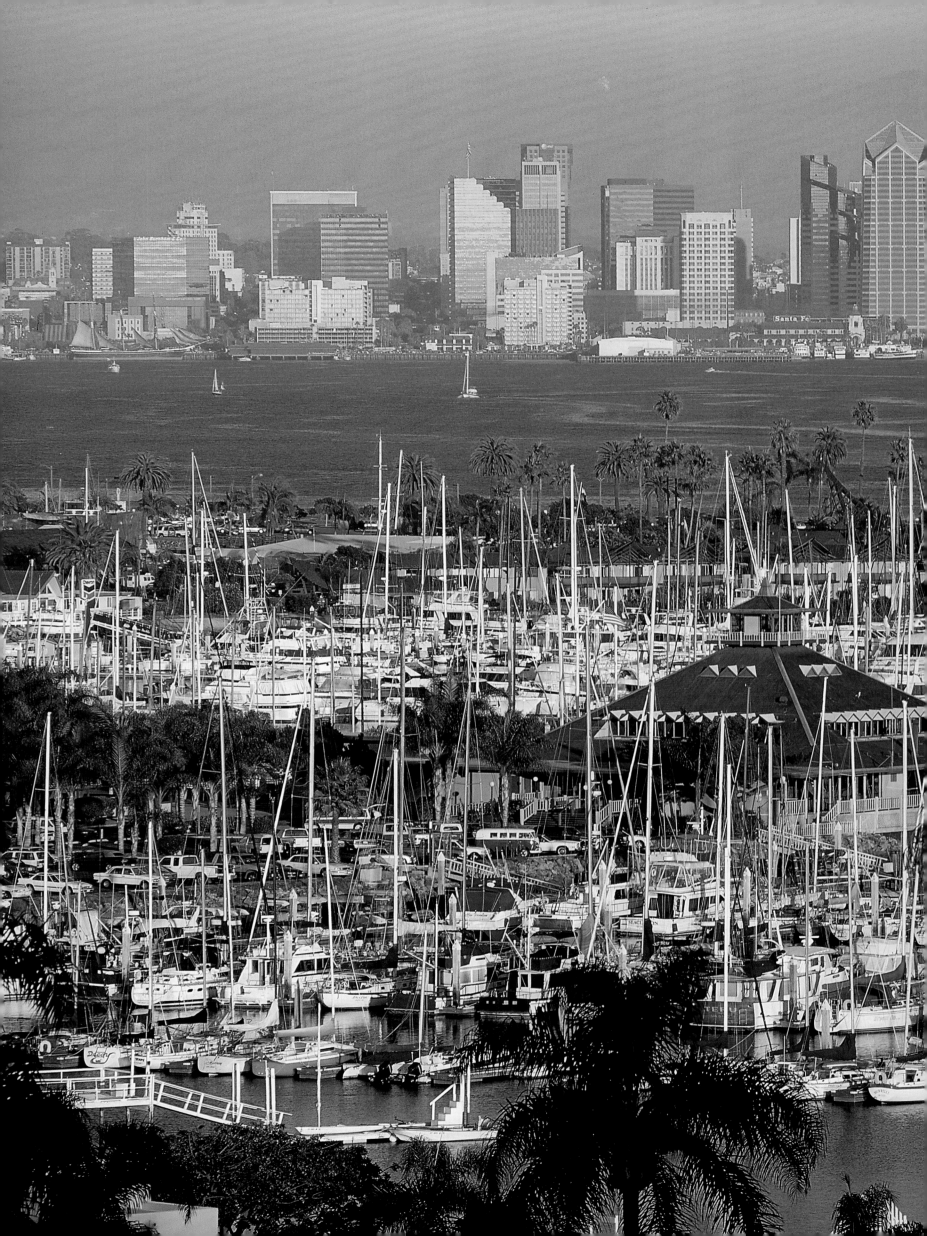

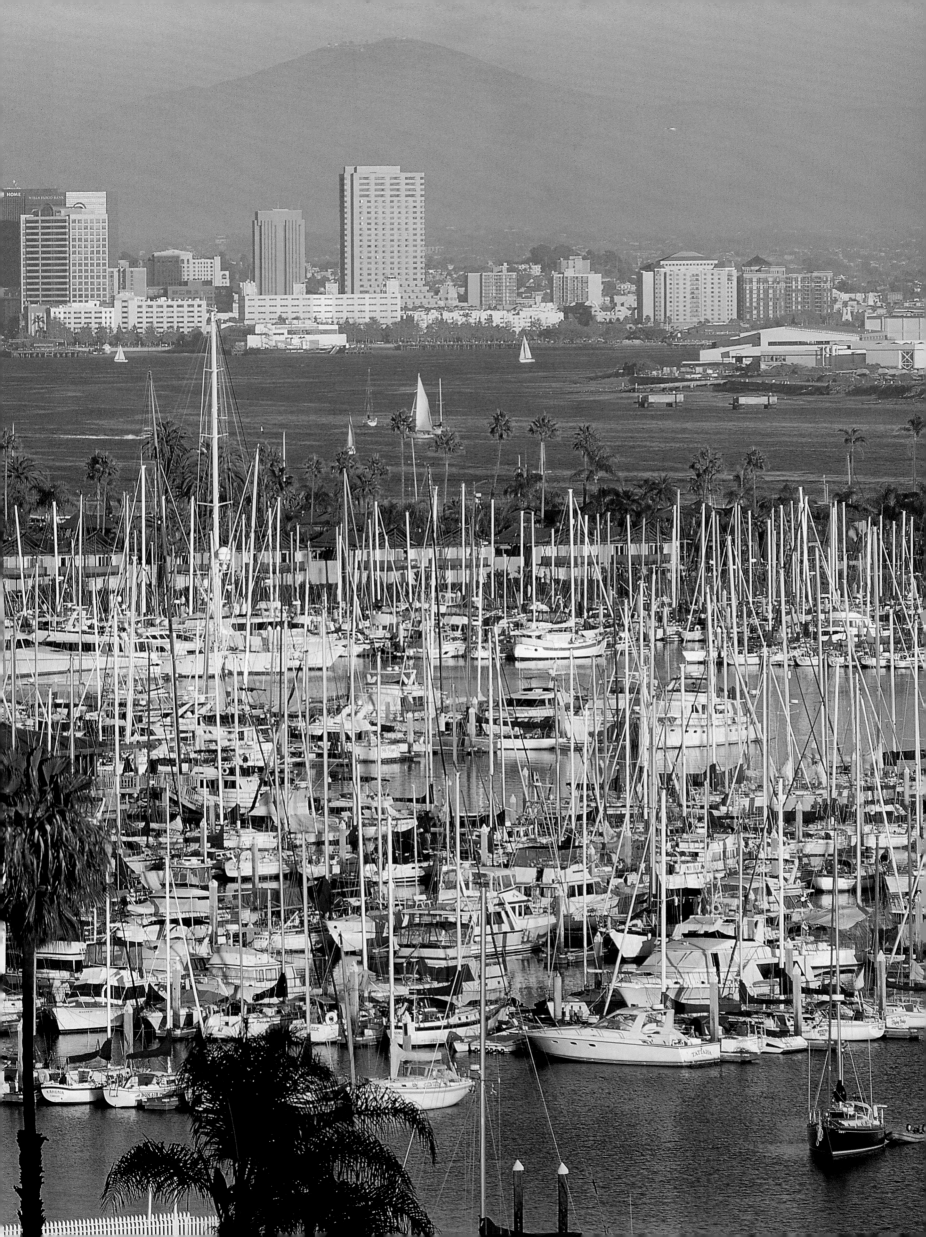

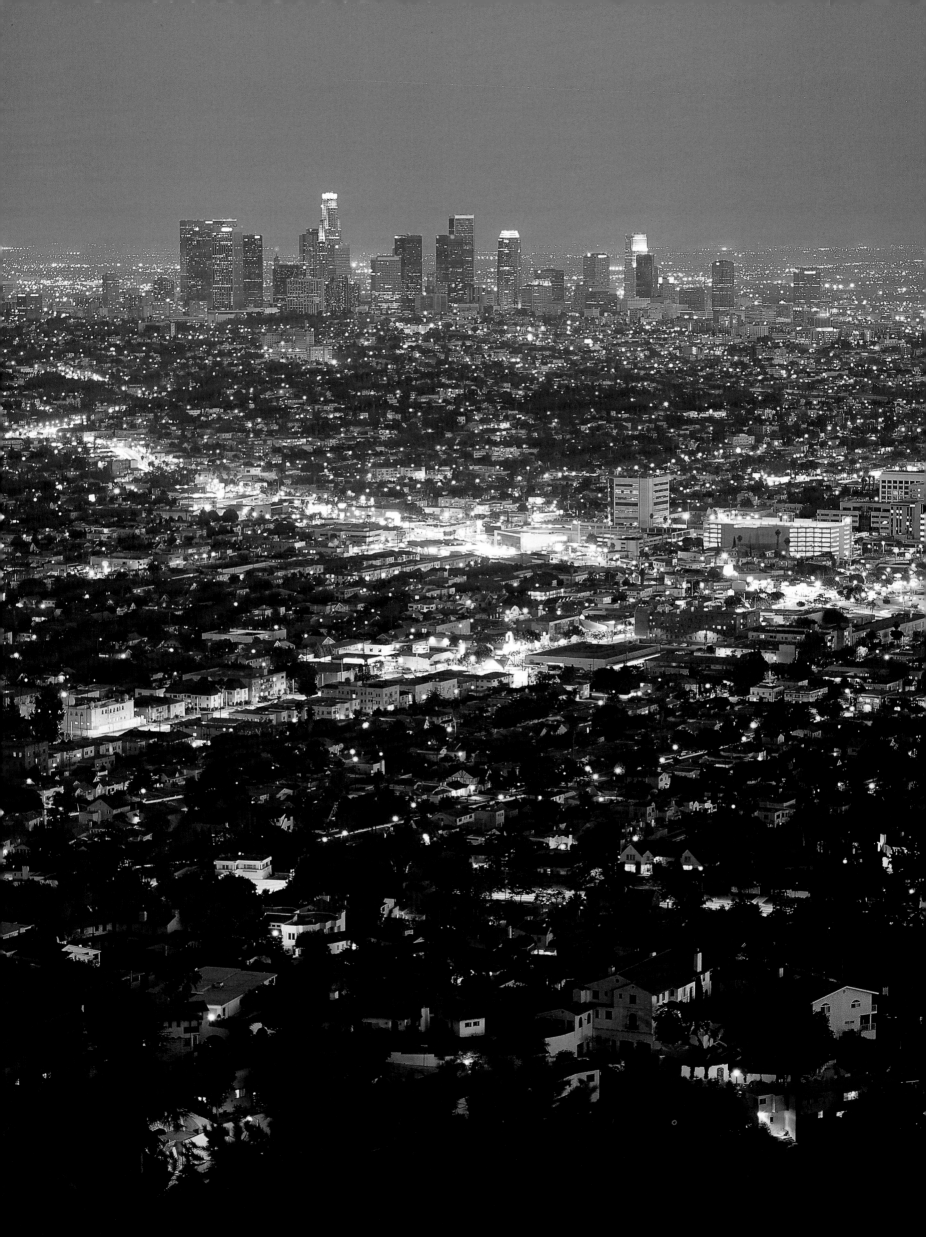

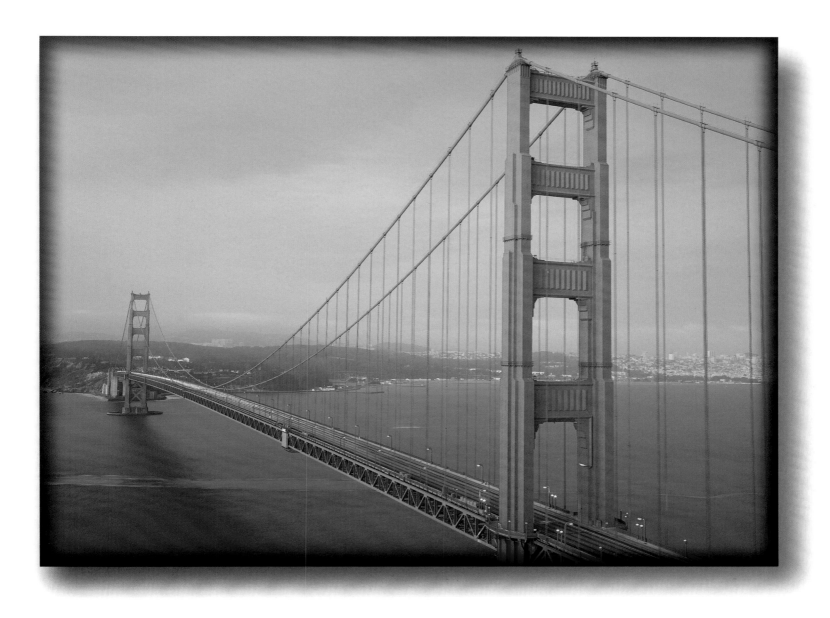

Built between 1930 and 1937 under the watch of Chief Engineer Joseph P. Strauss, the Golden Gate Bridge is one of America's most recognizable landmarks. Until 1964, it was the longest suspension span in the world. Despite a request by the navy to paint the bridge black and yellow, increasing its visibility, architect Irving Morrow chose the distinctive golden-orange.

Home to about 5,000 people in 1870, Los Angeles was only one-tenth the size of booming San Francisco. But when the railway arrived in 1876 the population doubled and has continued to grow ever since. By 1900 there were 100,000 residents — a number that's ballooned to 3.8 million today. Millions of sightseers each year explore the region's attractions, from Rodeo Drive to Disneyland. *(left)*

San Diego Bay, on the shores of California's second-largest city, is one of the world's best natural harbors. Along with pleasure craft like these, the harbor is also home to a bustling commercial port, a cruise ship center, and one of America's largest navy bases. Naval air stations and a submarine base are nearby. *(previous pages)*

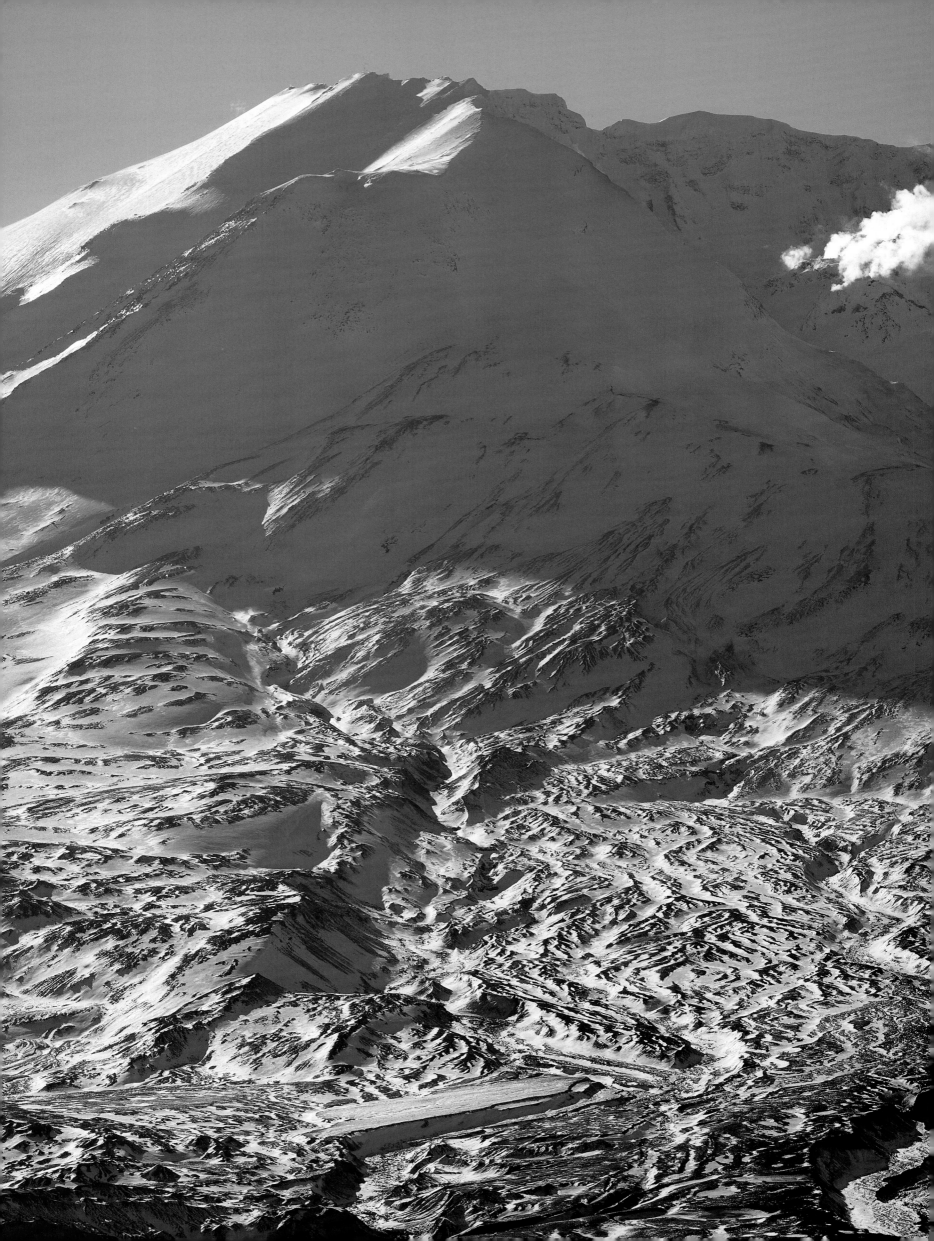

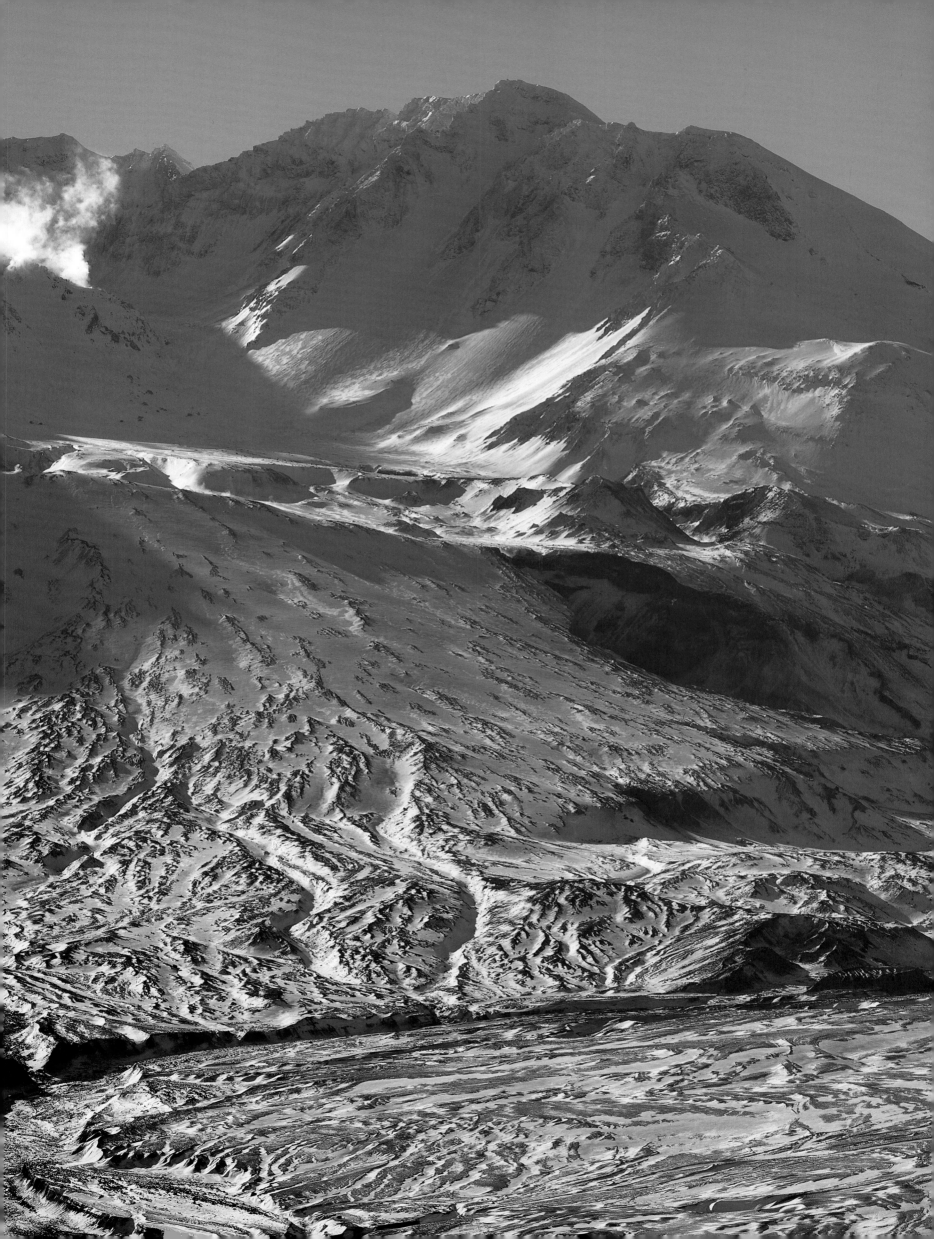

In the early 1800s, tales of fertile valleys and rich trade routes with Asia sparked "Oregon fever." Thousands of hopeful immigrants traveled a 2,000-mile trail from Independence, Missouri, to the Willamette Valley, homesteading in the hills and settling along the coast.

The native people of the region called Washington's Mount Saint Helens *Louwala-Clough,* or "smoking mountain." It earned its name on May 18, 1980, when a sudden eruption after 123 years of dormancy killed 65 people and decimated 160,000 acres of forest. Today it's possible to visit the very rim of the crater and look down into an active volcano. *(previous pages)*

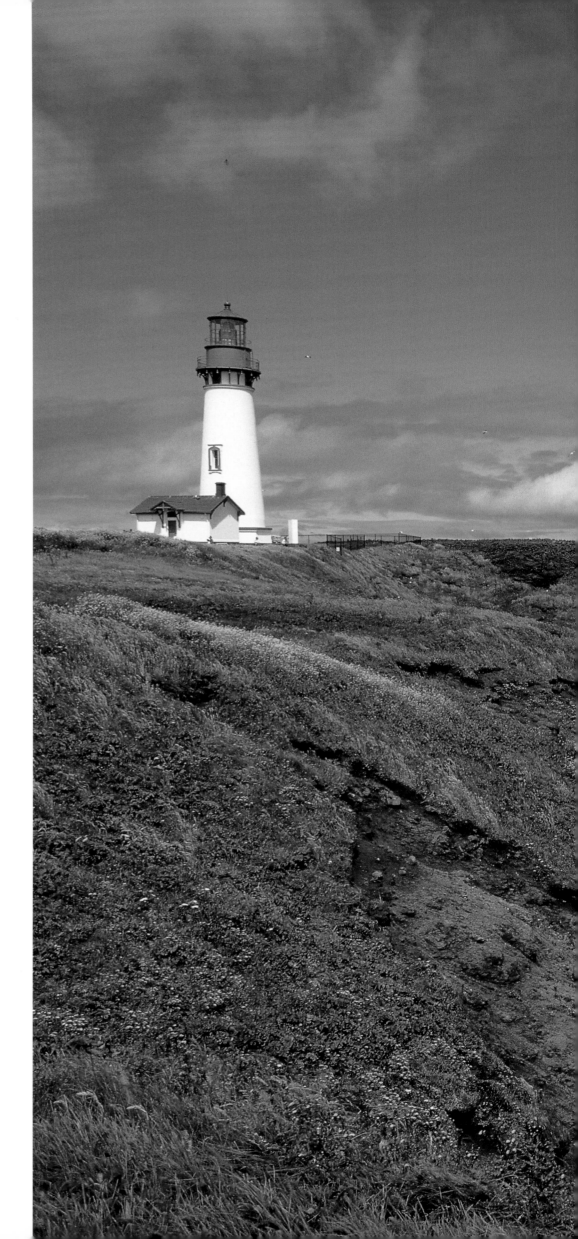

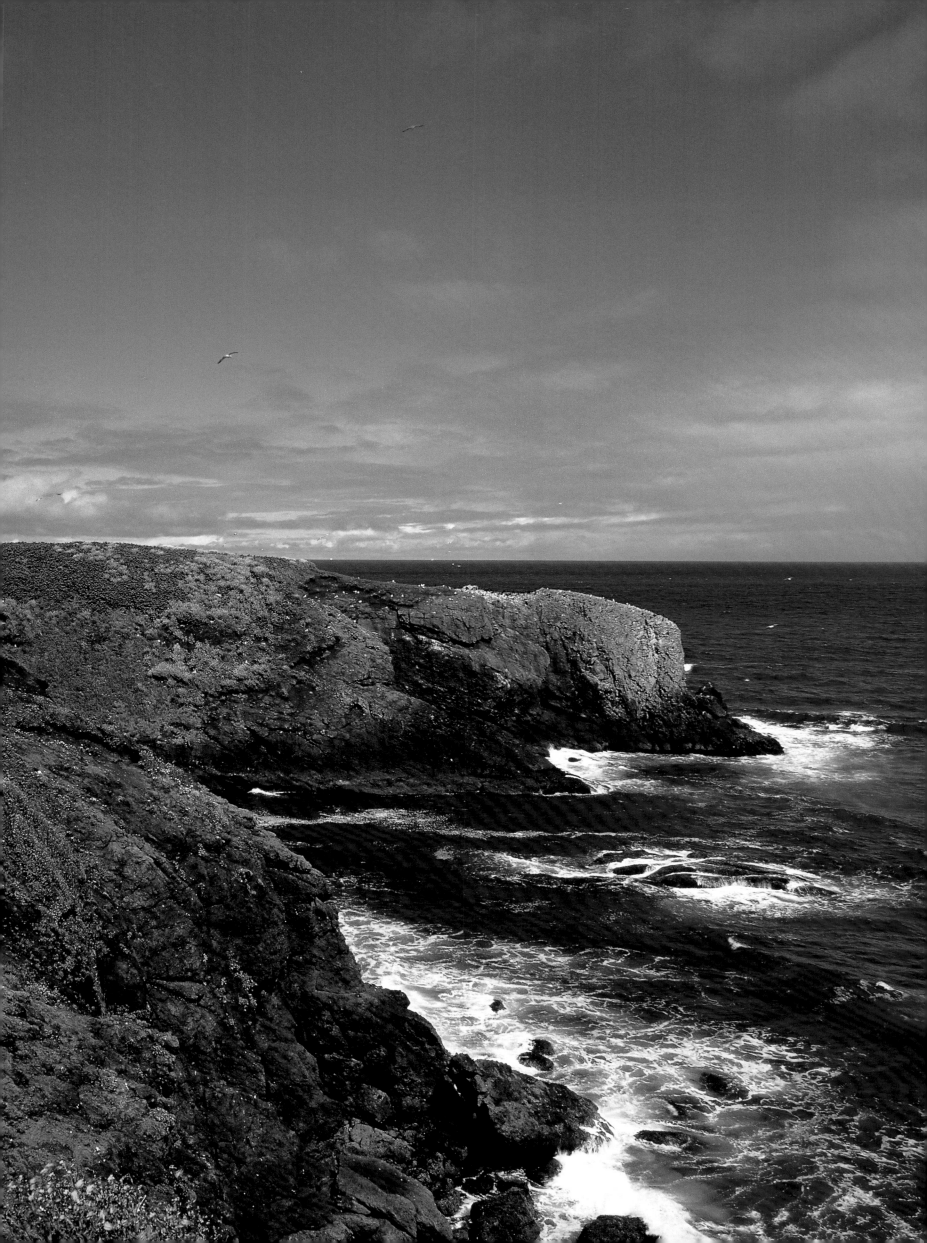

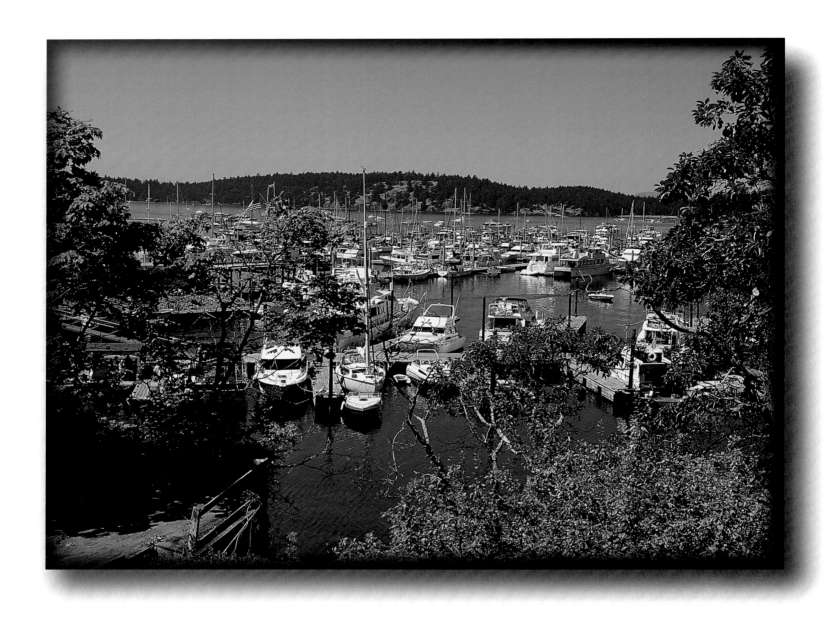

Washington State Ferries serve four of Washington's 172 San Juan Islands, most of which are small and privately owned. The Canadian-U.S. border was vague here until 1859, when an American farmer shot a British neighbor's pig. The event sparked the "Pig War," involving troops, warships, and blockades. No shots were fired, however, and a German mediator finalized the border in 1872.

This view of Ecola State Park is one of the most photographed in Oregon. Within the park, campers and picnickers enjoy the ocean breezes, hikers wander through the old growth Sitka spruce forest, and windsurfers, kayakers, and surfers brave the waters. *(right)*

In many cases, families have farmed the hills of Washington's Palouse region for several generations, each one bringing improvements in planting and harvesting. Wheat is now the state's fourth-largest agricultural product, after apples, milk, and cattle. Together, agriculture's yields contribute more than $5 billion to Washington's economy. *(overleaf)*

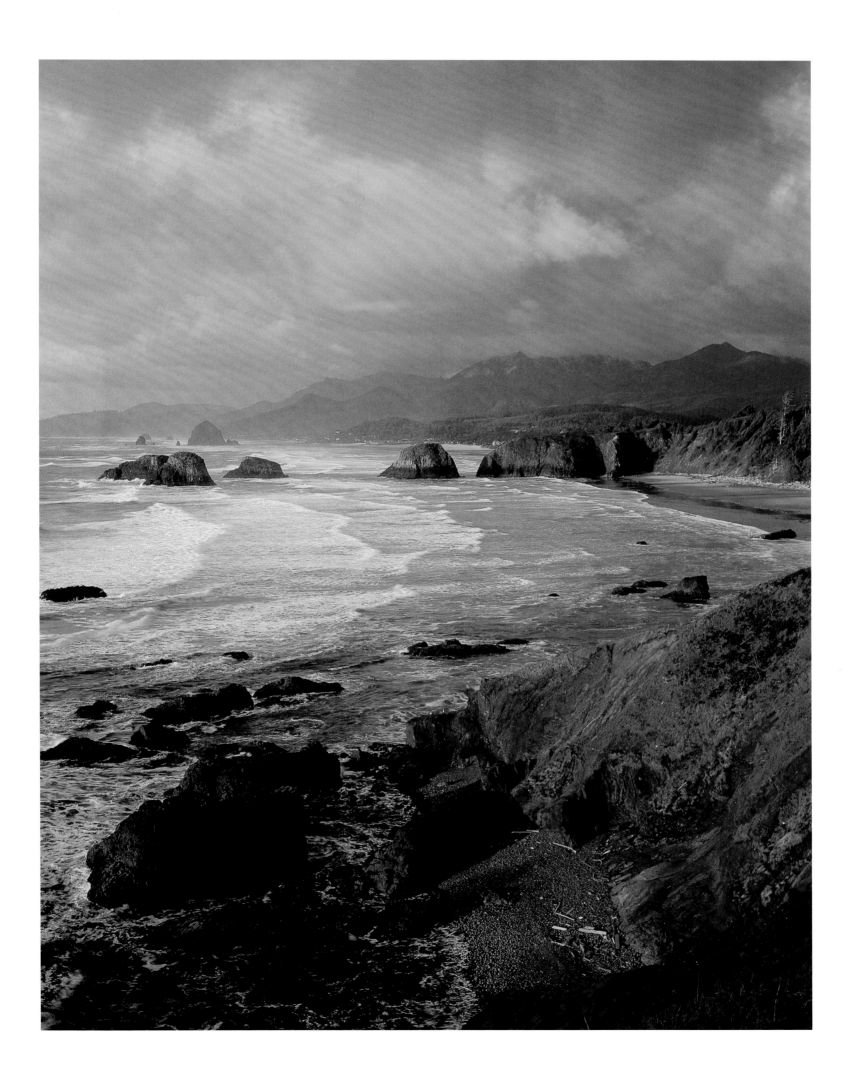

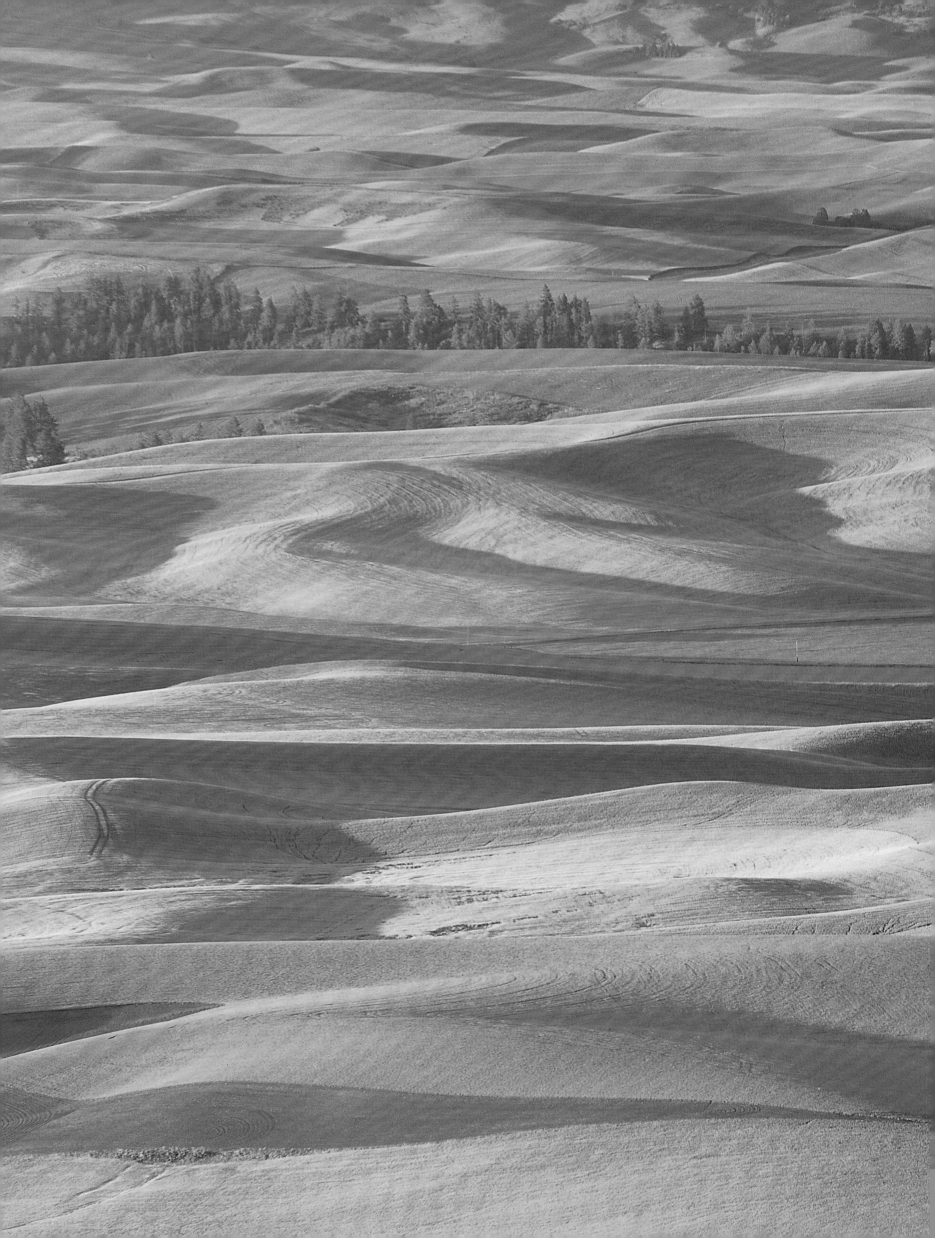

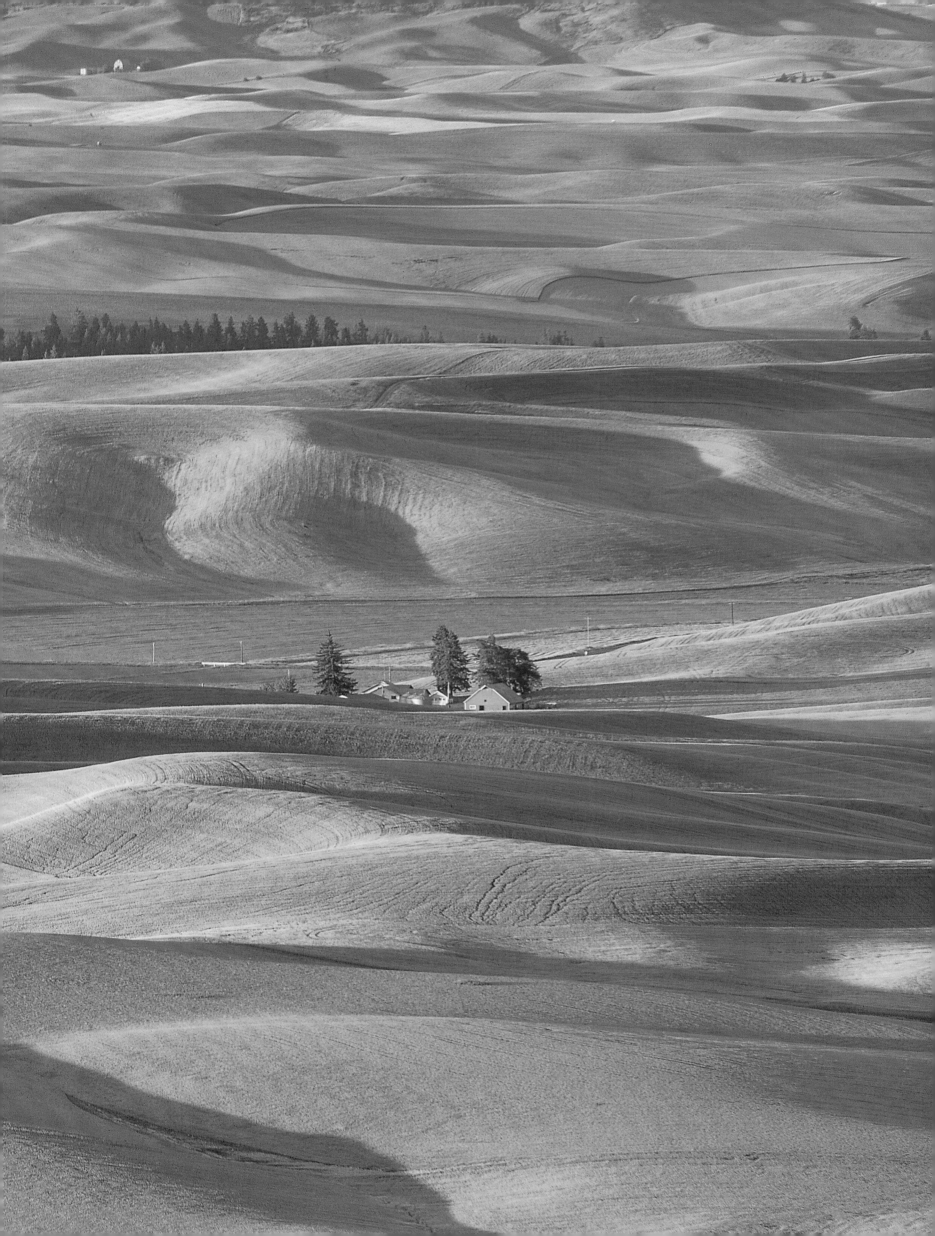

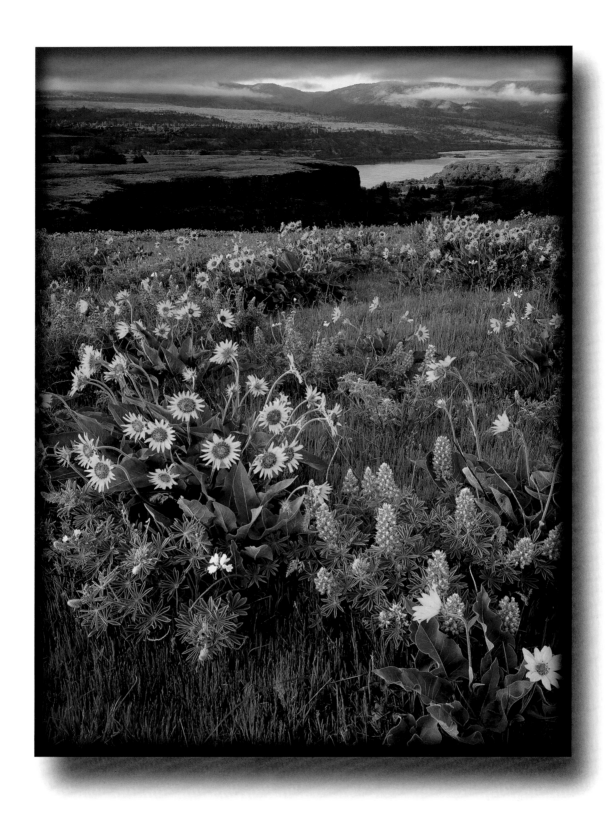

Eighty miles long and up to 4,000 feet deep, the Columbia Gorge divides Washington from Oregon along the river's route to the Pacific. The National Scenic Area, established in 1986, protects the wildflower meadows that line the rim of the gorge and the waterfalls that pour down the cliff faces, as well as premier windsurfing, boating, and camping destinations.

In 1849, a group of settlers and prospectors attempted a shortcut across California's Death Valley on their route to the coast. They named the region after narrowly surviving the desert. At Racetrack Playa, one of Death Valley National Park's most mysterious sites, seemingly immovable rocks and boulders have traced paths behind them. Scientists believe that high winds combine with slick surfaces, created after the playa floods, to allow the rocks to slide. *(right)*

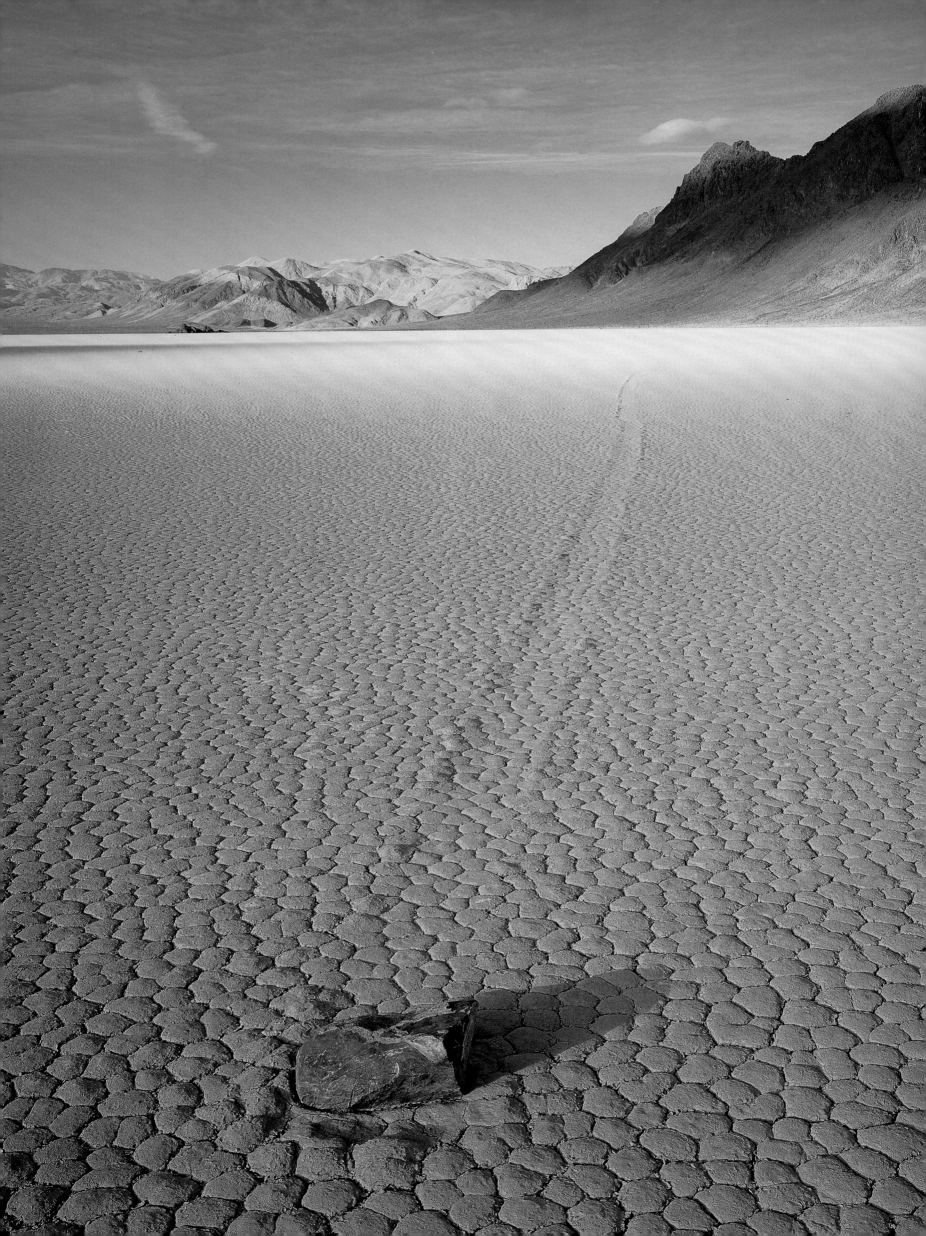

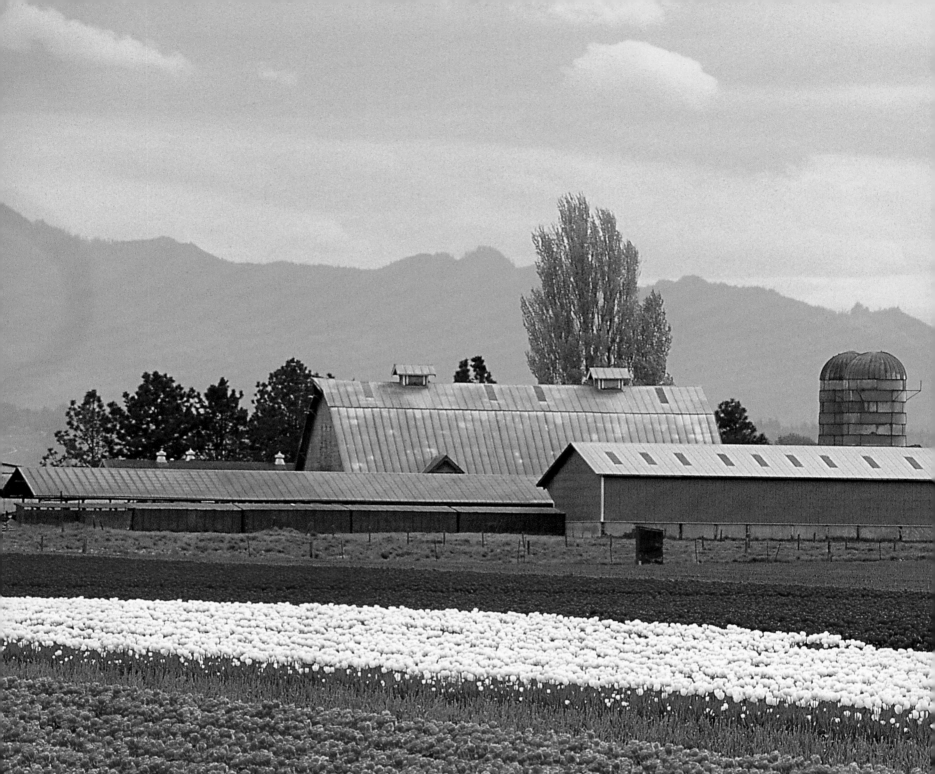

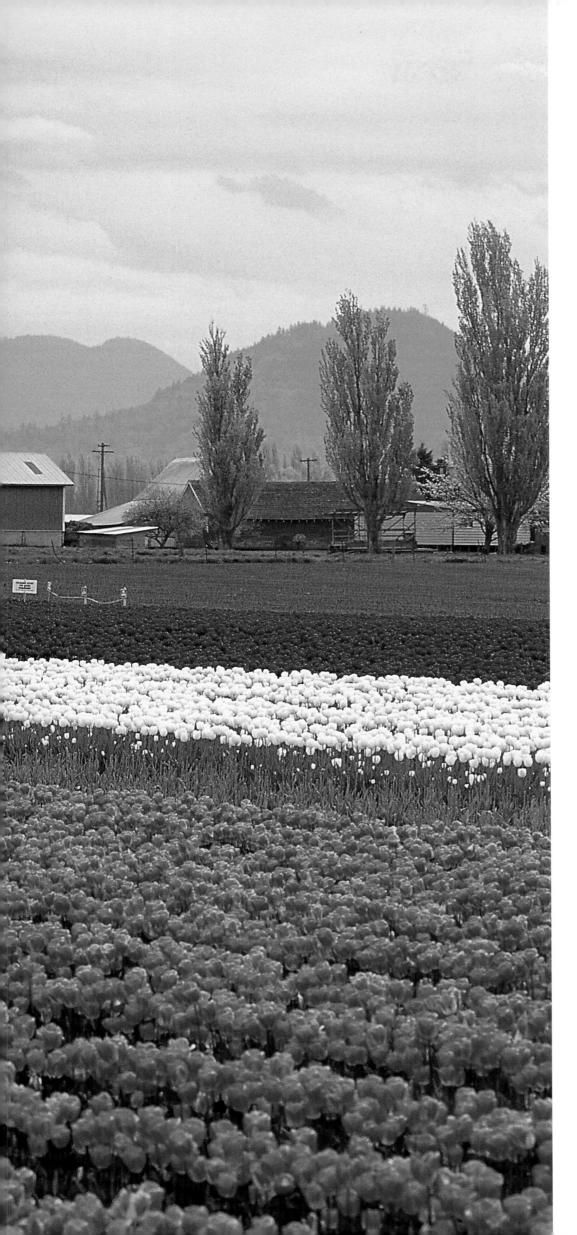

Mary Brown Stewart planted the first tulips in Washington's Skagit Valley in 1906, tending bulbs she had imported from Holland. Today, about 7,000 acres of local bulb fields produce more than $40 million of flowers each year. The Mount Vernon Chamber of Commerce organized the first Tulip Festival, one of Washington's most popular annual events, in 1984.

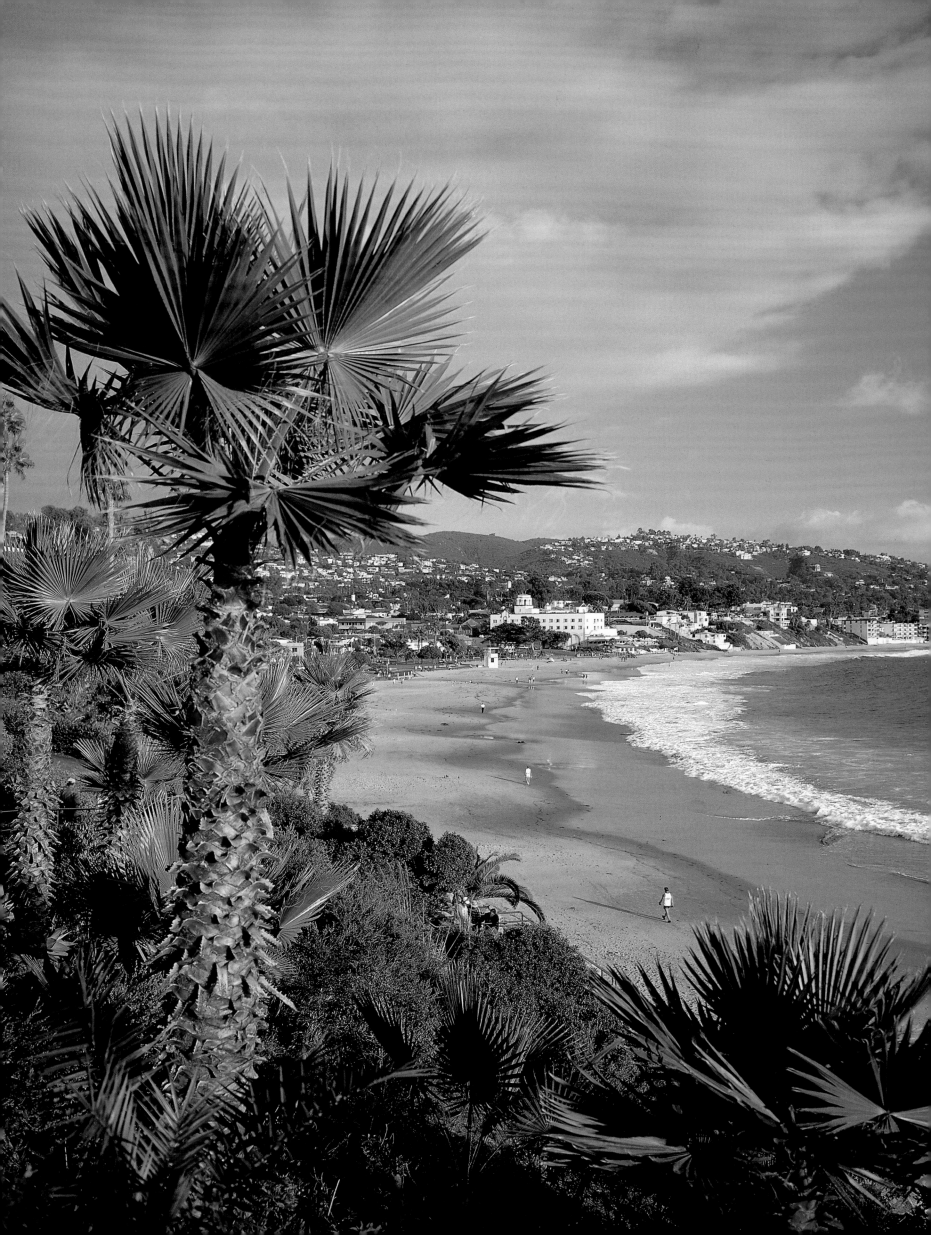

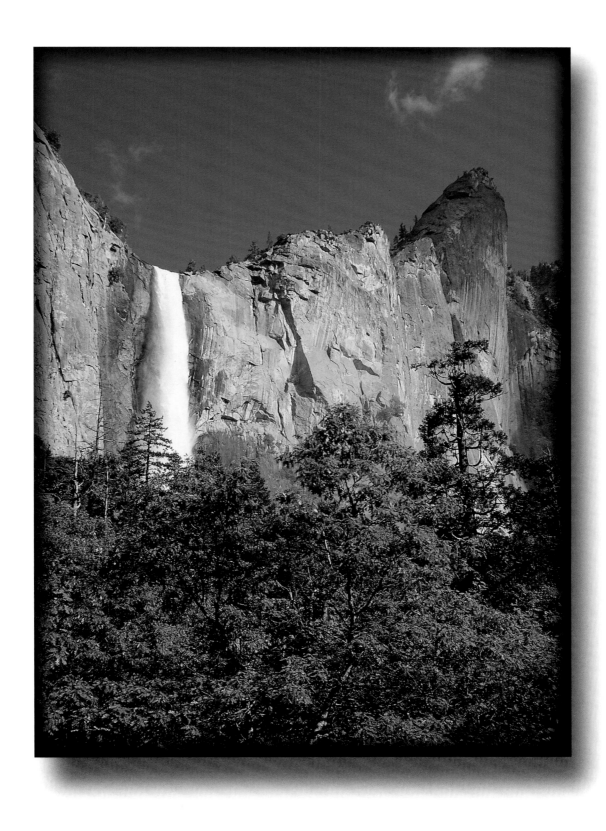

Visitors began pouring into the Yosemite Valley in the 1850s, eager to see the storied cliffs, towering trees, and roaring falls. To protect the region and its giant sequoias, Congress declared this a national park in 1890. Part of what brings 4 million visitors to the park each year, Upper Yosemite Falls thunders 1,430 feet down a sheer cliff face.

Since the early 1900s, Laguna Beach, California, has attracted painters and other artists, many of whom live here year-round. Arts fairs and festivals, as well as the community's seven sandy beaches, draw thousands of visitors — from movie stars to vacationing families. *(left)*

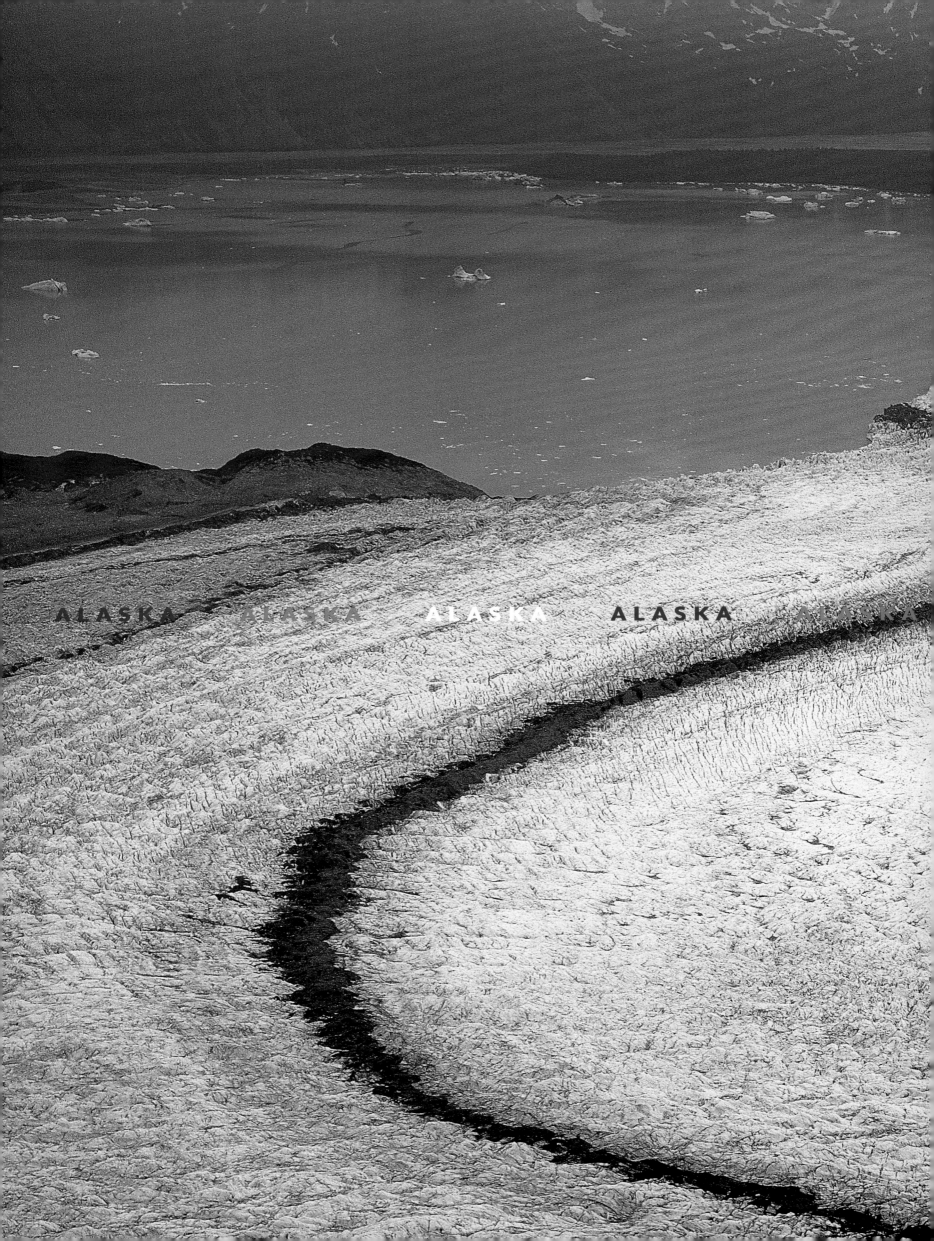

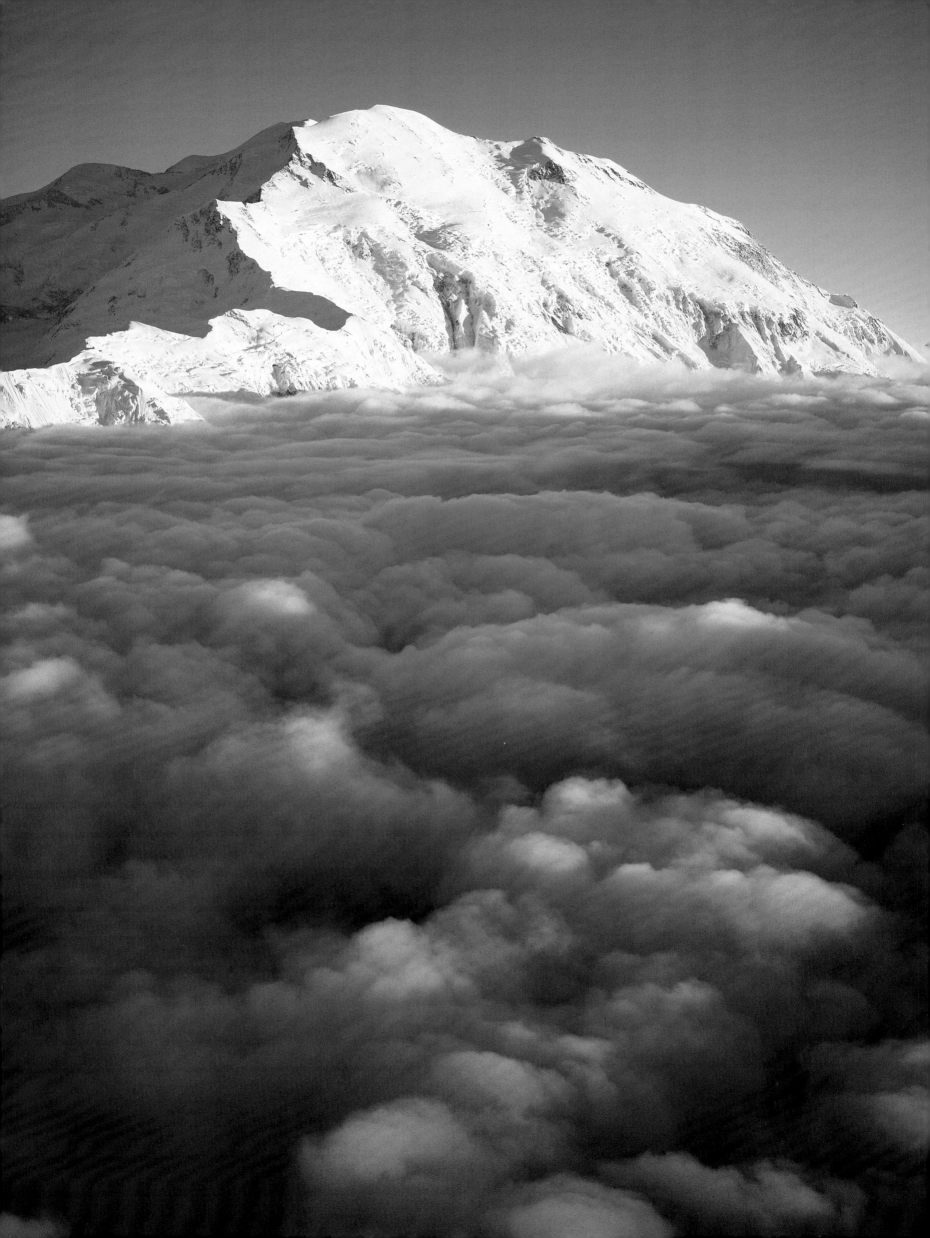

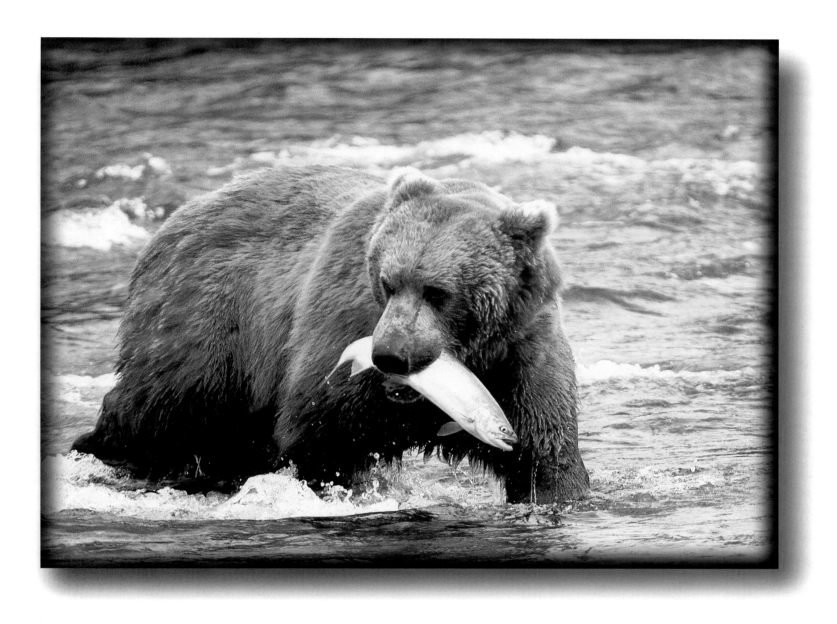

Brown bears, also known as grizzlies, roam the coast of Alaska in search of salmon. After the fall feast, a male bear preparing for hibernation may weigh up to 1,400 pounds — weight that will help it survive a winter without eating or drinking. Pregnant females are the first to enter their dens and may hibernate for five to seven months before emerging with their young in the spring.

Denali National Park and the nearby Denali National Preserve protect about 6 million acres of untouched peaks and valleys, home to more than 35 mammal and 150 bird species. Mount McKinley is the highest peak within the park, looming almost four miles above sea level and often shrouded in clouds. *(left)*

When explorer George Vancouver sailed through this area in 1794, Glacier Bay was not a bay at all — it was filled with ice. By the late 1800s, the glaciers had receded more than 40 miles, and today the bay is more than 60 miles deep. About 200,000 visitors, most of them cruise ship passengers, visit Glacier Bay National Park each year to see the massive ice flows meet the ocean. *(previous pages)*

In 1897, news of the Alaska gold fields sparked imaginations around the world, and boatloads of ill-prepared and adventurous men and women turned Ketchikan into a supply depot. The town remains an important stopping place, now for cruise passengers who disembark for a glimpse of the region's native heritage and natural history.

Alaska's Arctic National Wildlife Refuge serves as the calving grounds for the Porcupine caribou herd, 150,000 animals that take shelter on the tundra here each spring. One of the world's largest untapped oil resources is believed to lie under the refuge lands, a possibility that threatens the pristine land and sparks the tempers of industrialists and environmentalists alike. *(right)*

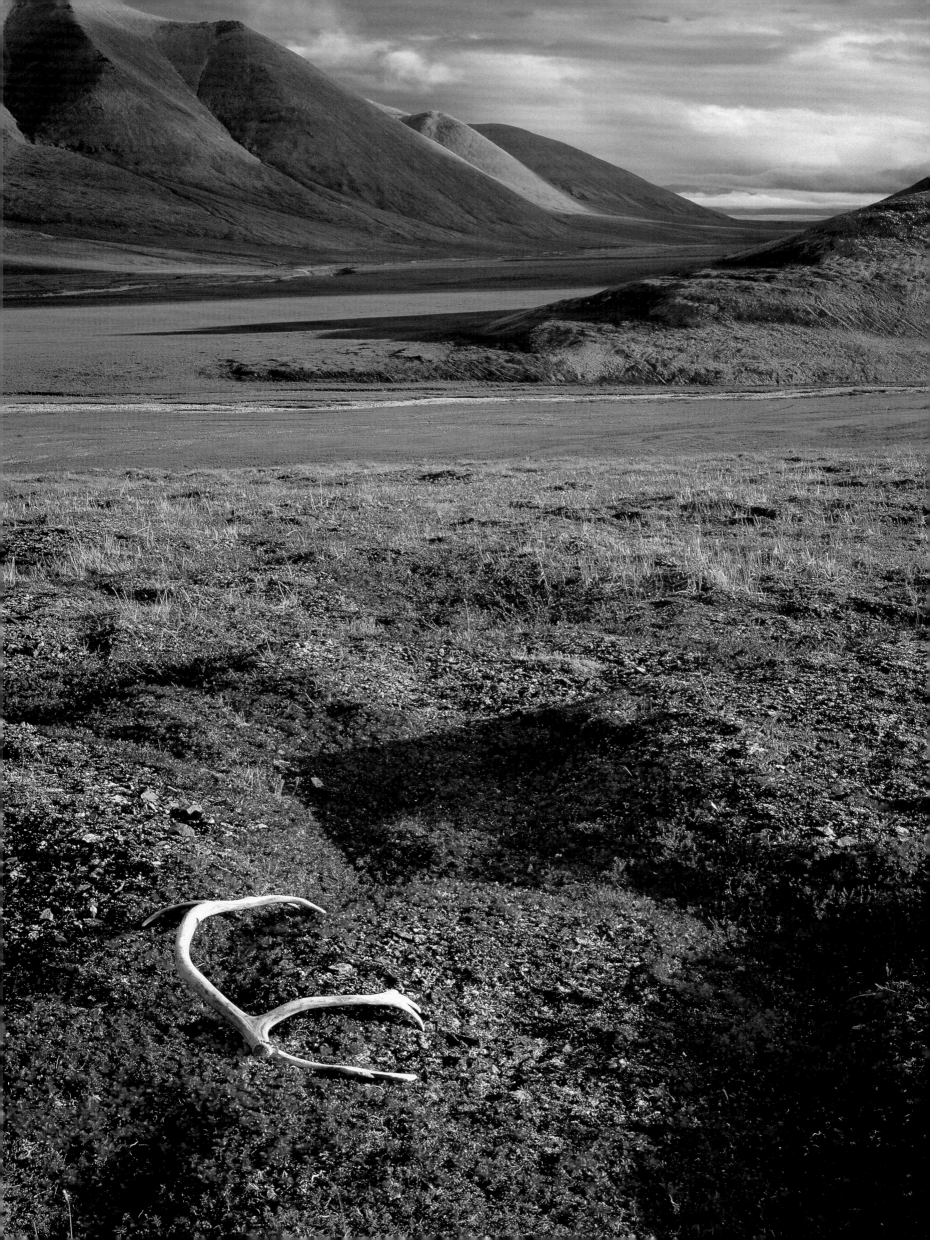

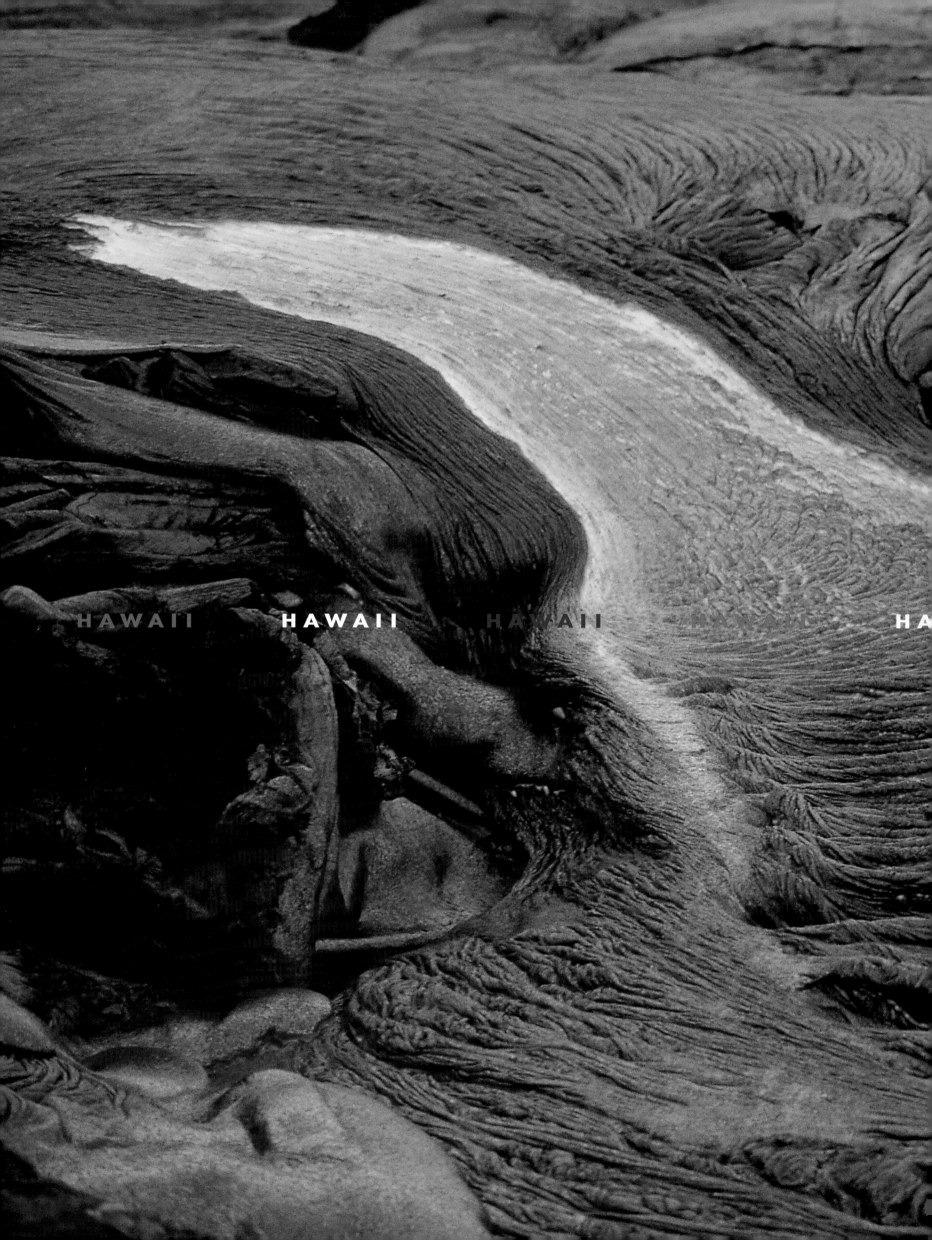

HAWAII HAWAII HAWAII HAWAII HA

HAWAII HAWAII HAWAII HAWAII

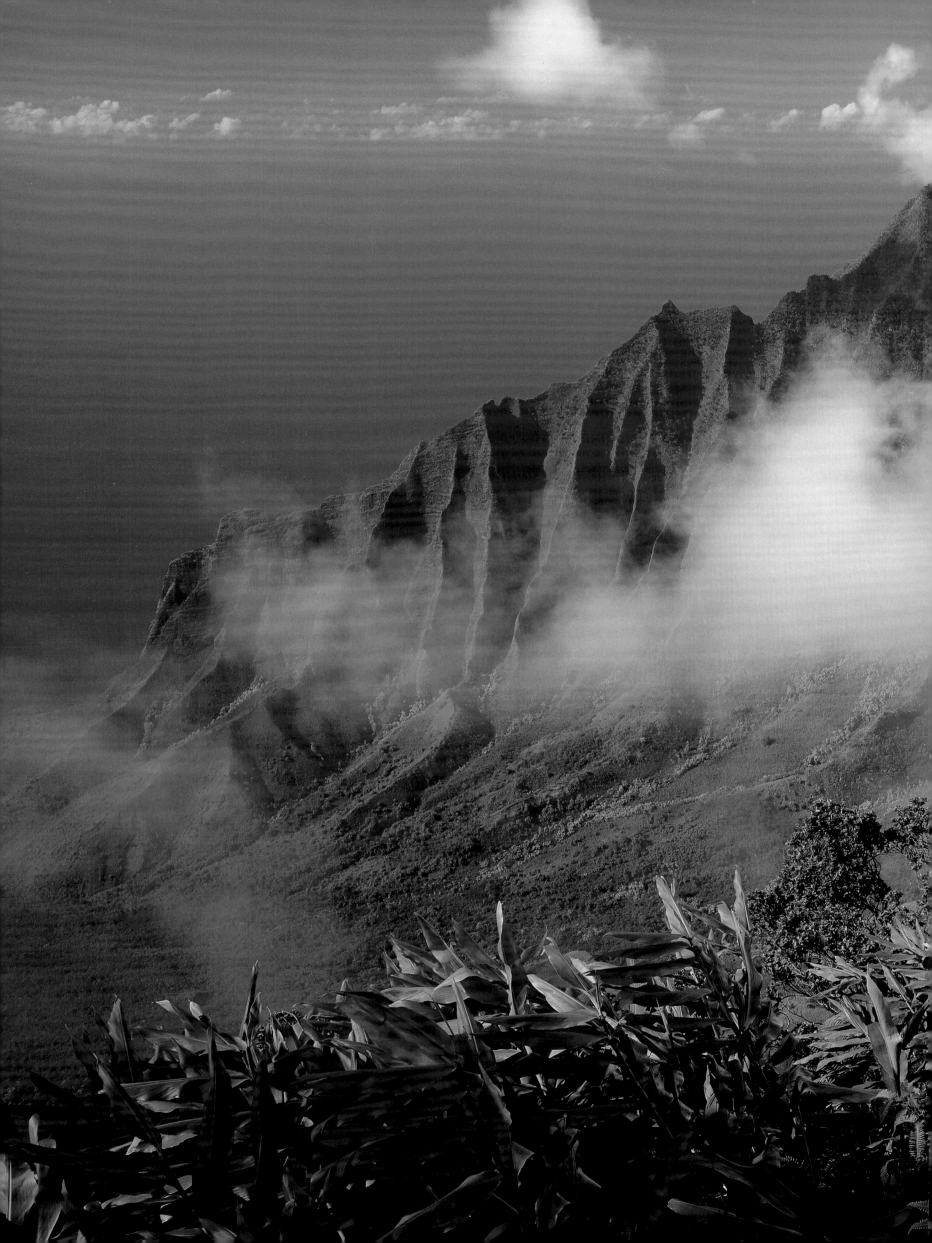

The lush Na Pali Coast on Kauai, the oldest of the Hawaiian Islands, attracts more and more hikers each year, though locals warn travelers to watch for spirit tricksters on the route. Along the Kalalau Trail, hikers discover cliffs thousands of feet high, reefs and tidepools, ancient lava flows, and a profusion of native plants.

Seventy million years ago, magma burst from vents on the floor of the Pacific and began forming the eight Hawaiian Islands. They continue to grow even today, with new eruptions constantly adding to the land. Hawaii boasts 13,677-foot Mauna Loa, the world's largest volcano, and Kilauea, the world's most active. *(previous pages)*

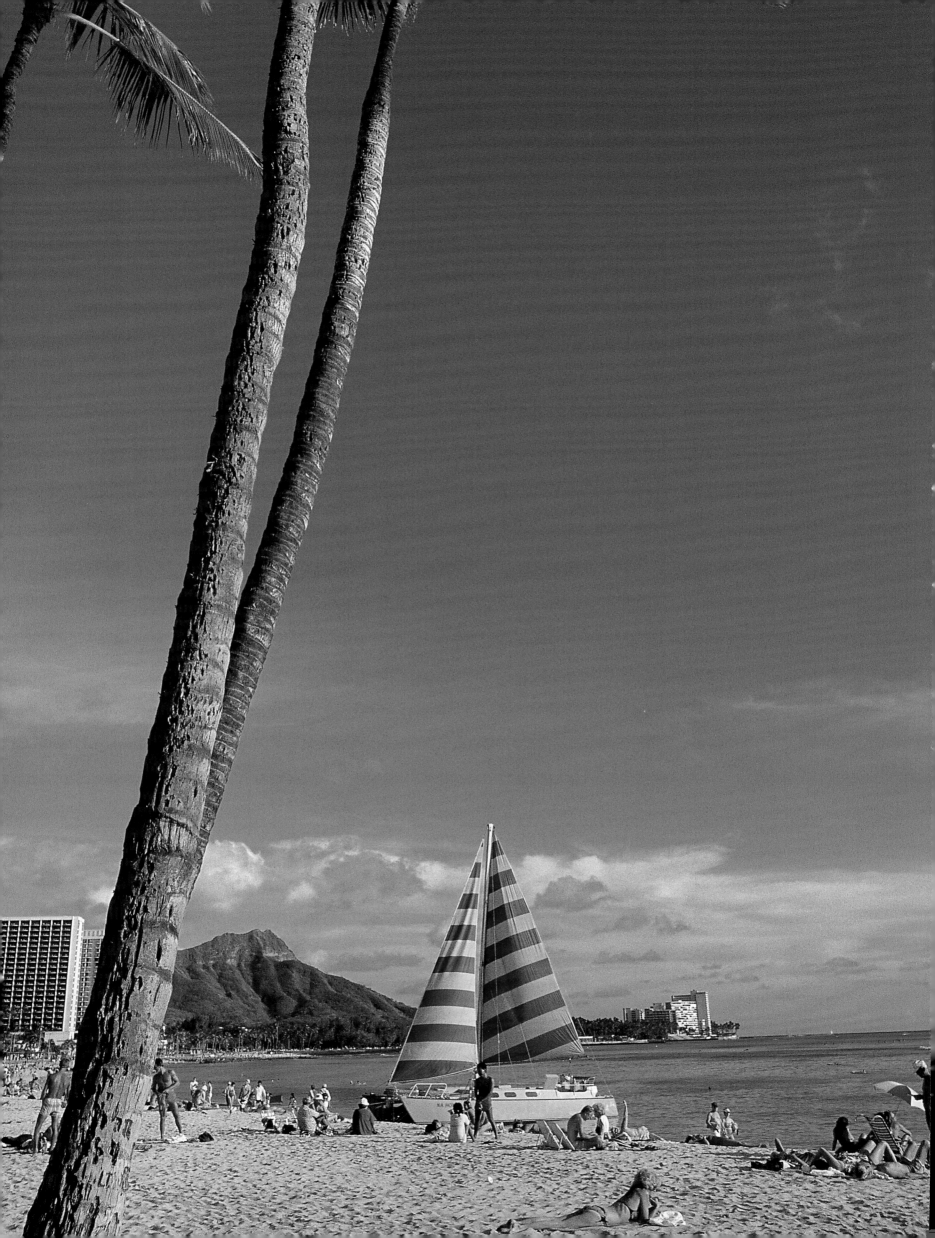

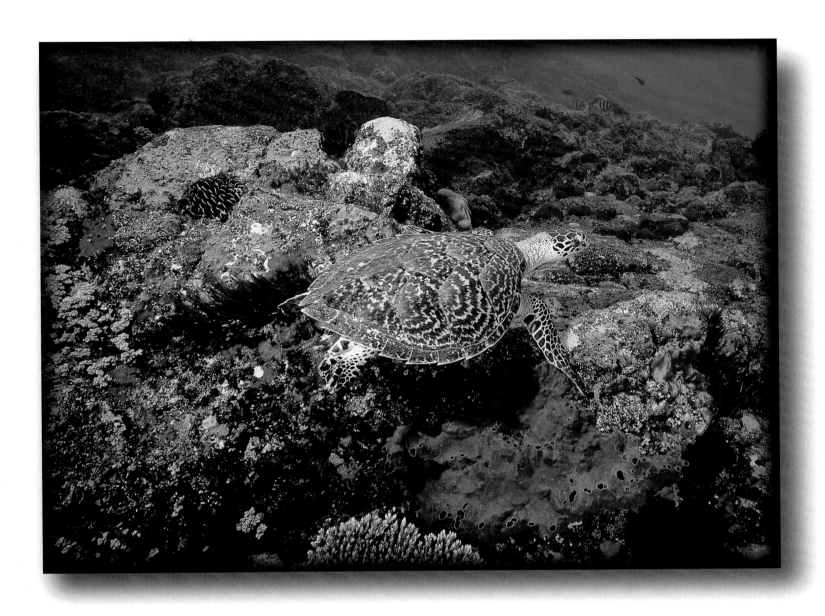

Millions of green sea turtles once swam the world's oceans. Only a few hundred thousand remain, many in the temperate waters near Hawaii, where state laws help protect them. Every few years, female turtles migrate to the northwestern shores of the islands, climbing on to the sand to nest. Each nest may contain a hundred eggs, but only a few hatchlings survive.

Honolulu means "sheltered bay," a name which describes the natural harbor that has made the city a successful port since the nineteenth century. At nearby Waikiki Beach, vacationers enjoy a different kind of refuge, soaking up sun on the two-mile-long white sand beach or surfing the breakers just off shore. *(left)*

Polynesians from the Marquesas Islands and Tahiti traveled up to 2,000 miles by canoe to arrive in the Hawaiian Islands almost 2,000 years ago. They brought with them their hierarchical society, a complex religion, food plants such as palm and taro, and expert fishing skills. *(overleaf)*

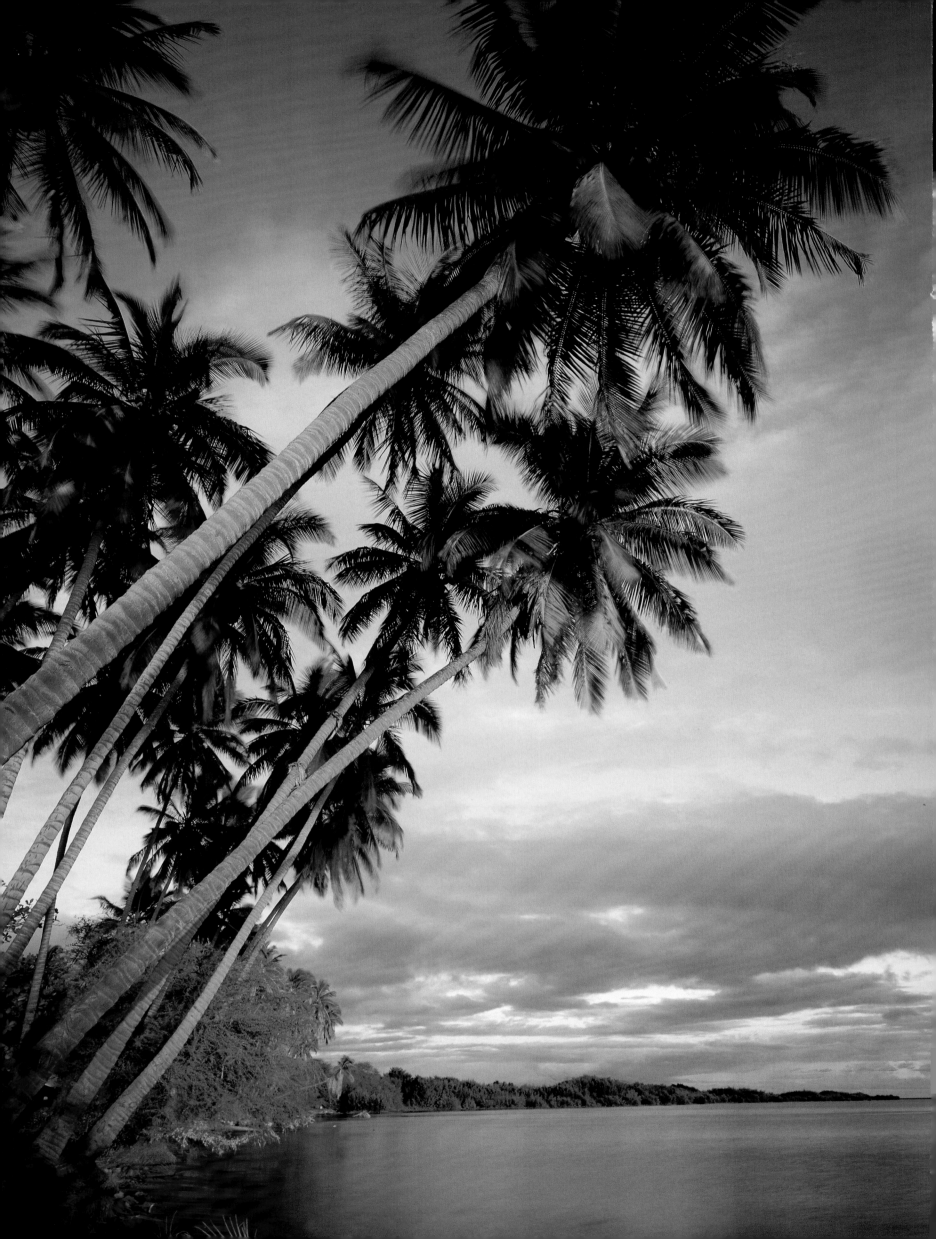

The rolling grasslands of western Kansas appear through Keyhole Arch, part of the
Chalk Pyramids. Encased in hard mineral deposits, these formations have withstood
the wind and storms that have flattened the surrounding prairie. Within the stones, tiny
fossils bear witness to the ancient sea that once covered the region. *(right)*

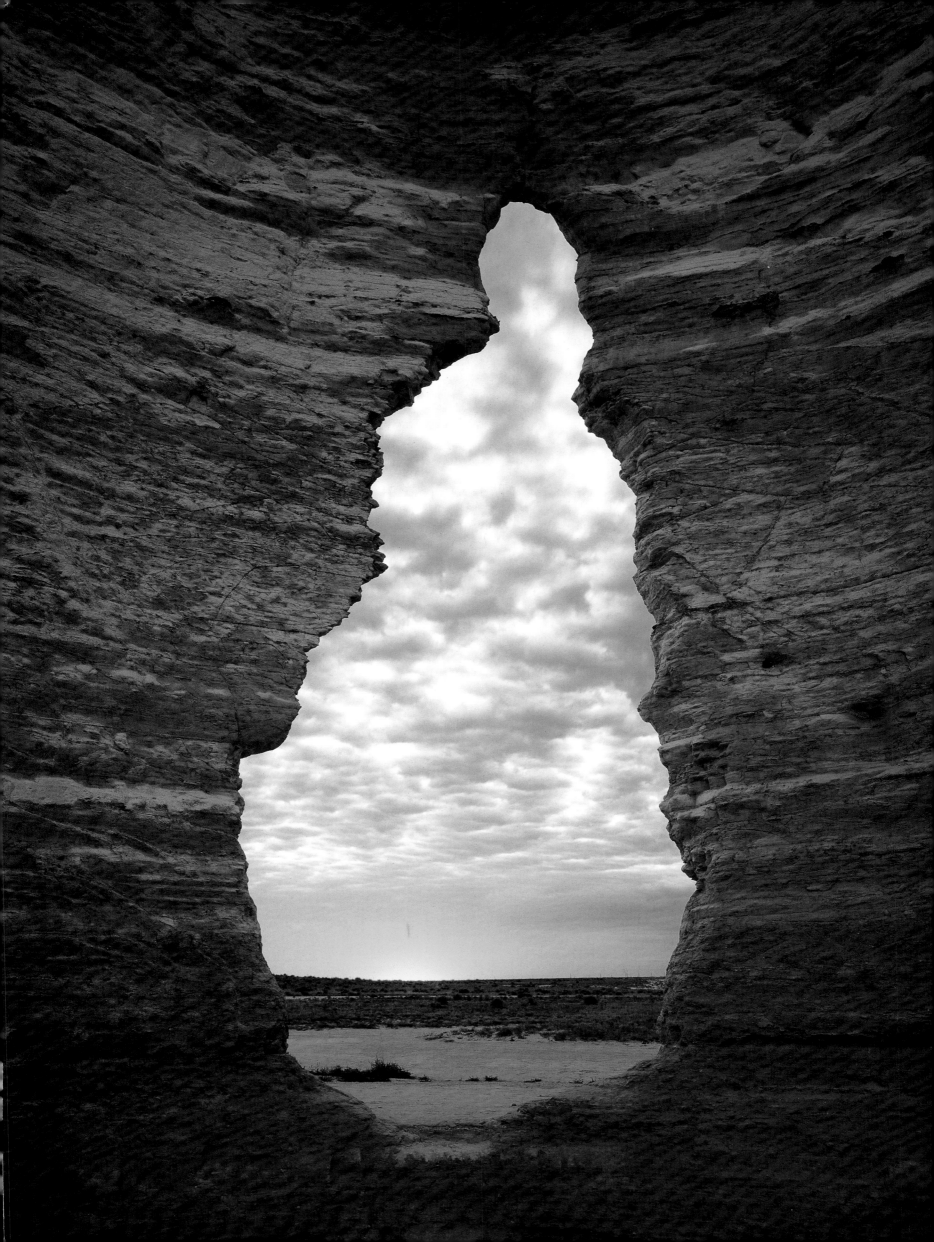

Richard Cummins/Folio, Inc. 1, 54, 55

Terry Donnelly 2, 44–45, 51, 80–81, 82, 86–87, 88–89, 91, 94, 95, 98–99, 101, 119, 122–123, 130–131, 137, 155–156, 157, 161, 164–165, 167, 170, 171

Scott T. Smith 5, 34–35, 64–65, 108, 181

Tom Till Photography 6, 22, 23, 29, 36, 40, 41, 42–43, 50, 58, 66–67, 68–69, 71, 72–73, 76–77, 84–85, 90, 96–97, 102–103, 104, 105, 106–107, 110–111, 112, 120–121, 125, 132, 134–135, 136, 138–139, 144–145, 146, 148, 149, 150–151, 152, 176–177, 178, 184–185, 188, 192

Paul Rezendes 10–11, 12–13, 18–19, 20–21, 26–27, 38–39, 48–49

Mary Liz Austin 14–15, 16, 100, 133, 143, 162–163

Steve Dunwell/Folio, Inc. 17

Michael E. Burch 24, 128–129, 166, 172–173, 175, 186

Richard T. Nowitz/Folio, Inc. 25, 46

Jeff Greenberg/Folio, Inc. 28, 78

G. Davies/Mach 2 Stock Exchange 30–31

Greg Pease/Folio, Inc. 32

Alan Goldstein/Folio, Inc. 33

Middleton Evans/Folio, Inc. 37

Adam Jones 47, 74–75, 83, 116–117, 124, 142, 168–169

Dennis Johnson/Folio, Inc. 52–53

Willard Clay/Dembinsky Photo Assoc 56–57, 63

Andre Jenny/Folio, Inc. 59

Michael Ventura 60–61

Walter Bibikow/Folio, Inc. 62, 113, 158–159, 160, 174

Andre Jenny/Unicorn Stock Photo 70

James Lemass/Folio, Inc. 79

G. Alan Nelson/Dembinsky Photo Assoc 92–93

Chuck Haney 109, 153

Darrell Gulin/Dembinsky Photo Assoc 114–115

Patti McConville/Dembinsky Photo Assoc 118

Mark E. Gibson/Folio, Inc. 126–127, 156

Scott T. Smith/Dembinsky Photo Assoc 140–141, 147

Mark Newman/Folio, Inc. 179

Fred J. Maroon/Folio, Inc. 180

Charlie Archambault/Folio, Inc. 182–183

Jesse Cancelmo/Dembinsky Photo Assoc 187